Mary
in Western Art

Timothy Verdon

Mary
in Western
Art

captions by Filippo Rossi

In association with
Hudson Hills Press
New York and Manchester

To my mother

No one can doubt Mary's importance in the spiritual history of Europe: every European city
has at least one grand church dedicated to this woman, and from the fifth century to the present,
Christian thinkers have devoted considerable space to her in their reflections. In the visual arts,
perhaps not even Christ has had so eminent a role as she, and in certain periods images of the
Mother indeed outstrip those of her Son both in quantity and in creative originality. The historical
identity of Europe's peoples – their self-image across time – in fact seems linked to the ways
in which they have venerated, imagined and depicted Mary.

Prepared with an eye to the cultural evolution now in course in Europe, the present volume
ponders this presence of Mary in art, suggesting its theological, devotional and social background.
It is not a manual of Marian iconography, nor does it propose to trace the doctrinal development
of Mariology, but seeks rather to evoke the affective rationale – what Pascal might have called
"the heart's reasons" – underlying Mary's centuries-old *cultus*. The text organizes the rich visual
material according to several methodological principles, using a thematic approach in the first
chapter, a biographical one in the second, and a historical example in the third: Mary as subject
in Florentine art.

The essay, although written from the viewpoint of religious faith, makes allowance for the fact that
many readers may lack direct experience of the individual relationship with Mary that determined
how she was represented in art: a relationship at once collective and intensely personal, shaped by
familiarity with the Judeo-Christian Scriptures and with the liturgical, devotional
and literary traditions of the Church. The text seeks to clarify the logical and emotional framework
within which that relationship made sense, relating the images to Church writings of different eras.
Passages quoted are intended as examples of a way of thinking, not as proofs in an argument;
however, they want to convey the mood of the civilization that generated Marian images, that is,
without presuming to "explain" individual paintings or sculptures. True works of art, in any case,
are never mere textual illustrations.

Like every book, this one is the result of implicit and explicit forms of collaboration, and it is the
Author's happy duty to acknowledge many who had a part in the work's genesis. I want to thank,
first of all, Stefano Zuffi, Valentina Lindon and Laura Lanzeni at Electa for their encouragement
and technical support, and to express special thanks – as ever – to my friend and assistant,
Filippo Rossi, both for preparing the longer captions and for enlightening conversations
in the context of our activity in the Office for Catechesis Through Art of the Archdiocese
of Florence. Thanks are also due to many Protestant friends who have helped me grasp the reserve
traditionally felt by Evangelical Christians in the face of Catholic veneration of Mary.
Above all I want to express gratitude to the women of my life and, in first position, to my mother,
who died while I was at work on the text. Any man writing about a woman has to draw
on personal acquaintance with specific women to deal with his subject, and when the author
is a priest as well he has to rely largely on the experience life has given him of good women,
courageous women, women marked by faith. Thus, along with my mother and sisters in America,
I want also to thank the Italian, French, German and English women friends who across
the years have inspired me, many indeed offering themselves as surrogate "mothers" and "sisters."
The figure of Mary that emerges in the following pages is as much their work as mine.

Timothy Verdon

Graphic Coordinator
Dario Tagliabue

Editorial Coordinator
Caterina Giavotto

Graphic Design
Anna Piccarreta

Layout
Lucia Vigo

Photograph Research
Laura Lanzeni

Technical Coordinator
Andrea Panozzo

Quality Control
Giancarlo Berti

Translation
Timothy Verdon

© 2005 Pope John Paul II Cultural Center
Original edition:
© 2004 by Mondadori Electa Spa, Milano
All rights reserved

In association with Hudson Hills Press LLC
74-2 Union Street, Manchester, Vermont 05254

Co-Directors: Randall Perkins and Leslie van Breen
Founding Publisher: Paul Anbinder

Distributed in the United States, its territories and possessions, and Canada by National Book Network, Inc. Distributed in the United Kingdom, Eire, and Europe by Windsor Books International.

Contents

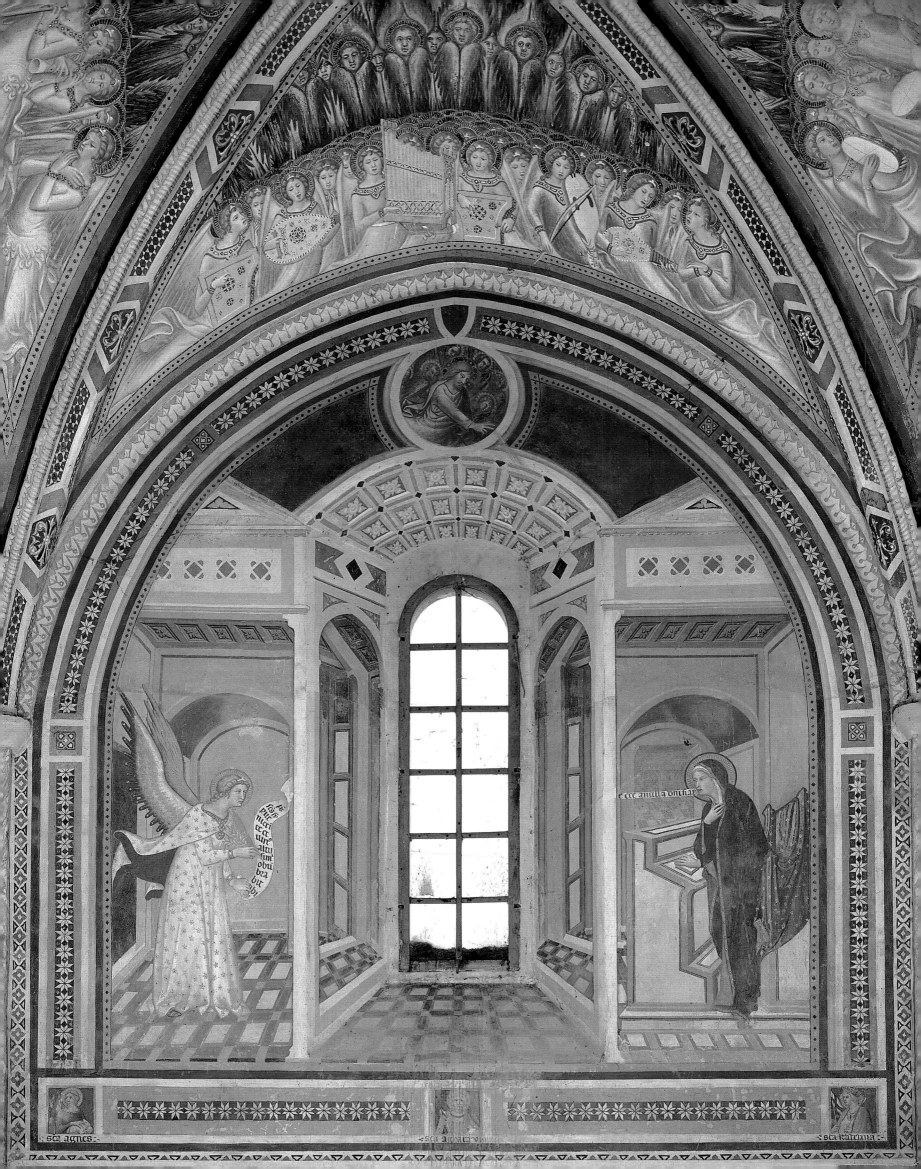

"Ecce ancilla Domini"

Mary.

For two thousand years, Christian civilization has been fascinated by the young woman who, to an angel inviting her to become God's mother, said: "*Ecce ancilla Domini*": "Behold the handmaid of the Lord." In poetry and song, in theological reflection as in devotional practice, the faith-community has not only thought about this girl, identifying with her answer, but has made Mary's words its own in order to insistently call attention to her. Especially in the visual arts – in splendid churches, in countless paintings, in mosaics, sculptures and stained glass, in works of the goldsmith's craft and in textiles – the Christian West has never ceased to set Mary before believers, as if in its turn saying: "Behold the handmaid of the Lord": behold a woman who was free, capable of self-gift, full of joy and open to life.[1]

A work chosen virtually at random can suggest the fecundity of Mary as an iconographical theme: the fresco attributed to Lippo Memmi in a small monastic church a few kilometers from Siena (fig. 1).[2] The event shown, the Annunciation, entirely fills the chancel wall behind the altar, dominating the building's interior, which consists in a single hall without side aisles. The actors in the scene – the Archangel Gabriel and Mary herself – are placed in *trompe-l'oeil* pavilions "open" each to the other thanks to arches giving on an intermediate space that corresponds to the embrasure of a window in the middle of the wall. The artist, that is, was able to organize the scene around this central architectural element, incorporating the window in his composition and – above all – in the sense of the event represented, obliging us to see the Angel and the Virgin in the context of light that, from outside, flows into the chapel above the altar where Mass is said.

It is not hard to grasp the symbolic message herein. At Mary's word of assent – the phrase "Ecce ancilla Domini" which the artist has painted beside her mouth – the Word of God entered the world as light: in the circular frame above the window we in fact see God the Father shedding rays of light on Mary. Lippo Vanni's symbolic vocabulary derives from the New Testament, and specifically from the Gospel of Saint John where Christ is presented as "the true light that enlightens every man," made visible when God's "Word became flesh and came to live among us" (John 1:1 – 14). In the fresco, the text borne by the Angel and a book on the lectern beneath Mary's left hand allude to this "Word" of God; the altar below the image, where bread becomes the body of Christ, alludes to the Incarnation;

and the window above the altar conveys the fact that the incarnate Word truly present in the Eucharist is himself *illumination*: "in Him was life, and that life was the light of men," as the fourth Gospel says (John 1:4).

Read in these terms, the *Annunciation* at San Leonardo al Lago allows us to make some initial observations that, while perhaps obvious, are so basic to the aims of this book as to require emphasis. The first regards the Christological frame of reference within which images of Mary normally function: at the heart of Marian iconography we always find her Son, even when – as in Lippo Vanni's fresco – He is not actually represented. In the same way, every representation of Christ presupposes his mother, since the visibility of the Son derives from the body He took from her.

A second observation regards the function of Marian images in the liturgical settings that generated the greatest part of them, and thus regards churches as places and the Church as institution, or – rather – as mystery. The eucharistic celebration that produces the Body of Christ, the building in which the celebration takes place and the mysterious communion among believers which it creates, strengthens and renders evident are all realities intimately connected to the woman from whom Christ took his human body: Mary, in whom the faith-community has traditionally contemplated its own life as in a mirror. Images of Mary that, like Lippo Vanni's *Annunciation*, are associated with a particular place of worship, and specifically with its liturgical space, have something autobiographical about them, communicating in figurative terms the understanding of their own life that Christians have developed in the course of history.

A third observation regards the "language" in which Marian images are often couched, deriving from Scripture but also from poetic *topoi* of biblical or literary origin developed in the liturgy, in popular devotion and in theological writing. In Vanni's fresco, for example, the Augustinian friars for whom the work was painted would have recognized, in addition to the Gospel terminology, references to Christ as "morning star" and "sun of justice" drawn from an antiphon used from the Middle Ages to the present at Vespers on one of the days leading to Christmas to introduce the Song of Mary or *Magnificat*. And the more learned friars might have grasped, in Mary's placement next to the window, a reference to the medieval theological *topos* explaining her virginal conception of Christ with the metaphor of *glass*, which remains intact even when penetrated by light.[3]

1. Lippo Vanni, *Annunciation*, 1360 – 70. San Leonardo al Lago, Pian del Lago, Siena.

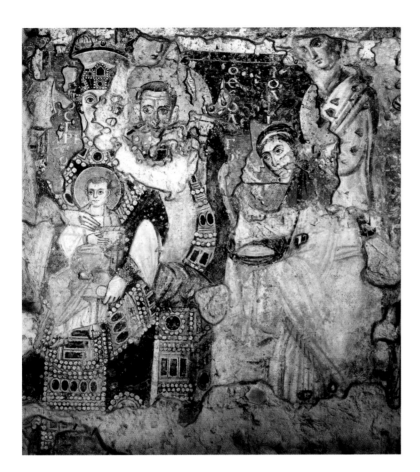

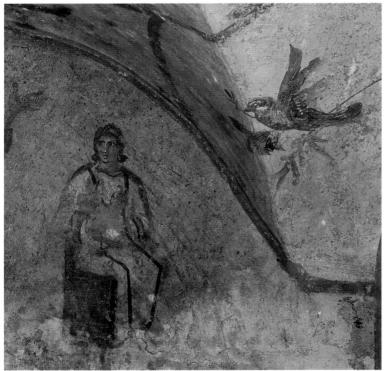

A second image permits further observations: the so-called "palimpsest wall" in the Roman church of Santa Maria Antiqua, consisting of the fragmentary remains of three distinct scenes painted from the 6th to the 8th centuries (fig. 2).[4] The newest part of the image is the male head superimposed on Mary's face and probably representing a Father of the Church; the intermediate phase is suggested by the heads of Gabriel and Mary in the upper zone, all that remains of an *Annunciation*; and on the most ancient stratum, in the area to the viewer's left, we see Mary enthroned, wearing a crown and the robes of a Byzantine princess, with the Child held in front of her.

Beyond evident stylistic differences in the successive phases of execution, and the fact that the oldest representational mode, showing Mary enthroned, is also the most *hieratic* (a clear indication that representation of Mary in symbolic terms predates efforts to narrate her human life), this image is emblematic of an important aspect of our theme. Mariology and Marian iconography are themselves "palimpsests," stratifications of ideas, beliefs and formal categories going back to remote and distinct historical periods that come to us reshaped by subsequent additions and interpenetrations; and to uncover the roots of Marian veneration and of the art it generated, we must – as for the wall in Santa Maria Antiqua – return to the seminal *loci* of Western history. This church in the Roman forum, carved out of the vestibule of the imperial palace of Domitian (81 – 96 A.D.), or perhaps from the "Athenaeum" built at the foot of the Palatine by Hadrian (117 – 138 A.D.), is located just yards away from the temples of Augustus, of Castor and Pollux and of Vesta with the attached house of the vestal virgins, and near to the so-called "royal house" in which the high priest of Roman state religion resided. The original structure, which at the beginning of the 6th century was still an entry to the imperial palace (then occupied by the Byzantine governor of Rome), was transformed into a church around 575 A.D., and embellished with frescoes by one pope after another up to the year 847, when an earthquake made it unusable, forcing Leo IV to transfer its *titulus* to a neighboring church, which for that reason came to be called Santa Maria *nova* ("new Saint Mary's": now Santa Francesca Romana).[5]

With these facts in mind, looking at the ancient, hieratic figure of Mary on the palimpsest wall, two things become clear: the first is the pagan origin of some aspects of Marian devotion; and the second, related to the first, is a striking similarity between the special protection that the popes extended to Mary's *cultus* and that which the Caesars had given religious cults associated with the identity of the State, such as veneration of Vesta and of the divinized emperors. Also clear in Mary's rigidly frontal pose in

the oldest layer of the Santa Maria Antiqua fresco, and in her gem-encrusted gown, is a link with the mental and artistic "style" of the Byzantine world and particularly with that of the imperial court in a crucial moment of passage from Antiquity to the Middle Ages. These cultural components, along with others that we shall now suggest, constitute the rich background of our theme.

The Mother, the Virgin, the Queen

It was indeed from this humus that, in their historical order, Mary's principal characterizations – "Mother," "Virgin" and "Queen" – sprang. Ancient, virtually primordial is the most important of her titles, "Mother of God."[6] Maternity is necessarily an element of the Incarnation, and already in the Letter to the Galatians (written before the definitive version of the Gospels), the Apostle Paul affirmed that "God sent his Son, born of a woman" (Galatians 4:4), without however naming the woman or ever mentioning Mary by name in his writings. Equally reserved, in all likelihood, was the original body of texts from which the Gospels of Matthew, Mark and Luke would later be developed, which probably treated Mary *en passant* as part of the life of her Son and present also at his death on the cross; in this early period, indeed, her maternal role seems to have been played off against other, more essential forms of relationship, as in Luke 11:27 – 28 where, to a woman who told Jesus "Blessed the womb that bore you and the breast that gave you suck," he answered: "Blessed rather those who hear God's word and keep it!" By contrast, the luminous opening pages of Matthew and Luke, where Mary is continually mentioned by name, represent a more mature stage in the evolution of the text, as does the Gospel of Saint John, in which Jesus' mother has an important role at both the beginning and end of his public life: at the marriage feast at Cana and at the foot of the cross.

A similar gradualness marks the development of Christian

iconography, which before portraying Mary as an individual or narrating her life, simply celebrated the fact of maternity. Thus the *Woman holding a Child* in the "Cubicle of the Veiled Woman" in the Catacomb of Priscilla at Rome, a work of the late 2nd or early 3rd century (fig. 3), does not represent Mary with Jesus but simply a mother with her baby: an ideal figure of maternity, juxtaposed in the lunette where she appears to a marriage scene, with a praying personage between the two. Birds and peacocks painted on the ceiling of the cubicle confirm the paradisiacal significance of these images which – with the funerary context of a catacomb – seem intended merely as affirmations of the eternal value of certain ordinary human conditions, among which that of motherhood.[7]

Emphasis on motherhood in a place of Christian burial reminds us of the extraordinary dignity ascribed to this state in Old and New Testament alike, where maternity serves as a literary figure of salvation. "As a mother consoles her child, so will I console you," God tells his people in Isaiah 66:13; and Jesus, to prepare his disciples to face his coming death, reminds them that "a woman, giving birth, is afflicted because her time has come; but no longer remembers her suffering once she has brought the child forth, for joy that a man has come into the world. So it is with you also. Now you are sad, but I will see you again and your hearts will be glad and no one will be able to interfere with your joy" (John 16:21 – 23).

To the salvific value of motherhood in Judeo-Christian culture, we should then add the strongly sacral sense that religions of the ancient Mediterranean world felt in the presence of the bearer and nurturer of life, woman, elevated by Greeks and Etruscans to the dignity of "Great Mother" and considered a personification of the earth itself (fig. 4). The inherent cruelty of the civilizations of the classic age, in exposing unwanted children and recognizing the father's right over the lives of his offspring, had in fact

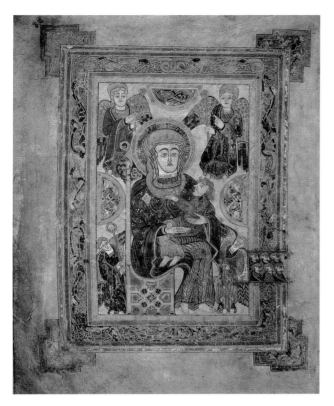

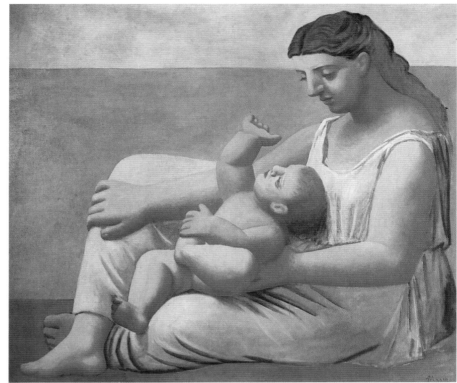

diminished by the 2nd century of the Christian era, as legislation dealing with the relations between parents and children from the time of the emperor Hadrian onwards makes clear,[8] and it is probably legitimate to see in the figure in the Catacomb of Priscilla the expression of a common sensibility destined for transmission to the early European Middle Ages, as a page of the Irish Book of Kells suggests (fig. 5). After 431 A.D., the year in which the Council of Ephesus formally accorded Mary the title "Mother of God," that sensibility fused generalized tenderness toward the mother-child relationship with the salvific meaning of motherhood in the Hebrew and Christian Scriptures, intermingling residual memories of the Greco-Roman Great Mother.

A far more complex question is the virginal condition which Christians have ascribed to Mary since the early centuries of their history: a condition that, together with her maternity, defines the mystery of this woman in an absolute sense.[9] The first person to raise the question was indeed Mary herself, who, at the Annunciation, when the angel told her: "You will conceive and bear a son," immediately asked; "How can that be? I know not man" (Luke 1:31 – 34), meaning: "I'm not yet married and haven't had physical relations with a man." The angel's response and Mary's reaction deserve to be recalled in full, so central are they to our theme:

"'The Holy Spirit will come upon you' the angel answered, 'and the power of the Most High will cover you with its shadow. And so the child will be holy and will be called Son of God. And know this too: your kinswoman, Elisabeth, has, in her old age, herself conceived a son, and she whom people called bar-

ren is now in her sixth month, for nothing is impossible for God. 'I am the handmaid of the Lord,' said Mary, 'let what you have said be done to me.'" (Luke 1:35 – 38).

The evangelist Matthew, in what is probably the most ancient written version of the "Good News," also insists on this point. Speaking of Jesus, he affirms that "his mother, being betrothed to Joseph, before going to live with him became pregnant through the intervention of the Holy Spirit" (Matthew 1:18). He returns to the question again later, quoting the explanation with which an angel urged Joseph not to hesitate to wed Mary, "for that which is generated in her comes from the Holy Spirit" (Matthew 1:20). And at the end of his account of the episode Matthew reiterates yet again the virginal state of the mother, saying that "Joseph took her with him as his wife, and she – without his having had relations with her – bore a child that he called Jesus" (Matthew 1:24 – 25).

Even Saint John, in the austere prologue to his Gospel (the last of the four in the order of composition), seems to allude to these facts when he says that believers in the Word – in Christ – "are generated not by blood nor by the will of flesh nor by the will of man, but by God" (John 1:13). An alternative reading of the verse, dating from early Christianity and preferred by such Fathers of the Church as Irenaeus and Tertullian, associates these phrases with Christ himself, who would thus have been "generated not by blood nor by the will of flesh nor by the will of man, but by God." The verse which follows, quoted on our opening page, is the one in which John announces that "the Word became flesh" – an assertion that would logi-

5. *Madonna and Child*, 8th century, Book of Kells, fol. 7v., Trinity College, Dublin.

6. Pablo Picasso, *Mother and Child*. The Art Institute of Chicago, Chicago.

7. Portico of the Maidens, Erectheum, 5th century B.C. Acropolis, Athens.

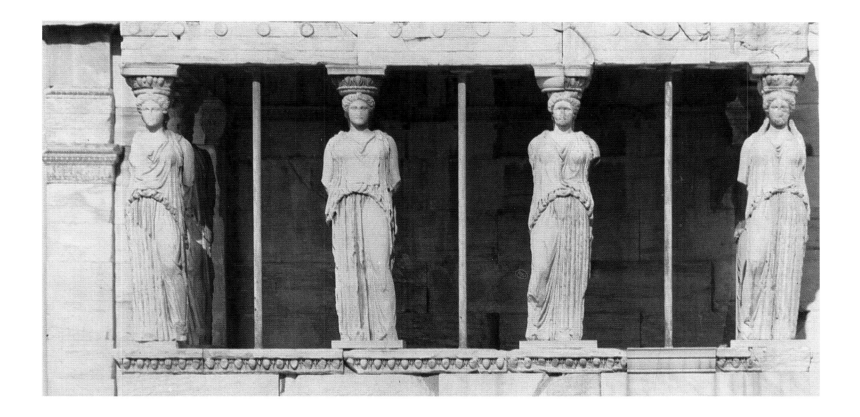

cally follow a reading of the preceding phrases in the singular.[10]

That faith in Mary's virginity was already widespread when the fourth Gospel was written is in any case confirmed by Saint Ignatius of Antioch, who at the beginning of the 2nd century wrote to the Christians of Ephesus that "our God Jesus Christ was borne in Mary's womb according to God's economy…. And Mary's virginity and her giving birth remained hidden from the prince of this world, as did the Lord's death: three clamorous mysteries accomplished in the silence of God."[11] Questioned by some but defended by the main Christian writers of late antiquity, faith in Mary's virginity finally became so total that an author of the late fourth century, Epiphanius, could wonder "when and in what era anyone ever dared pronounce the name 'Mary' without immediately adding, if asked, 'the Virgin'?"[12] It was in fact in Epiphanius' time that the doctrinal elements related to Mary's virginity – the assertions that she remained intact before, during and after giving birth – took definitive form, and, with them, the biblical figures used by the Fathers of the Church to characterize this mystery: the bush that burns but is not consumed; the closed door; the sealed tomb – a conceptual and poetic apparatus passed on to the Middle Ages in compendia such as the treatise *De virginitate sanctae Mariae* by Ildephonse of Toledo, a writer of the 7th century.[13]

Insistence on Mary's virginity developed in the broader context of a new importance ascribed by Christians to the virginal state, fascinating because it was without real biblical or classical precedents. If we exclude the Essene sect, whose maintenance of celibacy astounded pagan observers, Hebrew culture (like that of almost all ancient civilizations) considered virginity a passing condition, suited to the years of adolescence but destined to change with the physical and social maturation of the woman. The Greek world, which has left splendid images of virginal girls – the most famous are the caryatids of the Erechtheum porch on the Acropolis at Athens (fig. 7) – similarly considered virginity a temporary state. It is true that there were virgin goddesses such as Athena (Minerva) and Artemis (Diana), but their myths, with echoes of prehistoric conflicts between the sexes, do not explain the Christian idea of virginity and still less the figure of Mary. Among the Romans, the virgin goddess Vesta, Jove's sister and protectress of the hearth, suggests a parallel with Mary, mainly because the priestesses of her temple, the vestals, were consecrated virgins in a way comparable to that of Christian nuns; but no ancient source allows us to hypothesize more than a generic typological relationship between the two figures. The concept of "Mary ever virgin" defined by the Council of Constantinople (553 A.D.) and again by the Lateran Council (649) was, in short, the fruit of Gospel revelation and ecclesial reflection in the patristic centuries.

This theological originality was compromised during the Middle Ages, as the Christian concept of virginity suffered exposure to legendary and magical contaminations. A well known instance is the association of the mythical unicorn with female virginity in the context of chivalric culture (fig. 8). According to popular belief, the unicorn's strength and fierceness might be controlled only by an intact virgin; an idea perhaps born from the ascription of magic powers to the creature's horn, considered an antidote for poison. Behind such connections there is probably a confused layering of theological information (Mary's purity seen as a sign of the purification of the human spirit worked by Christ, for example) and talismanic traditions (the supposed curative virtue of the unicorn's horn).

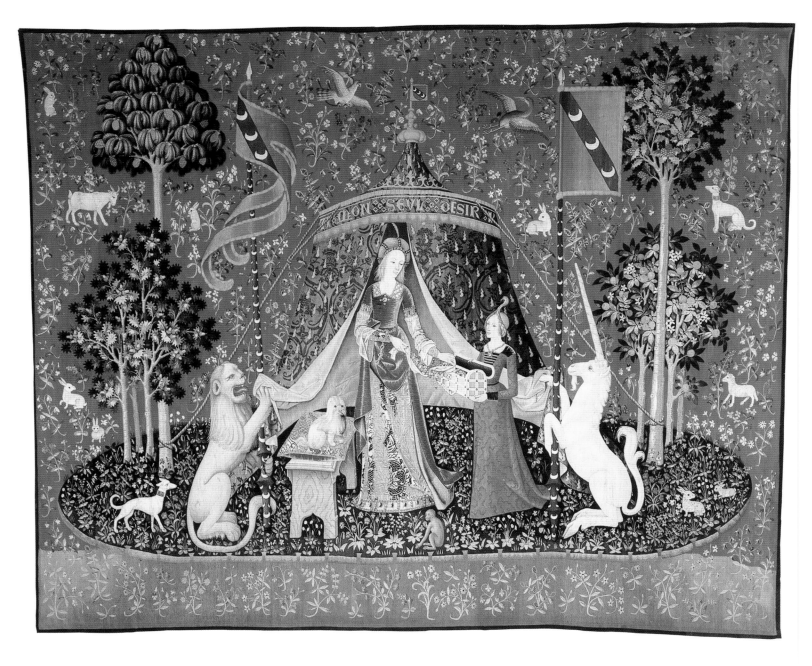

Generally speaking, though, the iconography of Mary "ever virgin" and the devotion it stimulated grew out of the faith and theological reasoning officially sanctioned by the Church. In art of the Eastern Christian tradition this was due to the imposition of a pictorial "canon" that limited experimentation with new interpretive models. In Latin Europe on the other hand, where fidelity to tradition did not preclude theological and iconographical innovation, original and singularly fascinating formulas developed, which – beneath their apparent novelty – often reveal depth and density of biblical and liturgical culture as well as refinement of devotional feeling. It is no exaggeration to say that, for the West at least, Mary became the most fecund subject, the most flexible poetic type, practically the "form" itself of Christian religious imagination.

A French painting of the later 15th century seems to confirm these assertions: the altarpiece commissioned of Nicolas Froment by Duke René of Anjou and his wife Jeanne de

8. Tapestry, *Lady with a Unicorn*, late 15th century. Musée de Cluny, Paris.

9. Nicolas Froment, *Mary in the Burning Bush*, 1476. Cathedral of Saint-Sauveur, Aix-en-Provence.

Laval for the Carmelite church of Aix-en-Provence, a triptych with portraits of the donors in the side panels.[14] The central panel (fig. 9) shows Moses who, at the command of an angel, removes his sandals before drawing near to a huge bush that occupies the whole upper part of the image, with, at its pinnacle, Mary and the Christ child. Between Moses at the right, and the angel at the left, a flock of sheep with attendant watchdog makes clear the reference to a specific Old Testament passage: "Moses was looking after the flock of Jethro, his father-in-law. He led his flock to the far side of the wilderness and came to Horeb the mountan of God. There the angel of Yahweh appeared to him in the shape of a flame of fire coming from the middle of a bush. Moses looked; there was the bush blazing, but it was not being burnt up. 'I must go and look at this strange sight,' Moses said, 'and see why the bush is not burnt.' Now Yahweh saw him go forward to look, and God called to him from the middle of the bush. 'Moses,

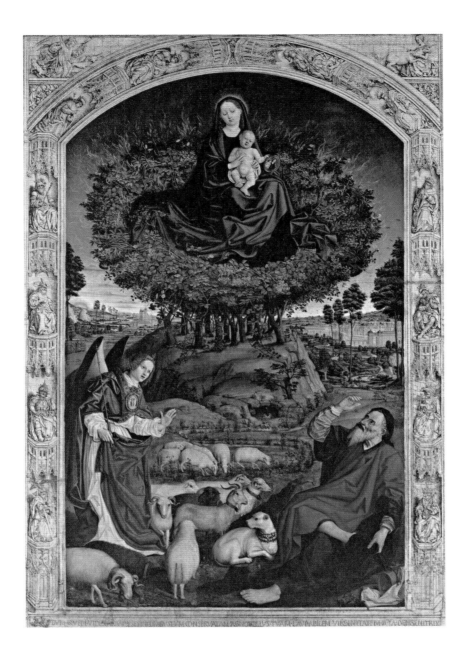

Moses!' he said. 'Here I am,' he answered. 'Come no nearer,' he said. 'Take off your shoes, for the place on which you stand is holy ground. I am the God of your father,' he said, 'the God of Abraham, the God of Isaac and the God of Jacob.' At this Moses covered his face, afraid to look at God" (Exodus 3:1 – 6).

The Marian significance attributed by this passage by the Fathers of the Church, rarely illustrated in monumental art, is spelled out in Froment's triptych: not only by the figure of Mary in the bush but also by an *Annunciation* painted on the outside of the lateral panels. When these are closed, the triptych thus immediately offers itself as a work dealing with Mary, showing the subject that focuses attention on her virginity mysteriously crowned by motherhood: the Annunciation. When the panels are then opened, the triptych shows another "annunciation": the angel in front of Moses inviting him to contemplate a phenomenon, impossible in the order of nature but real, in which God is revealed. Lest we fail to get the point, the artist has inscribed the words of a medieval liturgical text on the lower rim of the illu-

sionistic frame: "*Dum quem viderat Moyses incombustum conservatam cognovimus tuam laudabilem virginitatem, sancta Dei genitrix*" – "In the bush Moses saw burning but unconsumed, O Holy Mother of God, we have recognized the conservation of your praiseworthy virginity." (But note also, in the upper right of the frame, the small figure of a lady with a unicorn!)

The tendency to carry facts related to Mary from the New Testament back in time to the Old derives from the Gospel itself, where Matthew, after recounting the angel's appearance to Joseph and insisting on Mary's virginity, adds that "all this happened in order to fulfil what the Lord had said through his prophet: 'Behold the virgin will conceive and bear a son that shall be called Emanuel,' which means 'God-with-us'" (Matthew 1:22 – 23). The retroactive reference is to the book of Isaiah where, in token of salvation expected from God, the prophet tells King Achaz: "Behold, the virgin will conceive and bear a son ..." (Isaiah 7:14). The Hebrew original of Isaiah's text says "young girl," not "virgin," but Saint Matthew, writing in Greek, cites a Greek

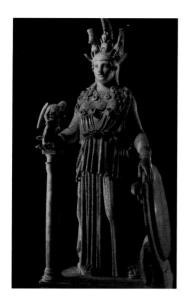

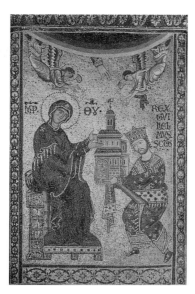

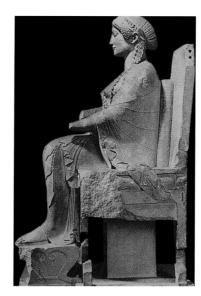

10. *Athena Parthenos,*
Roman copy of Phidias' statue
of 447 – 439 B.C. In the cella
of the Parthenon, National
Museum, Athens.

11. *William II Offering
His Church to Mary,* c. 1180.
Cathedral, Monreale (Palermo).

12. *Female Divinity*
from Taranto, c. 480 B.C.
State Museums, Berlin.

13. *Apse of the Abbey*
of Fuentidueña, c. 1000.
Metropolitan Museum of Art,
The Cloisters Collection, New York.

translation of Isaiah in the so-called Septuagint, where the more restrictive term is used. Early Christian tradition would follow his example, making of Mary's virginity one of the proofs of the Messianic identity of her Son: little Jesus is the very child promised by Isaiah as a sign of salvation.

We should stress the context of Isaiah's prophecy: with Jerusalem besieged by powerful enemies and ready to succumb because of Achaz's cowardice, the prophet offers the salvific sign of a virgin destined to conceive and bear a son. In analogous fashion, the burning bush also had to do with God's offer of help in an impossible situation: after identifying himself to Moses as the God of Abraham, Isaac and Jacob, Yahweh adds: "I have seen my people's suffering in Egypt, and heard their outcry against their overseers; in fact I know my people's sufferings, and have descended to free my people from Egypt's hands" (Exodus 3:7 – 8). That means that Old Testament foreshadowings of Mary, and specifically of Mary as *virgin*, are related to God's power to save and to free – a power definitively set in motion by the Son Mary bore, who indeed "descended" to free humanity from sinfulness. Old Testament textual adumbrations, that is, situate Mary and her virginity at the heart of a very ancient plan of salvation, announced in prophecy long before its realization in history.

The most radical expression of these ideas is the conviction – widely held in the Christian East from the 7th century onwards and (not without questions) in the West as well – that Mary's virginity was itself an aspect of a still more singular privilege: her immaculate conception, by which, unlike every other human being, Mary came into existence free from original sin. This question was so hotly debated in the years in which Nicolas Froment painted his altarpiece for René of Anjou that Pope Sixtus IV, with bulls of 1477 (*Cum praeexcelsa*) and 1482 (*Grave nimis*), forbade upholders of the opposing positions – adherents of one or the other view, called "maculists" or "immaculists" – to accuse each other of heresy. Froment's painting, where the infant Christ has a mirror in his hand in which he and his mother are reflected, in fact alludes to the immaculist view, which considered Mary a

"speculum sine macula": a human being preserved from sin so as to reflect the image of Christ without distortion. So also Mary's placement in the bush on "holy ground" (ground so holy Moses had to remove his sandals), probably echoes another patristic metaphor, which held that "Mary's body is earth which God has worked, first fruit of the adamitic mass divinized in Christ, true image of divine beauty, clay modeled by the hands of the divine artist."[15]

The point, absolutely crucial for our understanding of Marian iconography, is that this woman's physical virginity and still more the spiritual virginity of her soul free of every stain of sin are a mirror held up by God himself in which, together with the mother, we behold the perfections of her Son. Thanks to God's prior intervention, Mary was conceived free of sin as a sign of the liberation which her Son would subsequently accomplish for all mankind, and the sanctity that surrounds her – or rather the "holy ground" that Mary *is* – is inseparable from the sanctifying mission of the Son born of her womb. Just as Christ was announced by the prophets, so Mary too is part of the one plan of salvation ultimately made manifest in the Incarnation and Paschal Mystery. Correctly interpreted, Mariology is simply a reflection of the high Christology of the early centuries of church life: Christ, the "sun," irradiates healing and salvation; Mary, the "moon," immediately receives his light.

Within this privileged relationship, Mary is then invested with *power*. She has the implicit power of unsullied virginity – much like Athena, who was traditionally represented in armor (fig. 10), and she has a maternal power which Christ explicitly recognized three times: at twelve years of age when he allowed himself to be taken back to Nazareth and was subject to her and to Joseph; at thirty, when at the marriage feast at Cana he again obeyed her; and finally on Calvary, when, dying, he entrusted his friend, the beloved disciple John (and with him all other disciples) to her care (John 19:26 – 27). In the Middle Ages, moreover, in addition to the royal robes already noted in the mural on the palimpsest wall, Mary will have a title suited to her pow-

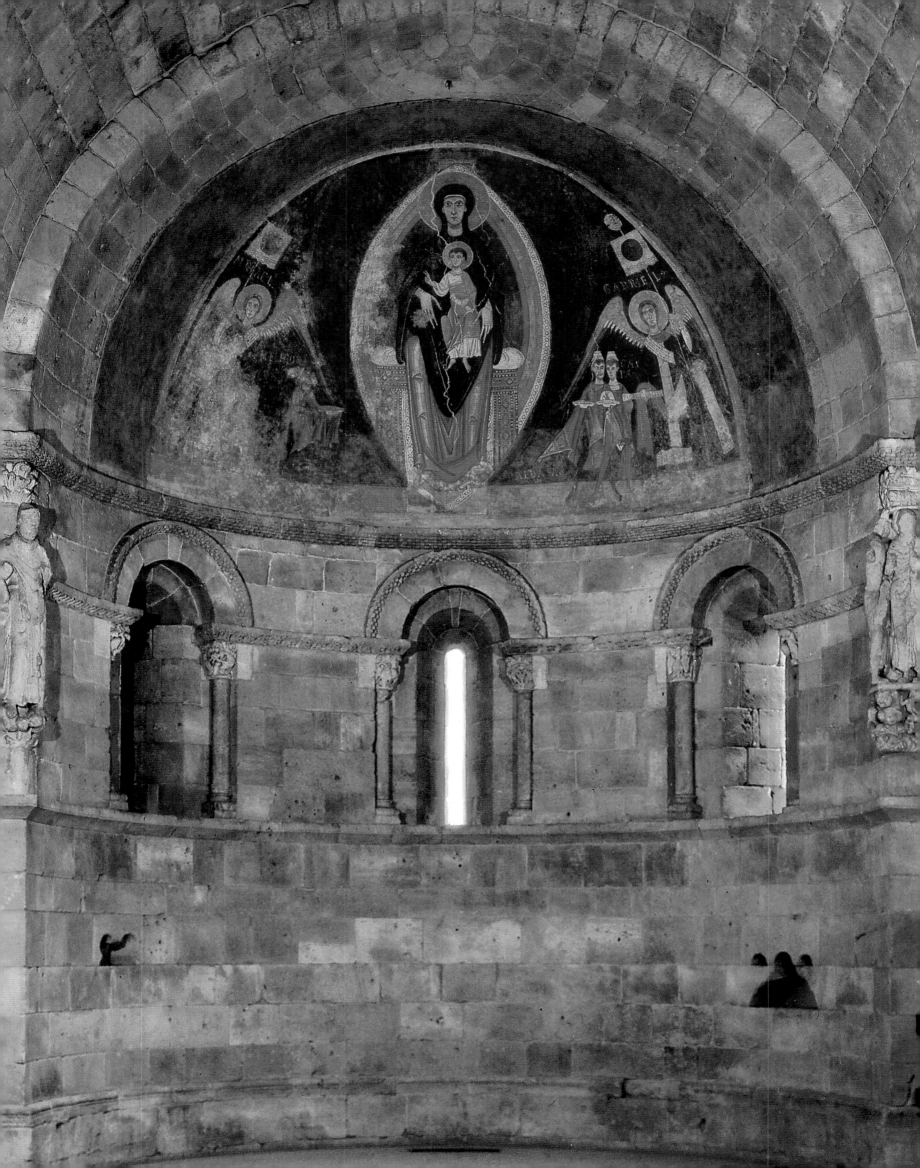

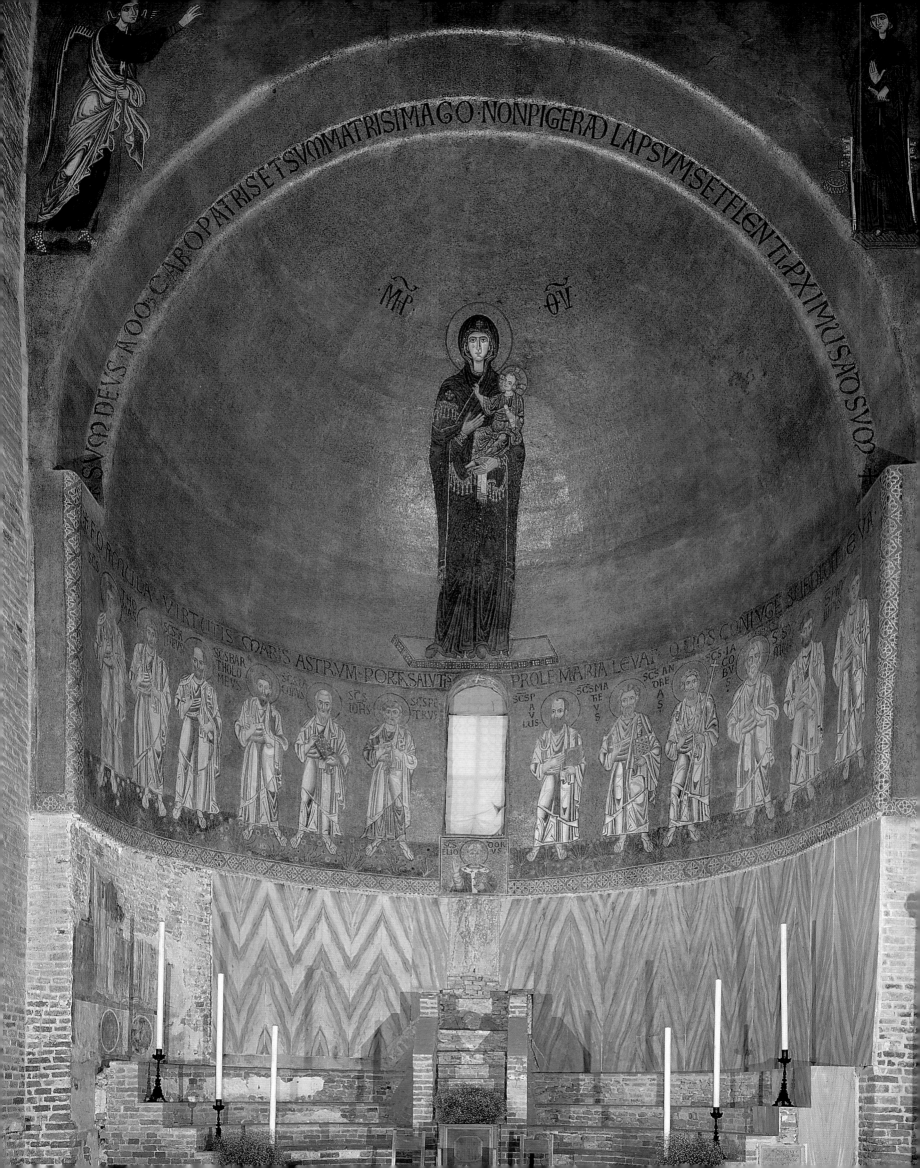

er: "Queen."[16] When a hymn in the 13ᵗʰ-century *Cortona Laud Book* greets her with the words, "Hail holy Lady, most potent Queen," it is simply echoing in vernacular Italian Latin liturgical antiphons in use since the XI century, which salute Mary in the same way: "*Salve, Regina!*"; "*Ave Regina coelorum!*"; *Regina coeli, laetare!*"[17]. In the same way, medieval Christian art, reactivating ancient Near Eastern and Mediterranean formulas, will represent her as heaven's queen, before whom the kings of the earth must kneel (figs. 11, 12).

Mary in Christian Art, Imagination and Life

Normally Mary's regal status, mirroring that of her Son, the "King of kings and Lord of lords" (Revelation 17:14), is made manifest in the same place designated to reveal Christ's own high dignity: the assembly hall of the faith community or "church," which becomes in fact a royal audience chamber. A mosaic showing William II of Sicily as he offers Mary a model of the church he had built, the Cathedral of Monreale (fig. 11), is located in the church itself, above the bishop's throne at the entrance to the chancel; in that position, Mary's relationship with her Son (who is not shown in the mosaic), is perfectly clear because in the apse dominating the entire east end of the building looms an enormous Pantokrator, the figure of Christ "Ruler of all things," "*Rex regum et Dominus dominantium.*"

When the figures of Mother and Son are united in a single image, Mary's position in church halls may be the dominant one in the apse over the altar, as in the frescoes of the Abbey of Fontidueña, Spain, today in New York (fig. 13). There we see the Child born of her body in her arms right above the altar on which bread offered by the community becomes *corpus Christi* and *panis angelicus*. Here moreover (as in many analogous cases) the relationship between the Marian image and the fenestration of the chancel is fraught with meaning, for the light that Christ is seems to enter *through* his Mother. In the monastic setting of Fontidueña, it is not hard to imagine that this symbolism was intentional; the already cited hymn from the *Cortona Laud Book* suggests that, a few centuries later at least, even the lay imagination would be able to decipher the message. Speaking of Mary, the hymn says: "As with a pane of glass when the sun's rays strike, the splendid sun itself enters and passes through her."[18]

Another example of this arrangement is the chancel mosaic of the Cathedral of Torcello, an island in the Venetian lagoon (fig. 14), where a large figure of Mary with her Child stands out on the gold background of the apse above a window at whose sides we see representations of the apostles; below the window and the apostle figures are the bishop's throne and seats for his priests, and below these we see the altar. Mary – not only Jesus' mother but also a type of the Church that he founded – is presented, that is, at the apex of a complex composition of various elements which, together, invite viewers to associate the body of Christ born of Mary (in the mosaic), with the *corpus Christi* present in the consecrated bread and wine (on the altar), and to see the bishop who teaches his people (from the throne) in relation to the light that enters from above (through the window). The figures of the apostles allude to the early Church, and their placement immediately over the seats reserved for the bishop and his priests projects the overall impression of a Church with some members in heaven and others still on the earth: a "Communion of Saints" that recognizes its own unity in the body born of the earthly woman who welcomed the King of Heaven, giving him the flesh with which he would then feed humankind.

These same ideas are illustrated in less symbolic terms in an extraordinary Flemish miniature of the 1480s (fig. 15), where – through an open window – we see the interior of a gothic church flooded with light and, in front of the altar, Mary with her Son and a noblewoman kneeling at our left (the right of little Jesus).[19] The same noblewoman, Duchess Mary of Burgundy, larger in scale, is shown reading in the foreground on the near side of the window, and on the windowsill between her space and the church interior are several objects: a diaphanous veil, a necklace, two red carnations and a vase of irises, while on the stool in front of the duchess is a brocade bag. A little dog rests on the noblewoman's knees.

This amazing image shows two levels of reality: Mary of Burgundy as she reads the very Book of Hours or Breviary in which the miniature is painted, and Mary of Burgundy as participant in a female liturgy in which her heavenly patron, Mary the mother of Jesus, shows her the Christ child. The duchess reads and prays in the comfort of her room (or perhaps in one of those closed "boxes" once built in churches for princes), but in imagination she is present at the court of the Queen of Heaven, whose throne stands before the altar where the body to which she gave birth becomes bread of eternal life. This vision, fruit of the duchess' prayer – of her *lectio divina*, is set in the light filtered by uncolored windows that are themselves figures of a virginity which, fecundated by God, remains intact.

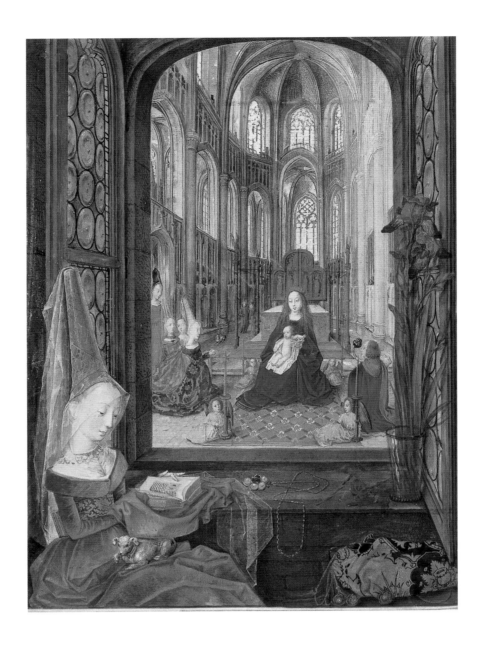

A similar glimpse into the lay imagination is afforded by a small painting by Lorenzo Lotto, *Christ's Farewell to His Mother, with Elisabetta Rota* (fig. 16), where the woman who commissioned the work is shown as, reading, she imagines Mary's suffering when the thirty-year-old Jesus took farewell of his mother to begin his public ministry. This apocryphal event is described in a book published in 1493, *Devout Meditations on the Passion of Our Lord, Drawn from the Writings of Saint Bonaventure, Franciscan Cardinal*, which may be the volume that Elisabetta Rota has in her hands.[20] A year before, Elisabetta, the wife of Domenico Tassi of Bergamo, had been present when her brother-in-law, Alvise Tassi, Bishop of Recanati and Macerata, was murdered; the awful anguish of Mary at the imminent separation from her Son should probably be understood as a mental projection of Elisabetta's inner state as, reading, she interprets the sacred event in light of her own traumatic experience. The

enclosed garden in the background, an allusion to the Song of Songs, and the undisturbed bed visible in an inner room remind us that, in addition to being virgin and mother, Mary is also, spiritually, *sponsa Christi*: Christ's bride.

This kind of deep emotional identification with Mary and the tendency to participate in Christ's life through a process of Marian transferal are not moreover late phenomena – Renaissance or Baroque – but ancient. The inside of the cover of a 6th-century reliquary, the Lateran Sancta Sanctorum coffer now in the Vatican Museums, illustrates this fact, inserting Mary into five of the six scenes shown – even two in which, according to the Gospels, she did not take part (fig. 17). Starting in the bottom tier, at the left, we see her necessarily present at the *Nativity*; then, at the right, she is absent from the *Baptism*, but again present (in the middle tier) at the *Crucifixion*. In the upper tier, there is someone dressed like Mary among the holy women who go to the sepul-

15. Master of Mary of Burgundy, *Mary of Burgundy at Prayer*, c. 1480. Österreichischte Nationalbibliothek, Vienna.

16. Lorenzo Lotto, *Christ's Farewell to His Mother, with Elisabetta Rota*. 1521. Gemäldegalerie, Berlin.

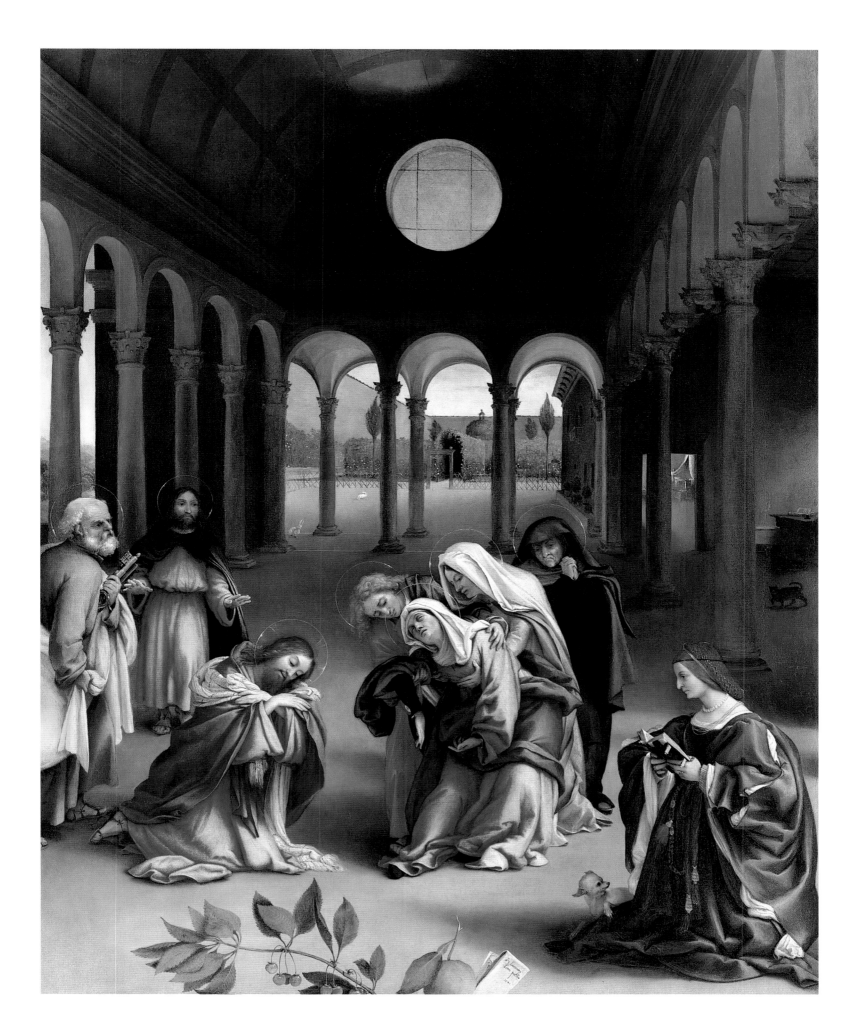

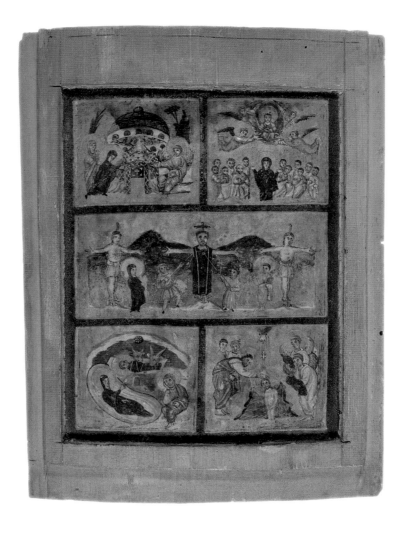

17. Cover of the relic box from
the "Sancta Sanctorum," 6ᵗʰ century.
Vatican Museums, Vatican City.

18. Woodcut with *The Annunciation,
The Temptation of Eve and Gideon
at Prayer Before the Fleece*, c. 1465. Biblia
Pauperum printed in the Low Countries,
Bibliothèque Nationale, Paris.

cher: an apparent manipulation of the Gospel text, which does not mention Jesus' mother in that context. Yet since the artist reproduces Saint Matthew's description of the event, with two women and only one angel, and since Matthew actually gives the name of only one of the women of whom he speaks, Mary of Magdala, identifying the other with the vague phrase "the other Mary," this inclusion of Jesus' mother is *possible*, even if unusual.

Clear at all events is the artist's desire to insert Mary in all the important events in the life of her Son, including that illustrated in the final scene (upper tier right), the *Ascension*, where again the Gospel accounts do not mention her. The artist did not put her into the *Baptism* (bottom tier right) not only because the Gospel does not mention her in that situation but for a theological reason: Mary's presence in the *Nativity*, next to the *Baptism*, identifies her as mother; her absence from the *Baptism* underlines the presence of the One who, on that occasion, from heaven identified himself as Christ's Father. The logic of this composite image derives, that is, from the artist's or iconographer's desire to suggest the two natures of Christ, true man but also true God – Son of Mary and Son of the Most High.

If Mary was present at the main events in Christ's life, and Christ both reveals and perfects the sense of the main Old Testa-

ment events (as the Christian Scriptures maintain), it follows that Mary is part of the overall history of salvation: her story is a *fil conducteur* in the history of the world. Or, as a monastic theologian – Saint Anselm, developing the idea of a complementarity of the maternal role of Mary with the paternal one of God – put it: "God is Father of the world's foundation, Mary is mother of its reparation, for God generated him through whom all things were made, and Mary bore him through whom all things were saved. God generated him without whom absolutely nothing is, and Mary gave birth to him without whom nothing is well."[21]

This centrality of Mary to salvation history, like her role in the life of her Son, became a standard element of religious imagination, as is suggested by an illustration in a late 15ᵗʰ-century *Biblia pauperum*: a Dutch or perhaps German woodcut (fig. 18). At the center of the image, we see the *Annunciation* with Mary who, interrupting her reading, tells the angel: "*Ecce ancilla Domini ...*"; in upper and lower compartments are Old Testament personages who prophesied Christ's Incarnation, including Isaiah with the text we analyzed earlier, "*Ecce virgo concipiet*," "Behold the virgin shall conceive." But it is above all the pair of scenes flanking the *Annunciation* that confirms Mary's centrality in the history of humankind's relationship with God: *Eve Tempt-*

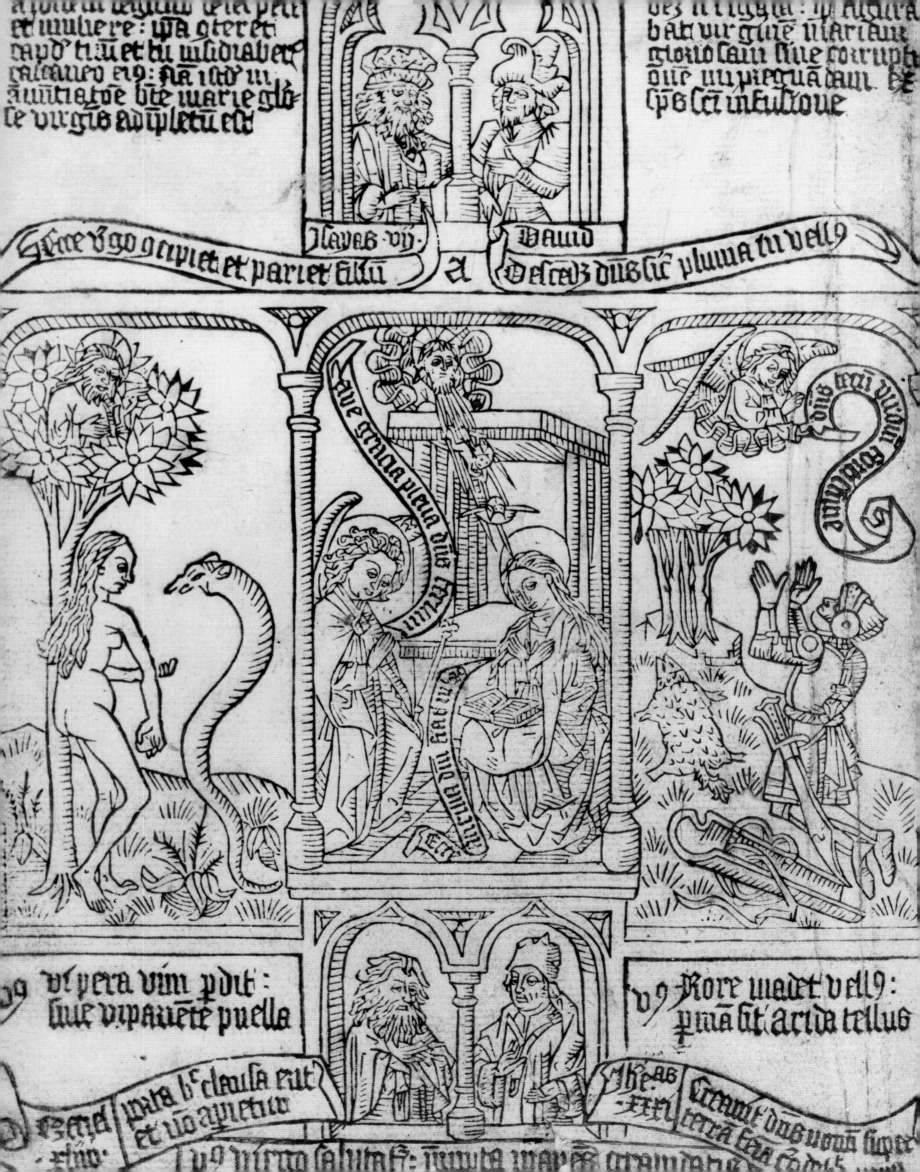

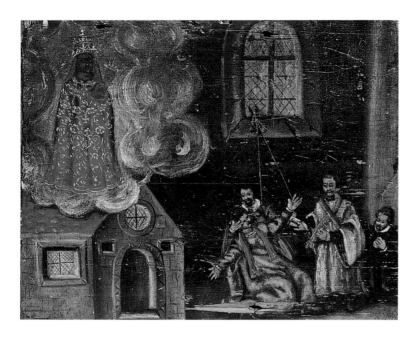

ed by the Serpent and, at the right, *Gideon at Prayer before the Fleece*.

These events have always been associated with the mystery of Mary. The first, involving Eve's weakness in the face of temptation and her disobedience to God's command, was, as early as the 2nd and 3rd centuries, set over against Mary's strength and perfect obedience. Saint Justin Martyr says: "If it is through a virgin that Christ became man, this is because in God's plan we should find a solution in the same way as that in which disobedience, born of the serpent, had its origin,"[22] and Saint Irenaeus echoes this image, insisting that "just as humankind was bound to death by a virgin [i.e. Eve], so it is saved by a virgin [i.e. Mary]."[23] Following a historical schema called *recirculatio* (the illness contracted by humankind at birth finally healed by an inversion of the circuit), Irenaeus calls Mary "Eve's advocate"; this concept, modeled on the Pauline idea of a *recapitulation of all things in Christ the new Adam* (cf. Romans 5:12 – 21; 1 Corinthians. 15:21 – 22; Ephesians 1:10), in fact allows Irenaeus to think of Mary as a "new Eve." "It was just and necessary that Adam be reconstituted in Christ so that mortality might be absorbed and swallowed up by immortality, and that Eve be reconstituted in Mary so that a Virgin, having become the advocate of a virgin, might erase and annul the disobedience of that virgin with her own virginal obedience."[24]

The second event shown, *Gideon at Prayer before the Fleece*, offers a different kind of parallelism. Gideon, like Mary later, had been greeted by an angel with words that astounded him: "The Lord is with you, O strong and valorous man!" And, like Mary, Gideon hesitated before believing, asking why, "if the Lord is with us," Israel was losing its war against Madian (Judges 6:11 – 14). To be sure the angel's invitation to lead his people to victory really came from God, Gideon asked for two related demonstrations: first, that a wool fleece left on the ground overnight be bathed in dew while the surrounding earth remain dry; and that the second night the opposite happen, with the earth wet and the fleece dry (Judges 6:36 – 40). When both these miracles in fact took place, Gideon understood that God is able to suspend the normal laws of nature when He wants to give a sign: a lesson which Church tradition will associate with the mysteries of Mary's virginal conceiving and giving birth to Christ, each of which events is outside the order of nature or *supernatural*.

In placing Mary between Eve and Gideon, our woodcut alludes therefore to the double meaning of a role that is both *anthropological* and *soteriological*. In relation to the Son who will be born of her, Mary is presented as the model of a new humanity – not "mother of all living beings," like Eve, but "mother of all the redeemed." And just as the fleece convinced Gideon that God can give his people victory over their enemies, so Mary's virginity becomes the sign of an unhoped for salvation, impossible to man but which God both promises and gives. This humble work of popular art thus recapitulates an extraordinary theological heritage, helping us gauge the level of Mariological acculturation of ordinary Europeans at the dawn of the modern era: their tendency to read the history of the world and of its salvation in Marian terms, finding in this woman's life fundamental indications of God's plan.

It is in this perspective that Mary's human life, to which the Gospels devote but few and simple words, became a main theme of Christian devotion, nourished by apocryphal texts and embellished by legend. Marian piety also revolved around important relics, such as the Virgin's girdle, enshrined at Prato; her veil, venerated at Chartres; and the very milk from her breast, "conserved" in such quantity in Italian churches of the 15th century that Saint Bernardino of Siena indignantly asked whether his contemporaries took Mary for a cow. The most astonishing relic is at Loreto: the Virgin's house from Nazareth, traditionally believed to have been carried by angels to that Italian city – the so-called "Holy House" around which a sanctuary developed to which the faithful have come for seven hundred years in search of consolation and special graces (fig. 19). Everywhere in Europe, though, icons and other images were held to have miracle-

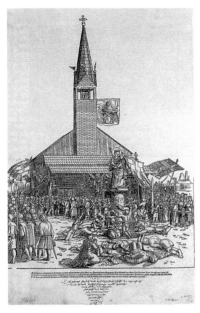

working properties. The frontispiece of a printed history of the sanctuary at Crea, near Casale Monferrato in Piedmont, can serve to suggest the piety roused by such ancient images, as well their role in stimulating new works of art (fig. 20). Around the small sanctuary at Crea, dating back to the 11th century, a "sacromonte" sprang up in the 16th and 17th centuries, with upwards of forty chapels in which the faithful could contemplate polychrome sculptural tableaux narrating Mary's life.[25]

It is useful to note the time frame of this latter development: the 16th and 17th centuries. The new importance given to the sanctuary of Crea and its enlargement into a "holy mountain" were in effect part of a Catholic Counter Reformation strategy particularly emphatic in border areas such as Piedmont, exposed to Protestantism. For, notwithstanding the moderate position of Martin Luther (who in given circumstances tolerated images, even those depicting Mary), most Protestants were iconoclastic and Christocentric, suspicious both of art and of Marian devotion.[26] A woodcut of 1520 illustrating the paroxysms of pilgrims at the Marian shrine at Regensburg suggests the spirit in which northern reformers reacted to such phenomena (fig. 21), and the autograph comment by Albrecht Dürer at the bottom of the print leaves little room for doubt: "At Regensburg, with the bishop's permission this ghost has arisen against the Holy Scriptures, and has not been abolished only for reasons of worldly advantage. May the Lord help us not to dishonor his dear mother by separating her from Jesus!"[27]

Although tolerant of intimate Marian images – those representing the Virgin as mother of the baby Jesus, Luther unequivocally condemned every image of her allusive to an "institutional" role for Mary: representations of her, that is, as Mother of the Church or dispenser of graces or queen of heaven.[28] He clearly understood the risk of manipulation inherent in such formulae, which link the human contents of Christian faith and believers' spontaneous devotion to the ecclesiastical institution and, by implication, even to non-religious institutions associated with it. Luther did not realize that some of the oldest iconographical articulations of this theme regard Mary precisely as a figure of Church life, and that only subsequently had iconographic modes of a narrative and evocative cast been developed.

The present volume follows the evolutionary schema Luther failed to understand. The first of its three chapters ponders the figurative sense of Marian iconography, treating in depth and through examples the themes mentioned in our Introduction and others as well. The second chapter narrates the human sense of Mary's life, reconstructing in orderly fashion the events upon which the imagination of believers has lingered across the centuries. And the final chapter narrows the focus to observe at close quarters how this theme evolved in a European center particularly active in defining Marian iconography, the city of Florence, whose artists tried to say something new and original on the subject.[29] Florentine painters and sculptors in fact put the particular gifts of their region at the service of traditional religion: passionate curiosity regarding the mystery of the human person, penetrating capacity for psychological analysis, and intellectual refinement coupled with eloquence in expressing ideas. In their hands, the typical themes of Marian devotion dilate and become occasions for profound, often mystic reflection.

Only the final chapter is organized diachronically, with the art of each century linked to that of earlier and later ones. The coordinates of organic development legible on the "small scale" of a local school of art – in this case the Florentine school – become practically unusable on the larger canvas of European art, due to cultural inequalities among the different regional areas considered (more evident in the past than they are today), and due also to real differences in the level of information available for given regions in the distinct moments of their evolution. The goal in any case is not to write a "history of Marian iconography" but rather to immerse the reader in the experience of a relationship whose spiritual and intellectual coefficients – everywhere present and operative right from the start – emerge differently in different times and places, as responses to unpre-

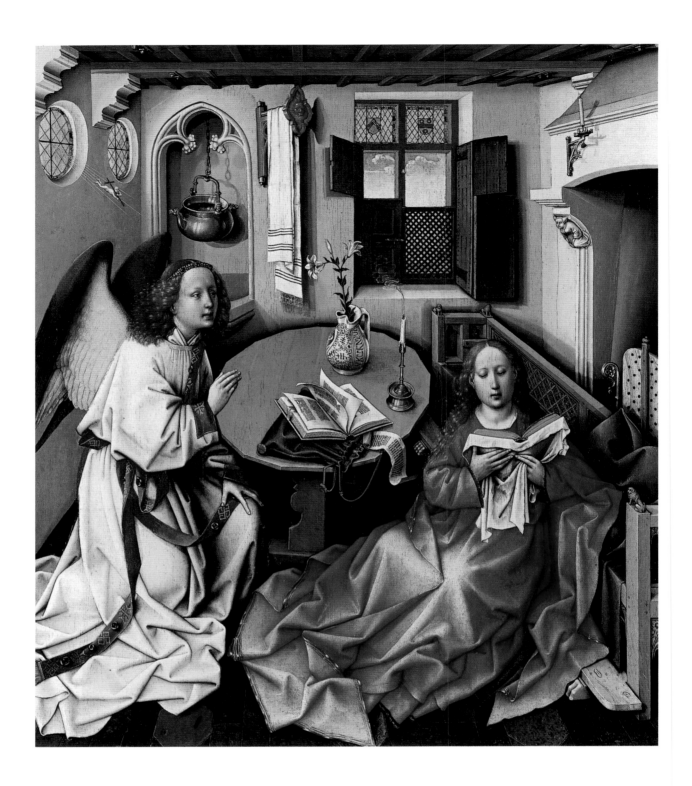

22. Robert Campin,
Annunciation, c. 1425.
Metropolitan Museum
of Art, New York.

dictable needs and to prophetic inspirations. Obviously, the book does not attempt the impossible task of discussing every artist and every work, or try to illustrate every subject in the Marian repertory; rather, it *recounts*. The present volume recounts and relates, each to the other, characteristic episodes in a search that has lasted almost two thousand years – a search that in Mary painted and carved has sought to show what is beautiful in the Christian life of faith.

By a curious and significant process, Marian imagery ultimately favored the birth of a spiritual art that is not specifically Christian. Objects that in works like the Flemish master Robert Campin's *Annunciation* (fig. 22) still have an allusive function, would in time become autonomous visual themes; the book, the vase of lilies and the extinguished candle that, on the table between the angel and the Virgin, speak of the Word conceived in *purity* as *light*, would later be transformed into mere still-life subjects, as the art of Breugel and Chardin, Cèzanne, Morandi and others suggests. But the gaze with which the West still looks at the material world recalls – albeit distantly – the mystery of the woman in whom matter was raised up when the Word descended: Mary, who "in the silence of God" brought the Invisible into our world of visible things.

[1] The bibliography on Mary in Western art is enormous. A brief list of essential texts should include the following: G.B. de Rossi, *Immagini scelte della beata Vergine Maria tratte dalle catacombe romane*, Rome 1863; G. Rouhault de Fleury, *La sainte vierge. Etudes archéologiques et iconographiques*, 2 vols., Tours 1878 – 1879; A. Venturi, *La Madonna*, Milan 1900; A. Munoz, *Iconografia della Madonna*, Florence 1905; A.B. Jameson, *Legends of the Madonna as Represented in the Arts*, London 1907; J.H. Clément, *La réprésentation de la Madonne à travers les ages*, Paris 1910; M.C. Nieuwbarn, *Die Madonna in der Malerei* (Die Kunst dem Volke), Münich 1912; C. Jéglot, *La Vierge dans l'art*, Paris 1924; M. Vloberg, *La Vierge et l'enfant dans l'art français*, Grenoble 1933/1954; V. Lasareffe, *Studies in the Iconography of the Virgin*, in "The Art Bulletin," 20, 1938, pp. 26 ff.; C. Cecchelli, *Mater Christi*, 2 vols., Rome 1944 – 1948; M. Trens, *Maria. Iconografia de la Virgen en el arte español*, Barcelona 1946; (various authors), *La Vierge dans l'art français* (catalogue of the exhibit at the Petit Palais), Paris 1950; G. Fallani, *La Madonna: profilo iconografico*, in "Fede e arte," 14, 1966, pp. 398 – 429; H.W. van Os, *Marias Demut und Verherrlichung in der sienesischen Malerei, 1300 – 1450*, The Hague 1969; A. Tempera, *Il linguaggio della pietà mariana negli ex voto. Testimonianze romane*, Rome 1977; H. Egger, *Weihnachtsbilder im Wandel der Zeit*, Vienna-Münich 1978; S. de Fiores, *Lettura religiosa degli ex voto, in Maria presenza viva nel popolo di Dio*, Rome 1980; G.A. Mina, *Studies in Marian Imagery. Servite Spiritualità and the Art of Siena (c. 1261 – c. 1328)*, doctoral thesis, Courtauld Institute of Art, University of London 1993; D. Norman, *Siena and the Virgin. Art and Politics in a Late Medieval City State*, New Haven-London 1999.

[2] E. Borsook, *The Frescoes at San Leonardo al Lago*, in "The Burlington Magazine," 98, 1956, pp. 351 – 358.

[3] M. Meiss, *Light as Form and Symbol in Some Fifteenth-Century Paintings*, in *The Painter's Choice: Problems in the Interpretation of Renaissance Art*, New York 1976, pp. 3 – 18. Cf. also D. Norman, *Siena and the Virgin*, cit. (above, n. 1), p. 149.

[4] E. Tea, *La basilica di Santa Maria Antiqua*, Milan 1937; P. Romanelli, P. Norhagen, *Santa Maria Antiqua*, Rome 1964.

[5] M. Webb, *The Churches and Catacombs of Early Christian Roma*, Brighton-Portland 2001, pp. 112 – 122.

[6] B.J. Le Frois, *The Theme of the Divine Maternità in the Scriptures*, in "Marian Studies" (Washington, D.C.), 6, 1955, pp. 102 – 119; S. Lyonnet, *Il racconto dell'Annunciazione e la maternità divina della Madonna*, in "La scuola cattolica," 82, 1954, pp. 411 – 446; J. McHugh, *The Mother of Jesus in the New Testament*, London 1975; R. Moretti, *Maria madre di Dio*, in "Rivista di vita spirituale," 28, 1974, pp. 477 – 495; O. da Spinetoli, *Maria nella tradizione biblica*, Bologna 1967; E. de Roover, *La maternité virginale de Marie dans l'interpretation de Gal. 4,4*, in (various authors), *Studiorum Paulinorum Congressus Internationalis Catholicus 1961*, Roma 1963, pp. 17 – 37; Y. Roy, *Realitas ac sensus maternitatis Beatae Mariae virginis secundum Sacras Scripturas*, in *Maria in Sacra Scriptura. Acta congressus internationalis in Republica Dominicana celebrato anno 1965*, 6 vols., Rome 1967, vol. VI, pp. 199 – 202; S. de Fiores, *Maria nella teologia contemporanea*, Rome 1978; M. Thurian, *Maria madre del Signore, immagine della Chiesa*, Brescia 1980.

[7] V.F. Nicolai, F. Bisconti, D. Mazzoleni, *Le catacombe cristiane di Roma*, Regensburg 1998, pp. 105 – 108.

[8] J. Carcopino, *Daily Life in Ancient Roma*, tr. E.O. Lorimer, New Haven-London 1940, pp. 76 – 77.

[9] Cf. the article "Vergine" in the *Nuovo dizionario di mariologia*, ed. by S. de Fiores, S. Meo, Cinisello Balsamo (Milan) 1986.

[10] *Lettera agli Efesini*, 19. Funk 1, pp. 175 – 177.

[11] *Adversus Haereses* 1,3. Cf. J.P. Migne, *Patrologia cursus completus, series graeca* (=PG), 242 vols., Paris 1857 – 1867, vol. 42, 706 – 707.

[12] Cf. the article "Vergine" in *Nuovo dizionario di mariologia*, cit. (above, n. 10).

[13] J. Snyder, *Northern Renaissance Art. Painting, Sculpture and the Graphic Arts from 1350 to 1575*, New York 1985, pp. 262 – 264.

[14] Andrew of Crete, *Homily 1, In dormitionem Beatae Mariae*: PG 97, 1068.

[15] L. De Gruyter, *De beata Maria Regina. Disquisitio positiva speculativa*, Turin 1934; J.C. Fenton, *Our Lady's Queenship and the New Testament Teachings*, in *Alma socia Christi. Acta congressus internationalis in Roma celebrato 1950*, 13 vols., Rome 1952, vol. 3, pp. 68 – 86; F. Spadafora, *La regalità della Madonna*, in *Maria Regina presentissima. Atti del congresso sacerdotale di Bologna, 10 – 13 settembre 1956*, Rome 1958, pp. 21 – 33.

[16] *Poeti del Duecento*, ed. G. Contini, t. ii, Milan-Naples 1960, pp. 15 – 16; *The Hymns of the Breviary and Missal*, ed. M. Britt, New York 1924, pp. 86 – 89.

[17] *Poeti del Duecento*, cit. (above, n. 17), pp. 15 – 16.

[18] F. Winkler, *Die Flemische Buchmalerei des XV und XVI Jahrhunderts*, Leipzig 1925, p. 10; O. Paecht, *The Master of Mary of Burgundy*, London 1948.

[19] D.A. Brown, P. Humphrey, M. Lucco, *Lorenzo Lotto. Il genio inquieto del Rinascimento*, Geneva-Milan 1998, pp. 121 – 124.

[20] Saint Anselm, *Discourse 52*: J.P. Migne, *Patrologia cursus completus, series latina* (=PL), 221 vols., Paris 1854 – 1865, vol. 158, 955 – 956.

[21] Saint Justin Martyr, *Dialogue with Trypho*, cited in S. De Fiores, D. Meo, *Nuovo dizionario di mariologia*, cit. (above, n. 10), in the article "Nuova Eva," pp. 915 – 925.

[22] Saint Irenaeus of Lyons. *Adversus Haereses* 5,19,1: PG 7,1775A – 1776.

[23] This phrase of Epideixis has survived only in the Armenian version of his text. Cfr. *Patrologia Orientalis*, ed. R Graffin, F. Nau, Paris 1903, 12 (1919), 685.772 – 773.

[24] G. Gentile, *I misteri mariani del Sacro monte di Crea dal trattato di Costantino Massino alla Breve Historia e Descrittione di Michel Angelo Coltella*, in A. Barbero, C. Spantigati, *Sacro monte di Crea*, Alessandria 1998, pp. 81 – 92.

[25] S. Michalski, *The Reformation and the Visual Arts. The Protestant Image Question in Western and Eastern Europe*, London-New York 1993, pp. 35 – 36.

[26] G. Winkler, *Die Regensburger Wallfahrt zur Schönen Maria als reformatorisches Problem*, in *Albrecht Altdorfer und seine Zeit*, ed. D. Henrich, Regensburg 1981, pp. 103 – 121. Cf. also C.C. Christensen, *Art and the Reformation in Germany*, Athens (Ohio) 1979, pp. 45 ff. e 192.

[27] S. Michalski, *The Reformation and the Visual Arts*, cit. (above, n. 26), p. 36.

[28] The last chapter of the present essay reworks T. Verdon, *Maria nell'arte fiorentina*, Florence 2002.

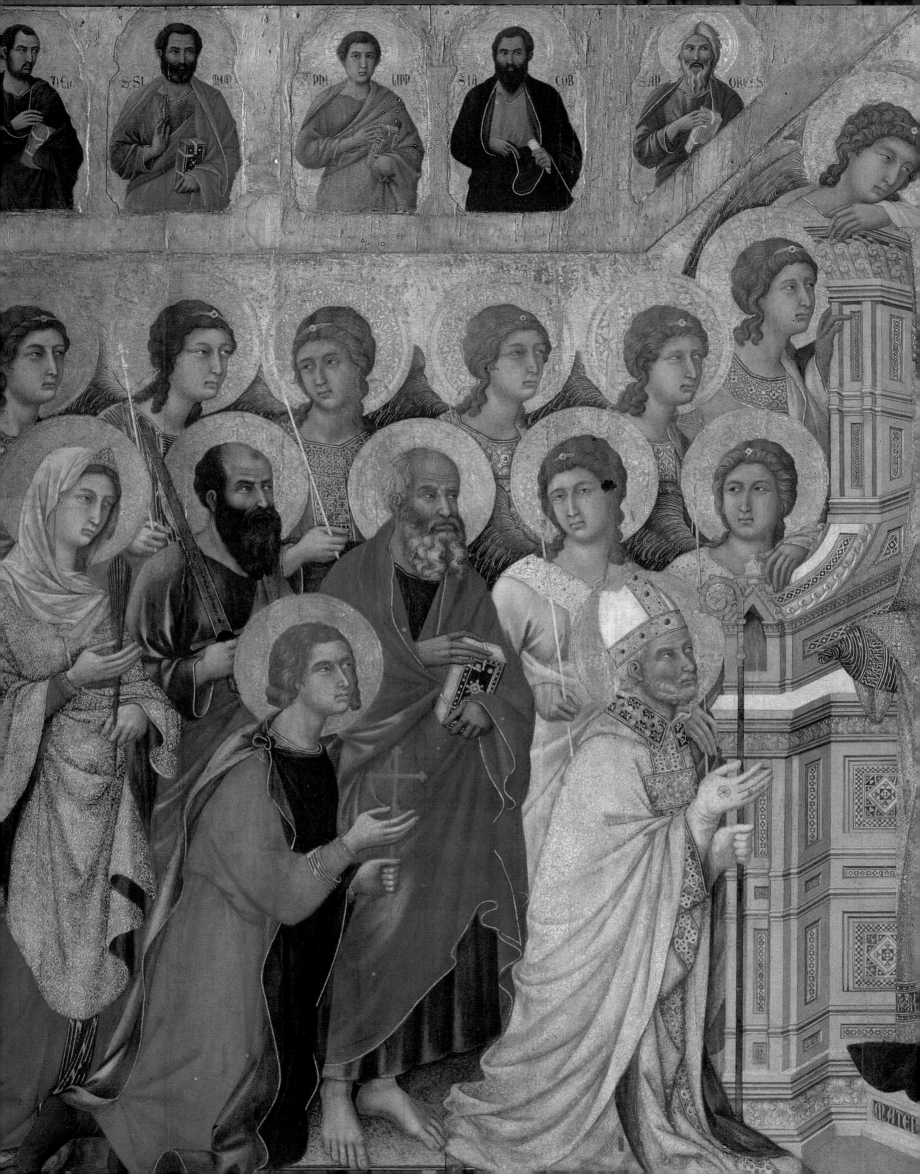

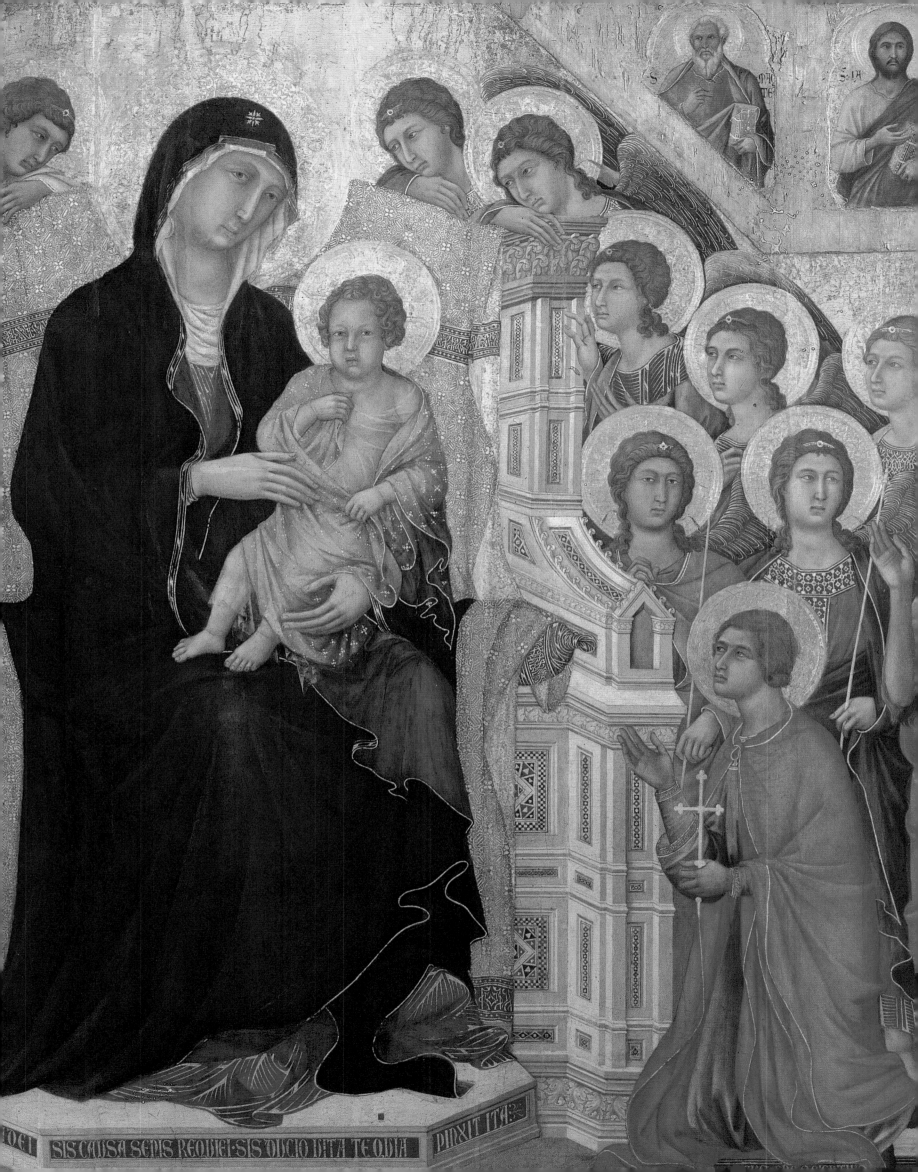

SISCROSA SCVS RCCVECS SICVCIO DTA TE CODA PIXIT ITER

Mary as Figure

Inseparably linked to the Son who took from her the body later
given to save mankind, Mary is a figure of the blessed state to
which every human being aspires: a figure of the Christian's hope
to rise from earth to heaven, to be found in God, to eternally
share his life. She is the personal expression of a love so all-em-
bracing it elevates and purifies other relationships, opening them
to the Holy.[1]

An extraordinary mid-15th-century painting supports these am-
ple claims: Enguerrand Charonton's *Coronation of the Virgin* (fig.
23), in which Mary appears with the three Persons of the Trini-
ty in heaven, royally crowned by Father, Son and Holy Spirit.
Surrounded by assembled angels and saints, together with the
three Persons she presides over the affairs of *earth* (represented by
two cities on opposite shores of a sea) and simultaneously over
what happens *below the earth* (where – aligned with the two cities
– we see the souls of the deceased). At the center of the painting's
lower register, on a promontory between the two cities, Christ
crucified is adored by a white-robed monk, the man who com-
missioned this work of art: Jean de Montagnac, a Carthusian
from Villeneuve-les-Avignon in Provence. The painting was in
fact destined for an altar in his Charterhouse, and its small cru-
cifix was meant to remind the priest saying Mass before it of the
relationship of the bread and wine with Christ's body and blood
offered on Calvary. For lay viewers, however, who saw the host
and chalice only at the moment of the elevation, the effective as-
sociation was with the figure in the middle of the composition,
Mary, shown on the same scale and as brilliantly colored as the
Divine Persons: Mary who, seen together with the Eucharist,
thus became a visual figure of "communion" of life in the body
Christ had received from her own womanly body. Mary's recep-
tion in the bosom of the Trinity, the honor accorded her and the
splendor of her raiment are signs that that communion is desired
by God, who calls to himself for all eternity the mother from
whom his Son was born in time.

We know the meaning of this painting's details thanks to a con-
tract with no fewer than twenty-six provisions, in which the
learned Jean de Montagnac indicated to the artist those aspects of
the subject he wished to stress. Specifically mentioned are the form
in which the Trinity is to be shown, with Father and Son of simi-
lar appearance; the identity and relative position of the saints; the
two cities (Jerusalem at the viewer's right and Rome, the new

23. Enguerrand Charonton, *Coronation of the Virgin*, 1454. Musée de l'Hospice, Villeneuve-les-Avignon. This mid-15th-century masterpiece represents Mary received by the Persons of the Holy Trinity and crowned by Father, Son and Holy Spirit. It represents the intimate communion of the creature with her Creator: a communion desired by God himself, who calls to his side for all eternity the woman who bore his Son in time. The theme, spelled out for the artist in its least details by the demanding patron, the monk Jean de Montagnac, presents Mary as "daughter of the Father, mother of the Son, bride of the Holy Spirit," suggesting above all how human beings are called to be sharers in God's own nature.

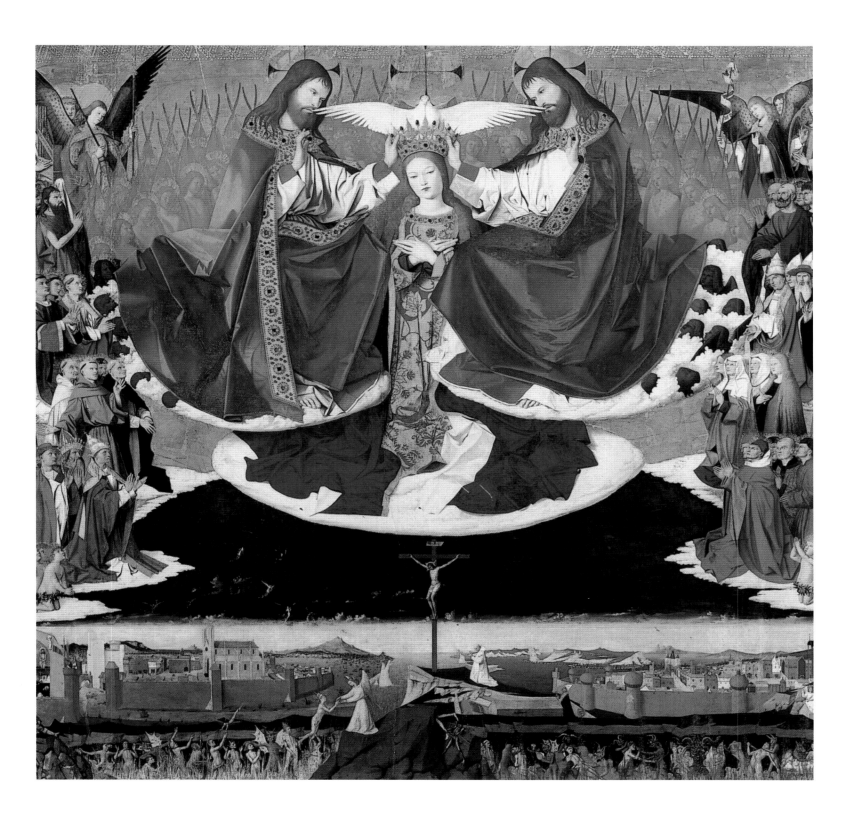

24. *Coronation of Mary*, c. 1220. Tympanum of the main portal, Cathedral, Reims.

25. Gaddo Gaddi, *Coronation of Mary*, c. 1310. Cathedral, Florence.

26. Donatello, *Coronation of the Virgin*, 1436. Cathedral of Santa Maria del Fiore, Florence.

Jerusalem, at the left); the two subterranean zones (hell below Jerusalem and, below Rome, Purgatory with the souls looking up toward heaven and a pope being invited to ascend). The requirement of rich robes for Father and Son, and a precise description of the rare fabrics to be used for Mary's vesture are also part of this contract signed in the presence of witnesses on April 25, 1453, in the shop of one Jean de Bria, an Avignon spice merchant.

The theme chosen by the monk Jean de Montagnac – Christ's mother lifted up to become virtually the fourth Person of the Holy Trinity – develops an idea enunciated in the New Testament, according to which Christians are called to "share the divine nature and to escape corruption in a world that is sunk in vice" (2 Peter 1:4). Elaborated in Marian terms by the Greek Fathers of the 4th century, in the West this sharing in the life of the Trinitarian God was articulated in the formula which described Mary as "daughter of the Father, mother of the Son and spouse of the Holy Spirit." There were, however, several versions of the concept, and in the 12th century, speaking of Mary, Aelred of Rievaulx would say: "*Quam Pa-*

ter sanctificavit, et Filius fecundavit, obumbravit Spiritus sanctus" ("She whom the Father sanctified and the Son fecundated was under the shadow of the Holy Spirit"); still later Elinand de Froidmont defined the Virgin as "*Conjux Patris, mater Filii, sacrarium Spiritus Sancti*" ("the Father's wife, the Son's mother, tabernacle of the Holy Spirit").[2] Whatever their bent, similar formulations sought to suggest an absolute and singular intimacy in the relationship of this chosen woman with God.

Mary's special election was symbolized, from the 11th century onwards, through the metaphor of regal status dear to a medieval Europe fascinated by the idea of parallelism between this world and the next. It is no accident that, above the main portal of Reims Cathedral – the church in which ancient tradition required that the kings of France be consecrated, we find a *Coronation of the Virgin* that visually legitimizes the sacral character of the monarch (fig. 24). Even far from the courts of northern Europe, though – in free Italian republics like Florence and Siena, the poetry of royal status conditioned Marian iconography: the first work commissioned for the inte-

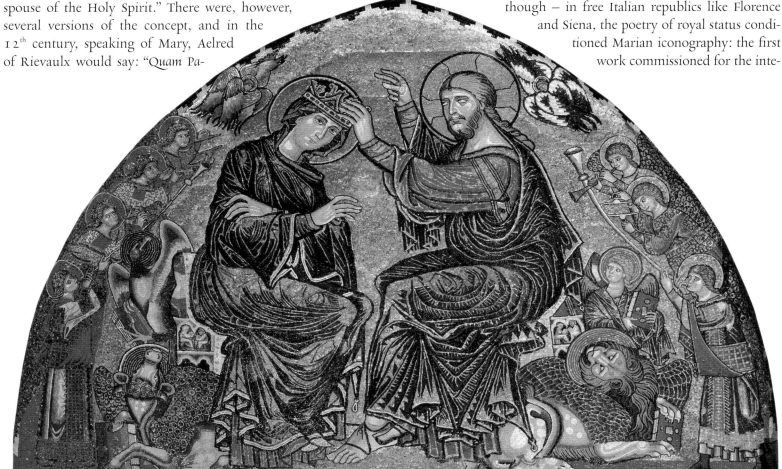

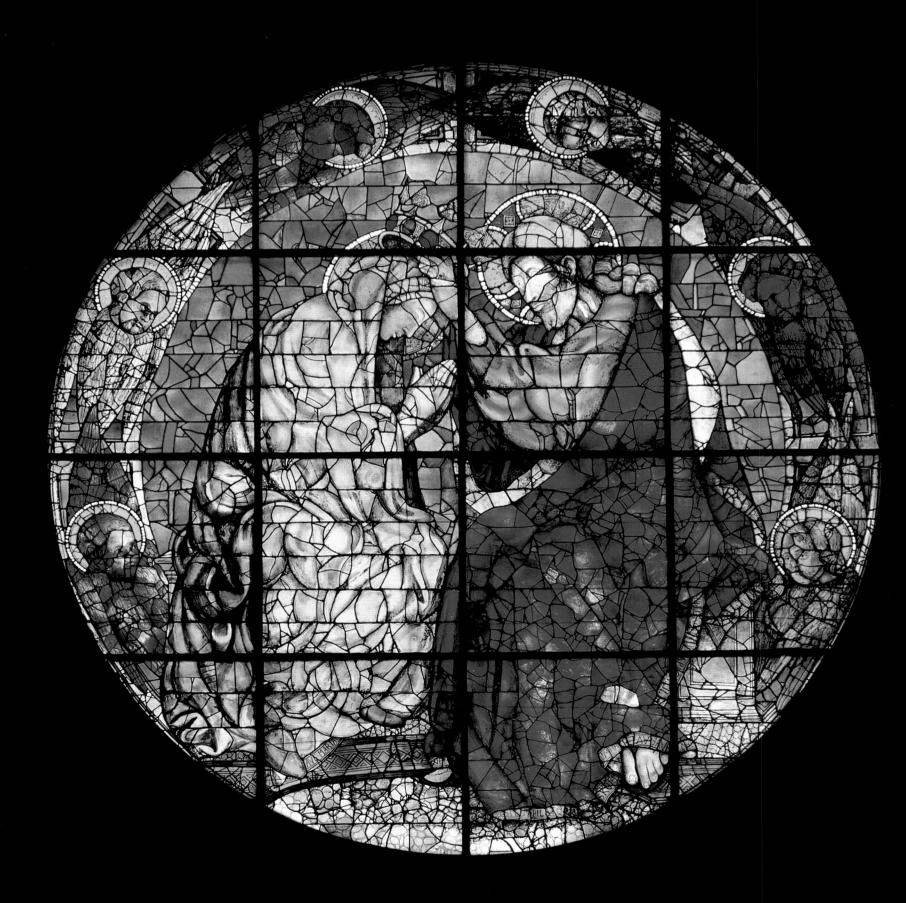

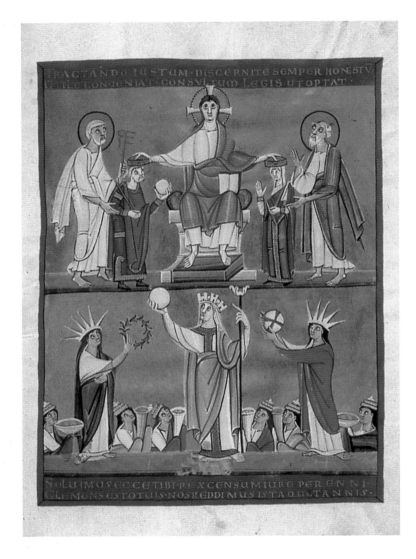

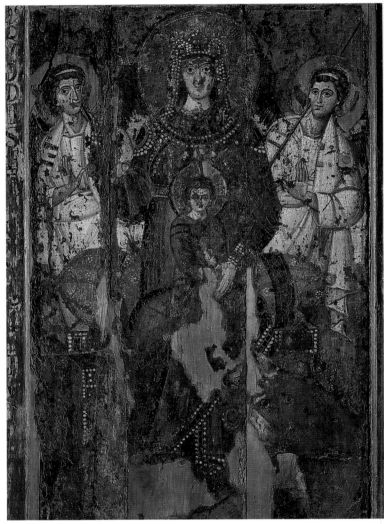

rior of the rising cathedral of Florence, Santa Maria del Fiore, was a mosaic depicting Mary's coronation (fig. 25), and one hundred thirty years later, as the church finally neared completion, the subject chosen for the enormous stained glass window above the main altar was again the *Coronation of the Virgin* (fig. 26). The third chapter of this essay, entirely devoted to Florence, treats the cathedral's iconographic program at length, and here we should simply stress the tendency to conceive important urban churches as Marian throne rooms, extending the metaphor of regality to the places of worship springing up everywhere in Europe between the year 1000 and 1500.

A writer of the 12th century, Bishop Amadeus of Lausanne, a pupil of Saint Bernard of Clairvaux, helps us savor this Marian application of the regal metaphor: "The Holy Virgin Mary was assumed into Heaven," he says, "but her admirable name shone forth in all the earth independently of this singular event: her immortal glory was everywhere irradiated even before she was lifted above the heavens…. She dwelt in the sublime palace of holiness, enjoying divine favor in the greatest possible abundance, and she, who in wealth of grace surpassed all other creatures, in turn showered grace to slake the thirst of ordinary believers."[3]

The danger inherent in the use of such poetic figures of speech – of a sort of hypostatization of Mary (who here is projected into a zone distinct from that of the people of God, somehow distinct

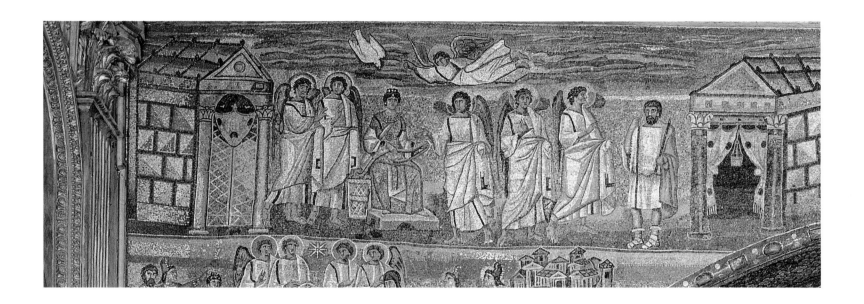

from the "regal" status ascribed to all members of the Church) – was generally avoided in the Middle Ages thanks to the symbolic inclination of popular imagination. Great churches dedicated to Mary, built across many generations and at staggering creative and material expense, conferred on entire cities a "Marian identity" intelligible to all thanks to the ancient and medieval habit of allegorizing collective life in female terms. An 11th-century miniature in which Christ crowns Emperor Henry II and the Empress Cunegonde presented to Him by Saints Peter and Paul (fig. 27), shows the provinces of the empire symbolically present at the ceremony as women wearing crowns, participants in the royal status of their rulers. For a world that reasoned in that fashion, *Maria Regina* (Mary the Queen) was legible as a representative figure whose exalted dignity ennobled all of Christian society.

Sponsa Christi and Figure of the Church

To be a queen implied being a bride, as in the case of the Empress Cunegonde who received her crown from Christ thanks to the bond with her husband, Henry II. The biblical texts that the liturgy associates with Mary – the Old Testament psalms employed to suggest her relationship to Christ – in fact link her dignity as queen with that which she has as bride: "Listen, daughter, pay heed, bend your ear / forget your nation and ancestral home, / for the king will be pleased with your beauty. / He is your master, bow down to him. / Emissaries from Tyre bearing gifts solicit your fa-

vor, / the wealthiest nations with jewels set in gold. / Dressed in brocades the king's daughter / is led into the king, with bridesmaids in her train. / Her ladies-in-waiting follow / and enter the king's palace amid general rejoicing (Psalms 45 [44]:11 – 16).

In visual terms, this bridal dimension gives special meaning to the sumptuous garments in which Mary is shown as queen. In Charonton's *Coronation* – as in the oldest stratum of the palimpsest wall in Santa Maria Antiqua (fig. 2) and in other works having Byzantine character, such as the *Basileia* in Santa Maria in Trastevere (fig. 28), the crown and gem-encrusted robes evoke the "bride adorned with jewels" of the Old Testament (cf. Isaiah 61:10) and "dressed in brocades" for presentation to the king on her wedding day. It is again Amadeus of Lausanne who specifies that "The bride rich with spiritual jewels was Mary, mother of the one Husband and font of all sweetness, delight of the spiritual gardens and the spring from which flow the living, life-giving waters that descend from the heavenly Lebanon.... As this Virgin of virgins was assumed into Heaven, the prophecy was fulfilled in which the Psalmist says to the Lord: "The queen stands at your right in cloth-of-gold, in brocades and embroidered garments" (Psalms 45 [44]:10).⁴

As the palimpsest fresco and the icon in Santa Maria in Trastevere suggest, the presentation of Mary in regal and bridal terms was especially insistent in the ancient imperial capital, Rome. In the first grand Marian program realized in the West, the mosaic

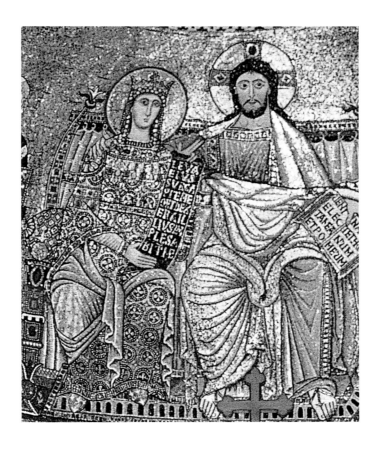

decoration of the "arch of triumph" in the Roman church of Santa Maria Maggiore (a 4ᵗʰ-century basilica enlarged by Sixtus III between 432 and 440), we find the Virgin "in cloth-of-gold, in brocades and embroidered garments" (fig. 29): an immediate iconographic response to the solemn declaration of the Council of Ephesus a year earlier, in 431, which gave Mary the title "Mother of God." The collective nature of her royal condition is underlined here by the dedicatory inscription on the mosaic-clad arch, "*Xistus episcopus plebi Dei*" ("Bishop Sixtus [had this made] for the people of God"); a phrase that suggests how such images were read, with Mary conceived not primarily as an individual but as a collective figure of the God's people: the *Domina Ecclesia* or "Lady Church."

The most emphatic visualization of the high dignity reserved to the Church and of the splendor of her royal nuptials with the "King of kings" is the monumental apse mosaic in another Roman church, Santa Maria in Trastevere, showing Christ and Mary seated on the same throne, so close that their bodies in gold, gem-embroidered robes actually touch, and Christ can put his right arm around the shoulders of the Lady, who here already wears a crown (figs. 30, 31).⁵ Executed in the mid 12ᵗʰ century, in the thick of the popes' struggle to defend Church autonomy from the interference of the Germanic emperors, the mosaic intentionally evokes early Christian elements of form and content in order to suggest uninterrupted continuity between the formative centuries of Ro-

30. *Christ and Mary-figure-of-the-Church*, mid-12ᵗʰ century. Apse of Santa Maria in Trastevere, Rome. This grandiose apse mosaic showing Christ and Mary seated on the same throne is a splendid visualization of the high dignity reserved to the Church, figuratively represented in Mary's person since early Christian times. Done in the mid-12ᵗʰ century, the work elements of style and content going back to the first centuries of Roman Church life, and thus suggests uninterrupted continuity between the formative period of ecclesial experience and the medieval "present." At the same time, in the physical embrace of Christ and his Church, and the intimacy of the texts from the Song of Songs, this work anticipates the strong emotional climate of 13ᵗʰ-century spirituality.

31. Detail.

man Church life – the waning centuries of the Empire – and the medieval present.

Thus (as at Santa Maria Maggiore) even though the woman represented is obviously Mary – we are after all in a church dedicated to her –, the figure shown is above all the "Lady Church," young and splendidly attired for her eternal nuptials. Christ bears a book with the invitation to his "chosen one" to herself become his throne – "*Veni electa mea et ponam in te thronum meum*," and the "chosen one" (the Church) displays a scroll on which we read words drawn from the Song of Songs: "*Laeva eius sub capite meo, et dextera illius amplexabitur me*" – "His left arm is under my head, his right embraces me" (Song of Songs 2:6; cf. 8:3). Seen in the curvature of the apse, above the altar on which the Eucharist makes present the Bridegroom's "passion" for his Bride and the gift of his body, this explicit statement of a spousal vocation, and this way of conceiving believers' future blessedness as an embrace, reveal unexpected humanity: a personalist poetic anticipating the new, affective spirituality of the 13ᵗʰ century.

The relationship of this image to the great Old Testament love poem, the "Song of Solomon" or "Song of Songs," is extremely significant. Rabbinical and Christian tradition alike unanimously interpreted the Song's erotic subject matter in mystical terms, and the Fathers of the Church identified the male protagonist of the text, called "the bridegroom," as Christ, and the female protagonist, "the

The artist, a pupil of Pietro
Cavallini, shows Mary seated beside
Christ who crowns her Queen,
and with a footstool identical to his.
The final message has to do with
the heavenly calling of the human
flesh in which Christ himself
was born of Mary. The moon under

her feet, and the sun under
his, remind us that Mary – and
the Church which she represents
in a figurative way – do not possess
their own light, but receive
illumination from Christ, "sun
of justice."

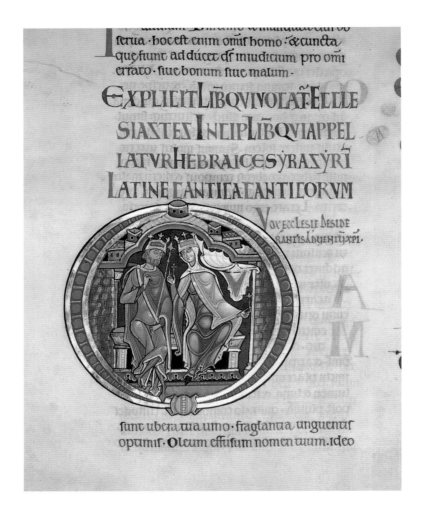

bride," as the Church. An English miniature more or less contemporary with the Santa Maria in Trastevere mosaic shows – in an arrangement similar to that of the Roman work – the Song's putative author, King Solomon, and his beloved wife side by side in royal robes (fig. 32), while the textual gloss identifies the woman speaking to the king as "*vox Ecclesiae,*" the voice of the Church, thus inviting us to read the poem's intimate dialogue between a bride and her bridegroom in terms of the love relationship between Christians and their Lord. We have only to cite the startling opening verses of the Song, written beneath the miniature in the English manuscript, to grasp the emotional force of this interpretation, in which it is the Church herself who says to Christ: "Kiss me with the kisses of your mouth, / for your caresses are sweeter than wine! / The fragrance of your perfume is inebriating, / your name is fragrant unguent / and that is why the maidens love you. / Draw me in your footsteps, let us run! / The king has brought me into his

chambers. / We shall praise your love above wine; / how right it is to love you" (Song of Songs 1:1 – 4).

The same iconographical scheme will be used again at Rome, in the spectacular apse mosaic in Santa Maria Maggiore executed between 1291 – 1296 to a design by Jacopo Torriti (fig. 33), where however Mary – seated on Christ's throne – is shown in the act of receiving the crown from him. This image is situated above a smaller one depicting Mary's death, and thus represents not only the love between "bride" and "bridegroom" but also the moving reunion of a mother with her Son in Heaven;[6] above all it represents the final goal of every woman and man, the heavenly vocation of our human flesh in which Christ was born. An inscription set between the representation of Mary's death and the image of her beside Christ on the throne in fact clarifies that "mother" and "bride" are one and the same: "*Maria virgo assumpta est ad ethereum thalamum in quo rex regum stellato sedet solio. Exaltata est sancta Dei genitrix super*

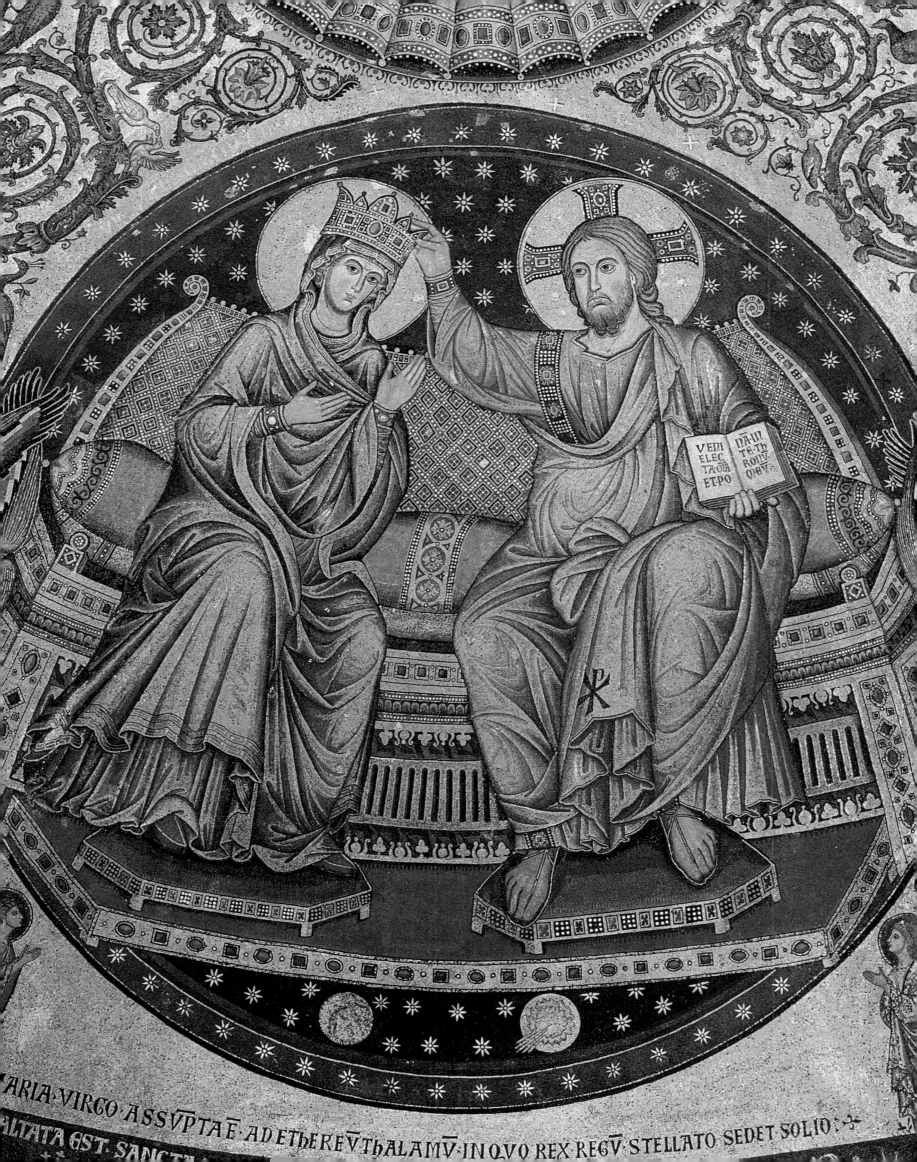

VENI PAM
ELEC TE TI
TA OR ROM
ET PO OBV

ARIA VIRGO ASSVPTA E AD ETHEREV THALAMV IN QVO REX REGV STELLATO SEDET SOLIO
LTATA EST SANCTA

34. The Creation of Eve,
the Creation of the Church,
13th century, Moralized Bible
of King Saint Louis of France,
Österreichische Nationalbibliothek,
Vienna.

35. The Church Contemplating
Christ Ascending to Heaven,
5th century, Santa Sabina, Rome.
One of the panels of the 5th-century
wood doors of Santa Sabina, this
work shows Mary as the Church,
the bride of Christ yearning for
her Spouse. She is flanked by two
men as she lifts her gaze to Christ,
shown ascending to heaven in
a circle of light between the letters
"alpha" and "omega." This "Lady"
thus represents the Church crowned
by the apostles Peter and Paul
as she awaits the return of her
Spouse, Christ, the beginning
and end of human history.

choros angelorum ad celestia regna" – "The Virgin Mary has been assumed into the celestial bridal chamber at whose starry threshold sits the King of kings; the holy Mother of God has been lifted above the angelic choirs to Heaven's realm." And Christ, who with his right hand crowns Mary, with his left displays an open book with the same text we noted in Santa Maria in Trastevere: "*Veni electa mea et ponam in te thronum meum*" – "Come, my chosen one, and I will set my throne in you."

Beneath the footstools of Mary and Christ in the mosaic in Santa Maria Maggiore, at the level of the "starry threshold," we find elements useful to the *identikit* we are in the process of assembling: the moon below Mary, the sun below Christ – details meant to suggest the dependent character of the "bride's" relationship with her Lord: in fact neither Mary nor the Church has her (its) own light, but shines with the light of Christ. This dependence deeply marks their relationship, giving it particular urgency since Christ long ago left earth, in his Ascension going to Heaven where he awaits us. The Church, as it waits to share Mary's happy sort and be received in the celestial bridal chamber, thus lives in desire and in hope.

Mary, Figure of Spiritual Desire

The Church's urgent desire for her Bridegroom is the theme of a series of early Christian and medieval images, in which we grasp – among other things – the *feminine significance* of a Marian characterization of the faith-community. The most ancient is a panel from the wooden doors of the Basilica of Santa Sabina in Rome, a work of the mid-5th century in which we see a woman flanked by two men (in the lower register), looking upwards to where Christ ascends in a ring of glory between the letters Alpha and Omega (fig. 35). The woman does not only look upward but raises her hands as well, in a gesture that expresses at one and the same time *desire* and (in the manner of the ancients) *imploration, ardent prayer.* The men alongside her hold a wreath inscribed with a cross over the woman's head as if it were a halo, and with her look up at Christ ascending.

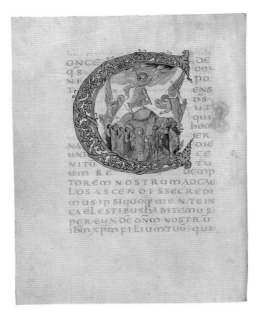

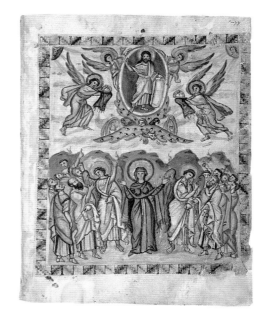

36. *Ascension*, 826 – 55,
Sacramentary of Drogo of Metz.
Bibliothèque Nationale,
Lat. 9428, fol. 71v, Paris.

37. *Ascension*, c. 586,
Evangelary of Rabbula, fol. 13b.
Biblioteca Medicea Laurenziana,
Florence.

Who is this woman and who are the men? Some time later it became customary to include Mary among those present at Christ's Ascension (see our Introduction, the discussion of the Sancta Sanctorum coffer, fig. 17), and the woman here might already represent the mother of Jesus. But she certainly represents – in the first place and beyond all doubt – the Lady Church crowned by the apostles as she lifts her mind, heart and hands toward Christ who leaves her, in the spirit of the last book of the New Testament, the Revelation, where on the final page, when Christ identifies himself with the letters Alpha and Omega and promises to return soon, "the Spirit and the bride say: 'Come!'" (Revelation 22:17), and Christ, from above, promises: "Yes, I will come soon!" (Revelation 22:20).

This dramatic dialogue, in which we hear all the bride's yearning for her Bridegroom – the yearning of the Church for Christ – constitutes literally the last page of the Judeo-Christian scriptures and is linked to the analogous relationship between a woman and her husband described in the opening pages of the Bible: in the Book of Genesis, where among the consequences of original sin God mentions woman's frustrated desire for the love of man, who is no longer capable of sincere response. "Your yearning will be for your husband," God tells Eve, and adds: "Yet he will lord it over you" (Genesis 3:16). This causes Eve intense suffering – a practically physical anguish, since (as Genesis recounts) woman comes from man, being shaped from the rib God took from the side of Adam, who, when he saw Eve for the first time in fact exclaimed: "This at last is bone from my bones and flesh from my flesh!" (Genesis 2:23).

The same physical intimacy was ascribed to the Church's relationship with Christ, as is suggested by the miniature from a French 13th-century *Bible moralisée* (fig. 34), where in the upper circle we see Eve created from the side of Adam as he sleeps, and then, immediately below, the Church created from the side of the "new Adam," Christ, "*in somno crucis*" – "in the sleep of death upon the cross." From the water and blood pouring from Christ Crucified, that is, flow the sacraments from which the Church draws life – Baptism and the Eucharist – so that she, like Eve, is "bone of the bone" and "flesh of the flesh" of her Husband, with whom she forms a single body. "This is why a man leaves his father and mother and joins himself to his wife, and they become one body," the already quoted passage from Genesis concludes (Genesis 2:24), and the Pauline Letter to the Ephesians, inviting husbands to love their wives, cites these very words in reference to the relationship between Christ and the Church: "This mystery [i.e. marital love] has many implications, but I am saying it applies to Christ and the Church" (Ephesians 5:30 – 32).

The line of theological reasoning suggested here, which seems to underlie the iconography of the Santa Sabina panel, assumes more explicitly Marian connotations in later periods. Miniatures from the 6th to the 12th centuries situate a woman whom we immediately recognize as Mary at the center of the group of apostles present at the Ascension, giving her gestures that again express yearning, prayer and imploration, as if she continued to utter the heartrending appeal of the Revelation, saying: "Come!" (figs. 36, 37, 38).[7] In one of these, a Byzantine *Ascension* of the 12th century (fig. 38), the event unfolds inside a magnificent church, as if to insist on the ecclesial nature of the relationship of love and desire illustrated. And in all these images Mary, the new Eve and figure of the Church, is joyous, her desire colored by hope because her Bridegroom, the new Adam, has neither refused her nor lorded it over her but rather "sacrificed himself for her to make her holy" (Ephesians 5:25 – 26); even in their physical separation, He loves her as He loves his own body, feeding her and looking after her (cf. Ephesians 5:28 – 29).

At this point readers may ask what sense there is in continually

shifting our discussion from Mary to the Church and back, especially when speaking of such apparently contrasting features as Mary's virginity and the all but physical desire of the "bridal" Church, or Mary's presence in the bosom of the Trinity and the Church's yearning for its departed Lord. The answer to this query, formulated in no uncertain terms in the early centuries of Christian life, has all the flexibility of patristic and medieval thought: when, for example, Saint Augustine comments on the Gospel verse in which Jesus, informed that his mother and brothers were looking for him, indicated his disciples and said: "These are my mother, these are my brothers; for whoever does the will of my Father in Heaven is for me a brother, a sister, a mother" (Matthew 12:49 – 50), he notes that such a response neither excludes nor humiliates Mary (who perfectly accomplished the Father's will) but rather *distinguishes her two roles.* "It counted more that Mary was Christ's disciple than that she was his mother," the Father of the Church says.[8]

Augustine then reiterates the idea, commenting on a second New Testament passage: that in which, to the woman who from the midst of the crowd called to Christ, "Blessed the womb that bore you and the breast that gave you suck," he replied, "Blessed rather are those who listen to God's word and keep it" (Luke 11:27 – 28). Augustine reflects that "Mary too was blessed for this reason, listening to God's word and keeping it. She in fact kept the truth in her mind even more than the babe's flesh in her womb. Christ is truth, Christ is flesh; Christ is truth in Mary's mind and flesh in Mary's womb. But what is in the mind counts more than what is in the womb."[9] He then concludes

with an astounding assertion that fully clarifies the fluid relationship between Mary and the Church: "Mary is holy, Mary is blessed, but his Church is better than the Virgin Mary. Why? Because Mary is a part of the Church: a holy part, an excellent part, a part that surpasses all others in dignity, but still only one part in respect to the entire body. And if she is but a part of the whole, then surely the whole body is worth more than any single one of its parts."[10]

It follows that everything we can affirm with regard to the Church, we both can and should affirm with regard to Mary who is part of the Church. What is more, according to the 12th-century theologian, Blessed Isaac of Stella, this equation works in the opposite sense as well: "In the divinely inspired Scriptures, whatever is said in general of the virgin mother Church should be understood in a personal sense as applicable to the virgin mother Mary." Isaac (echoing Saint Augustine) adds: "And what is said specifically of the virgin mother Mary should be applied to the virgin mother Church; and whatever is said of either one of the two can, without distinction, be said of the other."[11]

We can illustrate this conceptual to-and-fro with a famous work that – unlike miniature paintings executed in the restricted monastic context – was intended for a vast and variegated public: an altarpiece by Raphael signed and dated shortly before his departure from Umbria, the *Marriage of the Virgin* (fig. 39). Painted in 1504, the year in which Michelangelo completed the *David*, this work still has the delicately proportioned figures beloved of 15th-century masters; done when Raphael was only twenty-four years old, it in fact betrays the en-

38. *Ascension*, early 12th century. Sermons on the Virgin by James Kokkinobaphos, Ms. gr. 1208, fol. 3v. Bibliothèque Nationale, Paris.

39. Raffaelo Sanzio, *Marriage of the Virgin*, 1504. Brera Museum, Milan. Commissioned for the chapel dedicated to Saint Joseph in the church of San Francesco in Città di Castello, this work by a youthful Raphael, signed and dated 1504, alludes to the nuptial relationship between Christ and the people of God. The building in the background represents the Jerusalem temple, where according to tradition Mary had been brought up (in the foreground we in fact see the High Priest presiding at the ceremony), but also represents the new "temple," the Church, the bride of Christ "figured" in Mary. In its architectural form, the building is similar to the chapel created in Rome in the same years in honor of Saint Peter, the so-called "Tempietto" in San Pietro in Montorio, a work by Raphael's friend and fellow Umbrian, Donato Bramante.

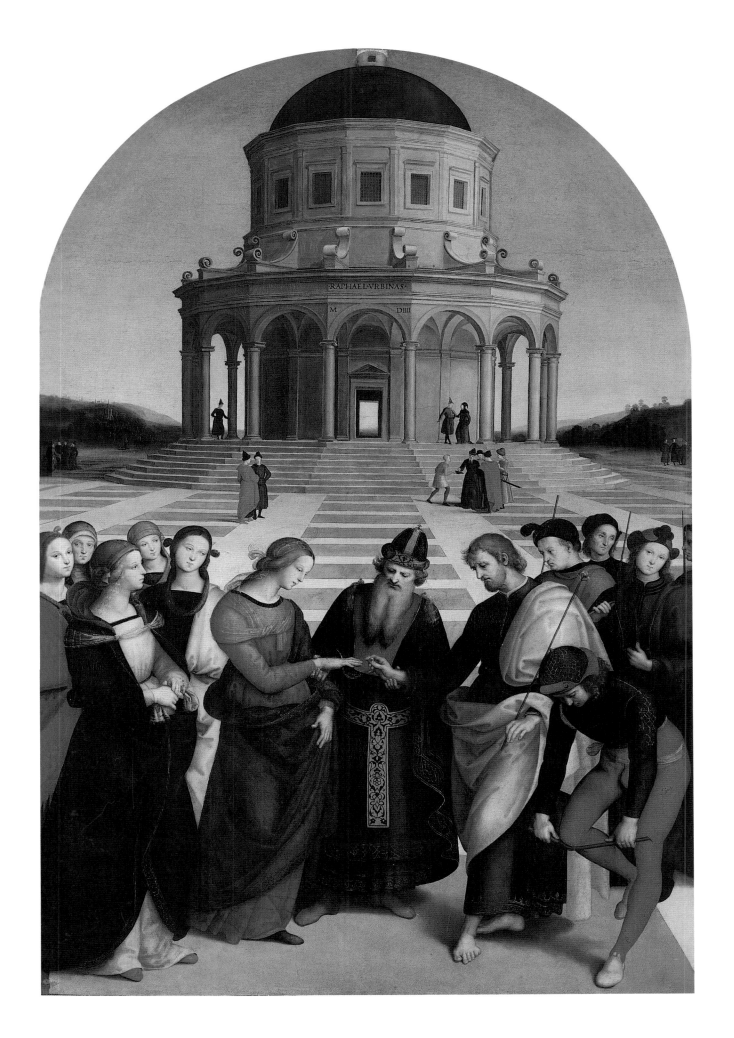

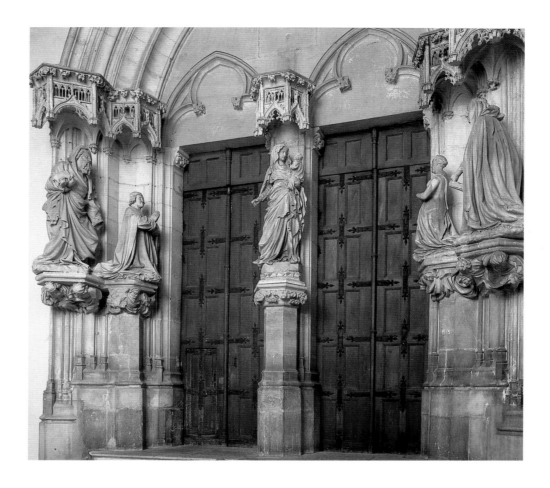

during influence of his teacher, Pietro Perugino – even though pupil here surpasses teacher in his ability to unify and animate the composition. Particularly brilliant is Raphael's repetition of the central iconographic element – the ring that Saint Joseph puts on Mary's finger in the foreground is evoked in the ring-like arcade encircling the imposing, centrally-planned temple in the background, and the rhythmic, complementary movements of all the figures echo the circular perfection of these two rings.

The only monumental element in this work is the temple in the background, which thus assumes considerable importance. It alludes to the Temple in Jerusalem where tradition held that Mary had been raised, and in the foreground we in fact see the high priest officiating at her wedding. But this temple-like building also alludes to the Church, the "bride of Christ" figured in Mary. Playing on the nuptial character of his subject, young Raphael appeals to the well-known identification of Mary and the Church, to extend to the ecclesiastical institution the same feeling of harmony that his composition confers on the historical event. We know, moreover, that the design of the temple shown here is related to the ideas of Donato Bramante, Raphael's older contemporary, also from Urbino, who in 1502 had been commissioned to create a small chapel at the center of the cloister of San Pietro in Montorio at Rome: the so-called "Tempietto." Raphael's temple in the *Marriage of the Virgin* probably echoes an early version of Bramante's plan for the Tempietto, which in turn was part of the architect's

development of a project for rebuilding Saint Peter's Basilica, formally commissioned of him in 1506. It is thus possible that, far from being a merely generic allusion to the Church, the temple in Raphael's painting is a specific adumbration of the new papal basilica then being planned, Saint Peter's: the building destined to become an emblem of Catholic Christianity.

Door, Ark and Womb

In the center of Raphael's painting – at the vanishing point of the remarkable perspective system structuring his *Marriage of the Virgin* – an open door affords a glimpse of sky. This door, which gives breath and life to the whole composition, alludes to one of the most poetic of Mary's symbolic functions: that of *janua coeli*, "gate" or "door" of Heaven.

Like many ideas associated with Mary, this figure of speech derives from an analogous Christological figure: that found in the fourth Gospel where Christ says of himself: "I am the gate. Anyone who enters through me will be safe: he will go freely in and out and be sure of finding pasture" (John 10:9). The meaning of this assertion is suggested in another New Testament text, the Letter to the Hebrews, which explains that Christians have access to Heaven's sanctuary thanks to "a new way which [Christ] has opened for us, a living opening through the curtain, that is to say, his body" (Hebrews 10:20). If however it was through his *body* that Christ became a "way" (and hence a "gate" or "door") giving

40. Claus Sluter, Portal of the Charterhouse of Champmol, 1385 – 93. Dijon (Champmol).

41. Jan Van Eyck? Petrus Christus?, *Annunciation*, early 15th century. Metropolitan Museum of Art, New York.

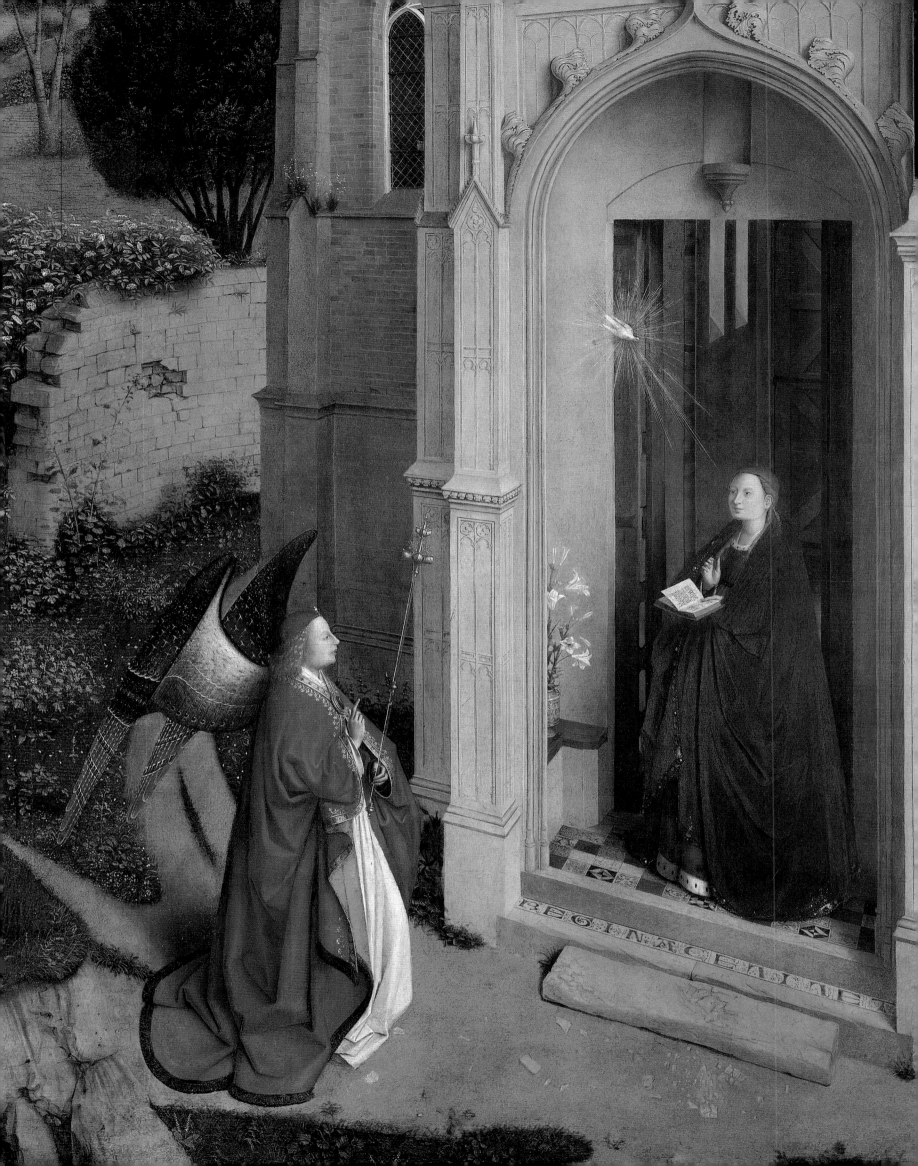

men access to God's life, then the first "way" or "gate" or "door" was actually Mary, who by her assent gave God access to man's life. And Mary, like Christ, is a "two-way door," by which the Divine enters the human and the human opens to the Divine.

In this perspective it is easy to understand the custom of putting statues of Mary and the Christ Child at church entrances, as in the case of the portal of the Charterhouse of Champmol, a masterpiece by Claus Sluter (fig. 40), where all who go into the church (the noble patrons first of all) enter *through* Mary, from whose flesh came the flesh of Christ, the "new and living way" into the sanctuary. Still more explicit is a painting produced in the same Burgundian context from which Sluter had come: an *Annunciation* now in the Metropolitan Museum at New York, variously attributed, where the artist sets Mary in the door of a church at the very moment when the Word becomes flesh in her womb (fig. 41). In this work Mary herself becomes the door admitting God to the experience of human life, and – since Mary is an ecclesial figure – the Church appears as the door through which man is admitted to the experience of God.

One of the most of eloquent such images in 15th-century art is the carved emblem of Milan Cathedral, where the then-rising structure is shown protected by a colossal figure of Mary who spreads her mantle over the building (fig. 42). As imagined by the anonymous artist, the doors in the cathedral façade introduce believers "into Mary," bringing them under her protection but also *into her body*, those who enter the edifice thus becoming "other Christs" whom the mother Church carries in her womb until the moment of their birth unto Heaven. Saint Augustine had developed precisely this idea when, commenting on a phrase of Saint Paul's – "My children, I must go through the pain of giving birth to you all over again, until Christ is formed in you" (Galatians 4:19), he argued that Paul "said this as if he were depicting the mother Church.... For Christ is born and takes shape in all who believe by means of the faith existing in our inner selves." Augustine adds that anyone who believes "becomes a copy of Christ and – to the degree his human condition allows – becomes Christ himself."[12]

Those entering Milan Cathedral thus "enter Mary" – enter the Church – in order to be formed as other Christs. A similar association of the Church with a womb is apparent in a carved *Annunciation* on the south side of Florence Cathedral (discussed at length in Chapter Three) where – between the angel who announces and

42. Emblem of the Milan
Cathedral, 15th century.
Museo del Duomo, Milan.

43. Florentine Master, *Annunciation*,
13th – 14th century. Cathedral
of Santa Maria del Fiore, Florence.
Carved in the late 13th century
in a transition style between
Romanesque and Gothic,

this work characterizes the
Annunciation in a very explicit
way, showing – between the angel
at the viewer's left, and Mary
at the right, a symbolic structure
"invaded" by the Holy Spirit:

an evident architectural symbol
for what happened when Mary's
womb was "inhabited" by God
and she became the "tabernacle"
of the Holy Spirit.

Mary who accepts – we see the Holy Spirit penetrate the space of a small, domed structure, in which are inscribed the angel's words: "*Ave, gratia plena!*" – "Hail, full of grace!" (fig. 43). The "grace" and the Christ-to-be-formed are *inside this symbolic structure*, which seems to stand for the womb of mother Church! A similar message is perhaps implied in Jan Van Eyck's *Madonna and Child in a Cathedral* (fig. 44), where both mother and babe seem formed by sunrays flooding into the luminous "womb" of a church.

A particularly rich articulation of these ideas is found in the so-called "cupboard Madonnas" of the late-15th and early-16th centuries: statues that, when closed, simply show Mary with her Child, but which, when open (in the manner of altarpieces with cupboard doors), show the inside of the Virgin's womb with the cross supported by God the Father and adored by Church members in their different ranks (figs. 45, 46). These works show Christ in Mary's womb not as a baby but on the cross because – as Saint Leo the Great says – "the Divine majesty assumed the humility of our state: his force our weakness, his eternity our mortality, and, to pay the debt burdening our condition, his superior nature assumed ours subject to suffering."[13] In figure 46 we see the Father behind the cross because, as Saint Leo continues, Christ, even when he

took flesh in the Virgin's womb, was still God and the Son of God. "He lifted up our humanity without diminishing his Divinity. His self-annihilation made the Invisible visible and the Creator of all things mortal, yet this was a merciful condescending toward our wretchedness, not a loss of power and dominion."[14]

Saint Leo saw the Incarnation itself as a first form of self-annihilation prefiguring the cross, and read both events as expressions of God's merciful condescension toward men. That is why, in the "cupboard Madonnas," we find human beings adoring the crucified Christ: they are adoring Him who, in his mercy, assumed our flesh to "pay the debt burdening the human condition." God's children through their acceptance of Christ (cf. John 1:12 – 13), these believers are also children of the Church figured in Mary – shaped in her womb as Christ himself was – and beneficiaries of a mercy that consists precisely in God's choosing to share our fleshly condition.

Mater Misericordiae

In this light Mary, the mother who gave God's Son the flesh in which he saved us, is also "mother" of the concrete mercy God shows human beings – a maternity, this, normally expressed not

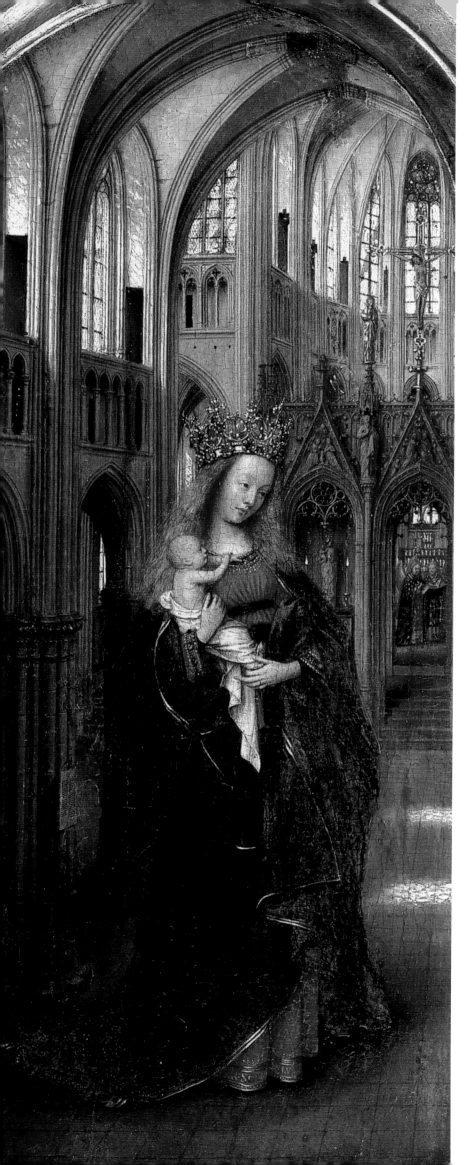

44. Jan Van Eyck, *Madonna and Child in a Cathedral*, c. 1430. Gemäldegalerie, Berlin.

in images of her open womb but through the visual metaphor of a spread mantle. The iconographical type known as the *Mater Misericordiae*, which shows Mary gathering believers beneath her cloak, has this meaning: it is a special illustration of the motherhood that unites God with men, extending the Father's merciful love to all. A delightful relief of the early 15th century in San Primo, at Kamnik, Slovenia, suggests the universality of this vision, cramming more than fifty people of different ranks and conditions beneath Mary's immense mantle held open by angels.

The most famous representation of Mary as *Mater Misericordiae* is that by Piero della Francesca (fig. 47), commissioned in 1445 by a lay confraternity in Borgo San Sepolcro known as the "Brotherhood of Mercy."[15] This image is the central panel of a larger altarpiece (fig. 48), and situates Mary and the faithful who take refuge beneath her cloak (the members of the confraternity) amid figures of saints, with a *Crucifixion* in the pinnacle above and a *Burial of Christ* below. Crucifixion and burial: the message of divine mercy shown through Christ's self annihilation in the flesh he took from Mary is perfectly clear, as is the eucharistic connotation of this work originally set on an altar – a work in which we in fact perceive the confraternity members near Mary and the other great figures of Christian history as parts of a "communion of saints" that here is evidently related to the sacramental communion of Mass.

Use of the "Mother of Mercy" as the main subject of an altarpiece was unusual in the 15th century. This iconographic formula presents Mary *without her Son*, as an autonomous protective figure, whereas normally it was the Son's *presence* that legitimated Mary's own representation in a eucharistic setting (for all the reasons already adduced, Mary being the source of the flesh Christ would offer on the cross to become bread of eternal life). The usual subject of 15th-century altarpieces, the Madonna and Child, by contrast stressed Mary's dependent status, inviting viewers to associate the bread in the celebrant's hands with the baby seen in his mother's arms, in an overall vision of the Eucharist as the continuation in history of God's presence in the midst of his people beginning at the Incarnation.

Just as unusual for the 15th century is the fact that living men and women are shown interacting with the main subject. To be sure, the members of the confraternity are represented on a smaller scale than Mary and the flanking saints, yet their sharply dif-

ferentiated reactions, like the arrangement of the group in a circle under the Virgin's mantle, would have surprized contemporary viewers – the more so because Mary and the surrounding saints are presented in hieratic, frontal poses and without particular emotional involvement. Evidently, Piero wanted to emphasize the importance of the lay people shown.

The spiritual sense of these innovations becomes clear if we imagine the altarpiece, which today is in a museum, in its original position in the chapel of the Brotherhood of Mercy. At the consecration of the Mass, when the priest elevated the host and chalice, confraternity members present for the rite, kneeling before the altar and its painting, would have perceived themselves as included in the same communion of saints shown in the image. Beyond the raised bread and wine, they could see themselves gathered beneath the cloak of her from whose body came the body offered on the cross and present in the Eucharist! The arrangement of the men and

women in the painting, in a circle around Mary, seen in relation to the circular host and chalice rim, would have suggested that they too were "body and blood" of Christ, born of the same mother.

And that was the point. For what the Eucharist *is* in a sacramental way – the body of Christ – the faith-community *is* in a mystical way. "You together are Christ's body; but each of you is a different part of it," Paul had told the Christians at Corinth (1 Corinthians 12:27). This assertion concluded an elaborate analogical presentation of the interdependence of constituent parts in a "corporate" reality such as the Church: "Nor is the body to be identified with any one of its many parts.... The eye cannot say to the hand, 'I do not need you.'... If one part is hurt, all parts are hurt with it" (cf. 1 Corinthians 12:14 – 26). This in fact was the *raison d'etre* and operative rationale of charitable groups such as the Brotherhood of Mercy of Borgo San Sepolcro, whose healthy members helped less fortunate brethren. "God has arranged the body so that more dignity

47. Piero della Francesca, *Madonna of Mercy* (detail), c. 1450. Pinacoteca Comunale, San Sepolcro. The most famous example of the "Mother of Mercy" formula is this work by Piero della Francesca, commissioned in 1445 by a lay confraternity in Borgo San Sepolcro.

The central element of the altarpiece, which includes scenes relative to Christ's passion, is the figure of Mary spreading her mantle over the members of the confraternity – an eloquent expression of God's mercy operative in Christ's self annihilation in the

human flesh he had received from Mary his mother. Originally placed on an altar, this work also expresses the eucharistic sense of Mary's life, out of which came the body offered as food allowing human beings to participate in God's life.

48. The same: the entire altarpiece.

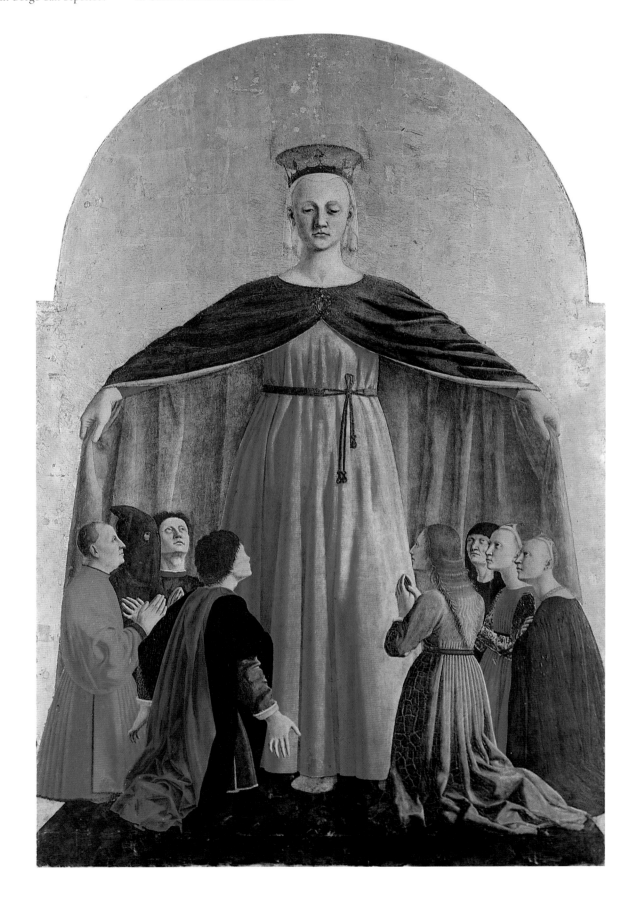

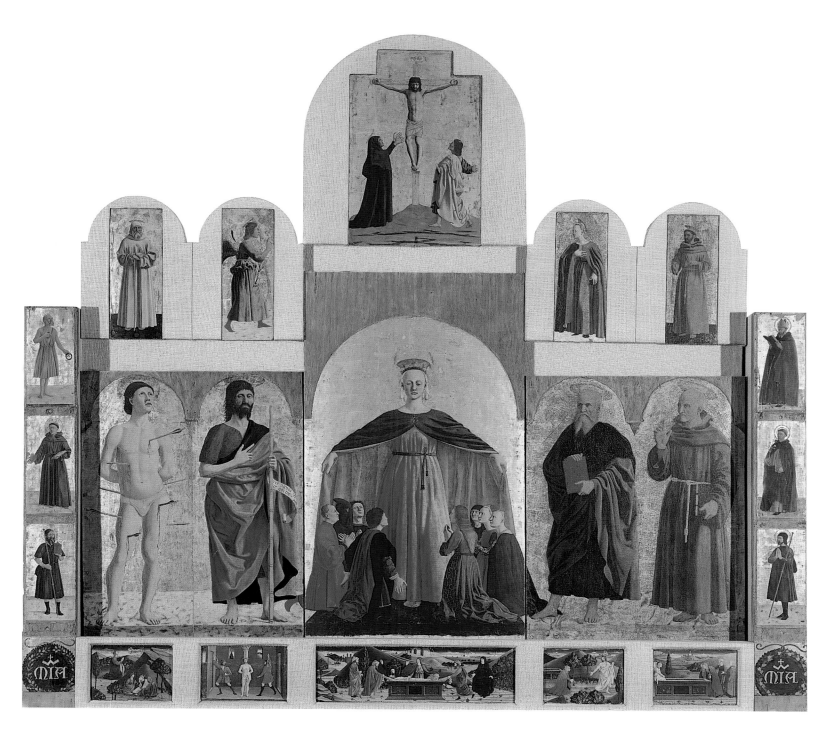

is given to the parts which are without it, and so that there may be no disagreements inside the body, but that each part may be equally concerned for all the others" (1 Corinthians 12:24 – 25).

The relationship of these ideas to Mary is suggested by a 15ᵗʰ-century theologian, Nicholas of Cusa. Reflecting on the Eucharist, he says that Christ "is not a bread that gets transformed into our human nature, as bodily food does; rather he is the bread of life who unites us to himself and makes us live with his very life…. But this union with Christ can only be realized through union with his body: union that is with the holy community of the Christian Church."[16] Mary, the woman from whose body comes the food that makes us participants in God's life, is thus *Mater Ecclesiae* and *Mater Christianorum*, and the confraternity members shown beneath her mantle in Piero della Francesca's altarpiece are sons and daughters of her body just as Christ is: lesser expressions of that same divine mercy whose mother she, Mary, is.

Another *Mater Misericordiae* – not public and theological, like Piero's, but private and intensely personal – can suggest how such ideas touched people's lives: the altarpiece commissioned of Hans Holbein the Younger by Jacob Meyer of Basle, a banker and mayor of the Swiss city (fig. 49).[18] Intended for the patron's private chapel, the painting shows Meyer and his family at prayer beneath Mary's mantle; even the banker's first wife is included: Magdalene Bauer, deceased in 1511 but here shown in profile right next to Mary, together with Meyer's second wife, Dorothy Kannengiesser. The girl kneeling in the foreground in front of the two women – the eldest of the children, already wearing a *Jungfernbandl* (the cap of a maiden of marriageable age) – is probably daughter of the deceased first wife, whose straight, strong nose she clearly inherited! The adolescent boy and little baby, on the other hand, must be

49. Hans Holbein the Younger, *Madonna of Mercy with the Family of Jacob Meyer*, 1525 – 28. Schlossmuseum, Darmstadt. Commissioned by Jacob Meyer of Basle, a banker and mayor of the Swiss city, this painting was intended for the patron's private chapel. The air of sadness surrounding the scene is due to the historical time in which the image was made, the years 1525 – 28, when the Protestant reform swept through Basle. Meyer and his family, wanting to remain Catholic despite the threats which both the old faith and its images had to face, have here placed themselves under the protection – under the mantle – of Mary.

Meyer's children by his second wife.

The aura of sadness that envelops this scene, and the urgency with which Jacob Meyer directs his gaze toward Mary are due to the historical circumstances of the years in which the image was made: 1525 – 1528, when the Protestant reform raged in Basle. Meyer and his family wanted to remain Catholics, as their commissioning of an altarpiece that puts them under the protection of Mary, figure of the Church, suggests. It was a threatening time, however, for the old faith and for its images. The painter, Holbein the Younger, himself just back from England and bearer of a drawing sent by the future Catholic martyr, Thomas More, to Erasmus, must have understood Jacob Meyer's moral anguish, which he moreover shared, being similarly obliged to choose sides; this work indeed is one of the last masterpieces of sacred art produced in what was then becoming Protestant Europe. Some years later Holbein would himself make the difficult decision to go over to the new faith.

The Woman Robed in the Sun, Figure of Prayerful Suffering

Mary, a figure of the Church, is also a figure of the Church's suffering, of its fortitude, of its victory. This dramatic role is suggested in an early 14ᵗʰ-century miniature illustrating the central images of the New Testament book that closes with the already mentioned dialogue between bride and Bridegroom: Revelation (fig. 50). At the end of the eleventh and beginning of the twelfth chapters of this text comprised of twenty two, the author describes how, in the midst of the visions accorded to the apostle John, "the sanctuary of God in heaven opened, and the ark of the covenant could be seen inside it" (Revelation 11:19), and that is what the anonymous miniaturist shows us in the upper left of his work. The ark of the covenant – the portable container in which Israel kept the tablets of the Law given by God – is another

50. *The Woman Clothed with the Sun*, c. 1320, in an English Revelation of 1320, Metropolitan Museum of Art, The Cloisters Collection, New York. The theme of the suffering of the Church – of its fortitude and final victory – is suggested in this miniature. The artist has diligently represented the whole scene described in chapter 12 of Revelation: the woman, the sun, the moon, the crown of stars, the dragon and the other stars that fall, the child carried up to heaven and the woman again, in her refuge in the desert. The author of Revelation represented the anguish of the early 2ⁿᵈ-century Church through the figure of a woman, and the medieval artist does not hesitate to identify that woman with Mary.

among several traditional biblical figures in which the Church has seen an adumbration of Mary, who "contained" and "bore" Him in whom the ancient Law would be fulfilled.

The other images in the miniature regard the rest of this central passage of the Revelation: "Now a great sign appeared in heaven: a woman, clothed in the sun, standing on the moon, and with the twelve stars on her head for a crown. She was pregnant, in labor, crying aloud in the pangs of childbirth. Then a second sign appeared in the sky, a huge red dragon which had seven heads and ten horns, and on each of the seven heads a crown. Its tail dragged a third of the stars from the sky and dropped them to the earth, and the dragon stopped in front of the woman as she was having the child, so that he could devour it as soon as born. The woman brought a male child into the world, the son who was to rule all nations with an iron scepter, and the child was taken straight up to God and to his throne, while the woman escaped into the desert, where God had made a place of safety ready, for her to be looked after in the twelve hundred and sixty days" (Revelation 12:1 – 6).

The miniaturist has left nothing out: we see the sun, the moon, the crown of stars, other stars that fall, the child "taken straight up to God" and – on the right – the woman in her "place of safety" in the desert. And, even though the original context of this passage was ecclesial – the author of Revelation was speaking about the situation of the Church at the beginning of the 2ⁿᵈ century, that is, and the "child" threatened but saved is a figure of the Christian community – the artist has given the "woman" Mary's features, and the "child" those of baby Jesus (including the cruciform halo), thus associating with the Virgin Mary the drama the primitive faith community had lived through: the anguish of the Roman persecution and the peace of a

HEC · EST · ILLA · DEQVA · SACRA · CANVNT · EVLOGIA · SOLE · AMICTA ·
IN NAM · HABENS · SVB · PEDIBZ · STELIS · MERVIT · CORONARI · DVODENIS

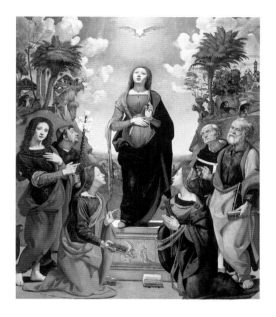

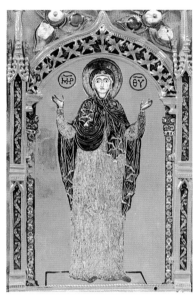

"safety" consisting in concealment and silence (note the lovely figure at the right, the woman reading amidst the trees).

The identification of this simultaneously threatened and saved "woman clothed in the sun" with Mary is crucially important for the later development of several iconographic types, among which the Immaculate Conception, the *Mater dolorosa* and representations of Mary as a figure of contemplative prayer. That this identification in fact became the normal way of reading the relevant text in Revelation is, moreover, confirmed by numerous works of late medieval and Renaissance art, among which the central panel of an important triptych painted circa 1498 at the behest of Duke Pierre de Bourbon for the collegiate church at Moulins (fig. 51).[20] Twenty-four years earlier, in 1474, the patron's older brother, Duke Jean II, had donated to the same church a stained glass window showing the same subject, and the 1498 triptych was clearly meant to "outshine," with its emphasis on light and color, the earlier work: the choice of the same subject in fact suggests competition. In both cases, moreover, the use of the apocalyptic "woman clothed in the sun" was part of the process of development of an iconographical formula for the Immaculate Conception, a Marian dogma hotly debated in the latter 15th century, as noted in our Introduction.

The artist, known as the "Master of Moulins," illustrates the Revelation text with great care, clothing Mary in an incandescent solar orb, showing her crowned by angels and with the moon beneath her feet, where other angels display a scroll with the words: "This is the woman whose praises the Sacred Scriptures sing: clothed with the sun, with the moon beneath her feet, worthy to be crowned with twelve stars." In the French context, we may say, this detailed identification is probably related to the particular support given the dogma of the Immaculate Conception by northern European theologians: the professors at the Sorbonne, for example, had — just two years earlier, in 1496 — solemnly sworn to sustain this teaching.

The relation between the dogma and the Revelation passage illustrated here can be articulated on several planes. The introductory phrase, "the sanctuary of God in heaven opened, and the ark of the covenant could be seen inside it" (Revelation 11:19), resonates in the most ancient stratum of reflection on Mary's special sanctity: in Saint Hippolytus, who in addition to calling her "holy virgin" affirms that Mary was like an ark "made of wood free of rot."[21] The idea that Mary had been preserved from every stain, even that of original sin, came then to be associated with the "place of safety in the desert" offered by God to the pregnant woman so that the huge red dragon would not have power over her. And from the 4th century on, defenders of the dogma held that all of this, albeit representing a singular privilege, had come about within the normal logic of redemption: that Christ, "the sun of justice with healing in his rays" (Malachi 3:20), had justified his mother prior to her birth in token of the future purification of all humankind (to accomplish which he would take a human body from her). In this way the words, "a great sign appeared in heaven: a woman clothed in the sun," came to be interpreted as a reference to Mary, in whose privileged state the Church even today sees "a sign of consolation and sure hope."[22]

The "sign" that Mary's experience offers mankind is that of perfect union between human beings and God. Her preservation from sin served to shape an inner freedom so total that she could finally say "yes" to the angel, welcoming God's life into her own. In Mary, first and more fully than in others, God's promise to pour his spirit "on all flesh" was fulfilled (cf. Joel 3:1), for — at her conception, at the Annunciation and finally at Pentecost — she was purified, quickened and filled by the Holy Spirit.

Mary's permanent condition of "woman under the Spirit" is the subject of an extraordinary painting by Piero di Cosimo: an altar-

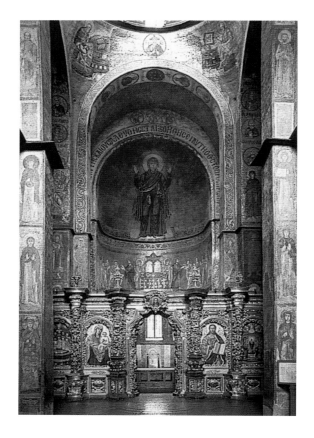

piece until recently erroneously considered an *Immaculate Conception* but which in fact represents *The Incarnation* (fig. 52).[23] At the center of the composition we see Mary on a pedestal, her right hand on her womb as she lifts her gaze to the Spirit shown in the form of a dove; a relief on the base of the pedestal depicts the *Annunciation*, and background scenes at right and left recount the *Nativity* and the *Flight into Egypt*. It is clear, therefore, that this altarpiece, executed for the Florentine church of the Servite Order (the "Santissima Annunziata" discussed in our third chapter), sought to ponder what happened in Mary when she accepted the significance of the angel's words, "the Holy Spirit will descend upon you, and the power of the Most High will overshadow you" (Luke 1:35). The image is not an *Annunciation* in a conventional sense, but rather a pictorial meditation on the spiritual state of this woman perfectly united to God, whose face turned toward the light, ecstatic gaze and hand on her womb visually translate the words: "Hail, full of grace!"

Mary's perfect union with God – her permanent openness to the Spirit – makes her an ideal figure of Christian prayer, as is suggested by one of the small Byzantine enamels of the "Golden Altarpiece" in San Marco in Venice – the *Pala d'Oro* (fig. 53). The pose that the anonymous Constantinopolitan master gave her – with arms raised and hands open – is the ancient position of prayer and supplication, preserved right down to the present at Mass, where the celebrant lifts his arms and hands in this way. Of the same period as the *Pala d'Oro* enamel is a monumental version of the same subject, the figure of Mary in the apse of the church of Sviata Sofia in Kiev (fig. 54), where, standing above the altar, Mary appears to officiate at the Divine Liturgy! A figure of the whole Church at prayer, she gathers and offers believers' individ-

ual prayers to the God with whom, through her Son, she is perfectly united.[24]

Mary and the Eucharist

Mary's relationship to the liturgy, and the resulting link between Marian images and places of eucharistic worship, have never been adequately studied.[25] The basic link, as suggested above, regards the one body of Christ born of her womb, offered on the cross and present in the Eucharist. A small 14th-century tabernacle makes the bond explicit, showing the announcing angel on one side of the door, Mary on the other and God the Father above (fig. 55).[26] In the intermediate space, where the *Verbum Dei* is both proffered and accepted and, in this case, where the Eucharist is reserved, we see the Word become flesh and the flesh become bread in a way that makes it easy to associate the sacramental *corpus Christi* with the body conceived in the Virgin's womb. The same idea was communicated by the typical arrangement of altarpieces in front of priests celebrating, as suggested by a representation of *The Mass of Saint Denis* (fig. 56), since – as already noted – both priest and people saw the small body in Mary's arms just beyond the consecrated bread.

A particularly eloquent illustration of the Mary-Eucharist relationship is the altarpiece commissioned of the Carmelite painter Filippo Lippi by the Medici family for the private chapel of their palace in Florence (fig. 57). The image – which became the focal point of a cycle of frescoes painted in the chapel a few years later by Benozzo Gozzoli – shows Mary adoring her Son beneath the Father who pours forth his Spirit, with figures of Saints John the Baptist and Romuald at the left. Gozzoli's frescoes, covering the re-

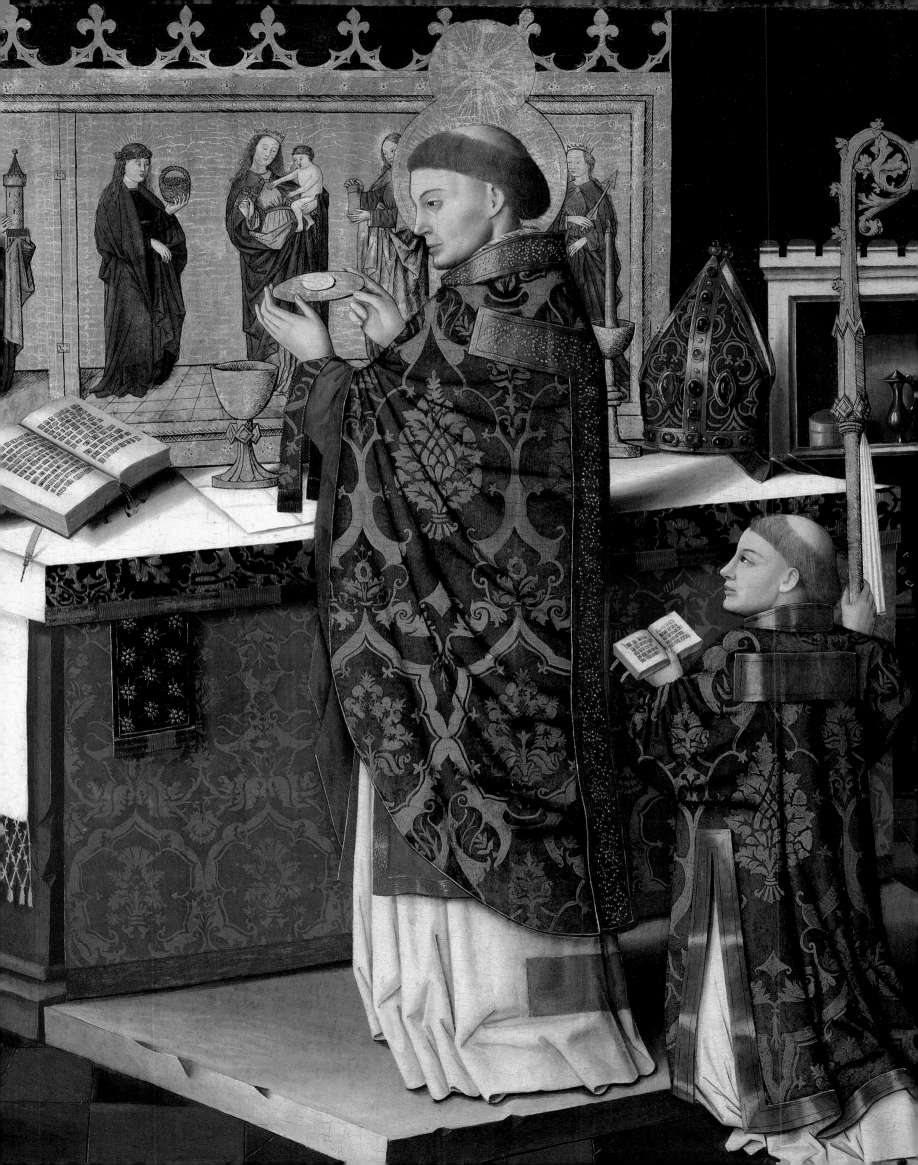

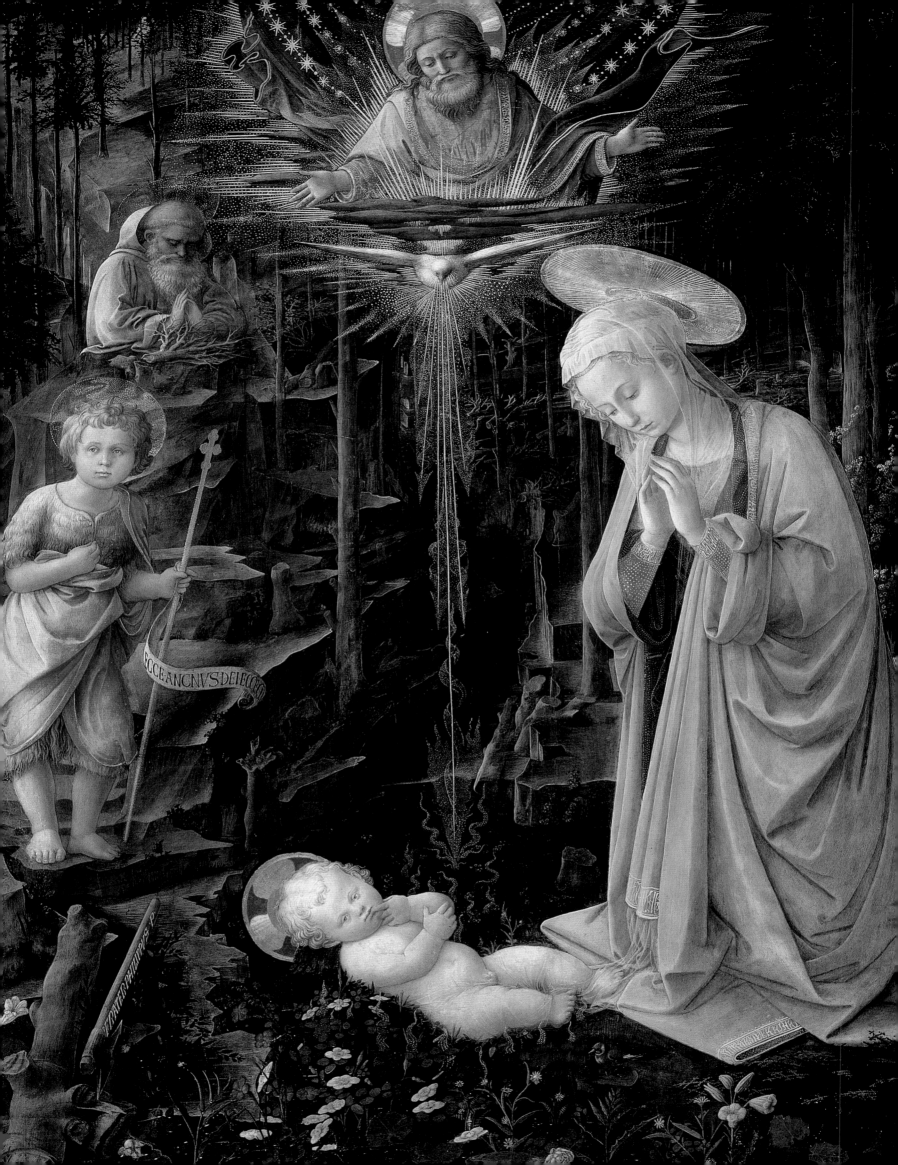

maining walls of the chapel, recount the journey of the Magi, who thus seem to move toward the scene depicted in the altarpiece; in the wall above the altar a circular window serves as a "star," so that visitors read the event shown in Lippi's painting as the end of a journey: the three Kings' arrival at their destination.

The "event" in question is God entering the world: the Son of God born on the earth. The Father is visible in the upper center; under him the Holy Spirit, and then (beneath the rays descending from the Spirit) there is the Son, third Person of the most holy Trinity. This central axis of the image – constituted by

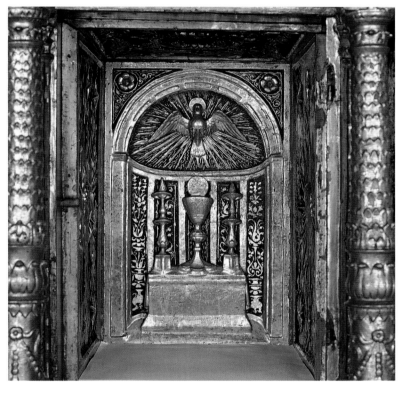

the Father who spreads his arms, by the Spirit hovering, and by baby Jesus – is in turn aligned with the center of the altar, where the celebrant consecrated bread and wine during Mass, and those elements coming from the earth were visually linked to Christ's body depicted as born upon the earth. The Eucharist itself was here perceived as an extension of the Trinitarian life revealed with Christ's birth, especially since the bread and wine of the Mass in fact becomes the Savior's body and blood when the Father, invoked by the priest, sends his Spirit upon the gifts, as is suggested by the relief inside an early 16th-century Tuscan tabernacle, showing the Spirit descend on host and chalice (fig. 58). In addition, in the Medici altarpiece the sacrificial character of the Eucharist is stressed by the inclusion of Saint John the Baptist, the prophet of Christ's future death, and by the presence of Saint Romuald, the ascetic founder of the semi-eremitical Camaldolite Order. The whole scene moreover unfolds in the centuries-old forest surrounding the Sacred Hermitage of Camaldoli, where the Medici regularly withdrew to pray.

Among these many interconnected themes, the main figure – "dominant" even if not centrally placed – is again Mary, shown like her Son under the Spirit poured forth by God the Father. Indeed it is her deep recollection and attitude of prayerful adoration that invest this image with silence and mystery. Like other representations of Mary kneeling before her newborn Son, Lippi's painting derives from the *Revelations* of the 14th-century mystic, Saint Bridget of Sweden, who in her visions saw the Virgin kneel on the bare earth to adore the Child, from whom dazzling light irradiated.[27] Still more directly, Lippi's work is indebted to the Florentine mysticism of the Dominican friars Blessed Giovanni Dominici and Saint Antonino Pierozzi, who taught that devout Christians can identify with the Virgin, cultivating in themselves a "garden of the soul" in which Christ will be born.[28] At a time in history when the faithful actually received the Eucharist very rarely, preferring to contemplate with the eyes and to adore with the heart, this altarpiece – where the largest figure, Mary, contemplates and adores, clearly suggested the right way to participate at Mass: like Mary, from whom Christ is truly born.

The meditative intimacy of this altar in the Medici Palace chapel represents a unique moment in the history of iconography: a "pause for reflection" between the ceremonial formality of Marian images associated with the liturgy in the Middle Ages (see above, figs. 13, 14), and the theatrical exuberance of grandiose Baroque assemblages like the Mary-altar in the parish church of Saint Nicholas at Überlingen (fig. 59) or the phantasmagoric *Trasparente* in the cathedral of Toledo. In the first case, the whole central part of the enormous wood construction – the part directly above the point where, at the altar, the Eucharist is consecrated – relates Mary's body to the *Corpus Christi*: right over the altar, we see her conceiving the Child at the moment of the Annunciation; at the middle level the baby is born in the body taken from Mary; and at the upper level Mary's body is lifted (in the Assumption) to a place at the heart of the Trinity. At the pinnacle – at the point of

59. Jorg Zurn, *Mary Altar*,
1609 – 13.
San Nicola, Uberlingen.

60. *Mary Breastfeeding*,
15th century. Fresco in the grotto
at Greccio, Rieti.

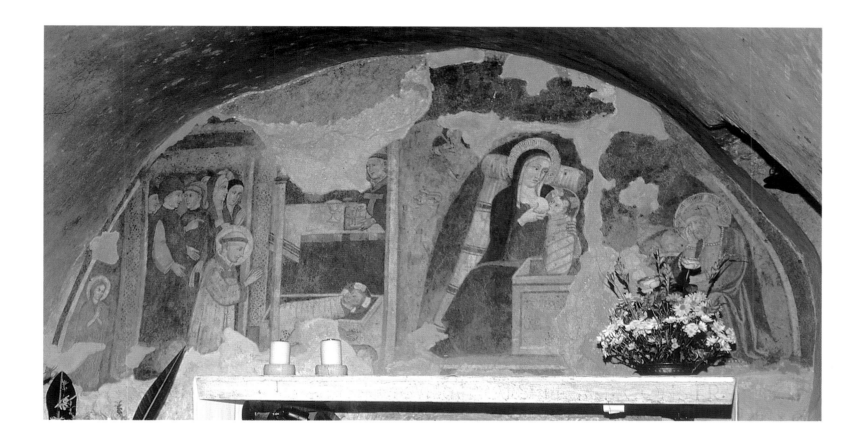

visual and theological culmination – we then see Christ's body on the cross: the offering, pleasing to the Father, which renders possible the sanctification and glorification of Mary's body.

Such insistence on Mary's role – comprehensible in the polemic context of early 17th-century Germany, where both the *cultus* of Mary and that of the Eucharist were rejected by Protestant Christians – would in due course give way to a dawning Catholic concern to bring Marian devotion back to a Christological framework. An illustration of the new mood is provided by the Toledo *Trasparente*, done in the third decade of the 18th century, where, over the altar, we again see Mary and the Christ Child, but at the operative level of this spectacular liturgical "machine" – in front of the apse window that illuminates it, and behind the tabernacle in which the Eucharist is kept in the towering high altar *retablo* for which the *Trasparente* serves as back-façade – we find a representation of the *Last Supper*, the moment when Christ offered the body taken from Mary in the signs of bread and wine, the night before he died.

Milk and the Earth

A special iconographical feature of the Mary-Eucharist theme was emphasis on the Virgin's maternal role as giver of nourishment, and on her resulting relationship with "mother earth." At Greccio, for example – in the fresco done by an anonymous 15th-century master for the grotto where, two centuries earlier, Saint Francis had invented the Christmas crib – Mary is shown breast feeding her Son (fig. 60). Situated at the exact center of the eucharistic altar, where the priest consecrates the bread and wine, this woman giving suck perfectly expresses the mystery of the earth that nourished the physical life transmitted in Mary's milk, forming Christ's flesh, which, offered on the cross, became bread of life eternal. The fresco seems to translate a passage in Saint Augustine's *Commentary on Psalm 98*, where the Church Father explains that Christ "took earth from the earth, taking flesh from Mary's flesh. And since in that flesh he walked in this world, and for our salvation gave us that flesh to eat – and since no one may eat of that flesh without first adoring it," Christians should "adore" – venerate – the earth as

well, which Christ associated with his divinity when he took his body from another human body nourished by the earth (i.e., from Mary's body fed with things come from the earth). In that body – or, rather, in that "earth" – Christ died and rose in order to be corporally present in elements taken from the earth: bread and wine.[29]

This bond between Mary's milk, the earth and the Eucharist is implied in numerous works, among which the curious *Salting Madonna* by Robert Campin (fig. 61), where the heavy breast the mother is about to give her Child, and the position she has assumed – seated on the ground in sign of humility – are related to each other, as is the fact that in place of a halo the artist shows a straw screen, practically insisting on Mary's rootedness in everyday, earthly things. The open book on the bench, at the left, alludes to the Word become flesh, and the chalice on the table where Mary rests her arm brings the sense of the painting back to the mystery of Christ's human flesh, nourished by the earth but destined to become heavenly food in the Eucharist.

Other versions of the *Virgo lactans* seem simply to celebrate the transmission of life from mother to child (fig. 62), at times dwelling

61. Robert Campin (Master of Flémalle?), *Salting Madonna*, c. 1430. National Gallery, London.

62. Nino Pisano, *Mary Breastfeeding*, 14th century. Museo Nazionale di San Matteo, Pisa.

indiscreetly upon the individual beauty of the young woman shown breast-feeding. This is the case with Jean Fouquet's *Mary Breastfeeding* now in Antwerp (fig. 63), which – according to the older sources – represents Agnès Sorel, the mistress of Charles VII, the king of France crowned with the help of Joan of Arc. Commissioned by the nobleman who served Charles VII as treasurer, Etienne Chevalier, this elegant "queen" uncovering her lovely, firm breast was part of a diptych with – in the other panel, on the left – a portrait of Etienne Chevalier himself presented by his patron saint, Stephen, to "Mary." The exquisite but worldly work originally occupied an altar in the cathedral of Melun, Chevalier's native city.

Clearly, however, the bond between Mary's maternity and earth's fecundity had a deeper level of meaning. Mary "represents" the earth, and Saint Augustine – pondering the significance of the Incarnation – sets alongside the crucial New Testament phrase, "the Word became flesh" (John 1:14), a verse from the Old Testament: "Truth has sprung up from the earth, and justice has looked down from Heaven"

(Psalms 85 [84]:12), affirming that "truth has sprung up from the earth because the Word became flesh.... Truth has sprung up from the earth: from Mary's flesh."[30]

Mary is the "virgin soil" from which Christ took his human nature, and in her Nature itself is healed, purified, restored to its original state. As Saint Anselm, speaking directly to Christ's mother, puts it: "Sky, stars, earth, rivers, day, night and every creature subordinated to man or meant for his use rejoice, O Lady, for through you they are lifted again to their lost splendor and receive new and ineffable beauty.... They exult in inexpressible new grace, sensing that God himself, their very Creator, not only rules them invisibly from on high, but is also visibly present in their midst, sanctifying them by the use he makes of them. And such great benefits come from the blessed fruit of the blessed womb of blessed Mary."[31]

We grasp the poetry of this concept in numerous works of the waning Middle Ages: Jan Van Eyck's delightful *Madonna and Child* in the Frick Collection, for example (fig. 64), where – beside Mary in the fragrant cool of a rose garden – a fountain's water captures light, echoing

63. Jean Fouquet, *Mary Breastfeeding*, detail of the Melun Diptych, c. 1450. Musée Royal des Beaux-Arts, Antwerp.

64. Jan Van Eyck, *Madonna and Child*, c. 1430. Musée Royal des Beaux-Arts, Antwerp.

praise that Saint Bernard gives the Virgin in Dante's *Paradiso*: "Here [in Heaven] you are the noonday face of love, and down below, among mortals, you are hope's lively fountain" (*Paradiso* 33:10 – 12). In the same way, in the innocent, imaginary world of Stephan Lochner's *Madonna in the Rose Garden* in Verona we again behold a vision of Nature restored to its original purity – as also in Carlo Crivelli (fig. 65), where garlands announce that "the earth has yielded its fruit" (Psalms 67:7): that in Mary freed from corruption, that is, human nature has produced a woman worthy to bear God's Son, and He, a full participant in human nature, has in turn sacrificed himself for sinners, restoring harmony to the relationship between Heaven and earth. In Crivelli's small painting, the presence of baby angels bearing *musical instruments* and the *instruments of Christ's Passion* in fact supports such a reading, focused on "harmony" regained through suffering.

It was in Venetian painting that the eucharistic implications of the connection between Mary and the world of Nature were most effectively expressed. An altarpiece by Cima da Conegliano, commissioned for the church of San Bartolomeo at Vicenza and signed by the

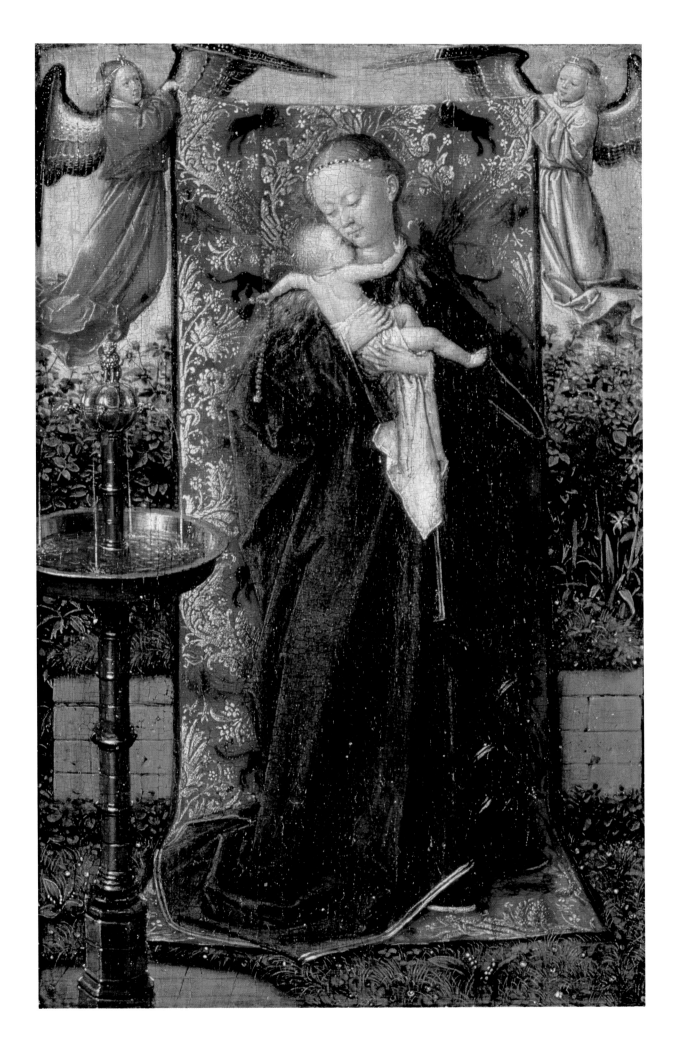

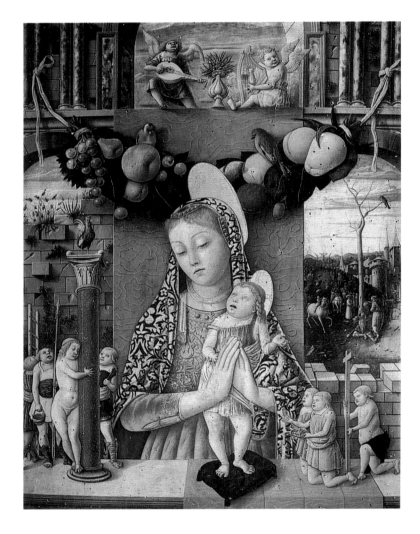

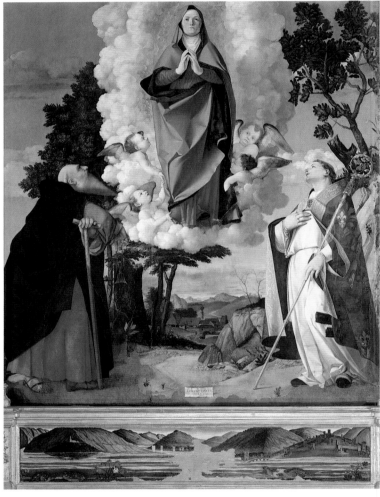

artist in 1498, suggests the Venetian capacity for invention in this respect (fig. 67), showing Mary and the Child on a high throne beneath a pergola heavy with grapes – clearly an allusion to the wine/blood of the Mass that once was celebrated before this image.[32] The pergola constitutes the entry corridor to a garden enclosed by a high wall: the *hortus conclusus* of the Song of Songs, with the bridal connotations previously illustrated. In this way, Mary becomes a figure not only of the mother, but also of the spouse of Him who loved enough to shed his blood for us. So personal is this relationship that even the saints at right and left of the throne remain outside the garden: only Mary leads into the mystery's depth, as Cima suggests with the marvelous perspective passage leading to the garden.

Still more surprising is Lorenzo Lotto's altarpiece for Asolo Cathedral, where over the altar on which the Eucharist was celebrated Mary's glorified body appears in the midst of Nature (fig. 66).[33] This is not an *Assumption* – there are no figures of God the Father or of the apostles – but simply a glorification of the creature who became God's mother at the heart of the universe God had created, a connection further underlined by the landscape in the *predella*, not done by Lotto but associated with the painting when it was restored in 1826. Looking at this no longer young woman lifted up in a cosmic setting, and imagining bread and wine on the altar in front of her, we are reminded of the series of paradoxes through which Saint Anselm described Mary's calling: "God created every being, and Mary generated God. God who had created everything became himself Mary's creature, thus recreating all he had created. And whereas he had created all things from

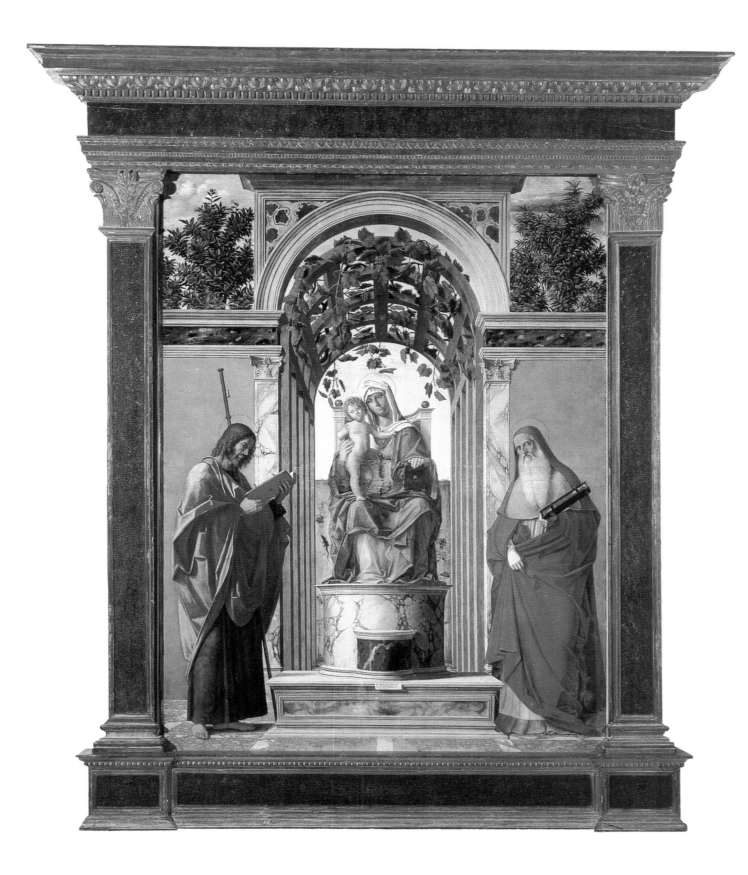

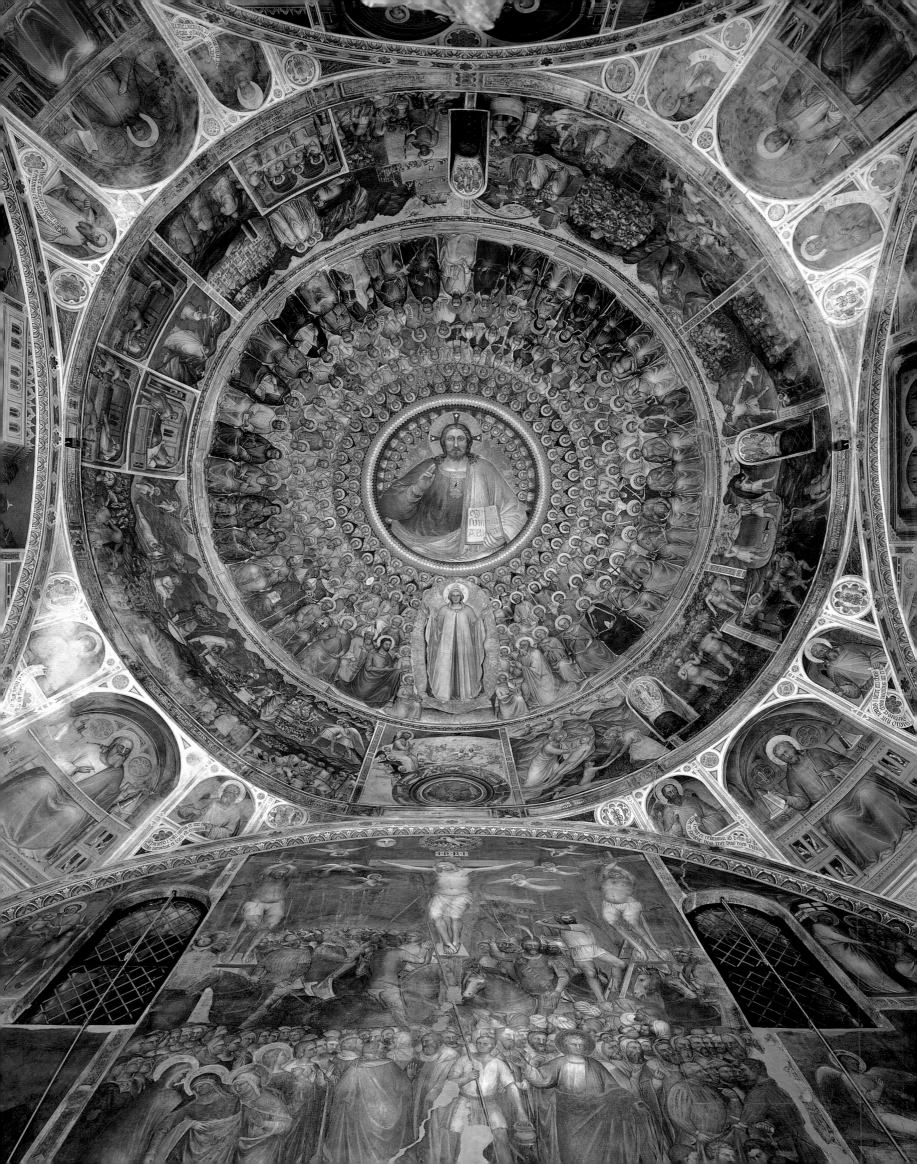

nothing, after their fall he did not want to restore them without Mary. God therefore is the Father of all things created, and Mary the mother of things recreated. God is Father from the world's foundation, Mary is mother since its restoration, for God generated him through whom all things were made, and Mary bore him through whose work all things were saved. God generated him without whom absolutely nothing is, and Mary bore him without whom nothing is good."[34]

New Eve, Seat of Wisdom, Regina sanctorum

The plan of salvation in which Mary has such a vital role is not something improvised at a given moment in history – in Jesus' time, that is – but an eternal project of God the Father: "the mystery of his purpose, the hidden plan he so kindly made in Christ from the beginning, to act upon when the times had run their course to the end" (Ephesians 1:9 – 10). Mary too is thus part of an eternal project realized in the fullness of time – as is suggested by the program of the inner dome of the Baptistery of Padua, where Giusto de' Menabuoi's frescoes link the beginning of history to its end, the world's creation to the Parousia, the Lord's second and definitive coming, through an enormous figure of Mary (figs. 68, 69).[35] On the outer rim of the dome (in the lower part of our photo) is the Creator Word shaping the universe; at the dome's apex is a gigantic Christ shown as judge, with a book that identifies him as Alpha and Omega, the beginning and the end; and in the area between these images – the area corresponding to all of history between the creation and the final judgment – are the thronged saints of all the ages with, at their center and three times their size, Mary who lifts her hands in prayer.

A similar view of historical time determined Mary's placement in the cupboard altarpiece in Ghent Cathedral, the masterpiece of Hubert and Jan Van Eyck where, beneath an Annunciation on the exterior (see below, fig. 102), when the doors are open we see Mary at the right of the glorified Christ (fig. 70), above the apocalyptic scene of the Adoration of the Mystic Lamb and near a figure of the first woman, Eve (fig. 72), shown looking toward Mary, the new Eve.[36] This all-embracing vision of history, in which Mary serves as fil conducteur between the beginning and the end, is at times abbreviated to the shorter passage from Original Sin to Incarnation, as an English 13th-century miniature suggests, juxtaposing Adam who reaches out to take the fruit offered him by a serpent, and Mary who at the Annunciation receives the fruit of her womb from on high (Bodleian Library Ms 270b).

If however the "new way" realized by God for man's salvation is her Son's flesh, then Mary – the virgin earth in which that "way" was made – has the task of "showing the way," of letting Christ be seen; like every mother she wants people to know her Child. This is the meaning of one of the most ancient iconographic formulae used for Mary, the so-called Hodegetria, "she who shows the way": the configuration of a painting attributed to Saint Luke and sent to Constantinople in 451 by the Empress Eudoxia, from which innumerable Byzantine and Western versions of the theme derive.[37] In some of these – the lovely ivory statuette at the Cloisters, for example (fig. 71) – the child in his mother's arms has a scroll evoking his identity as the Word made flesh; in the medieval development of the theme, artists at times omit the scroll but compensate by giving little Jesus a pronouncedly three-dimensional body that conveys the same message (fig. 73).

70. Hubert and Jan Van Eyck, Ghent Altarpiece (detail of upper part when open), c. 1425. Saint-Bavon, Ghent.

71. Madonna Hodegetria (Costantinople, 10ᵗʰ – 11ᵗʰ centuries). Metropolitan Museum, The Cloisters Collection, New York.

72. Hubert and Jan Van Eyck, Ghent Altarpiece (detail of upper part when open), c. 1425. Saint-Bavon, Ghent.

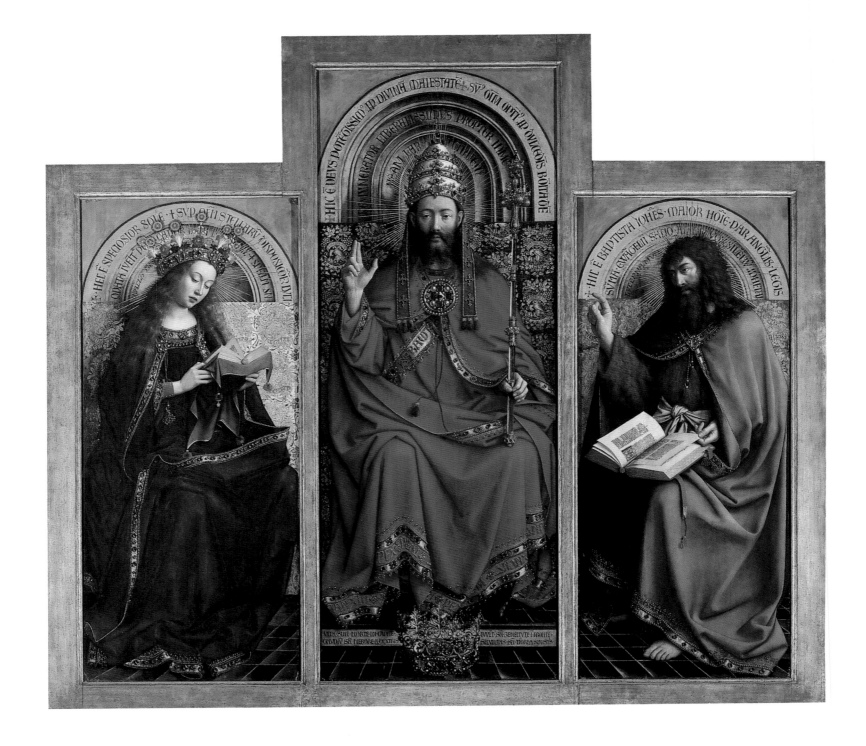

The mother holding Christ in her arms to show him to the world is also a "throne" or "seat" for Him whom Saint Paul called "the wisdom of God" (1 Corinthians 1:24); welcoming Christ in her body, and in her heart preserving and pondering all that concerned him (cf. Luke 2:19), she is also the "house" which divine Wisdom built for itself (cf. Proverbs 9:1), as Godfroid d'Amand suggested in the 12th century.[38] Filled with the Spirit at the Annunciation and again at Pentecost, Mary, who brought the Light into the world, in fact is a privileged figure of spiritual illumination. These in any case are some of the ideas underlying medieval representations of her as *Sedes Sapientiae*, "seat" of that wisdom which is God himself: an ivory relief of the Ottonian period shows Mary actually seated on a throne as she shows her Son to wise men come from afar, the Magi (fig. 75),[39] while a magnificent stained glass window at Chartres presents her as a living throne for her Son under the Holy Spirit (fig. 74); this latter approach is again found in a wood statue of Mary regally enthroned with her Son in Saint Peter's, Louvain.

The same theological elements define the most characteristic iconographic formula of Marian art in the 12th, 13th and 14th centuries: the *Maestà* or "Majesty image," of remote paleochristian and Byzantine derivation (as we clearly deduce from 13th-century versions such as that by Cimabue for the church of Santa Trinita in Florence, fig. 76). Uplifting visions of heavenly glory, these works recapitulate almost all the theological themes mentioned above, pictorially translating the spiritual enthusiasm of Amadeus of Lausanne and other writers, who imagined Mary surrounded by "the exultance of angels, the rejoicing of archangels and all heaven's festive cries."[40]

The most famous *Maestà* is that by Duccio di Buoninsegna in Siena Cathedral (fig. 77).[41] When finished in 1311, this enormous altarpiece – which in its original frame measured more than three meters in height and almost five in width – was borne from the artist's shop to the cathedral in triumph amid the cheers of the populace. The appeal of the "heavenly fatherland," the enchantment of contemplation, the lyrical inner joy of gazing into infinity become almost tangible here, in the

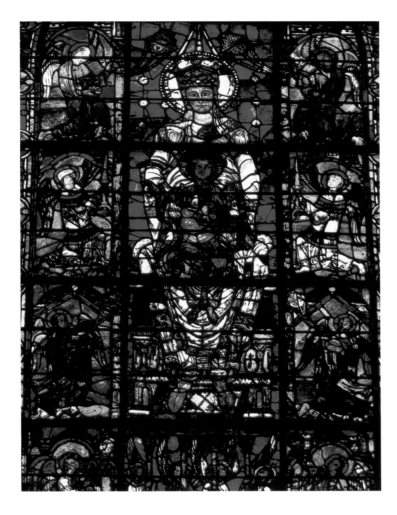

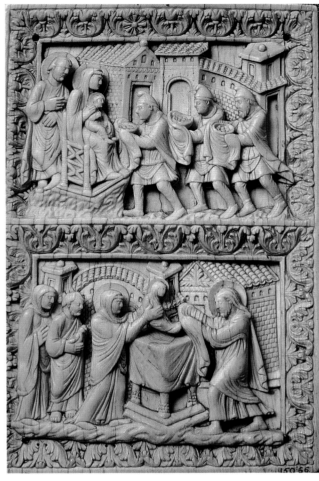

saints assembled at right and left of the throne where – in Duccio's beautiful figure of Mary – human nature is revealed as a worthy dwelling for the Spirit, fit to bear the Son of the Most High. An unhoped-for dignity – "regal" in character – a "majesty" meant to attract eye and heart, focusing the yearnings and defining the hopes of those who knelt before the altar, face to face with the saintly personages depicted.

The visionary impact of this work must have been felt with special force during Mass, in the context of sacramental communion in which, in the body of Christ present on the altar, the faithful perceive themselves as members of a "communion of saints" embracing all who – in every historical era – have believed and lived in Him. If we imagine the Maestà once again on the high altar where it stood until 1505, lit by candles and wrapped in clouds of incense, then our feeling of having ascended among the angels to join the saints and share their joy becomes both ultimate and proximate reality – more "real" in fact than everyday things: a world that beckons with sweet insistence, inviting us to enter.[42] And this explains yet other Marian titles: not only "Queen of Heaven" but sovereign as well of all Heaven's dwellers, *Regina sanctorum*, "Queen of Saints."

The capacity to visualize this specific regal condition – the life of Mary's "court," so to speak – was perfected from the 15th century

73. Guido da Siena, *Madonna and Child*, c. 1270. Palazzo Pubblico, Siena.

74. *Madonna of the "Belle Verrière,"* 13th century, Cathedral, Chartres.

75. *Adoration of the Magi and Circumcision*, late 9th – early 10th century. Detail of an ivory book cover. Victoria and Albert Museum, London.

onwards thanks to the invention of linear perspective. Perspective allowed artists to situate the "Queen" and her "courtiers" in credible groupings and settings, suggesting what in Italy would be called "sacred conversations": gatherings of persons shown in natural, not hieratic, poses, where the saints interact with each other and with Mary in a spontaneous manner, united by reciprocal spiritual understanding around the central presence of the Word incarnate. In the large altarpiece in San Zeno at Verona, for example (fig. 78), instead of the crowded and repetitive veneration of the saints in Duccio's *Maestà*, the artist, Andrea Mantegna from Padua, shows a mere eight figures at the sides of Mary's throne, arranging them naturally in the depth of his perspective space.[43] This egalitarian *humanitas*, like the classicizing architecture hung with garlands, evokes the style of a Renaissance court: a style inspired not by rigid protocol but by the ruler's relaxed interaction with "servitors" who were also friends.

The painter who perfected this kind of royal court scene was Mantegna's brother-in-law, the Venetian Giovani Bellini, who moreover enriched the Paduan master's intuitions with a religiosity at once very new and very old. In his triptych for the church of the Frari in Venice, for example (fig. 79), Bellini eliminates all Mantegna's learned archeological references, situating Mary and the saints in a recognizably ecclesiastical space gleaming with gold-

76. Cimabue, *Maestà*, c. 1280. Uffizi, Florence.

77. Duccio di Buoninsegna, *Maestà*, 1309 – 11. Museo dell'Opera del Duomo, Siena. Completed in 1311, this enormous altarpiece is Duccio's masterpiece and the most famous example of the kind of image known as a "Maestà" or "Majesty." Seen amid the glory of angels and saints, Mary here reveals our human nature as worthy to receive the Spirit and to bear the Son of God. Appealing to eye and heart, she focused the goals and defined the hopes of those who, when the painting was still in its original place on the high altar of Siena Cathedral, at Mass saw themselves reflected in the saints who surround the Virgin, who thus appears both as Queen of heaven and Queen of those who dwell in the heavens, *Regina sanctorum*.

backed mosaics like the interior of Saint Mark's Basilica.[44] The architecture shown in the altarpiece extends the real architecture of the rich wood frame, creating a private space in which the saints' inner stillness becomes almost palpable, and, in place of the halos still used by Mantegna, Bellini models the saints' noble faces in warm, evening light, suggesting interior, spiritual illumination. In the concave apse above Mary and the Child, reflected light gilds the mosaic surface to create a solar radiance around the young woman and her infant, as if the natural world too paid homage to the mystery hidden in the flesh Mary gave and God assumed.

Another *sacra conversazione* by Bellini, painted a few years earlier than the Frari triptych, allows us to analyze the religious and specifically Marian components of this kind of image: the monumental altarpiece done for the conventual church of San Giobbe (fig. 80), in which the artist articulates a number of fundamental pictorial and iconographic solutions.[45] The most novel element of the San Giobbe altarpiece, in the Venetian context for which it was made, was the organization of the figures in a unified space defined by architecture drawn in correct perspective: an "innovation" dependent on early 15th-century Florentine models developed by Piero della Francesca between 1450 and the 1470s. There is, in

fact, a connection between this altarpiece and Tuscan art, since the altar for which Bellini painted the image is directly across the nave of San Giobbe from the chapel of a Tuscan family living in Venice, the Martini from Lucca, who had summoned Florentine masters to create a "modern" domed oratory decorated by the Della Robbia. The Martini chapel is on the north side of the church, whereas the south side has no chapels but only altars against the wall, for one of which Bellini did his altarpiece (figs. 82, 83).

This first Venetian experiment with unified pictorial space conceived in terms of modern architecture was thus a response to the real context in which Bellini knew his work would function! In other words, opposite the real spatial profundity of the Martini chapel, Bellini wanted to create the illusion of a correspondingly deep space, as if there were an actual chapel (and not just flat wall) on the south side of the church as well. Yet the altarpiece is not a true "mirror image," since – in front of the Tuscan architecture of the Martini chapel, the architecture imagined by Bellini is unmistakably Venetian: the pilasters in the background (which replicate those of the actual marble frame, still visible in San Giobbe: cf. fig. 81) are adorned with reliefs in the Lombard fashion admired in Venice; the walls of the apse are sheathed in richly veined marble,

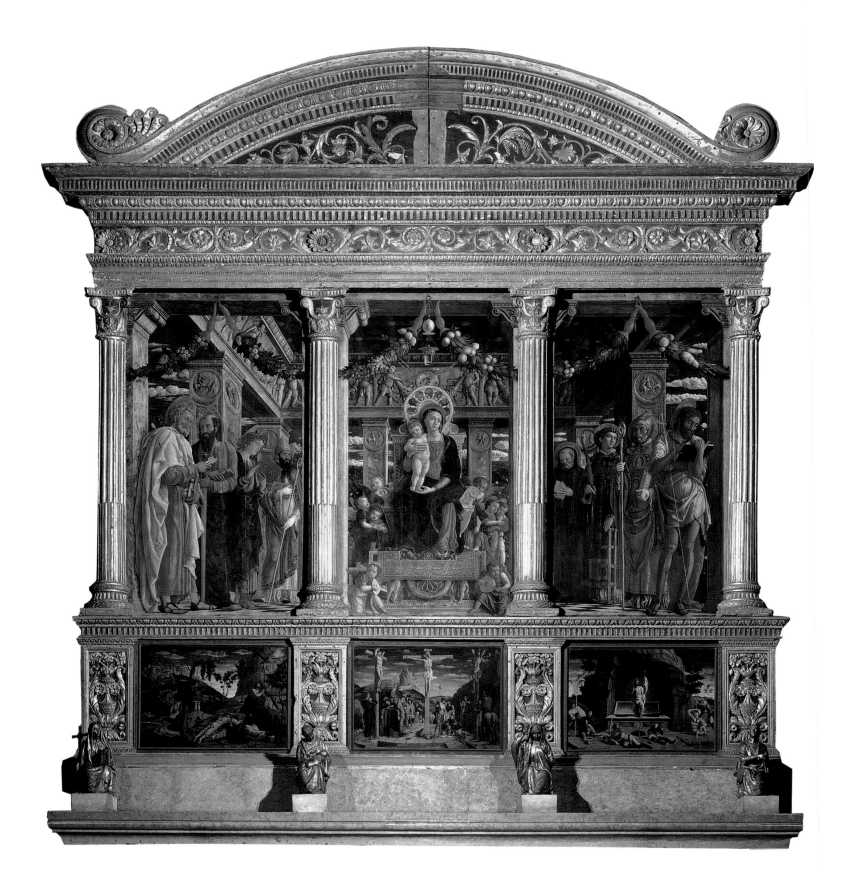

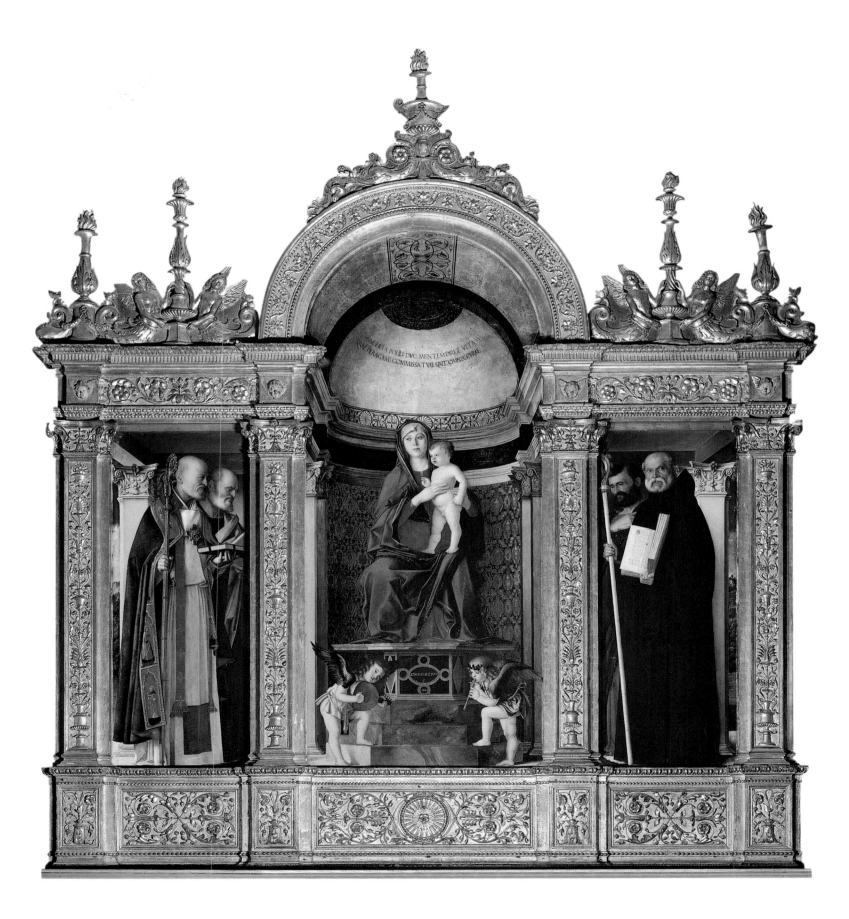

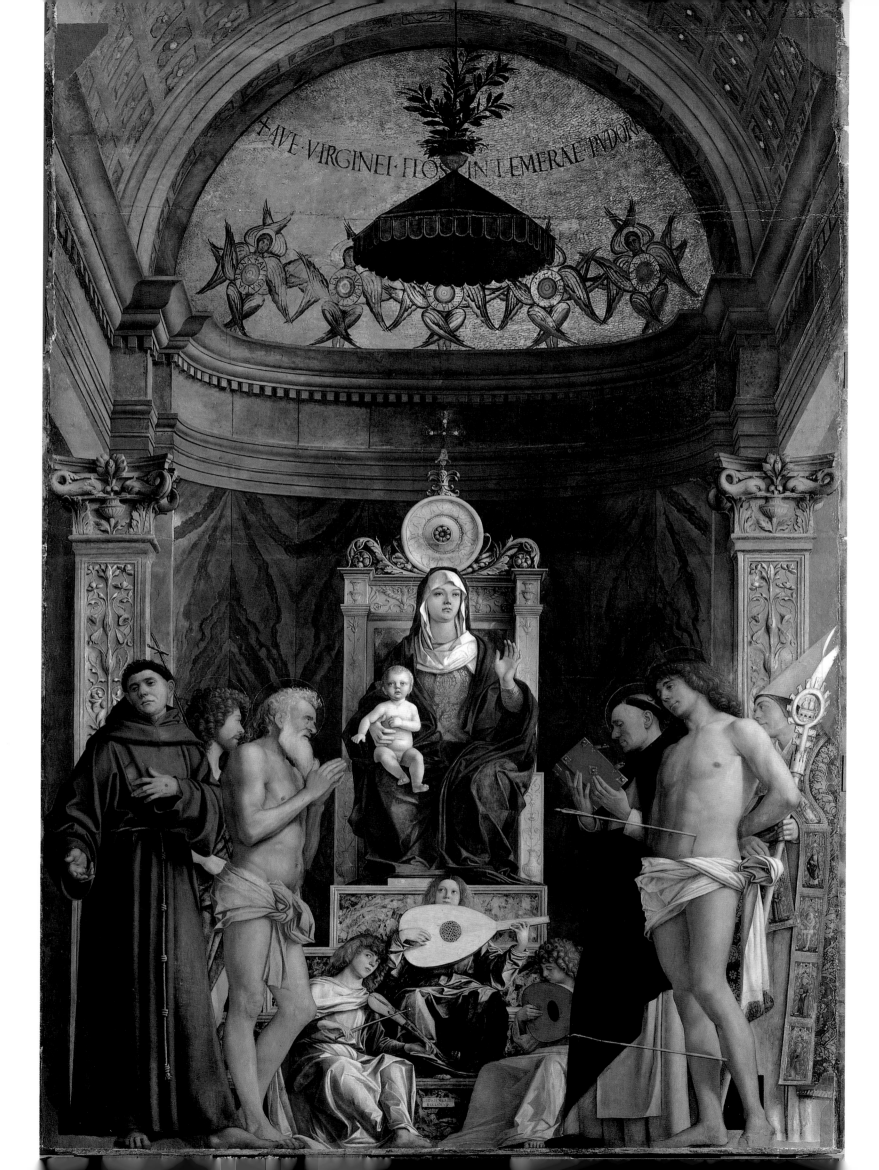

like the lower walls of Saint Mark's Basilica, the Lagoon City's main church; and the mosaic-clad apse cavity similarly evokes the interior of Saint Mark's. Even Mary's throne, surmounted by a disk bearing a cross, alludes to local tradition, imitating and updating the shape of a marble seat housed in Saint Mark's (fig. 84): a 6th-century Syrian work piously believed to be the bishop's throne used by the Evangelist Mark himself, patron saint of Venice!

Thus, right across from the Tuscan chapel of the Martini family, with its marble altarpiece showing the patron saint of Florence, John the Baptist, Bellini created an ideal vision of Christian Venice, presented in figure in Mary and her Son, shown seated on the throne of Saint Mark the Evengelist and surrounded by saints. Among these we find Francis of Assisi and Louis of Toulouse, for San Giobbe was a Franciscan church; there is also Saint John the Baptist, behind Saint Francis, and – in the place of honor at Mary's right – the patron of the church, the prophet Job, a splendid, still vigorous old man. Across from them are Saint Dominic, reading, and Saint Sebastian who, notwithstanding the arrows in his flesh, seems lost in quiet reflection. At the foot of the throne, three youths play musical instruments.

Figures of music-making angels were no novelty in 15th-century altarpieces – we have just seen examples of them by Mantegna for Verona and in Bellini's done several years later for the Frari. In the San Giobbe altarpiece, however, the musicians become the epicenter of the composition, directly below Mary and her Son, and the climate of dreamy inwardness pervading the image suggests that everyone is listening to them. Here, in fact, music becomes the key to a harmony which, above an altar where Mass was said, must have seemed to flow from Christ's body present in the sacrament and represented in the painting, and in various ways to touch the lives of individuals brought together in the Communion of Saints. That they are "individuals" and that the music touches them "variously" is clear from the natural variety Bellini gives the group at the foot of the throne, avoiding the predictable symmetry usual in such cases; his two groups of three are in fact arranged in an in-

verted complementary pattern, with the middle figure on the left almost hidden, while that on the right is fully visible. So too the nude personages, which another artist might have played off against each other in similar positions, are instead distributed asymmetrically, with Job next to the throne and Sebastian, on the opposite side, far from it.

Bellini risked asymmetry because he was in possession of an unbeatable unifying device, light, which here transforms figured music into perceptible visual harmony. Differently from Mantegna, who seemed to illuminate his figures with spotlights, and differently from Tuscan masters who situate their personages in full noonday sun, Bellini prefers the diffuse luminosity of late afternoon: soft light gently pervading the atmosphere, caressing human beings and material objects, animating every surface with its warmth. From Antonello da Messina, active in Venice in the years 1475 – 76, Bellini had learned to recreate the effect of natural light pervading and enveloping volumes and masses, and how to improve his oil painting technique, developed by Flemish masters and already known in Italy in elementary fashion. It was oil that allowed Bellini to abandon the bright but opaque tones of tempera in search of chromatic transparency and surface animation through glazes and *impasto* pigment effects; his warm flesh tones, resonant fabric colors and "points of light" in brocades and mosaic *tesserae* are in fact a feast for the eyes.

"Queen" of this world caressed by light is the woman in whom our human nature welcomed the God who illuminates: Mary, set above other men – above the other saints shown here – because she is daughter of the Light, mother of the Light, bride of the Light. Human "seat" of a Wisdom which believers find in her Son and especially in his cross, Mary sits on a high throne with a solar disk and a cross for pinnacle; she, who is the human space in which this Wisdom built his dwelling, occupies a marvelously delineated ecclesial space, symbol of the Church in whose womb are formed Christ and those who follow him in the way of holiness. Physical *locus* of the unimaginable meeting of virginity and moth-

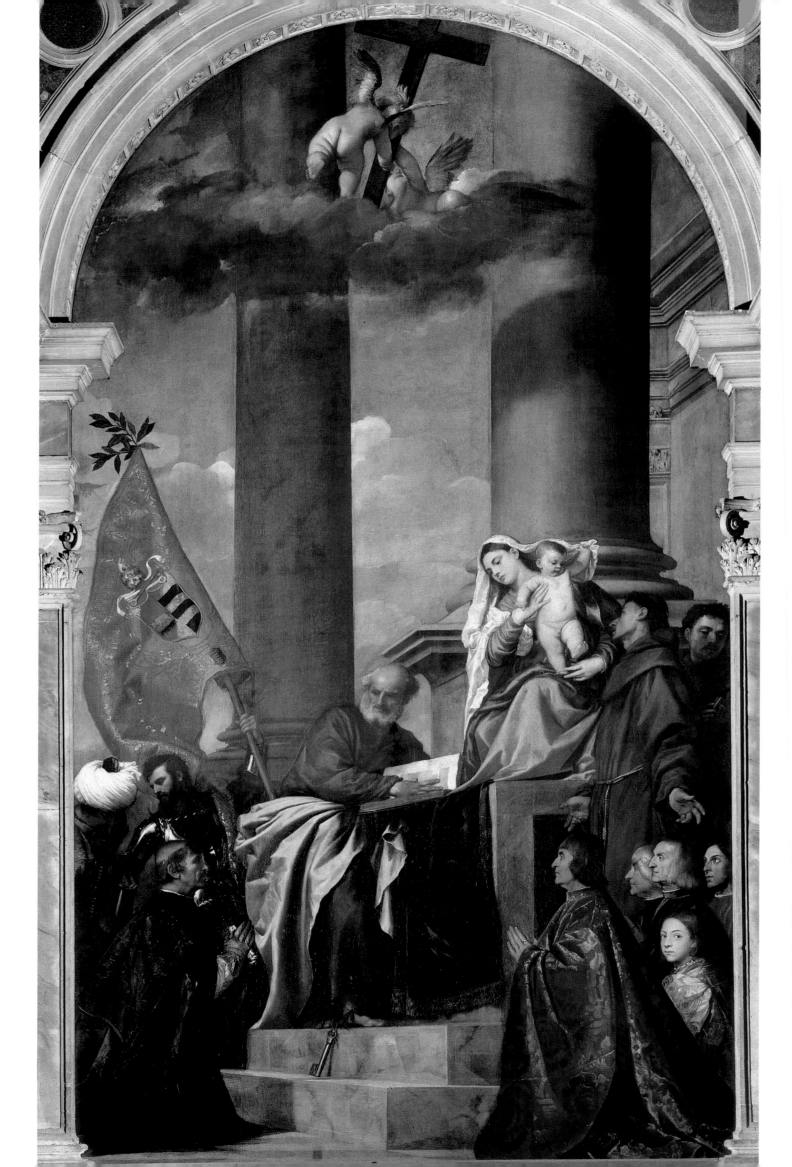

85. Titian, *Madonna of Ca' Pesaro*, 1519 – 26. Santa Maria Gloriosa dei Frari, Venice. In this innovative "sacred conversation," the architecture is no longer presented frontally but on the diagonal, and

Mary's high pedestal is moved from the center toward the viewer's right, creating a compositional asymmetry that, like the mobile lighting effects, anticipates the Baroque style. Giving sense to the movement of the figures

is Mary herself, lifted into the vastness of a Venetian lagoon sky: Mary who, as she turns graciously toward her Son's friends, appears as high "seat" of the Wisdom hidden in Christ's humanity.

erhood, she looms here above the bread and wine that, fecundated by the Spirit, became the body and blood of Christ; lowly and high-placed, she suggests the final harmony of all things, their mutual "conversing" in the mystery of her Son's body.

Venetian *sacra conversazione* paintings bring together many threads of early Christian and medieval Marian iconography, weaving them into a solemn but natural kind of image that anticipates the spirituality of the modern era. We can, in fact, close this chapter with the most famous example of the type, Titian's *Cà Pesaro Madonna* (fig. 85), in which compositional asymmetry and unexpected lighting effects become absolute principles heralding the Baroque.[46] In this altarpiece, which Titian worked on slowly between 1519 and 1526 for the noble Pesaro family, in the same church for which Bellini had painted the triptych discussed above (fig. 79), the architecture is no longer presented frontally but on a diagonal bias; Mary's high pedestal has been moved from the center toward the viewer's right; and the traditional *sacra conversazione* format has been enlivened by glances and gestures that give movement both to the figures' physical arrangement and to their psychological relationships. The broad areas of brilliant color typical of Venetian painting are multiplied and refined to give sophisticated tonal variations, and masterful control of his palette allows Titian to call attention – through subtle glazes and a virtually sculp-

tural build-up of paint – to the different material consistencies of velvet and brocade, of dazzlingly linen and gleaming silk.

A new element, for Venice at least, is Titian's inclusion of portraits of the patrons in a *sacra conversazione*. Here everything revolves around them: the man with a turban led in by a knight in armor at the left, for example, is a reference to the victory over the Turks of the cleric kneeling in front of him, Jacopo Pesaro, who in 1502 had defended the island of Maura in the Ionian Sea for Pope Alexander VI (whose coat of arms appears on the banner borne by the knight). In the same spirit, the figure of Saint Peter in the center of the composition, and that of Mary, above, look toward Jacopo Pesaro as if in recognition of his service to the Church; their gazes define a descending diagonal that Titian balances with the rising diagonal of the banner and with the movement of baby Jesus, who, turning in the opposite direction from his mother, looks at Saint Francis of Assisi; Saint Francis then gestures toward the people kneeling in the foreground at the viewer's right, the first of whom is the official head of the family, Francesco – "Francis" – Pesaro.

High above, against a seemingly boundless lagoon sky, we again find Mary, the Queen graciously turned toward her Son's good friends – Mary, noble seat of a Wisdom hidden in her Child's flesh, the mother who shows Christ to the world.

[1] Theological reflection on Mary is too copious to be adequately presented here, but, in addition to the *Nuovo dizionario di mariologia* mentioned in our Introduction (cf. n. 10), the following dictionaries, journals and specialized texts are useful: G. Raschini, *Dizionario di mariologia*, Rome 1961; *Ephemerides mariologicae*, Madrid; *Enciclopedia mariana Theotocos*, Milan-Genoa 1958; *Lexikon der Marienkunde*, Regensburg 1967; *Maria. Etudes sur la sainte Vierge*, ed. H. du Manoir, 8 vols., Paris 1949 – 1971; *Marian Library Studies*, Dayton (Ohio); *Mariologische Studien*, Essen; A. Tondini, *Le encicliche mariane*, Rome 1950; Paul VI's apostolic exhortation *Marialis culus*, 1974; John Paul II's encyclical *Redemptoris mater*, 1987. Cf. also R. Cantalamessa, *Maria. Uno specchio per la Chiesa*, Milan 1989; G. Ravasi, *L'albero di Maria*, Cinisello Balsamo 1993.

[2] *Nuovo dizionario di mariologia*, cit. (Introduzione, n. 10) at the voice "Dio Padre," pp. 430 – 431.

[3] Amedeo di Losanna, *Homily 7*. Cf. *Sources Chrétiennes*, Paris, from 1942, vol. 72, pp. 188 – 200.

[4] Ibid.

[5] V. Tiberia, *I mosaici del XII secolo e di Pietro Cavallini in Santa Maria in Trastevere*, Perugia 1966; R. Krautheimer, *Rome: Profile of a City 312 – 1308*, Princeton 1980, pp. 163 – 164; T. Verdon, *L'arte sacra in Italia*, Milan 2001, pp. 74 – 75.

[6] T. Verdon, *L'arte sacra*, cit. (above, n. 5), pp. 74 – 75.

[7] J. Beckwith, *Early Christian and Byzantine Art*, Hammondsworth, Middlesex (U.K.) 1970, pp. 63 e 245.

[8] Saint Augustine, *Discourse* 25,7 – 8: PL 46, 937 – 938.

[9] Ibid.

[10] Ibid.

[11] Blessed Isaac of Stella, *Sermon* 51: PL 194, 1863.

[12] Saint Augustine, *Comment on the Letter to the Galatians*, ns. 37-38: PL 35, 2131 – 2132.

[13] Saint Leo the Great, *Letter 28 to Flavianus*, 3 – 4: PL 54, 763 – 767.

[14] Ibid.

[15] D.C. Ahl, *The Misericordia Polyptych: Reflections on Spiritual and Visual Culture in Sansepolcro*, in (various authors), *Piero della Francesca*, ed. J.M. Wood, Cambridge 2002, pp. 14 – 29.

[16] N. Cusano, *Predica sul Padre nostro*, ed. P. Gaia, Turin 1995, p. 47.

[17] Cfr. T. Verdon, *The Spiritual World of Piero's Art*, in *Piero della Francesca*, cit. (above, n. 15), pp. 30 – 50.

[18] J. Snyder, *Northern Renaissance Art*, cit. (Introduction, n. 14), pp. 389 – 391.

[19] Cfr. F. Deuchler, *Forty Paintings from an Early 14th-century Manuscript of the Apocalypse*, New York 1970.

[20] J. Snyder, *Northern Renaissance Art*, cit. (Introduction, n. 14), p. 251.

[21] *De Cristo et anticristo* 4, *Die Griechischen Christlichen Schriftsteller*, Berlin 1897 ff., 1.6 and 2.41.

[22] *Roman Missal*, Preface IV of the BVM.

[23] M. Bacci, *Piero di Cosimo*, Milan 1976, p. 92.

[24] A. Poppe, *The Building of the Church of Santa Sophia in Kiev*, in "Journal of Medieval History," 7, 1981, pp. 41 – 43.

[25] But cf. T. Verdon, *Vedere il mistero. Il genio artistico della liturgia cattolica*, Milan 2003, pp. 26 – 28.

[26] M. Marchetti, *La custodia dell'Eucaristia. Il tabernacolo e la sua storia*, in (various authors) *Panis vivus. Arredi e testimonianze del culto eucaristico dal VI al XIX secolo*, Siena 1994, pp. 227 – 238.

[27] Santa Brigida, *Sermo Angelicus*, ed. S. Ecklund (*Samlingar utgivna av Svenska Fornskriftsaelskapet, Latinska skrifter*, VIII), Uppsala 1972.

[28] F. Hartt, *History of Italian Renaissance Art*, New Jersey 1989, p. 230.

[29] Saint Augustine, *Enarratio in Psalmum 98*: PL 37,1264. Cfr. Verdon, *Vedere il mistero*, cit. (above, n. 25), p. 27.

[30] Saint Augustine, *Discourse* 185: PL 38, 997 – 999.

[31] Saint Anselm, *Discourse* 52: PL 158, 955 – 956.

[32] P. Humphrey, *Cima da Conegliano at San Bartolomeo in Vicenza*, in "Arte veneta," 31, 1977, pp. 176 – 181; id., *Cima da Conegliano*, Cambridge 1983, p. 163.

[33] E.M. Dal Pozzolo, *Lorenzo Lotto 1506. La Pala di Asolo*, in "Artibus et historiae," 11, 1990, pp. 89 – 110.

[34] Saint Anselm, *Discourse* 52: PL 158, 955 – 956.

[35] A. Meneghesso, *Il Battistero di Padova e l'arte di Giusto de' Menabuoi*, Padua 1934; cf. also (various authors) *Giusto de' Menabuoi nel Battistero di Padova*, ed. A.M. Spiazzi, Trieste 1989.

[36] C. Gotlieb, "En ipsa stat post parietem nostrum." The *Symbolism of the Ghent Annunciation*, in "Bulletin Koninklijk Musea voor Schone Kunsten," 1970, pp.

75 – 100; H. Silvestre, *Le retable de l'Agneau mystique et Rupert de Deutz*, in "Revue Bénédictine," 88, 1978, pp. 274 – 289.

[37] Cfr. *Nuovo dizionario di mariologia*, cit. (Introduction, n. 10), at the voice "Arte/Iconologia," p. 127.

[38] PL 174, 957 – 959.

[39] J. Beckwith, *Early Medieval Art*, New York 1969, pp. 66 – 67.

[40] Amedeo di Losanna, *Homily 7*, *Sources Chrétiennes* 72, 188 – 200.

[41] C. Brandi, *Duccio*, Florence 1951; J.H. Stubblebine, *Duccio di Buoninsegna and His School*, Princeton 1979; F. Deuchler, *Duccio*, Milan 1984; J. White, *Duccio. Tuscan Art and Medieval Workshops*, London 1979; L. Bellosi, "Duccio," in *Enciclopedia dell'arte medievale*, V, Rome 1994; G. Chelazzi Dini, *Pittura senese dal 1250 al 1450*, in G. Chelazzi Dini, A. Angelini, B. Sani, *Pittura senese*, Milan 1997, pp. 9 – 259.

[42] T. Verdon, *L'arte sacra in Italia*, cit. (above, n. 5), pp. 91 – 93.

[43] R.W. Lightbown, *Andrea Mantegna*, Milan 1986, pp. 75 – 88.

[44] R. Goffen, *Devozione e committenza. Bellini, Tiziano e i Frari*, Venice 1991, pp. 23 – 52; *Giovanni Bellini*, New Haven-London 1989, pp. 159 – 162.

[45] R. Goffen, *Giovanni Bellini*, cit. (above, n. 44), pp. 143 – 159.

[46] F. Valcanover, *Tiziano*, Milan 1969, p. 105.

IOANNES
BELLINVS

Mary as Woman

In its reflection on Mary as "figure," across the centuries the Church has also sought to understand her as human person, as *woman*. This second, more biographical, inquiry is not entirely separable from the first, theological in character, which it continually intersects, assuming at times more, at times less importance. Both lines of research have the same starting point, in fact: the Gospel, a theological not biographical text which presents Jesus as the Son of God who died and rose to save humankind. In its unfolding, the Gospel also provides "a complete and homogeneous constellation of biographical data" for Jesus, whereas for Mary it offers little more than "crystals of her life, discrete icons."[1]

Information about Mary developed slowly, following the evolutionary pattern of the Gospel itself which from a "paschal" core – an original narrative tradition regarding the passion and resurrection – expanded, in the course of the first century, to include data related to the three years of Jesus' public ministry and (in the case of Matthew's and Luke's texts) about the Savior's birth, infancy and "hidden life." As Jesus' mother, Mary is often mentioned in this expanded account, but her presence has the same functional character as that of her Son, serving to prepare and illustrate the central message of salvation, human reconciliation with God and the call to share his glory. The Gospel, in fact, is never mere *reportage*.

The functional nature of biographical information in the Gospel, along with its evident revelatory intent and – in Mary's case – fragmentary character, led to the production of parallel accounts that from the 2nd to the 6th centuries assumed the form of "apocryphal" Gospels.[2] Conceived as didactic texts, the Apocrypha compensated for the lack of detailed data about key figures of Christian faith, at times resorting to narrative devices that mythologize the subject matter. Despite considerable influence on popular religiosity, the Apocrypha remained distinct from the scriptural "canon" that took form between the 5th and 7th centuries, and – while known and exploited by hymn writers, authors of mystery plays and artists throughout the Middle Ages – were rarely confused with the four "official" Gospel texts; in iconographical programs, indeed, we often find a highly self-aware differentiation of sources.

All this material, edited and re-edited from one century to the next, toward the end of the 1200s was collected by the Bishop of Genoa, the Dominican Jacopo da Voragine, into the so-called *Legenda aurea* or "Golden Legend": a vast anthology of edifying ac-

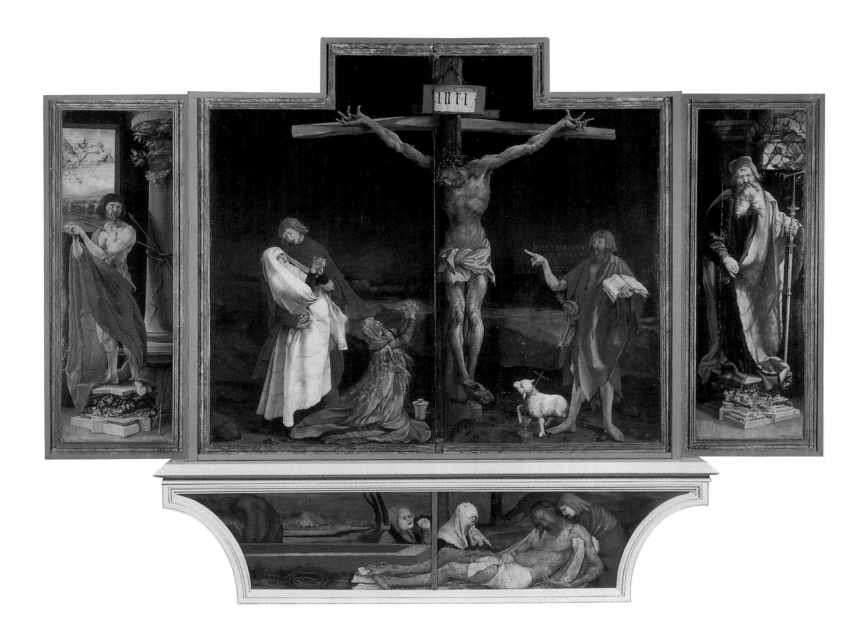

counts drawn from different sources that transmitted to the Renaissance the contents and spiritual wisdom of more than a thousand years of Christian meditation on Christ, Mary and the saints.[3]

We recall these well-known facts to suggest the historiographic problems inherent in any attempt to write a "biography of the Virgin," as well as the difficulty, when trying to tell Mary's life in images, of coordinating iconographical data with the centuries-long evolution of theological and devotional aspects of the theme. The beginning of Mary's existence, for example – the Immaculate Conception – took definitive iconographic form only in the 1600s and 1700s (leading up to Pope Pius IX's solemn formulation of the dogma in 1854), yet the earliest hints of a tendency to think of the Virgin's origins in extraordinary terms go back to the apocryphal *Proto-Evangelium of James* in the 2nd century, which maintains that Anne, Mary's mother, conceived her without male intervention.[4] This account,

87. Matthias Grünewald, *Isenheim Altarpiece* (view when closed), c. 1509 – 12. Unterlinden Museum, Colmar.
In this early 16th-century German masterpiece, Mary is "conceived" – pondered, dreamed of and desired – by God before time begins. Commissioned for a monastery with a hospital for people with skin maladies, the altarpiece suggests the relationship between the patients' sufferings and those of Christ, but also that – behind the horror of a body humiliated by suffering – there was an eternal plan to have God's Son born in a body to save the body. And at the center of this plan is the woman Mary, from whom Christ would take the body in which he died and rose.
88. The same, central part when open.

born among simple folk, elaborated in a fabulous literary genre and lacking any reference to the true sense of the Immaculate Conception (the absence of original sin in Mary), nonetheless represents what a distinguished modern Mariologist calls "a first, intuitive and mythical awareness of Mary's perfect and original holiness, carried back to the very moment of her conception."[5]

The iconographical unfolding of the Immaculate Conception theme, which reaches maturity in the "woman clothed in the sun, with the moon beneath her feet" (fig. 86), is part of a process of visualizing Mary's origins at once remarkably creative and rich in theological insight. In any early 16th-century German masterpiece, for example – Matthias Grünewald's layered cupboard altarpiece at Colmar (figs. 87, 88) – the mystery of the Virgin's origin gets shifted from the historical moment of her conception to an eternal "moment": not physical conception, but Mary

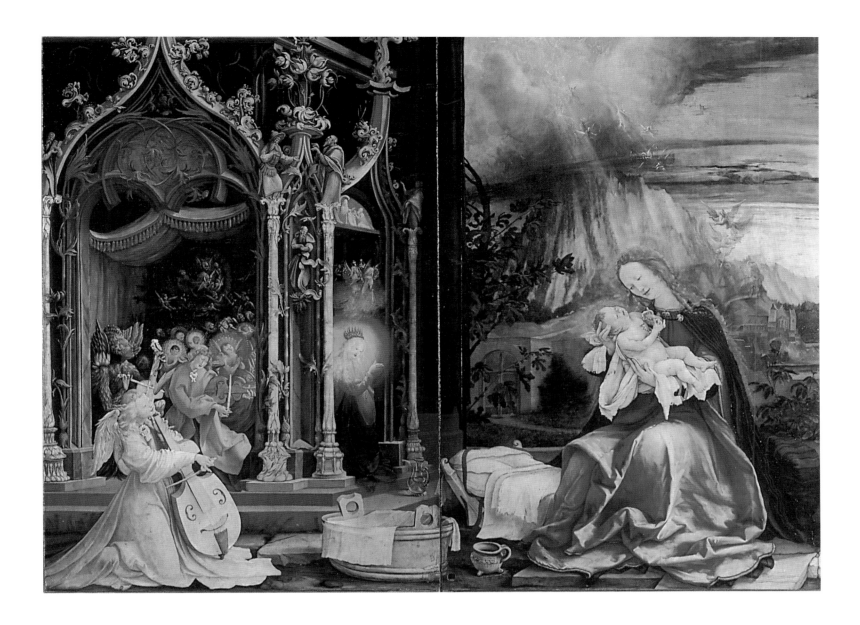

"conceived" by God (thought of, dreamed of, desired) before time began!

Grunewald's altarpiece was commissioned for the monastery of Saint Anthony Abbot, at the foot of the mountain known as the Grand Ballon d'Alsace, just outside the village of Isenheim, halfway between Colmar and Basle.[6] The monastery was also home to a hospital for people with skin maladies, including one called "Saint Anthony's fire," and the images in the altarpiece clearly allude to the patients' sufferings: the terrifyingly graphic *Crucifixion* visible on weekdays, when the cupboard doors were closed, invited the sick to associate their condition with the Savior's lacerated body. On Sundays, when the doors were opened, sufferers saw scenes with bodies that were healthy or healed: the *Annunciation*, the *Madonna and Child*, the *Resurrection of Christ*. The main scene, the *Madonna and Child* (positioned right behind the doors which, closed, show the *Crucifixion*), suggests the eternal moment before time began when Mary was "conceived" in God's thought (fig. 88).

The composition is divided in two parts, with Mary and her Child on the right, at the foot of a high mountain whose peak is wrapped in clouds; above the clouds, God the Father appears amid the celestial spirits, a scepter in his hand as he irradiates light in the direction of the Child. The sense of this unusual detail is found in the first of the psalms sung by the monks at Sunday vespers, where the psalmist tells the Messiah: "The Lord extends the scepter of your power from Sion," and God, speaking directly to his Christ, adds: "Dominate in the midst of your enemies. On the day of your power, royal authority is yours amid holy splendors; from the womb before the dawn have I begotten you" (Psalms 110 [109]:3 – 4). Here it is clear that the words are addressed to the baby in his mother's arms, "begotten" by the Father *ab aeterno* – "from the womb before the dawn," and born of Mary in time.

On the left of the composition we find the "holy splendors" of God's mountain, in the intense light, brilliant color and ecstatic expressions of the angels gathered in a fantastic late-gothic pavilion where they play musical instruments. Among these is a figure more luminous than the others, who emerges from the pavilion with her hands joined in prayer: not an angel, but a young woman with the same facial features and blond hair as Mary. In fact she is Mary, who thus seems also to have been "begotten" from

89. Taddeo Gaddi, *Expulsion of Joachim and Annunciation to Joachim*, c. 1338 – 40. Baroncelli Chapel, Santa Croce, Firenze.

90. Giotto, *Annunciation to Saint Anne*, 1303 – 05. Scrovegni Chapel, Padua.

91. Giotto, *Meeting of Joachim and Anne at the Golden Gate*, 1303 – 05. Scrovegni Chapel, Padua.

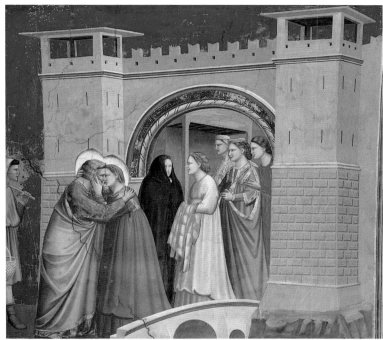

the womb before the dawn – at least as idea, a basic part of the plan of salvation that foresaw for the Messiah a body in which to die for human beings. Bearing in mind that this scene was visible only when the outer doors, with their image of Christ tortured, were open, we may say that the *Madonna and Child* on the right insists on the goodness of the body later crucified, and the light-shrouded woman emerging from the pavilion at the left obliges viewers to imagine such goodness, not as a casual fact, but as the mysterious lynchpin of the whole plan of salvation. With a single precept, the God who on the mountain generated the Savior from the womb before dawn also prepared the woman who would one day provide Christ with a body in which to "dominate in the midst of his enemies" by vanquishing sin and death through his own bodily death and resurrection.

These ideas derive from Saint Bridget of Sweden, who had described both Christ's atrocious sufferings in time[7] and the angels' jubilation when, before time began, God decided to create Mary.[8] In Saint Bridget's mystical language, Mary's soul, prepared by the Creator, was "a lantern emanating light" and "an ardent flame of love," while her body was "a most pure crystal vase" – poetic figures, these, illustrated very literally by Grunewald, who shows a glow around the woman in the pavilion and a crystal vase at her feet.[9] His overall message – that behind the horror of a humiliated, suffering body lies an eternal plan to have God's own Son born in a body to save the body – must have deeply touched those who, in the monastery hospital, suffered in their bodies. And, if we recall that when the altarpiece doors are open, the first scene

(reading from the left) is the *Annunciation* and the last is the *Resurrection*, it is clear that the iconographic journey led from the conception of Christ's body, through a flashback to Mary's predestination, to Jesus' birth in the body and final "healing" in the resurrection of his body. In that perspective, even if the altarpiece does not make explicit reference to it, the freedom from sin of the woman prepared before time began – whose soul is flame and whose body purest crystal – seems assured!

Parents, Birth, Education, Betrothal
Mary's conception in the mind of God followed by her Immaculate Conception in the flesh are, however, only the prelude.

The real story of the Virgin's life begins with her parents, her birth and her human and religious education.

A fresco in the Baroncelli Chapel in Santa Croce, Florence illustrates two of the opening episodes of this account: the priest Joachim, Mary's future father, expelled from the Temple with his offering because childless (and thus "accursed" by God), who then seeks refuge with shepherds in the countryside, where an angel informs him that his wife, Anne, will bear a daughter (fig. 89). The painter, Taddeo Gaddi, the collaborator and artistic heir of Giotto, seems to have followed the order of events established in the *Golden Legend* (compiled less than fifty years before the execution of the fresco), where these two moments in fact follow each other directly.[10] By contrast, in the *Proto-Evangelium of James* the expulsion of Joachim and the angel's announcement that he would soon become a father are separated by another episode, the announce-

ment made to Anne herself (once again by an angel) that her barrenness was at an end.[11] We should note, moreover, that in the Baroncelli Chapel, where the program disposed on two walls tells Mary's life up to Christ's infancy, the scenes illustrated here (and other episodes derived from apocryphal sources) are grouped together on the side wall, whereas the chapel's main wall surface – that against which the altar is placed – is reserved for events recounted in the canonical Gospels.

A similar differentiation of sources had been made by Giotto himself thirty years earlier, in the Scrovegni Chapel at Padua, where the accounts regarding Mary's birth and infancy are relegated to the highest of the three registers, whereas the canonical New Testament events involving both Mary and Christ are lower and thus nearer to the faithful. In the Scrovegni Chapel moreover – where the extended wall surface allowed a more detailed telling of the story – the intermediate scene, the *Annunciation to Saint Anne*, was included (fig. 90). This narrative order makes it clear that the author of the program preferred the *Proto Evangelium of James*, perhaps being as yet unaware of the Bishop of Genoa's anthology, published only several years earlier; in the *Proto Evangelium* the *Annunciation to Saint Anne* in fact precedes the *Annunciation to Joachim* and includes the female servant Juthine (shown at our left in the fresco, seated below the stairs just outside Saint Anne's chamber), with whom Saint Anne converses in the *Proto Evangelium* version.[12]

In the Scrovegni Chapel we also find the culminating episode of this first page of Mary's life: the embrace of the two elderly parents when – each having been informed by an angel – they meet at Jerusalem's Golden Gate following Joachim's return from the countryside (fig. 91). The reference to the Golden Gate does not go back to ancient versions of the *Proto Evangelium* (which speak only of "a gate"), but is found in such medieval editions as the 11th-century Manuscript 162 in Chartres Library,[13] and then in the *Golden Legend*; Giotto, who conspicuously gilds the arched city gate in the background of his scene, must thus have had access to an up-to-date version of the text. The passionate embrace of the aged couple in his fresco, their mouths pressed together and bodies touching, insists on Mary's generation according to nature, in opposition to the widespread tendency to mythologize the event by projecting the idea of "virgin birth" backwards in time to include Saint Anne.[14]

For much of the Middle Ages, the desire to assure concrete historical weight to Mary's existence had to be balanced against the need to explain her life in terms that were theologically meaning-

ful. In the Chartres manuscript, for example, in addition to the account provided in older versions of the *Proto Evangelium*, there is also a long catechesis on the phenomenon of sterility miraculously overcome: the angel who tells Joachim to go to the Golden Gate to be reunited to his wife explains that "God takes vengeance on sin, not on human nature. Thus, when he closes a woman's womb, it is in order to later open it in a more marvelous way, so that all may recognize that the child born is not the fruit of lust but a gift of God." The angel then lists the aged, sterile women in the Old Testament who, thanks to God's grace, gave birth to personages important for salvation history.[15]

The same way of reasoning determined the emphasis on Mary's relation to the Jerusalem temple, which in all versions both of the *Proto Evangelium* and the *Golden Legend* is mentioned immediately after her birth as the child's destination once weaned; even the Koran account situates Mary's education in a structure attached to the Temple: "the *mihrab* to the east."[16] Thus in an altarpiece for the cathedral of Regensburg – a city of Marian pilgrimage possessing a miraculous statue (as noted in our Introduction: cf. fig. 21), Albrecht Altdorfer situates Mary's birth in a modern "temple": a splendid church where, beneath the side-aisle arcades, we see old Saint Anne's canopied bed (fig. 92)! A squadron of baby angels flying through the church above the bed maintains perfect formation – we are, after all, in Germany, and a bigger angel hovering in the center of the composition incenses the newborn girl in the arms of her wetnurse – the infant Mary, the ark from whom would come One destined to be the new and definitive "temple."

The balance between symbolism and realism apparent in these works would change once and for all with the Counter Reformation, intent as it was on eliminating those elements of the tradition that might favor a process of mythologization. Thus Georges de La Tour, in the 17th century, in various works presents the *Education of the Virgin* in the veristic language of contemporary French spirituality, strongly concerned with social problems (fig. 93): Mary leaning to read or sew at her mother's knee in the candle-lit interior of a humble house. In de La Tour's remarkable chiaroscuro effects, we nonetheless sense that the meaning of the painting depends on the traditional Gospel symbolism of light; sometimes these image evoke the elaborate educational apparatus described in the apocryphal sources: in a 13th-century English version of the *Proto Evangelium* conserved in Hereford Cathedral library, for example, where we learn that Mary was an excellent student who "persevered in the study of the Law and the Prophets' writings with a diligence that aroused

amazement and admiration in the doctors of the Law."[17]

All the older sources agree that Mary was educated in the Temple, to which Joachim and Anna had brought the child at three years of age, and that she had mounted the fifteen steps leading to the holy place all alone (the number fifteen corresponding to that of the so-called "gradual" psalms in the Old Testament). Titian Vecellio imagined the moment in a monumental canvas for the Confraternity of Charity in Venice (fig. 94), organizing the event in scenographic terms and arranging the many personages like actors in a grandiose mystery play, with the "child lead," little Mary, highlighted on the landing of the Temple staircase. This staircase, which helped Titian solve the problem of an interruption in the wall surface – a door – also allowed him to enliven the upper part of the vast composition where, at the top of the stairs, we see the high priest and other personages awaiting Mary's arrival. On the opposite side of the canvas, a mountain landscape similarly gives life to the upper zone, while the crowd below (in which several of the confraternity members are por-

trayed) participates with gestures and animated gazes.

Titian developed the action from left to right, as on a written page, giving significance to what risks seeming more than an indistinct human mass. He created a centripetal composition without resorting to the ordinary balancing act, indeed going so far as to shift the "center" (the little figure of Mary) to the right. We do not perceive this as asymmetrical because – even if the eyes of thirty people carry our attention toward the right, where Mary is – three imposing figures at the top of the staircase, and the old woman of Michelangelesque proportions sitting beside the first ramp of stairs, let Titian suggest an equivalent movement in the opposite direction. In the same way, where on the right the foreground space is free, with few people on the stairs and the successive planes occupied by magnificent palaces seen in perspective, on the left this equation gets inverted, with the foreground occu-

pied and the background free, its open mountain landscape evoking Titian's native Cadore, in the Friuli region of north Italy.

According to the *Proto Evangelium* and the *Golden Legend*, the girls housed in the Temple devoted themselves to study, prayer and weaving. All the sources agree that it was in fact they who wove the Temple veil – the one that was violently sundered when Christ died (cf. Luke 23:45), and that while the other girls wove in silk, linen or even gold thread, and in cheerful colors, it fell to Mary to weave with "deep purple and scarlet,"[18] the colors of blood. This daily work is the subject of a mural painting of 1504 in the church of Saint Primus at Kamnik in Slovenia, where Mary's larger loom distinguishes her from the other young women (fig. 95).

When Mary reached the age of twelve (or, according to medieval texts, fourteen), the priests asked themselves: "What shall we do with her, to avoid contamination of the sanctuary of the Lord our

God?" They decided the Virgin should be given in marriage, and an angel ordered the priest Zachary to "summon the widowers among the people. Let each bring a staff, and, to the man to whom the Lord shows a sign, let her be given in marriage."[19] The widowers, including Saint Joseph, went up to the Temple with their staves, which the high priest took into the sanctuary where he prayed over them; then he redistributed the staves, but no sign appeared until, from Joseph's staff "a dove came forth ... and landed on the head" of the owner, to whom Mary was promptly handed over.[20] Medieval versions of the account stress Joseph's advanced age and his reluctance: at first, in fact, he had hidden his staff, being ashamed to compete for the hand of so young a woman. In medieval texts Joseph's staff moreover *flowers*, and it is upon this unexpected sign of life that the dove comes to rest — a detail exactly reproduced in Taddeo Gaddi's *Marriage of the Virgin* in the above-mentioned Baroncelli Chapel (fig. 96), where amid the joyous confusion of a 14th-century betrothal ceremony we see Joseph's flowering staff with the dove perched on it. Raphael, at the beginning of the 16th century, would be far more discreet (cf. fig. 39).

The Annunciation

At this point in the story the apocryphal material yields before the power of the Gospel, and it is here that the iconographical tradition really starts, for here Mary's life meshes with the life of Christ. A series of Gospel events, in fact, bring her to the fore: the Annunciation, the Visitation, her pregnancy, the Nativity, the Adoration of the Magi, the Circumcision and — with Saint Joseph — the Flight into Egypt and the Finding of Jesus in the Temple. The most important of these is the Annunciation, the event shown on the opening page of our Introduction in Lippo Vanni's fresco (cf. fig. 1): the moment when Light entered the world, thanks to the "Yes" of a young woman from Nazareth.

Christian iconography has tried various ways of representing the Annunciation. Among the most striking is the intimate vision of the event offered by Antonello da Messina (figs. 97, 98), which perfectly resumes a series of 15th-century experiments with close-up views of individuals; in this case, viewers find themselves in the position of the archangel Gabriel, a mere two steps from Mary who, as if perceiving their presence, interrupts her reading. Her right hand, shown in an extremely difficult foreshortened position, expresses surprise, while her left hand instinctively pulls her veil closed. What strikes us most, though, is this young woman's intelligent beauty: her glance full of self-awareness and the subtle smile that barely touches her lips. Her typically Sicilian beauty, with almond-shaped eyes and high cheekbones, transfers us to the world of southern Mediterranean femininity, and her luminous visage and ample blue veil (miracles of the new Flemish oil-painting technique so admired by Antonello) become metaphors of inner light: of the Light which, in that moment and in her, Mary, enters the world.

A similar intimacy is among the messages communicated by Lorenzo Lotto circa 1534, probably for the altar of a Marian confraternity at Recanati (fig. 99).[21] "Troubled at the angel's words"

99. Lorenzo Lotto, *Annunciation*, c. 1534. Pinacoteca Comunale, Recanati. The central message of this work has to do with *intimacy*. Probably painted for an altar in the chapel of a Marian confraternity of Recanati, the work shows Mary who – as she passes from initial surprise to quiet, inner joy – turns to the viewer to include him or her in her feelings. The cat at the center, fightened by the angel's apparition, represents evil defeated by Christ's Incarnation.

100. *Annunciation*, 8th – 9th-century Byzantine textile. Vatican Museums, Vatican City.

101. Theodore Prescott, *Annunciation*, c. 1970. Private Collection, U.S.A.

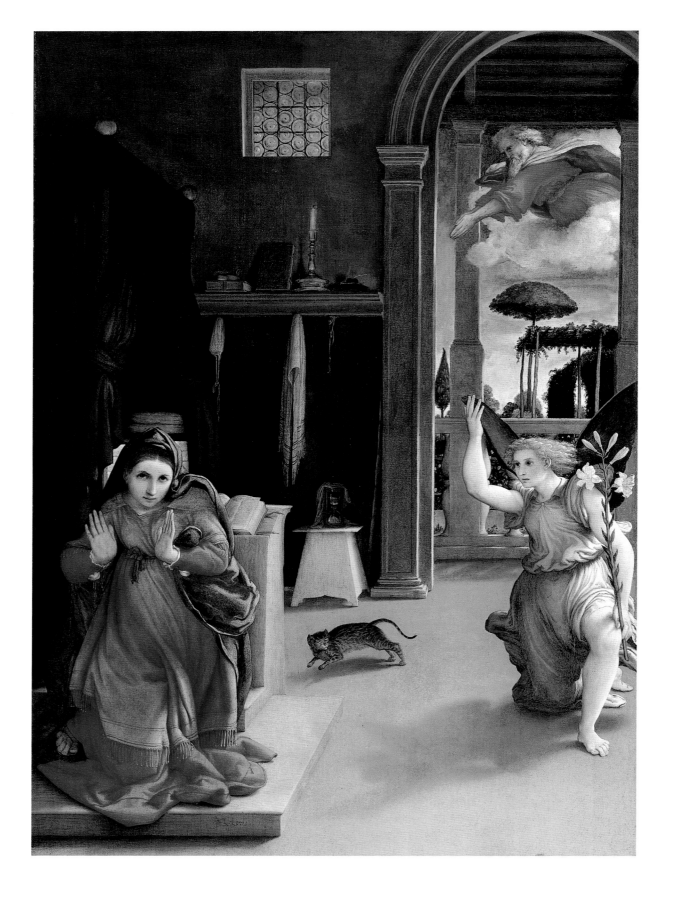

97

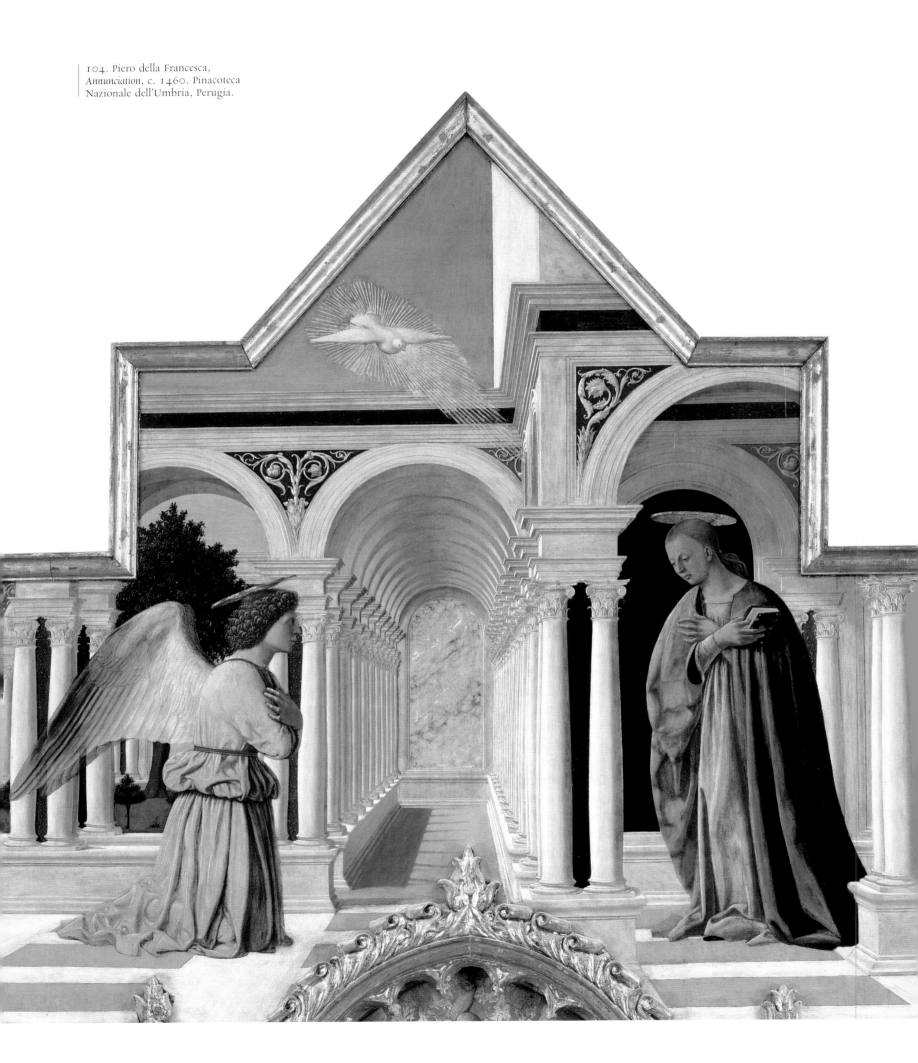

104. Piero della Francesca, *Annunciation*, c. 1460. Pinacoteca Nazionale dell'Umbria, Perugia.

105. Lorenzo di Credi, *Annunciation*, late 15th century. Uffizi, Florence. This refined work, small in scale, has echoes of the Savonarola reform, that swept through Florence in the last decade of the 15th century: an austere moralizing tone in the "false predella" representing Original Sin. The traditional theological juxtaposition of Mary and Eve invests this *Annunciation* with an implicitly heroic quality: right above Eve, shown in the predella expelled from God's presence, we see Mary who freely turns to receive God in her own body.

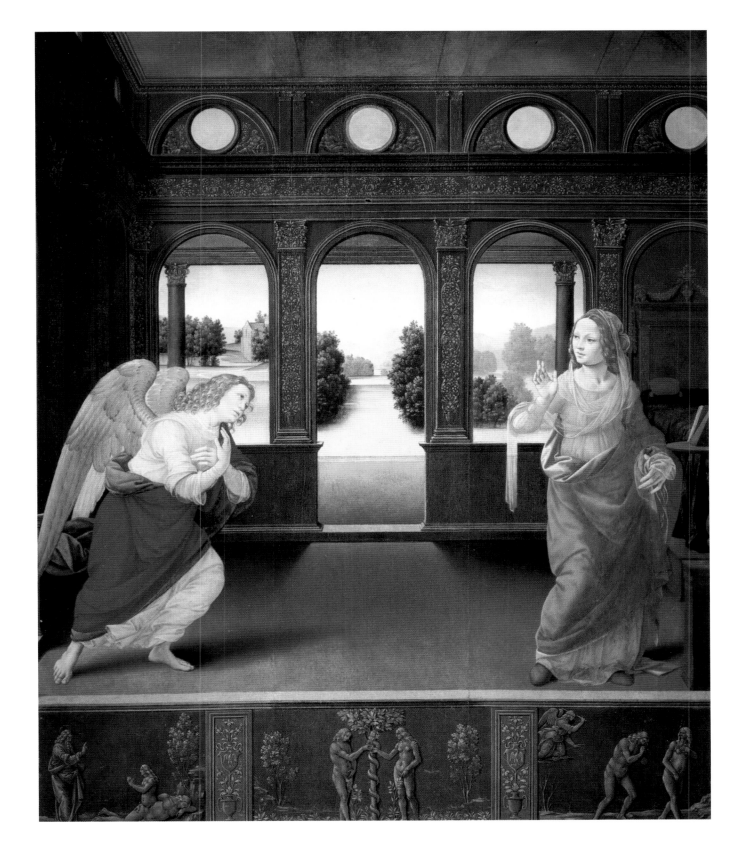

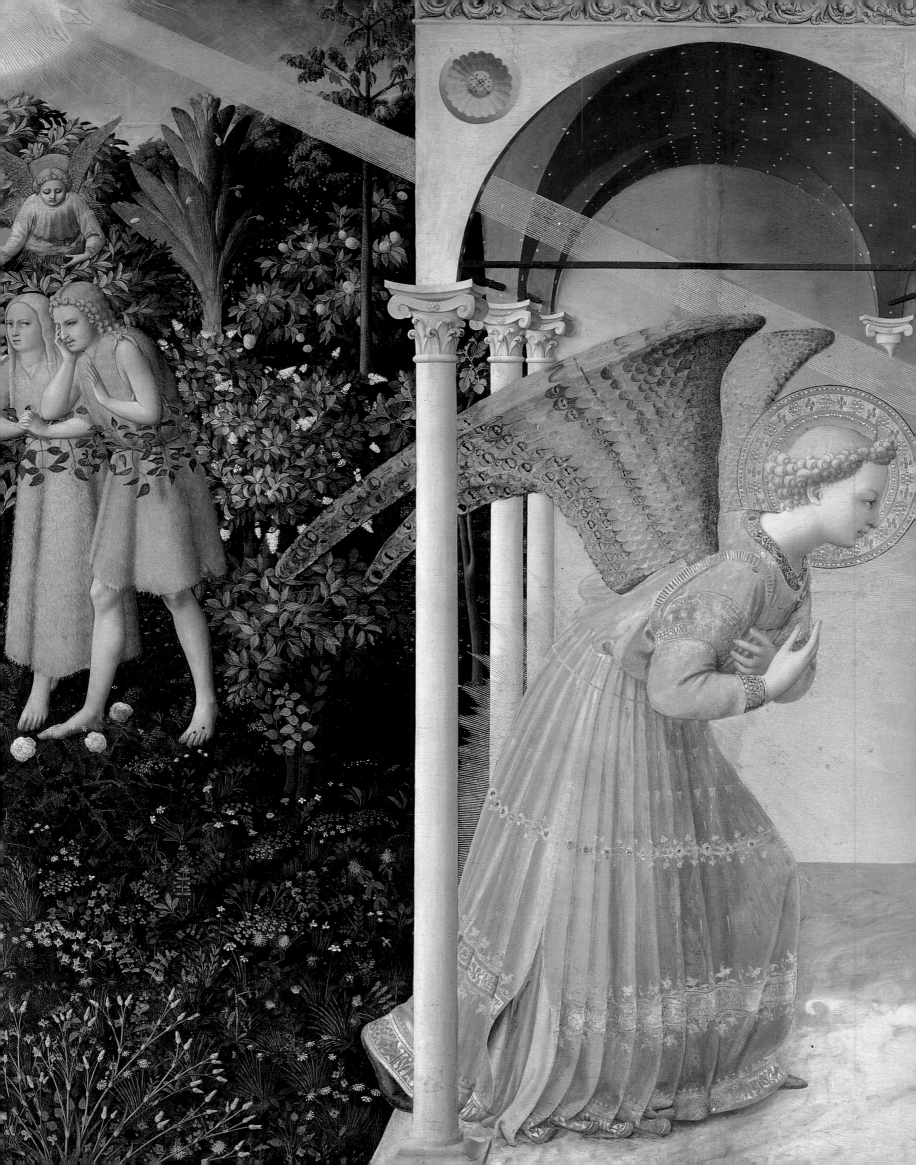

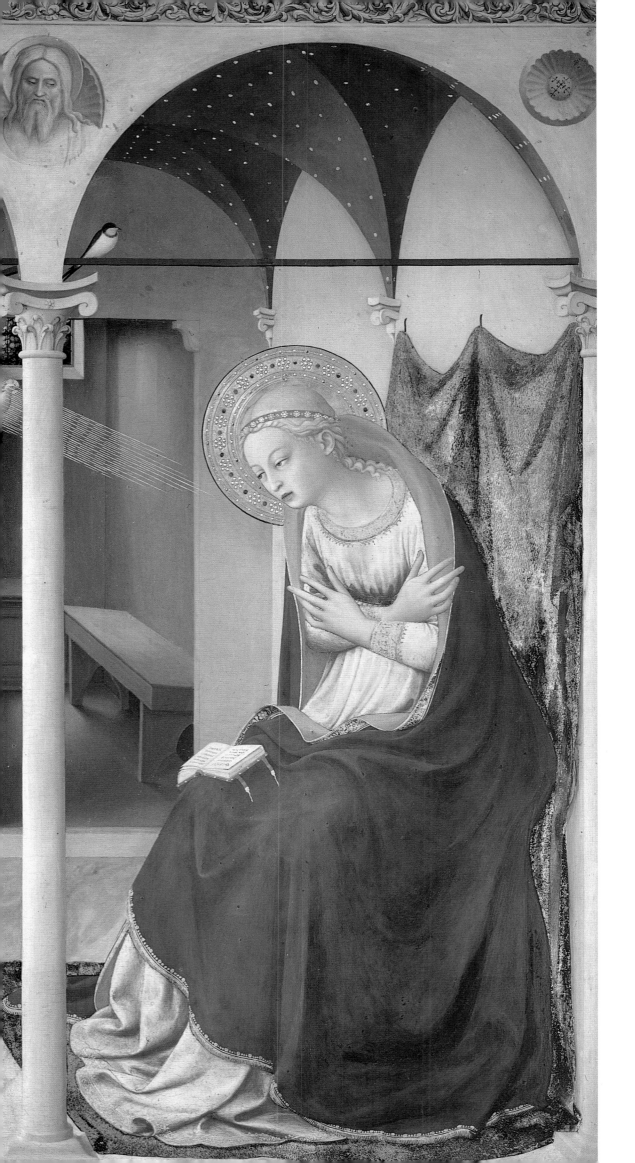

106. Fra Angelico,
Annunciation,
c. 1440. Prado, Madrid.

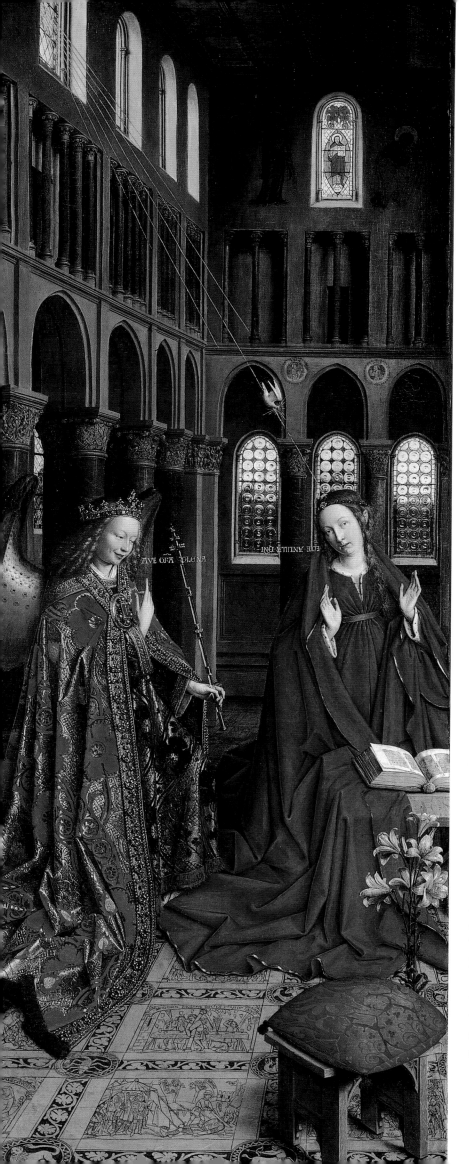

the Garden of Eden. The overall meaning of the work thus has to do with Mary as the new Eve, and it is no accident that the *Expulsion* – with Eve covering herself in shame as she flees before a minatory angel – is directly below Mary who turns, opening herself to the angel of the Annunciation. In theological and visual terms, the most important juxtaposition, however, is that at the center of the panel, where the predella shows the original sin through which earth itself was cursed (cf. Genesis 3:17), while above, in the open space between the two "actors," we see the earth restored to original innocence thanks to the woman who made herself "earth" for God's seed. The contrast between the opaque gray of the "relief," below, and the verdant, light-filled world, above, echoes Saint Anselm's assertion that the components of the created cosmos rejoice because, thanks to Mary, they have been "somehow brought back to the splendor they had lost," for while "God is Father of the world's foundation, Mary is mother of its reparation, since God generated him through whom all things were made, and Mary bore him through whom all things were saved."[23]

As Lorenzo di Credi's contrast between the *Expulsion* and the *Annunciation* suggests, the traditional theological juxtaposition of Eve and Mary invested the Annunciation event with implicit heroism. We find a similar contrast in Fra Angelico's *Annunciation* in the Prado (fig. 106), where the colorless tones of Adam and Eve expelled from Paradise, at the left, are played off against the bright tints and precious materials of the clothes worn by Gabriel and Mary, at the right. Still more explicit, in this sense, is an *Annunciation* done in Jan Van Eyck's shop and today in Washington (figs. 107, 108) where – in addition to the angel, the dove and several traditional symbols (i.e. the book of the Scriptures, a vase of lilies) – the artist has filled the foreground area with a crimson cushion on a stool. The cushion, a conventional symbol of lust, is situated *below* the white lilies in the vase, which are in turn situated *below* the book of the Scriptures, which is *below* Mary's womb, and, if we read from the top downwards, the sense of the unusual image seems to be that in the Virgin's *body* the Word became flesh without the mother's *purity* being compromised by *lustful desires*.

This "victory" of purity over lust is then qualified in biblical terms through two scenes in the figured pavement, visible between the hems of the angel's and Mary's robes and the crimson cushion on its stool (fig. 108): *Samson Destroying the Main Column of the Philistine Palace* (cf. Judges 16:29 – 30) and *David Decapitat-*

ing Goliath (1 Samuel 17:51). These violent events in the foreground, under Mary and next to the cushion, are clearly meant to suggest the heroic character of the humble obedience with which Mary allowed the Most High to "accomplish mighty deeds" in her life, as she herself says in the *Magnificat* (cf. Luke 1:49). Situated in a church, this *Annunciation* showing Mary as the supreme figure of the history of ancient Israel seems in effect to echo the *Magnificat*, in which Mary affirmed that God's name is holy, "and his mercy reaches from ages to age for those who fear him. He has shown the power of his arm and has routed the proud of heart; He has pulled down princes from their thrones and exalted the lowly He has come to the help of Israel his servant, mindful of his mercy, according to the promise he made to our ancestors: to Abraham and to his descendents forever" (Luke 1:49 – 55).

The mother's heroic humility serves, moreover, as prelude to the heroism and humility of her Son, as is suggested by the pairing,

107. Jan Van Eyck (?), *Annunciation*, c. 1440. National Gallery of Art, Washington, D.C.
Through a carefully codified "system" of symbols, this work asserts that the Word took flesh in Mary's womb without compromising her purity:
a kind of "victory" of virginity echoed in the scenes of Old Testament heroes represented in the pavement in front of Mary.
The Virgin, shown in a building that stands for the Jerusalem temple, is thus presented as the chief "heroic personage" of the whole history of the Chosen People.

108. Detail.

in a 12th-century reliquary, of the *Annunciation* with the *Crucifixion* (fig. 109), in practical illustration of Saint Leo the Great's assertion that the only reason God's Word assumed a human body in Mary's womb was to be able to offer that body on the cross.[24] A similar message is conveyed by the *Annunciation* in Piero della Francesca's fresco cycle of the "Legend of the True Cross," in San Francesco in Arezzo (fig. 110), where Mary receives the angel and conceives the Word in a portico whose architecture describes a cross, the vertical column and corner of the upper floor being intersected by a rich horizontal cornice.

The strongest expression of the bond between the conception and future death of Christ is a phrase found in a 13th-century English version of the *Proto Evangelium of James*, the Hereford Codex, where – after having listened to the angel – Mary says: "in my womb God's Son dons the garment of human nature, and goes forth to redeem the world like a bridegroom rising from his nuptial couch."[25] A practical illustration of this idea is the pinna-

109. *Annunciation and Crucifixion*,
12th century.
Musée de Cluny, Paris.

110. Piero della Francesca,
Annunciation, c. 1450.
San Francesco, Arezzo.

cle of an altarpiece by Simone de' Crocifissi where, after the Annunciation, Mary dreams of a Son who emerges from her womb already crucified (fig. 111).

The Visitation, the Pregnancy, the Nativity

As these examples suggest, popular tradition carried back to Christ's conception that maternal foreknowledge of his Passion which, in the New Testament, began with Jesus' presentation in the Temple, when Mary was told that a "sword" would one day pierce her heart (cf. Luke 2:35). Inevitably, the event that comes immediately after the Annunciation, the Visitation (Mary's visit to her aged cousin Elisabeth, whose pregnancy had been interpreted by the angel as a sign that "nothing is impossible to God" (Luke 1:37), was also interpreted in view of the future Passion. Art often alludes to this foreknowledge operative in the two events: a 13th-century French miniature pairs the *Annunciation* and the *Visitation* with a *Nativity* in which the manger in which Christ is born has the form of an altar (fig. 112), in illustration of the New Testament assertion that, "on entering the world, Christ said [to the Father], 'You did not want either sacrifice or offering, but you gave me a body … to do your will, o God" (Hebrews 10:5 – 7).

In the same spirit, as late as the 17th century Rubens frames his

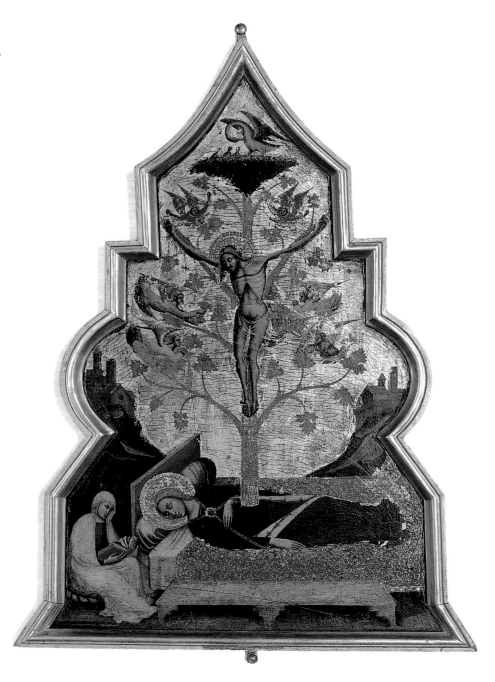

grandiose *Deposition of Christ* in Antwerp Cathedral with scenes representing the *Visitation* and *Presentation in the Temple* (fig. 113), associating the mother "carrying" the baby in her womb, at the left, with the people carrying the dead body of Christ, in the center, and with old Simeon at the right, who – moved by the Holy Spirit – carries the newborn Jesus in his arms, identifying him as a "sign of contradiction" and telling Mary that a sword would pierce her heart (cf. Luke 2:34 – 35). As far as the Visitation is concerned, we should moreover recall that the association of this event with the Passion derives from the fact that this meeting of two pregnant women included a meeting of the babies in their wombs, Jesus and John the Baptist, who was the prophet of Jesus' future death: John who, still in his mother's womb, exulted with joy at the Savior's coming (Luke 1:41 – 44).

The central theme of the Visitation, indeed, is a joy that art – unable to show John the Baptist and Christ, both of whom were still unborn – attributes to the two women bearing life in themselves. Artists show not mere human exultation but *spiritual joy*, as Jacopo Pontormo did in his *Visitation* at Carmignano (fig. 114), while a brilliant modern imitator, the American Bill Viola, had more trouble conveying this dimension (fig. 115).[26] What Pontormo illustrated is the joy of people who, trusting God beyond every human reason for hope, are touched by the miraculous – the joy which Elisabeth attributes to Mary: joy born of "believing in the fulfillment of the Lord's words" (cf. Luke 1:45). Above all, it is the joy to which Mary herself gave voice when, responding to Elisabeth's greeting, she said: "My soul magnifies the Lord and my spirit rejoices in God my savior ..." (Luke 1:46) – the joy Pontormo expressed in the grace of the two main female bodies in which, under the agitated, brilliantly colored draperies, we feel the movement of life, and in the gaze that passes between the two women, connecting the new life with the experience of faith.

Lannociacion. lacolement.

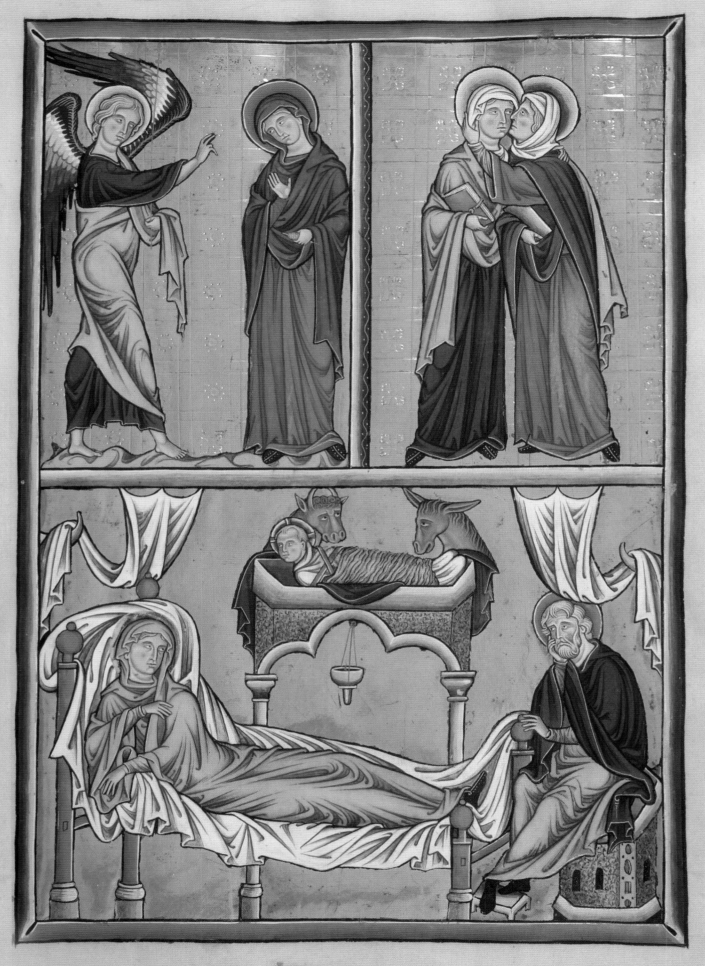

La gesine.

113. Peter Paul Rubens, *Triptych of the Deposition* (with the *Visitation* and the *Presentation of Christ in the Temple*), c. 1610 – 14. Cathedral, Antwerp.

114. Jacopo Pontormo, *Visitation*, c. 1528 – 29. Pieve di San Michele, Carmignano (Florence).

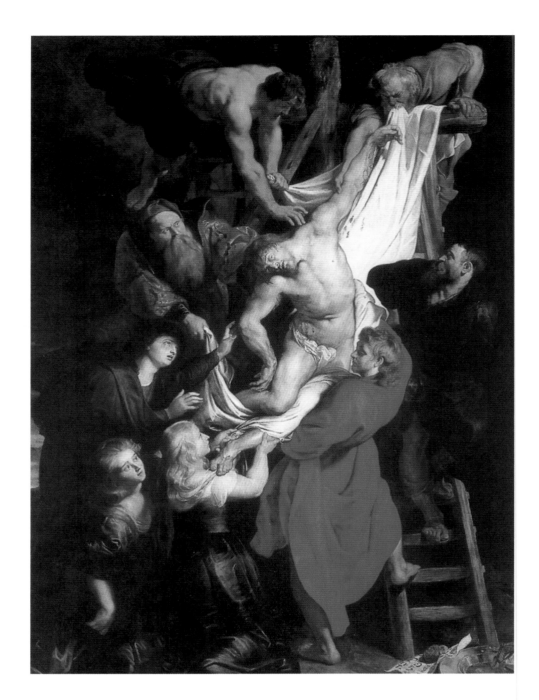

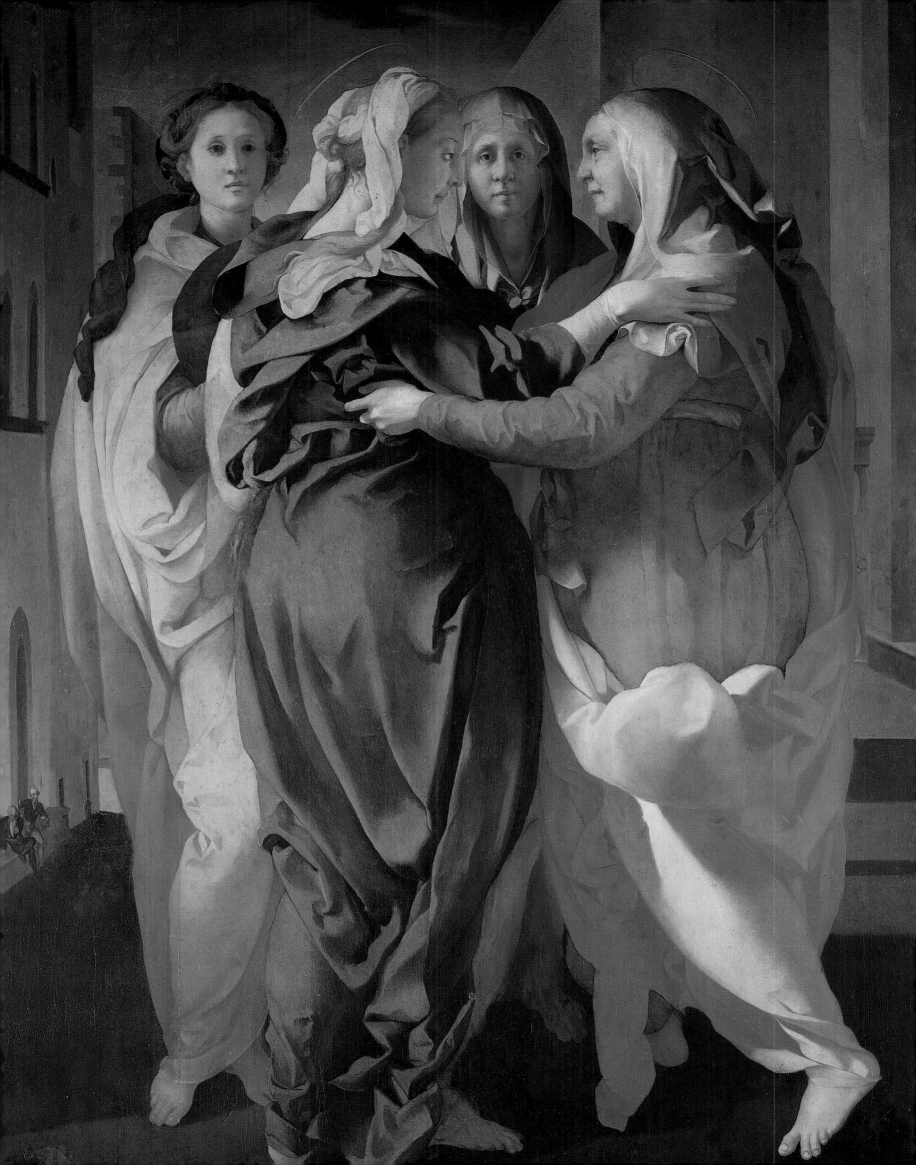

Normally artists express the intense spiritual joy of pregnancy chiefly in *physical* terms, in the changed bodily condition of Mary and Elisabeth due to the weight of new life they bear. This physical change is the larger subject of two sculptural groups set one beside the other in Reims Cathedral, an *Annunciation* and a *Visitation* (figs. 116, 117). The *Annunciation* figures, carved in the elegant Parisian style of the years 1220 – 1240, are so slender as to be virtually incorporeal; those of the *Visitation*, on the other hand – carved in the same years but by a master strongly drawn to Roman art, reveal bodies beneath ample draperies, clearly thickened by pregnancy. That condition is further emphasized by the expression of dreamy contentment that the anonymous master of the *Visitation* gave Mary (fig. 117); seen alongside the thin-faced Virgin of the *Annunciation*, this thriving soon-to-be mother "translates" the exultancy of the *Magnificat* in stone.

From the Visitation theme derives another subject: Mary "expecting" the birth of her Son, according to a verse of the *Proto Evangelium of James* where we learn that, in the three months she spent with Elisabeth (who was already pregnant at the moment of the Annunciation: cf. Luke 1:36), Mary's condition became ever more obvious: "Day after day, her womb grew larger."[27] The iconographical extrapolation of this verse was developed in the late Middle Ages as a devotional image dear to pregnant women or those who hoped to become so, as a small altarpiece by Bernardo Daddi suggests (fig. 118). It shows two women in diminutive scale – those for whom the work was made, presumably – kneeling before a figure of Mary "big with child" and beneath a blessing Christ; the older woman is shown in widow's black, while the younger has an elegant outer garment left open at the sides to accommodate her body, which is that of an expectant mother, and in the book in Mary's hands we find a prayer for the successful outcome of the pregnancy: "Most sweet Virgin Mary of Bagnolo,

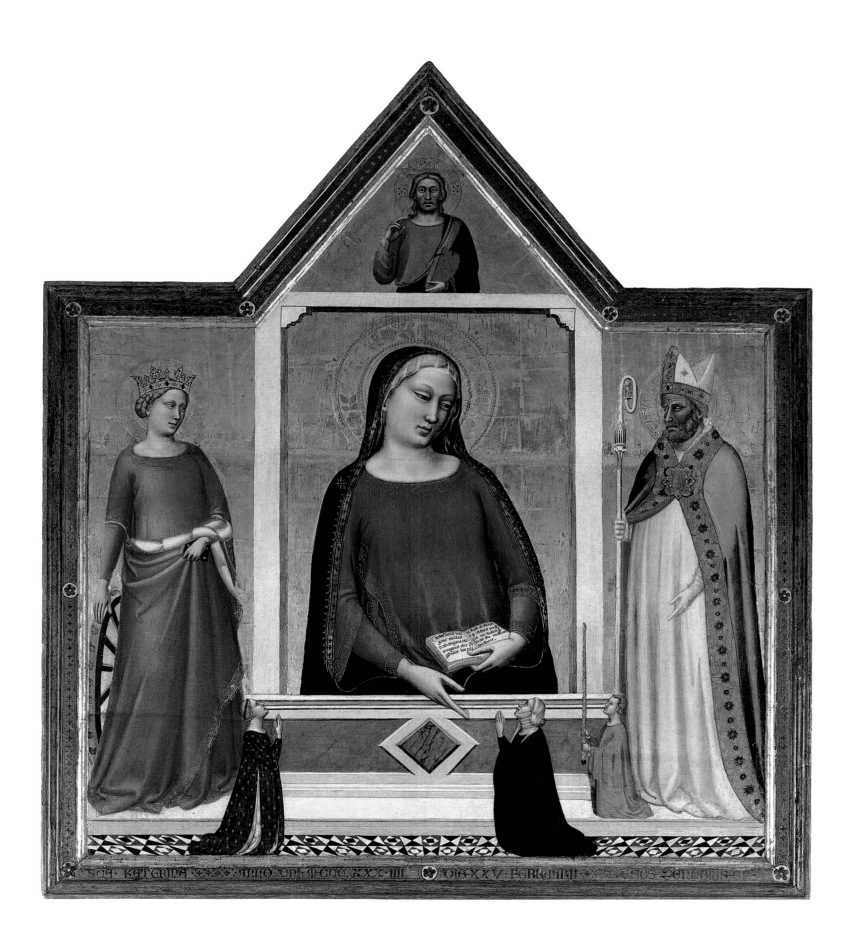

119. Piero della Francesca, *Madonna del Parto* (*Expectant Madonna*), c. 1450. Museo Comunale, Monterchi. Done for the cemetery of Monterchi, the artist's mother's home town, the image speaks of the sacredness of human life and its inviolable mystery, which for Christians are elements of their religious faith. Formerly, going to see this work (today unfortunately in a museum) was an experience of gradual discovery, a kind of revelation as, at the entrance to the cemetery, visitors were invited by Mary herself to not accept the closure that death apparently signifies, but to penetrate deeper to discover, at the heart of human mortality, the promise of new life.

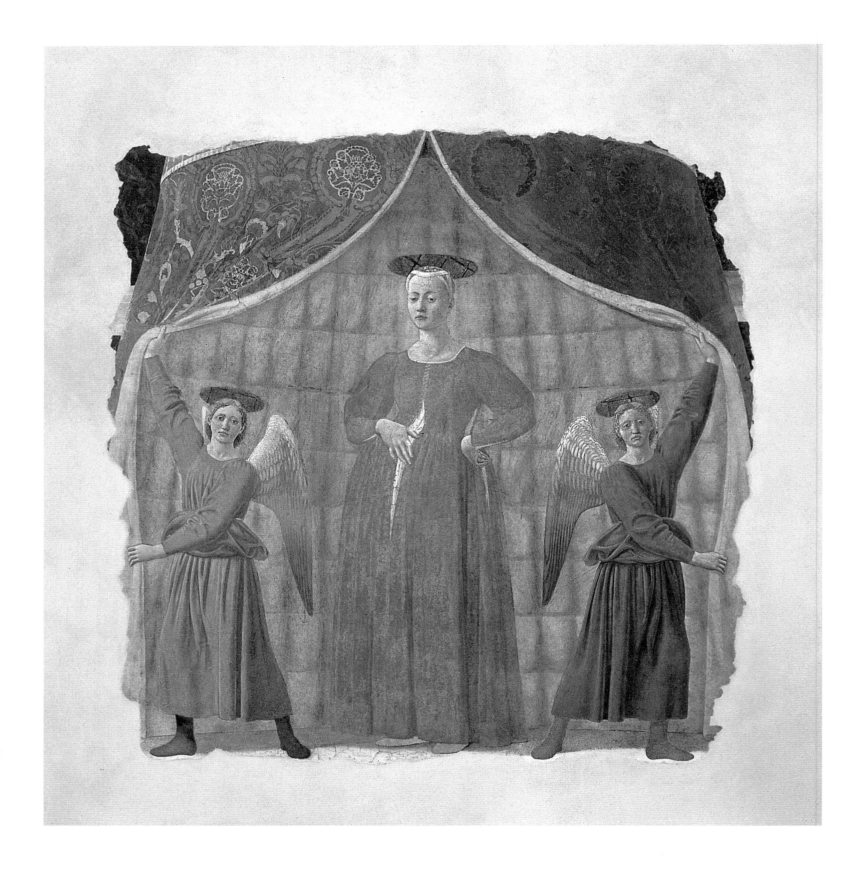

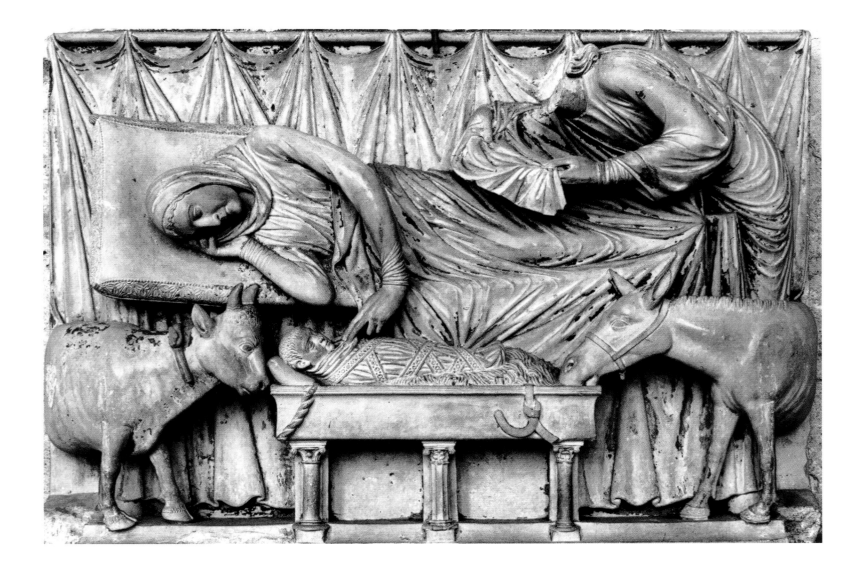

I pray you to pray to him [i.e. Christ] that his power give me the grace of my future state." The panel is dated: "Anno Domini MC-CCXXXIIII die XXV februari" – 25 February, 1334 (*more florentino*; 1335 in our terms).[28]

The most famous version of this theme is Piero della Francesca's *Expectant Madonna*, a fresco painted in the home town of the artist's mother, Monterchi (fig. 119).[29] In a pavilion of rare fabrics held open by angels, Mary opens the fabric of her dress to reveal a womb heavy with the fruit of the Spirit. The image is unforgettable: the perfect symmetry of the angels (realized through reuse of a single cartoon, reversed); the iconic frontality of all three figures; and the Virgin's solemn, meditative expression create a ritual climate, as if they were participants in a liturgical rite in church.

Mary's monumentality and her posture – that of a pregnant woman, standing straight with her shoulders thrown back and feet flat on the ground to support the weight of the baby in her body – seem to translate one of the biblical texts used on Marian feasts: a psalm which, speaking of the holy city of Jerusalem, says: "Her foundations are on the holy mountain" and "the Most High keeps her strong" (Psalms 87:1, 5). And Mary's fingers, delicately opening the outer garment to let us see her white shift, explain why (in the words of the same psalm), "the Lord loves the gates of Sion more than all of Jacob's dwellings" (Psalms 87:2): God

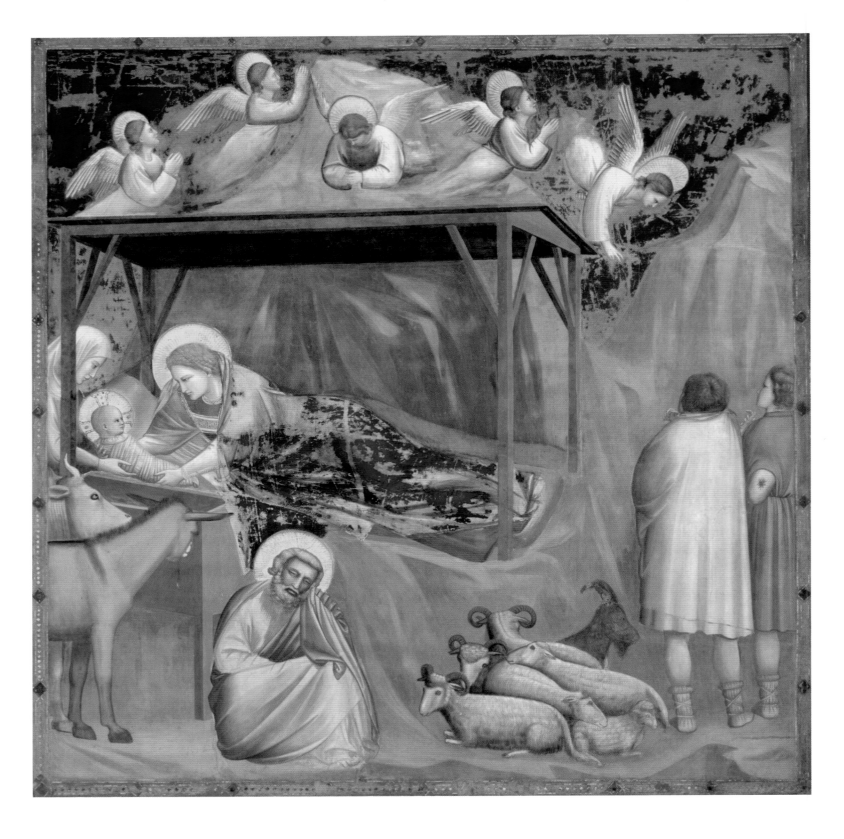

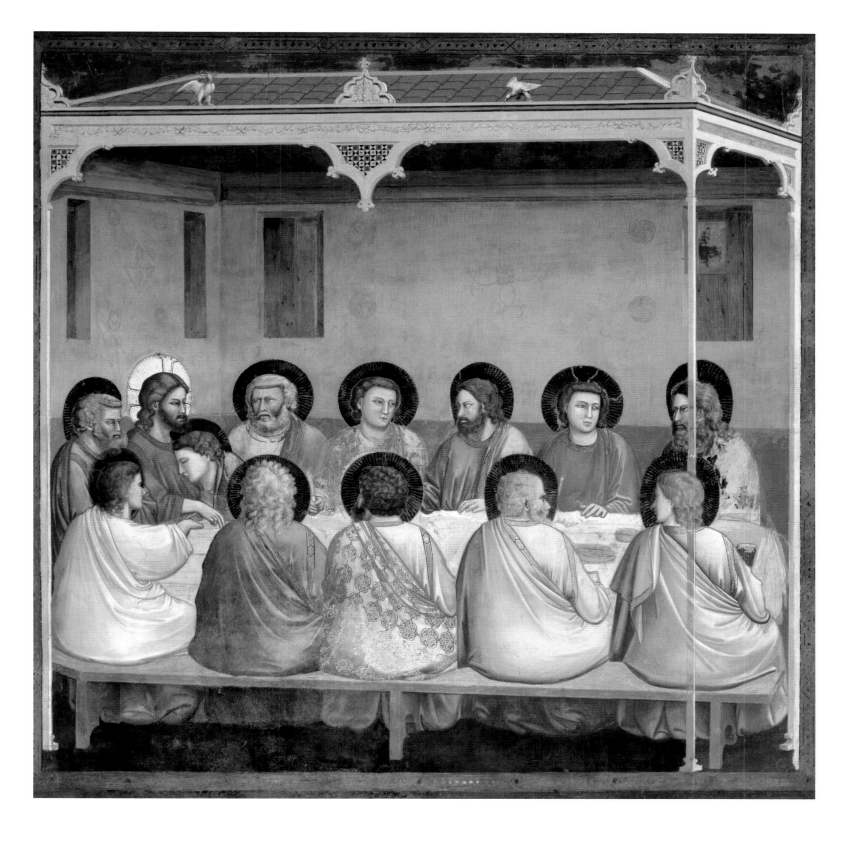

loves Mary because, from the "dwelling" of her body, through the "gate" of her selflessness, she gave the world Life.

Until relatively recently, this fresco was situated in a chapel at the entrance of Monterchi's cemetery: Mary "gate of heaven" in a place where people return to the earth. Going to see the work was an experience of gradual discovery, practically a revelation: in the midst of nature, the chapel; in the chapel, the fresco depicting a pavilion; in the pavilion, Mary; and in Mary – as yet hidden, but indicated by her hand separating the edges her dress – the light and life of human beings, real object of their every quest, Jesus Christ. It was as if, at the entrance to the cemetery, visitors were being invited to reject the seeming closure that death implies – to go forward, to go deeper, to discover at the center of mortality the promise of new life. "They are not dead, those who rest here," Mary seemed to say to all who crossed the chapel's threshold:

"Rather they are about to be born, my children and children of God in Christ, the Child born of my womb." For, as the medieval theologian Saint Aelred had explained, "All of us, as you well know, were imprisoned in death. But now, through the blessed Virgin Mary we are born with a better birth than we had through Eve, since Christ was born through Mary. In the place of decay we have regained freshness of life, incorruption instead of corruption, and instead of shadows, light. She is our mother, the mother of our life, the mother of our light."[30]

The humanity of images showing Mary as expectant mother help us grasp the more complex pairing of human and divine in representations of the Christ's Nativity from the Middle Ages onwards. The tenderness with which the mother reaches down to arrange her baby's swaddling bands in a relief in Chartres Cathedral, for example (fig. 120), is in no way contradicted, but on the

contrary reinforced, by the fact that the manger in which the child lies has the same altar-form already noted in figure 112. The eucharistic reference was still stronger here, for the relief originally adorned the enclosing wall of the cathedral chancel, with the high altar at its center!

In the same spirit, the Scrovegni Chapel fresco cycle – which in its highest tier narrates apocryphal episodes of Mary's life (cf. figs. 90, 91), and in the two lower tiers the evangelical account of the life of Christ – organizes the scenes in such a way that events shown in the middle tier are "completed" by those depicted right below them: an arrangement that allowed Giotto to represent the small body of Christ laid in the manger, in the Nativity, right above the bread Christ gave his disciples at the Last Supper (figs. 121, 122), each event shedding light on the other. The total seriousness of the gaze uniting mother and child in the Na-

tivity becomes thus comprehensible, for Mary knows that the body born from her own body will one day be offered to save the world.

Her sorrowful foreknowledge is, indeed, the explicit subject of numerous works, including the small diptych attributed to Simone Martini, where – caressed by her Son – Mary looks toward the Man of Sorrows that the child will one day be (fig. 123). Another example of the theme is Pesellino's *Adoration of the Magi* where, if the young mother lifted her gaze beyond those honoring her Son, she would see him already on the cross (fig. 124). In this case, we should recall the symbolic meaning of the gifts brought by the Magi: gold for a king, frankincense to venerate God; myrrh to embalm the dead.[31] Mary's foreknowledge is moreover a fundamental key to understanding such images as Mantegna's *Madonna and Child* in the Poldi Pezzoli Museum (fig.

125), where the child's sleep becomes a *simulacrum mortis* touching a chord of infinite sadness in his mother.

Among Marian images of this kind, particular interest attaches to a miniscule devotional panel, barely 12 centimeters high, painted by the Flemish master Petrus Christus (fig. 126), perhaps to mark his and his wife's admission to a confraternity dedicated to "Our Lady of the Dry Tree."[32] The panel shows Mary and the infant Christ in the branches of a thorny "dry tree" from which hang fifteen golden letters "a." The likely interpretation of meanings is fascinating: the thorns call into mind the crown of thorns of Christ's future Passion, while the dry tree recalls the tree of Adam's and Eve's sin, a small branch of which (as we read in the *Golden Legend*) had been given to Adam's son Seth, with the promise that his father would be healed only when the branch bore fruit. Here the "fruit" is Christ born of Mary, and the fifteen letters "a" evoke the "Hail Maries" of the rosary arranged in relation to the fifteen "mysteries" of Mary's participation in the life of her

Son (in the 15th century the recitation of the rosary was still an elite devotional practice, cultivated by lay sodalities such as the Confraternity of the Dry Tree).

There is, however, a probable further level of meaning that suggests the bond among these several elements. In the first important text to explicitly defend the Immaculate Conception, the *Tractatus de conceptione sanctae Mariae* written by the 12th-century theologian Eadmer, the possibility that Mary had been supernaturally preserved from original sin was illustrated through an example drawn from nature: the chestnut which emerges unharmed from its spiny shell. Eadmer asked, "Was God perhaps unable to allow a human body ... to remain free from the pricking of thorns, even if conceived amid the spikes of sin?" He concluded that, "it is clear that He could do this and that He wanted to do this; and if He wanted to do it, He did it" ("... *potuit plane et voluit; si igitur voluit, fecit*").[34] In Petrus Christus' painting, done in a period of lively debate about the Immaculate Conception, this Marian privilege – a

127. Bernardino Luini, *Presentation of Jesus in the Temple*, 1525. Sanctuary, Saronno (Varese).

128. Giovanni Bellini (shop), *Circumcision*, c. 1500. National Gallery, London.

sign of the purification from sin promised to all believers – is brought into relation with Christ's Passion (the crown of thorns) and with the resulting "repair" of the "damage" caused by Adam's sin (the dry tree bearing fruit). The Immaculate Conception itself is an anticipated fruit of the saving Passion, and Mary's full participation in her Son's life – the fifteen mysteries of the rosary – is proof of human nature's restoration: Mary, the new Eve, is perfectly united to her spouse, Christ, the new Adam.

In this framework of reflection on Mary's prescience regarding Christ's future suffering belong other subjects as well: the Circumcision and Presentation of Christ in the Temple, the occasion on which Simeon prophesied that a "sword" would pierce Mary's heart. Interesting, in this respect, is Bernardino Luini's fresco at the Marian sanctuary of Saronno (fig. 127), where – behind Simeon – we see an altar with an altarpiece and tympanum, both carved in high relief. The subject of the altarpiece, Eve, and that of the tympanum, Moses, allude to Saint Paul's assertion that "in the fullness of time, God sent his Son, born of woman, born under the Law..." (Galatians 4:4). Mary here is "woman" just as Eve was woman, and Jesus – brought to the Temple to fulfill the Law – is visibly "under the Law" written on the tablets Moses holds. The altar bearing the sculptures alludes finally to the expiatory sacrifice required by the Law of Moses – the sacrifice that Christ will supplant in the body received from Mary, becoming himself "offering," "lamb of God" destined for immolation; Saint Paul's phrase in fact concludes: "born under the Law, in order to redeem those who were under the Law" (Galatians 4:5).

The altar in Luini's fresco also alludes to Christ's circumcision, which took place eight days after his birth, when "he was given the name Jesus, as he had been called by the angel before being conceived in his mother's womb" (Luke 2:21). "Jesus" means "sav-

ior," and the first saving act of Mary's Son consisted precisely in an obedience to the Law that led him to shed blood: the few drops resulting from the cutting of his foreskin. It is interesting to note how, in a *Circumcision* painted in Giovanni Bellini's shop (fig. 128), it is Mary herself who holds the little "savior" still as he offers his body above an altar covered in white linen: even if the Child's name and mission were both assigned before she conceived him, Jesus' mother agreed and took active part in his work.

Mary as Mother and Educator

Focusing on individual moments suggested by everyday experience and by the faith, Christian art has roughed out a portrait of Mary as mother, emphasizing her love and contemplative interiority. In innumerable images from the Middle Ages on, we feel that the artist sought to illustrate the attitude described by Saint Luke when, speaking of the adoration given the newborn babe by certain shepherds, he says that "Mary treasured all these things and pondered them in her heart" (Luke 2:19). It is precisely the silence of someone treasuring and meditating marvellous events that enfolds Mary in Nativity scenes by Geertgen tot Sint Jans and Georges de La Tour, for instance (figs. 129, 130), and in both works the nocturnal context allows the artists to stress the intimacy of the moment shown. In both works, moreover, Christ is presented as radiant light, and the meditative love with which Mary contemplates him thus assumes the character of "illumination."

In Christian iconography, Mary, who treasures and ponders the mystery of her Son, is also the central figure of the Flight into Egypt, a subject which the Gospel itself associates rather with Jesus' surrogate father, Saint Joseph. In a version of the theme by Fra Angelico, for example (fig. 131), two inscriptions explain the event: one in a literal sense, the other in relation to Mary. The lower inscription quotes the Gospel passage in which an angel orders

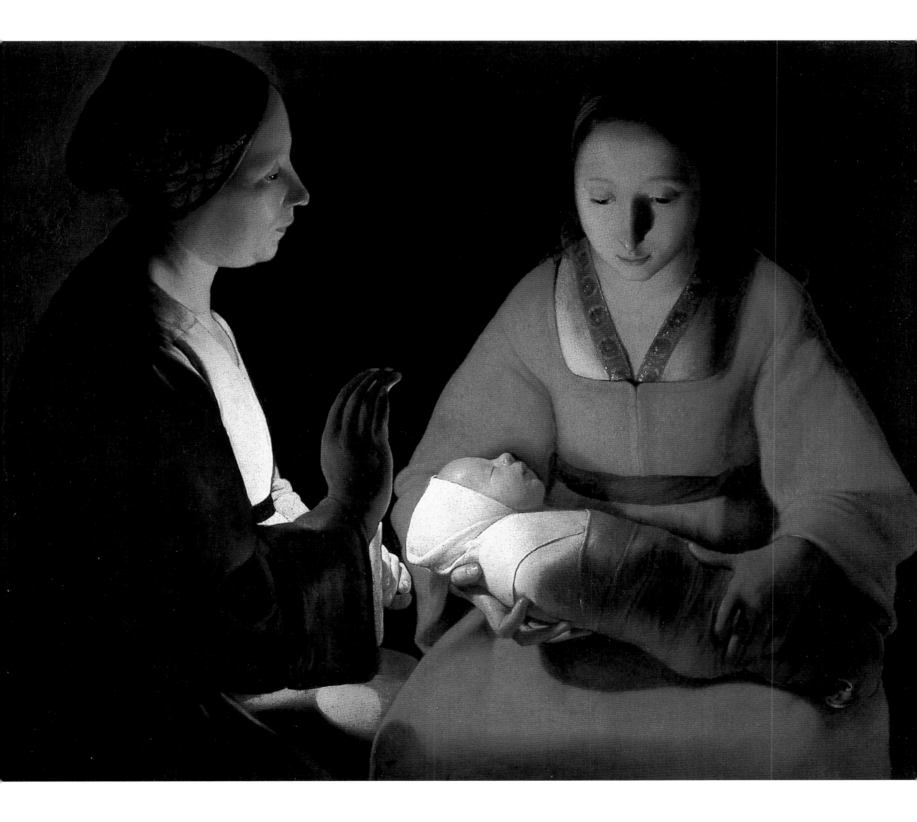

131. Fra Angelico, *Flight into Egypt*, c. 1440. Museo del Convento di San Marco, Florence.

132. Martin Schongauer, *Flight into Egypt*, c. 1475. Cleveland Museum of Art, Cleveland.

133. Caravaggio, *Rest on the Flight into Egypt*, c. 1595 – 96. Galleria Doria Pamphilj, Rome.

Joseph to get up, take the child and his mother and flee into Egypt (Matthew 2:13); the lower inscription, on the other hand, is a phrase from the Old Testament, "How far I would take my flight and make a new home in the desert!" (Psalms 55 [54]:8), alluding here to the "woman clothed in the sun" in the Revelation who "fled into the desert, where God had prepared a refuge for her" (Revelation 12:6). This indeed is the more important of the two

inscriptions, since – while the lower one is simply a "caption" – these words offer an interpretative key, poetically linking the image of Mary who presses little Jesus to her breast with the psalmist who, disappointed by the duplicity of men and of the world, asks: "Who will give me the wings of the dove, to fly away and be at peace? How far I would take my flight and make a new home in the desert! I would rest in a place protected from the fury of wind and storm" (Psalms 55[54]:7 – 9). Mary, carrying Christ into the desert, thus becomes a figure of every soul in search of interior peace far from the world's noise – a figure of contemplative life, an example for monks and nuns.

The same mystic role is assigned her in Martin Schongauer's *Flight into Egypt* (fig. 132), where above the mother fleeing with her Son we see angels who bend a palm tree, both to provide shade and to allow Joseph to gather a bunch of dates. This charming conceit alludes to yet another Old Testament passage, where we learn that "the forests and every fragrant tree will provide shade for Israel at the command of God" (Baruch 5:8). The context of this passage is a long sapiential poem in which God tells his chosen people to "learn where knowledge is, where strength, where understanding, and so learn where length of days is, where life, where the light of the eyes and where peace" (Baruch

3:14), promising to make their return to him easy; to this end, He decrees "the flattening of each high mountain, of the everlasting hills, the filling of the valleys to make the ground level, so that Israel can walk in safety under the glory of God. And the forests and every fragrant tree will provide shade for Israel at the command of God; for God will guide Israel in joy at the light of his glory with his mercy and integrity for escort" (Baruch 5:7 – 9). In Schongaurer's print, Mary looking down at little Jesus and hugging him to her breast thus becomes a figure of all who have "learned" "where knowledge is, where strength, where understanding, and so ... where length of days is, where life, where the light of the eyes and where peace." For Mary, these things are found in her Son, Jesus.

The same mood permeates the Enchanting *Rest on the Flight into Egypt* by Caravaggio (fig. 133), where the Hellenistic beauty of an angel seen from behind, and the imagined harmony of the music he makes with Saint Joseph's help prepare our eyes to linger on the figures at the right of the composition: a youthful Mary bent over her Child and with him asleep in the fragrant, woodland night. Here it is the rhythm of Caravaggio's composition – the movement of our gaze from Joseph, to the angel and finally to Mary – that associates the mystery of maternal love with the "strength ..., understanding ..., light of the eyes and ... peace" of those who have learned to know God.

This contemplative atmosphere gives sense to innumerable images of the Madonna and Child, communicating, along with human sentiments, divine Wisdom made flesh in a mother's arms and Light reflected in a virgin's eyes. From the solemn icons of the Eastern tradition, where God's Son is fascinated by the beau-

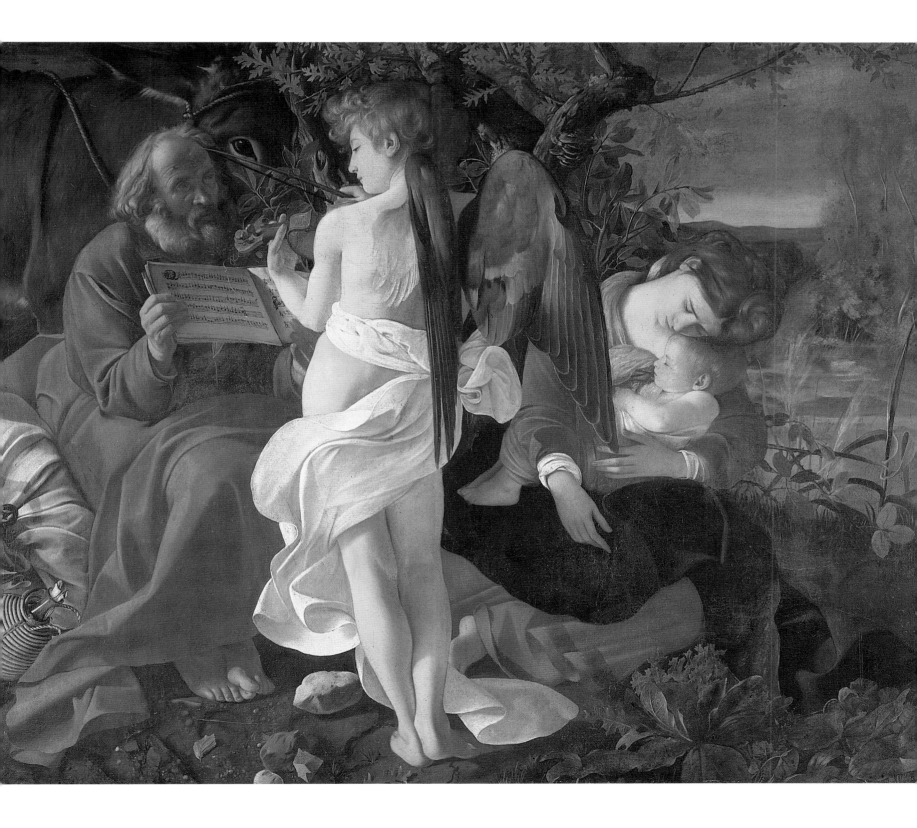

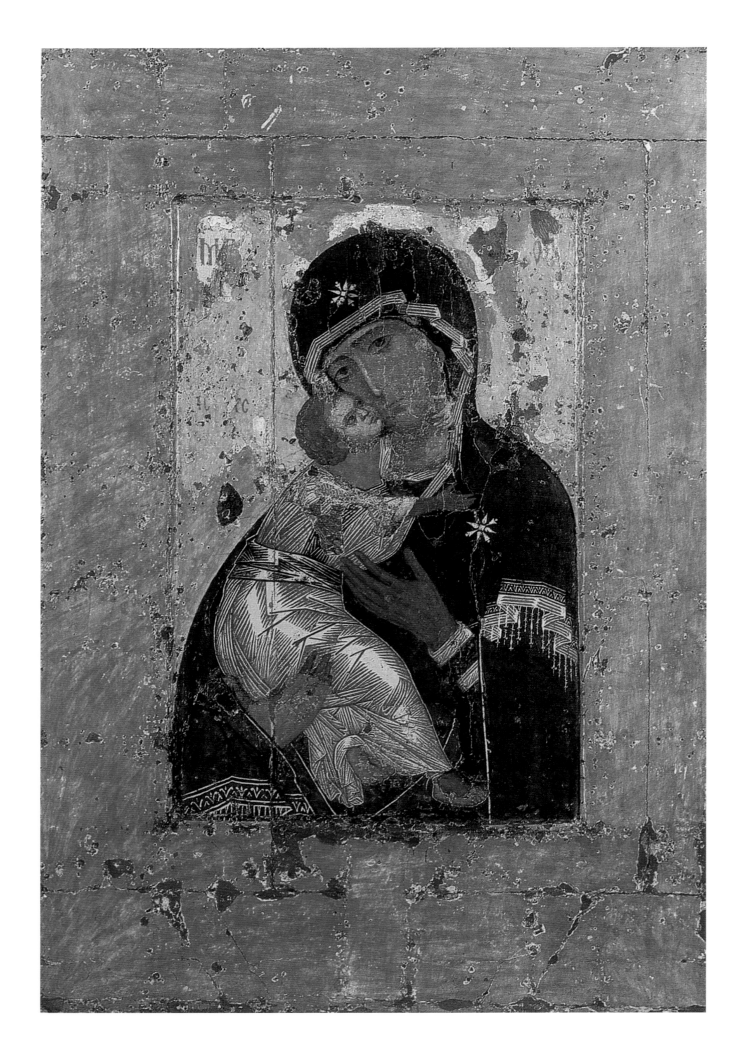

ty of the chosen woman and embraces her (fig. 134), to delightful Western images in which Mary plays with little Jesus just as every mother does with her baby, a single message is conveyed: God who is Love learned the gestures of human love from Mary, trusting her affection, and far from disdaining caresses, he gave and received them with joy. For a certain time, God limited his universal thirst to a single human breast, putting his small hand into Mary's bodice in a familiar way, sure that she would not refuse to feed him (fig. 135). Living bread come down from heaven (John 6:51), he satisfied his earthly hunger at this young woman's breast, nourishing himself with her goodness.

Mary's stillness as she holds a God to feed in her arms (fig. 136); the intelligence of this daughter of Jacob the dreamer who saw a ladder stretched between heaven and earth with angels ascending and descending (fig. 137) and, when he awoke, exclaimed: "What a fearful place this is: the very house of God, the gate of heaven!" (cf. Genesis 28:12 – 17); and the sweet intimacy of her who became "ladder" and "gate" and "house" so that Light might descend to "a people who walked in darkness ... and dwelt in a land of shadows" (fig. 138: cf. Isaiah 9:1): these are some of the themes hidden in the apparent simplicity of Christian Madonna images, leading even non-be-

lievers to instinctively repeat another of the patriarch Jacob's exclamations: "Truly, the Lord is in this place, and I did not know it!" (Genesis 28:16).

The Lord is in this place. Where the mother is, there we also find the Son – at least while he is still a baby. But Mary's Son is also Son of the heavenly Father, to whom he remains intimately united in the one Spirit. Thus where Mary and the child are, there too is the Holy Trinity, and the relationship between mother and Son *in time* intersects that between the Father and the Son *in eternity.* This at least is the subject of a canvas by Murillo (fig. 139), in which the holy family on earth and the eternal "family" comprised of Father, Son, and Holy Spirit flow together in a single reality, at whose center we see the child Jesus, point of intersection in the horizontal relationship between Mary and Joseph, and at the same time vertical bond between humankind and God.

At the end of the Middle Ages, in the context of northern European lay spirituality, the idea of a "family of Jesus" developed around a spurious genealogical text, the *Trinubiam Annae,* which maintained that Mary had two step-sisters, born after Joachim's death from two successive remarriages of Saint Anne: the first to a certain Cleophas, and then, on his death, to one Saloma.[35] All three daughters were called Mary, and thus the holy

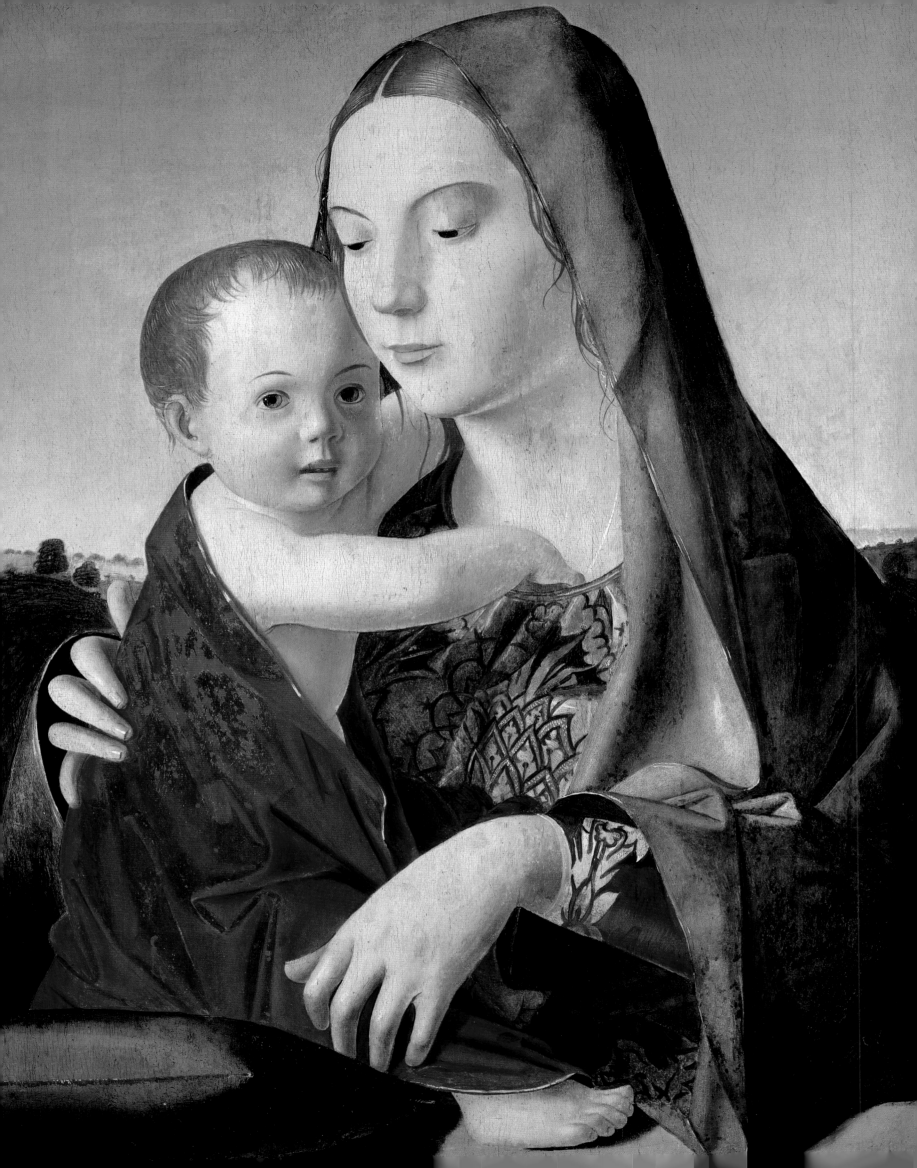

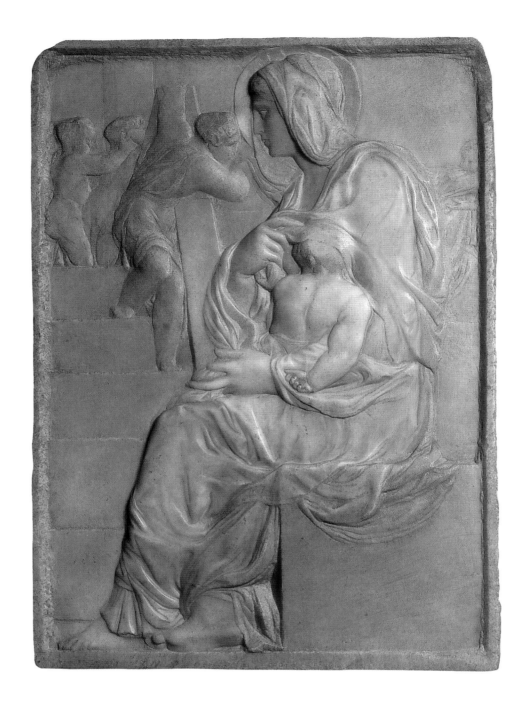

women named in the Gospel as "Mary Cleopha" and "Mary Sa-lome" were actually close relatives of the Virgin, as was Saint Elis-abeth. Naturally enough, these women's children – the "brothers" (or, more precisely, cousins) of Jesus – grew up together in what came to be called the "Holy Kinship," and this is the subject of a panel by the Dutch painter Geertgen tot Sint Jans for the chapel of the knightly Order of Saint John the Baptist at Haarlem, a so-dality to which the artist belonged as *famulus et pictor* (fig. 140). Geertgen shows an expanded Holy Family, with Saint Anne and Joachim (at the left), Jesus, Mary and Joseph (just left of center), Saint Elisabeth with the baby John the Baptist (at the right: the Baptist reaches out toward Christ), and other children and husbands in the middle ground and background. The scene is set in a "temple," and the sculptural group on the altar, the *Sacrifice of Isaac*, suggests the

purpose of this early socialization experience of Jesus: as future savior, Mary's Son had to acquire "insider" information about the human race for which he would offer his life.

Representations of Christ's human upbringing normally have a prophetic character similar to that of Geertgen's *Holy Kinship*. The tender *Madonna of the Spoon* by Gerard David, for example (fig. 141), where Mary teaches her Son to eat by himself, has a knife, a bad apple, and a piece of bread in the foreground, alluding to Christ's future death (the knife) to redeem the sin of Adam and Eve (the apple) through the sacrifice of his body (the bread, in a eucharistic sense). Significantly, it is Mary who helps the Child nourish himself: Mary, figure of the Church in need of someone to sacrifice himself for her. A comparable message emerges from the painting by Sandro Botticel-li in which the Christ child whom Mary teach-

136. Antonello da Messina, *Madonna and Child*, c. 1470. National Gallery of Art, Washington, D.C.

137. Michelangelo, *Madonna of the Stairs*, c. 1492. Casa Buonarroti, Florence.

138. Rembrandt, Holy Family,
c. 1640. Louvre, Paris.

139. Bartolomé Esteban Murillo,
Holy Family with the Trinity, 1675 –
82. National Gallery, London.

140. Geertgen tot Sint Jans,
The Holy Kinship, 1480 – 85.
Rijksmuseum, Amsterdam.

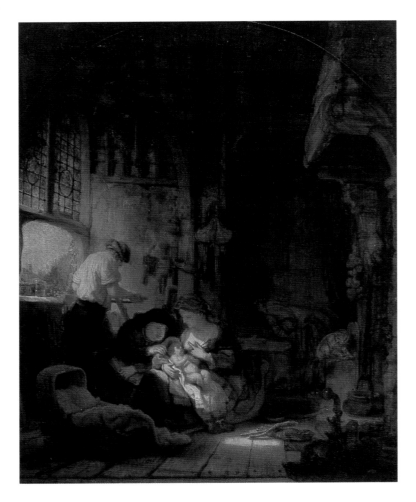

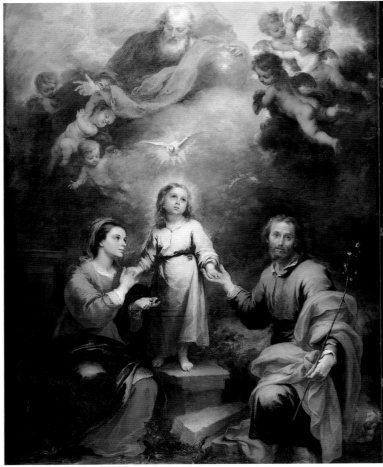

es to read has a crown of thorns around his right wrist and three small gold nails in his hand (fig. 142), and again from Michelangelo's so-called *Pitti Tondo* (fig. 143), where – behind the mother – we see Saint John the Baptist, Jesus' cousin and the prophet of his future death. In this case as in the Botticelli painting, moreover, the book shown is evidently that of the Scriptures that Christ came to fulfill, and the Baby's arm resting on its open pages alludes to the Word who became flesh in order to offer his body for the salvation of all.[36]

As late as the 17th century, Caravaggio will use similarly symbolic terminology to show Mary teaching her Child how to deal with a snake (fig. 144), in illustration of God's condemnation of the serpent who persuaded Eve to eat the apple: "I will put enmity between you and the woman, between your offspring and her offspring; it will crush your head and you will strike its heel"

(Genesis 3:15). Here, Mary, new Eve and figure of the Church, teaches Christ how to crush the reptile's head; Caravaggio, however, shows the Son's little foot is on Mary's foot – not only because he is still learning to walk, but because it is his weight, not his mother's, that defeats Evil. And, with still more transparent symbolism, the mid-17th-century artist Jacques Stella imagines a game in the Holy Family (fig. 147), the little cousins Jesus and Saint John the Baptist playing, with the Precursor leading a lamb ridden by the infant Redeemer who waves an olive branch. It is an evident allusion to the adult Jesus' entry into Jerusalem mounted on a donkey and hailed by a crowd waving olive branches, five days before dying on the cross as the Lamb of God announced by John the Baptist.

The heavy hand with which Baroque artists treat the themes of Jesus' education and growth – their insistent symbolism, so dif-

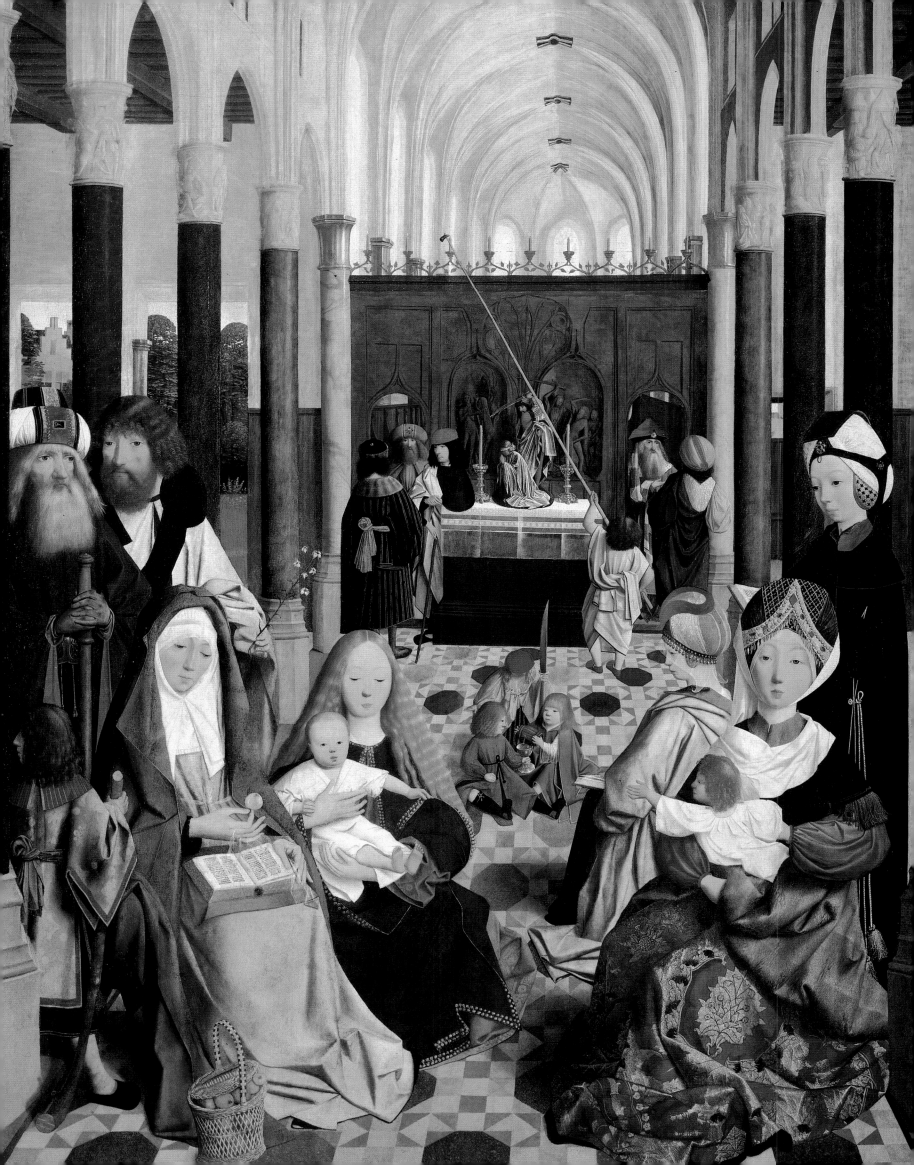

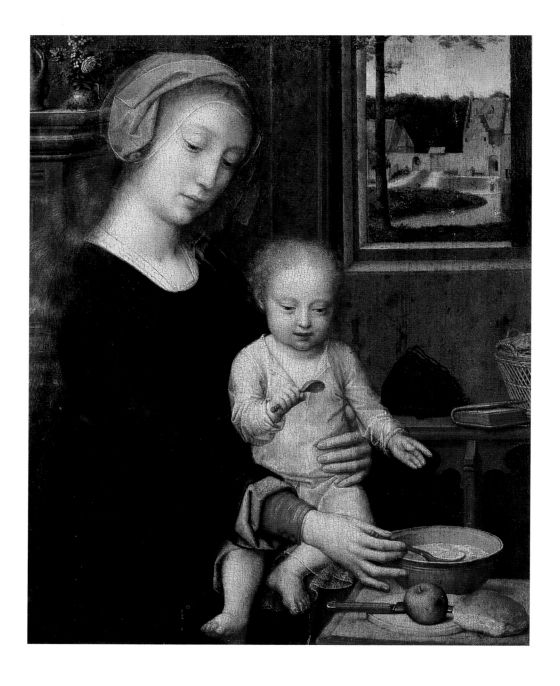

ferent from the "hidden" symbols of 15th – and early 16th-century art – reflects the emphasis Tridentine Catholicism placed on theological indoctrination, and the typically pedagogical concern to form the sensibility of children in mystical terms. The results, as Jacques Stella's painting suggests, could be pedantic and even slightly absurd – in any case less effective than earlier art's delicate use of allusion and even than the realism with which some late medieval works told the story of Christ and his mother.

A delightful example of this last type of image is Simone Martini's panel depicting *Mary Scolding the Twelve-Year Old Jesus After Finding Him in the Temple* (fig. 145). This is the Gospel episode in which, having celebrated the Passover in the capital with their adolescent Son, Mary and Joseph departed for Nazareth but "the boy Jesus remained in Jerusalem, without his parents realizing it" (Luke 2:43). After an anxious three-day search, they found him sitting in the Temple with the rabbinical teachers, listening and asking questions. And, even though she was amazed at the lad's intelligence, his mother did not hesitate to scold him, saying: "Son, why have you done this to us? Your father and I, deeply worried, have been looking for you" (Luke 2:48). Simone Martini illustrates precisely that verse, leaving no room for Jesus' famous reply, "Why were you looking for me? Did you not know I must be about my Father's business?" Rather, he shows us a cross Saint Joseph leading Jesus to Mary, who stern-faced and with a strong gesture explains to the sulking teenager that his behavior has caused them pain. The psychological honesty of Simone Martini's touchingly fresh interpretation is, in the last analysis, faithful to the Christian message that God became true man and thus also true adolescent!

According to the Gospel, after the scolding received from Mary

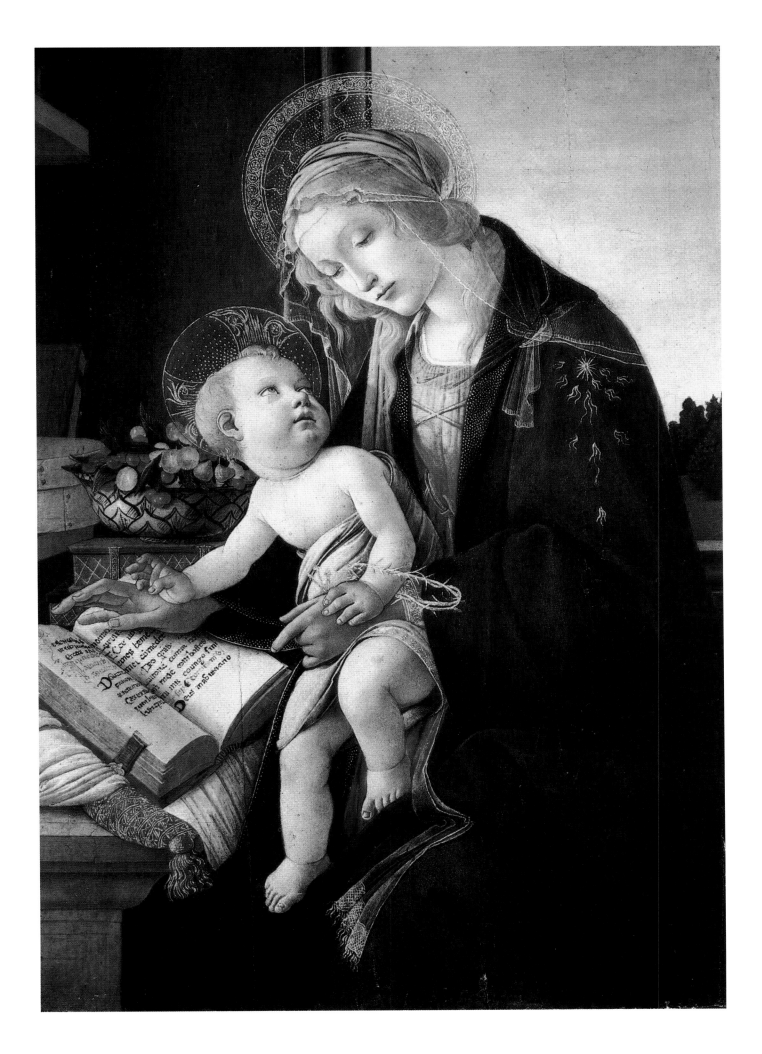

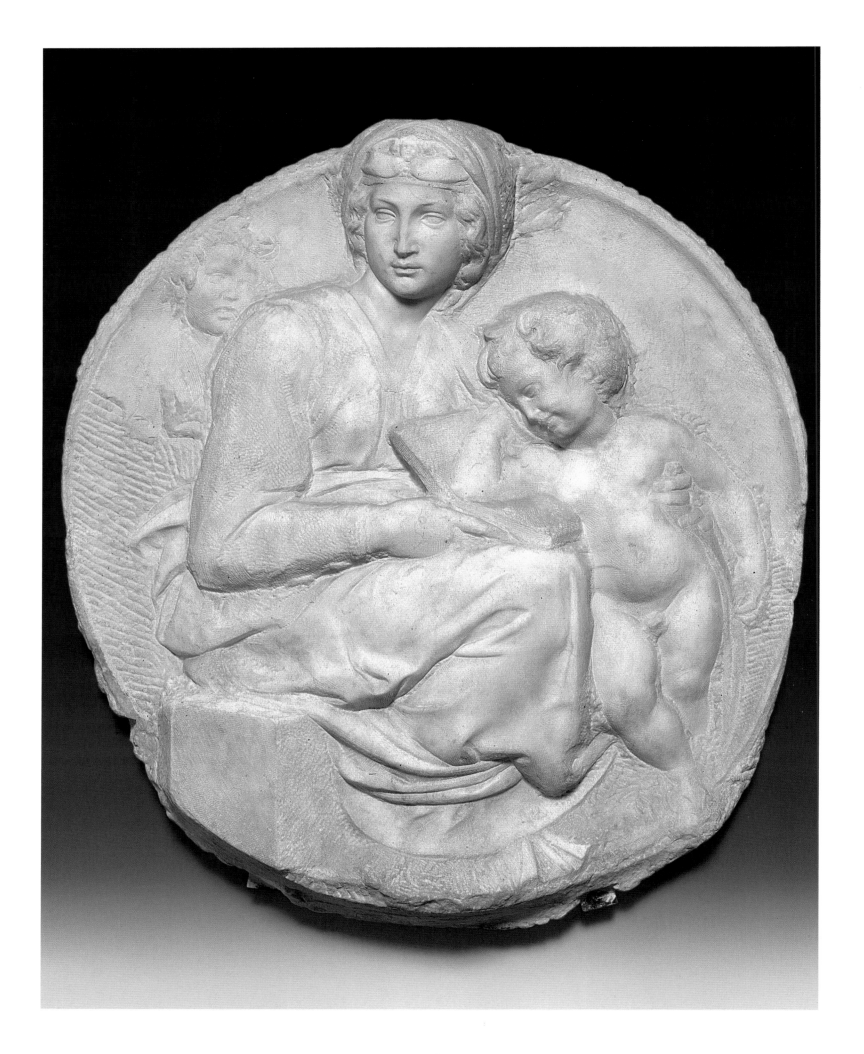

143. Michelangelo, *The Pitti Tondo*, c. 1505. Museo Nazionale del Bargello, Florence.

144. Caravaggio, *Mary Teaching Baby Jesus to Crush the Serpent's Head*, 1605 – 06. Galleria Borghese, Rome.

145. Simone Martini, *Mary Scolding the Twelve-Year Old Jesus After Finding Him in the Temple*, 1342. Walzer Art Gallery, Liverpool. This painting, done as an inscription makes clear in 1342, is highly unusual. Saint Joseph indicates the suffering which

the boy's behavior caused his mother, but the adolescent Savior seems clearly annoyed by Joseph's and Mary's rebukes. The artist's original narrative approach has interpretative freshness and psychological verisimilitude,

and his touching image is curiously true to the Christian message, which involves a God who becomes true man and, therefore, also true teenager.

and Joseph, the boy "left with them and returned to Nazareth, where he was subject to their authority. His mother treasured all these things and pondered them in her heart. And Jesus developed in wisdom, age and grace before God and men" (Luke 2:51 – 52). From these few, sketchy pieces of information about the Savior's "hidden life," Christian artists would develop images of the Holy Family at work, each member according to his or her state: Mary as housewife, Joseph as carpenter and Jesus "subject to their authority," as his surrogate father's helper. An interesting example is the *Holy Family* by an anonymous country painter in the small Oratorio del Binengo at Sergnano near Crema (fig. 146), where – in addition to Mary and Joseph bent over their respective tasks, and Jesus sweeping up the wood shavings left by Joseph – we see the scaffolding of a tower being built by angels. This is an allusion to what Jesus would promise one of his first disciples, referring to the dream of Jacob mentioned above: "You will see the

heavens laid open and, above the Son of man, God's angels ascending and descending" (John 1:51). The message for the farm families who attended Mass in this chapel was that – in children's obedience to parents and in the humble, everyday work of the family – believers build a *scala paradise* from earth to heaven, from man to God.

A more fascinating moment in the life of the Holy Family was imagined by Francisco de Zurbaran, again in light of the New Testament assertion that Jesus' mother "treasured all these things in her heart" (fig. 148). In his painting, Mary, at the right, has interrupted her work and is near tears as she gazes at her Son who has cut his hand while weaving little crowns of thorns. Despite the improbability of its "plot" (due, again, to post-Tridentine Catholic insistence on easily decipherable symbolism), this work has extraordinary psychological and even physiological verisimilitude: the young Christ – a fine looking seventeen-year old, intelligent

146. *The Holy Family at Work*, early 16th century. Oratorio del Binengo, Sergnano, Crema.

147. Jacques Stella, *Holy Family*, 1651. Musée des Beaux-Arts, Dijon. This 17th-century artist imagines a game played by the two little cousins, Jesus and John the Baptist, in which the baby Precursor guides a lamb ridden by the baby Redeemer, who is shown waving an olive branch – an evident allusion to the adult Christ's entry into Jerusalem. The insistent way in which Catholic art of this period sought to theologically indoctrinate the faithful is related to the concern of the Tridentine Church to communicate the faith and its symbols.

148. Francisco de Zurbaran, *Christ and Mary in the House at Nazareth*, 1640. Cleveland Museum of Art, Cleveland.

149. Modesto Faustini, *Death of Saint Joseph*, c. 1886 – 90. Santuario della Santa Casa, Loreto.

150 – 151. Giotto, view of the south wall, 1303 – 05. Scrovegni Chapel, Padua.
Among the Gospel events that stress Mary's anything but marginal role are the marriage feast at Cana and her presence at the foot of the cross, where Christ entrusted his beloved disciple, John, to her care. One might say, in fact, that the Savior's public ministry unfolded between these two private moments which he lived in the company of his mother and a few friends: the water turned into wine at Cana and the blood shed on Calvary. The deep connection between these moments is made evident in the Scrovegni Chapel program, where the *Marriage Feast at Cana* is placed directly above the *Lamentation Over the Dead Christ*.

152. Giotto, *Marriage Feast at Cana*, 1303 – 05. Scrovegni Chapel, Padua.

153. Giotto, *Lamentation Over the Dead Christ*, 1303 – 05. Scrovegni Chapel, Padua.

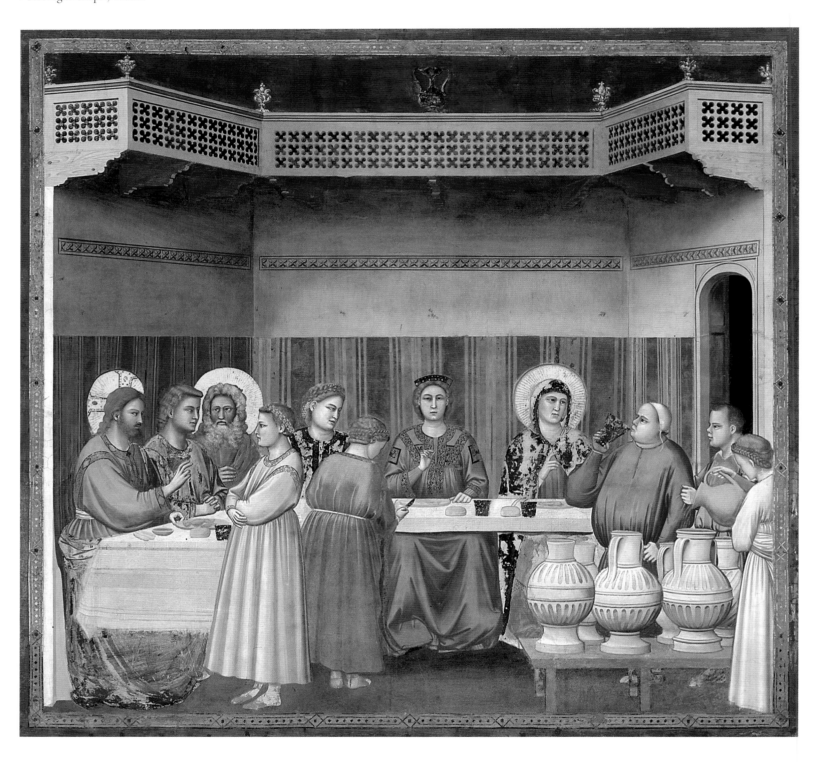

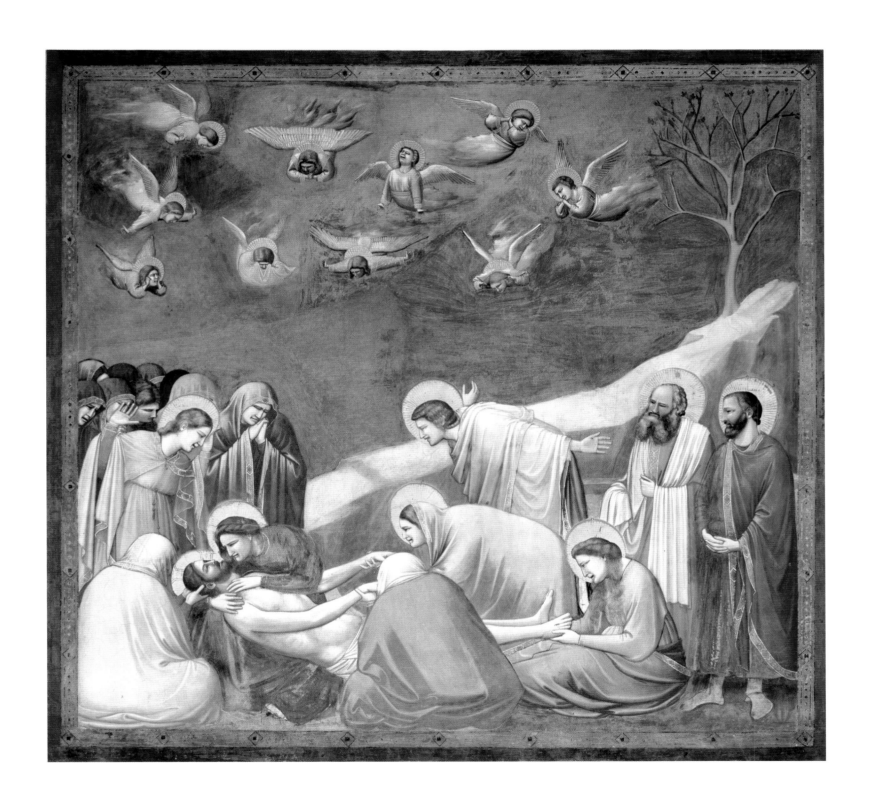

154. Andrea da Firenze, *Via Crucis*, 1365. Charter Hall, Santa Maria Novella, Florence.

155. *Crucifixion*, c. 1030. Echternach Sacramentare, Bibliothèque Royale, Bruxelles.

156. *Mary, John and the Holy Women at the Foot of the Cross*, early 16th century. Chapel of the Crucifixion, San Vivaldo, Montaione (Florence).

157. Giovanni da Milano, *Mystical Crucifixion*, c. 1400. San Petronio, Bologna.

and serious – has truly grown in age and grace; and Mary's gaze and the weary curve of her shoulders convey the weight of a terrible awareness, the foreknowledge she has of her beloved Jesus' coming Passion. Two white doves at Mary's feet in fact recall the moment when Simeon predicted that a sword would pierce her heart – the moment when, many years before, she and Joseph had brought a pair of turtle doves to the Temple, to be offered in place of the Child in accordance with Jewish law (Luke 2:22 – 24).

After its few, discreet indications regarding the Holy Family's hidden life, the Gospel moves on straight away to the baptism and public ministry of Christ – and so too Christian art, which normally does not represent other episodes in which (in this life, at least) Mary has a central role. A rare exception is the death of Saint Joseph, an event described in an apocryphal text datable between the 2nd and the 4th centuries, the *History of Joseph the Carpenter*, in which the narrator, Jesus himself, speaks of a visit made with his mother to the saint's deathbed.[37] The text – a kind of philosophical disquisition on death that attributes no particular sentiments to either Jesus or Mary – is not really suitable for illustration, but a beautiful late 19th-century fresco in the Marian shrine at Loreto dramatizes the moment (fig. 149), showing Mary embracing her aged companion while an adult Christ blesses their chaste conjugal love and angels sing in heaven. Victorian sentimentalism has replaced Baroque symbolism, but the work still touches us, and the painter's presentation of Mary as a middle-aged woman deeply attached to the dying man echoes with genuine human and Christian *pietas*.

From Cana to the Foot of the Cross

Faced with the question of Mary's part in Christ's public ministry, artists have stressed the only New Testament event that gives her a more than peripheral role, the Marriage Feast at Cana. Recounted in the fourth Gospel, whose first chapter consists of a Prologue in which Mary is never named, this "marriage at Cana in Galilee" opens the second chapter and focuses attention on her: the first verse informs us that "the mother of Jesus was there" (John 2:1), adding that "Jesus and his disciples had also been invited" (John 2:2) – "*also*," as if his presence were secondary! And indeed, when the wine runs out, it is Mary who asks her Son to help the embarrassed couple, and, in the face of his apparent unwillingness to do anything, it is again she who insists, directly ordering the servants to "do whatever he tells you" (John 2:5). Christ finally obeys his mother, commanding that six big jars be filled with water which he then changes into wine, in the process realizing the first of his miracles. "After this he went down to Capernaum with his mother and brothers ...," John concludes (John 2:12), and Mary then disappears from the pages of the fourth Gospel until the Passion account, which states that "near the cross of Jesus stood his mother, his mother's sister, Mary Cleophas, and Mary of Magdala" (John 19:25). The Savior's public life thus unfolded between these two private moments lived in the company of his mother and a few family members: the water turned into wine at Cana and the blood shed on Golgotha.

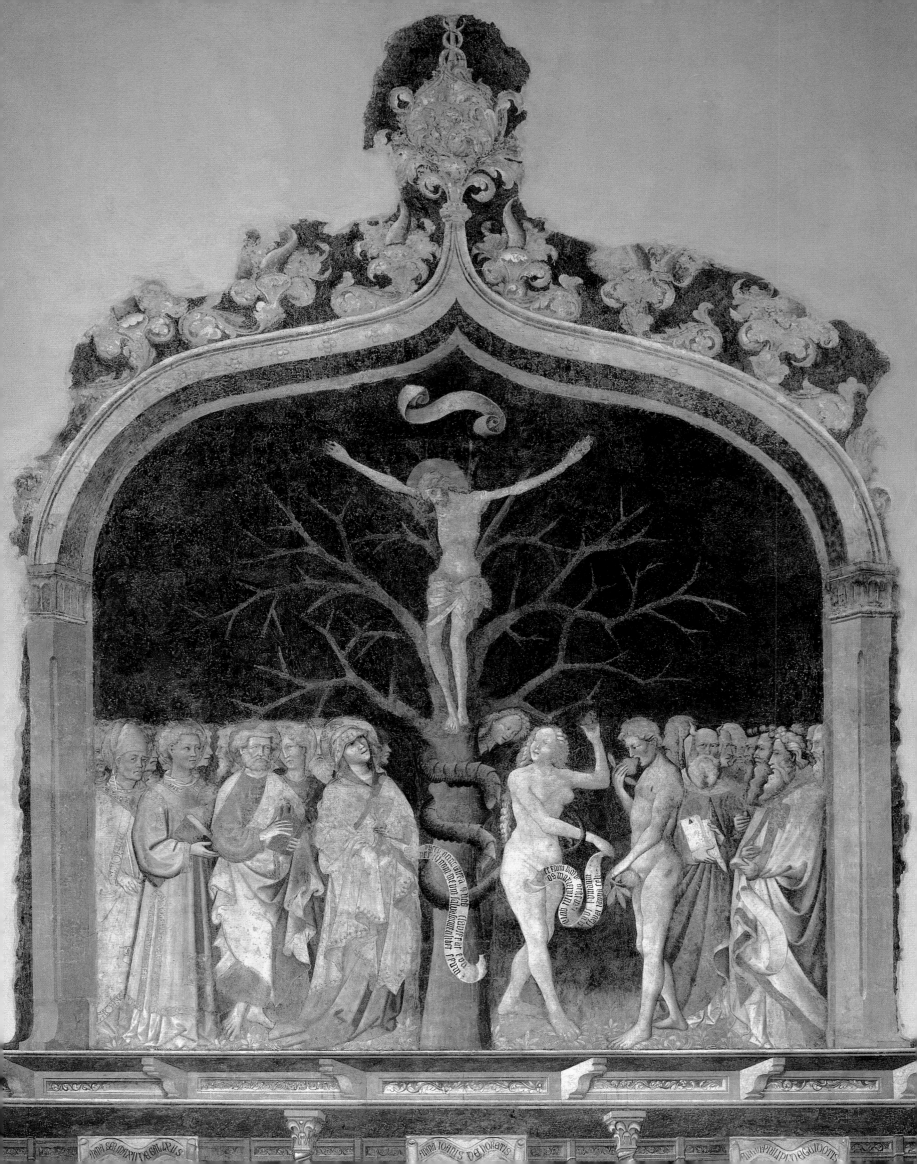

158. Masaccio, Holy Trinity, 1425 –
27. Santa Maria Novella, Florence.
A famous visual adaptation of the
Gospel account of the sacrifice of
Calvary is Masaccio's fresco, where
the Crucifixion with Mary and Saint
John becomes the central element
of an image alluding to the Holy
Trinity and to human death.
This work was painted across
from a door leading to the church
graveyard, and Mary's strong gaze
and gesture toward her son, clearly
intended for those entering the
church from the graveyard, are like
words of consolation – as if she were
saying to those coming in from the
tombs of their loved ones, "I lost
someone too: my Son. But, even if
he died – as we all must die – he
was then raised by his Father, as you
too will be!"

159. Detail.

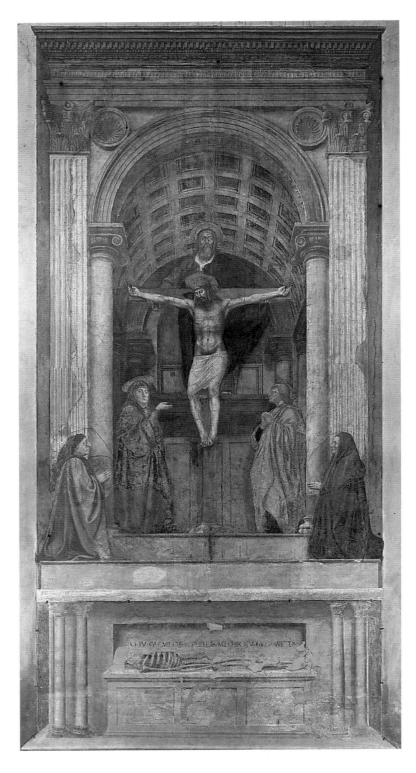

The deep connection between the wine of the marriage and the blood of the cross is suggested in the Scrovegni Chapel program, where – due to the organizational pattern of the cycle of scenes, with episodes of Christ's public ministry in the middle register and others, regarding his Passion, in the lower one – the *Marriage Feast at Cana* appears directly above the *Lamentation over the Dead Christ* (figs. 150, 152, 153). Above, we see Mary, who in a nuptial context obtains what Christ was not immediately willing to give her, and right below we find her again, embracing her Son deposed from the cross, bringing her mouth close to his as if she would give him back the life he had from her in the Incarnation. After all we have already said of Mary as figure of the Church and of the nuptial relationship of the Church with Christ, it is clear that the miracle in the upper scene is requested by the Church, the true "bride," which then, in the lower scene, mourns the death of her Spouse; and the water turned into wine – a sign of our human nature glorified through God's intervention – is here played off against the human humiliation God's Son accepted so that we might be saved.

Even if artists sometimes included Mary in episodes of Christ's Passion where the New Testament does not mention her – in the *Via crucis*, for example, when Jesus tells the women of Jerusalem not to weep for him but for their children (Luke 23:28: cf. fig. 154), the "canonical" moment remains that recounted in the fourth Gospel, which not only asserts that "near the cross of Jesus stood his mother," but adds that "seeing his mother and the disciple he loved standing near her, Jesus said to his mother, 'Woman, this is your son.' Then to the disciple he said, 'This is your mother.' And from that moment the disciple made a place for her in his home" (John 19:26 – 27). Represented from early Christian times onwards, this grouping of three personages became the most typical configuration for Crucifixion scenes (cf. fig. 155), evoked even when the specific contents of the image changed: in a *Crucifixion* by Giovanni da Milano, for example (fig. 157), this classic, tripartite composition is maintained even though the cross has become the tree of original sin, and – instead of Saint John – at the right we see Eve and Adam, while at left Mary becomes a "new Eve" just as Christ, in the center, is the "new Adam."

The most famous adaptation of the grouping suggested by the fourth Gospel is a fresco by Masaccio in which the Crucifixion

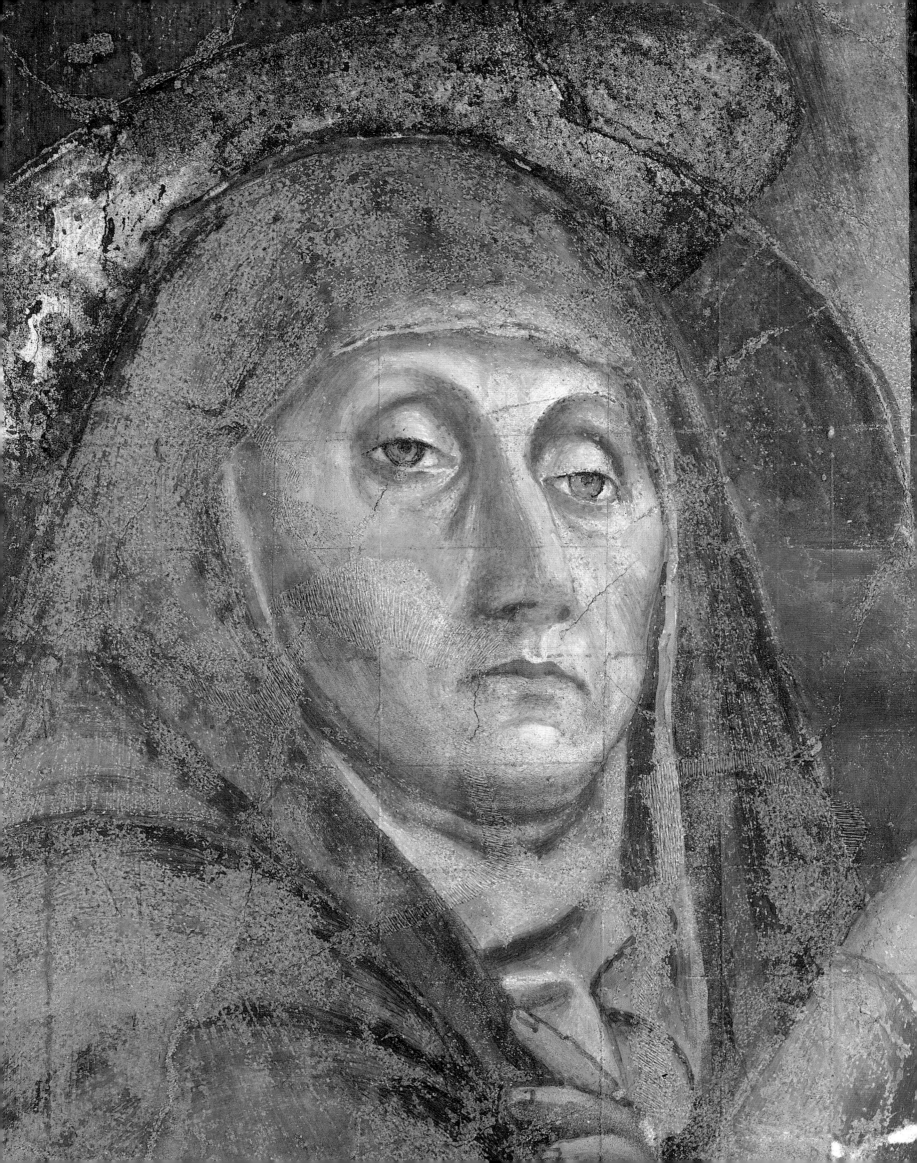

160. Benedetto Antelami, *Deposition*, 1178. Cathedral, Parma. One of the best known medieval images of Mary at the foot of the cross, this relief signed by the artist and dated 1178 was originally set on the parapet in front of the raised altar of Parma Cathedral. Thus the carved body of Christ in the relief was aligned with the altar where Mass was said. The descending diagonal of Christ's head and body carries our attention to his right, where Mary and his disciples stand.

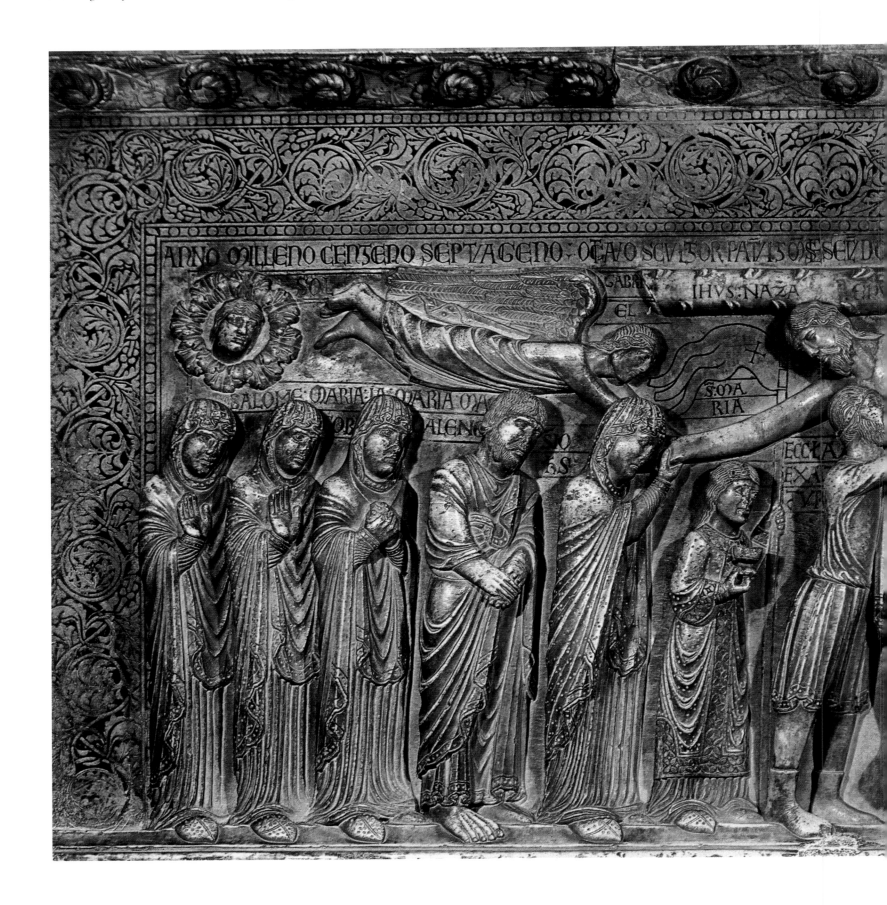

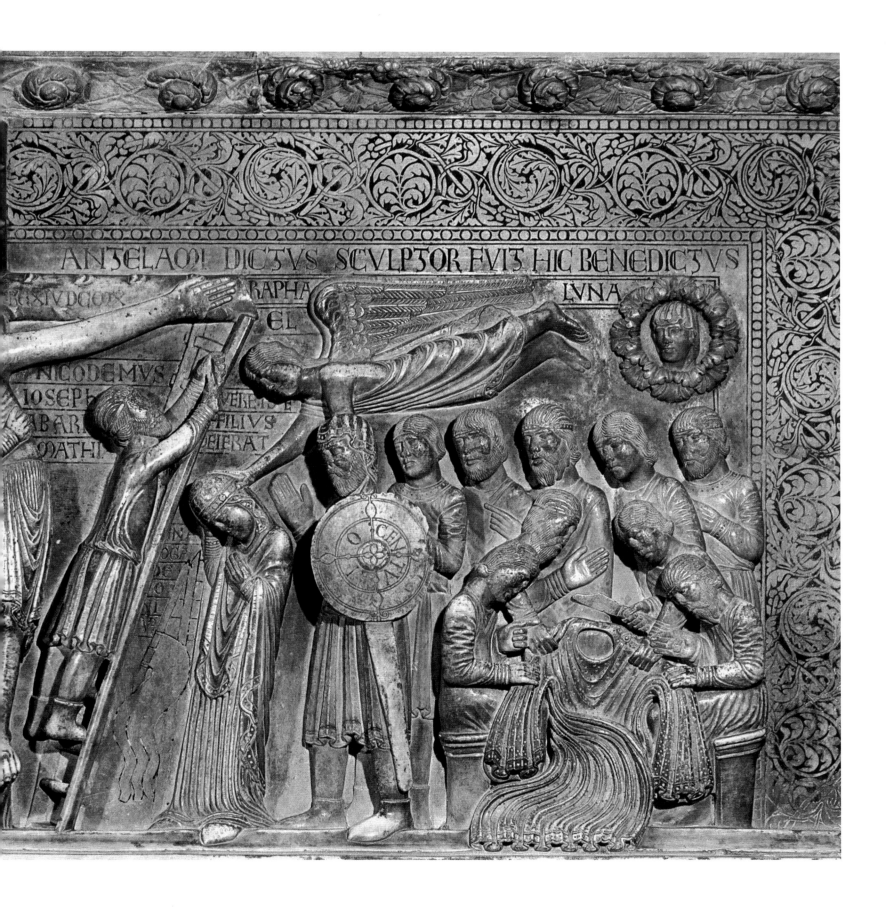

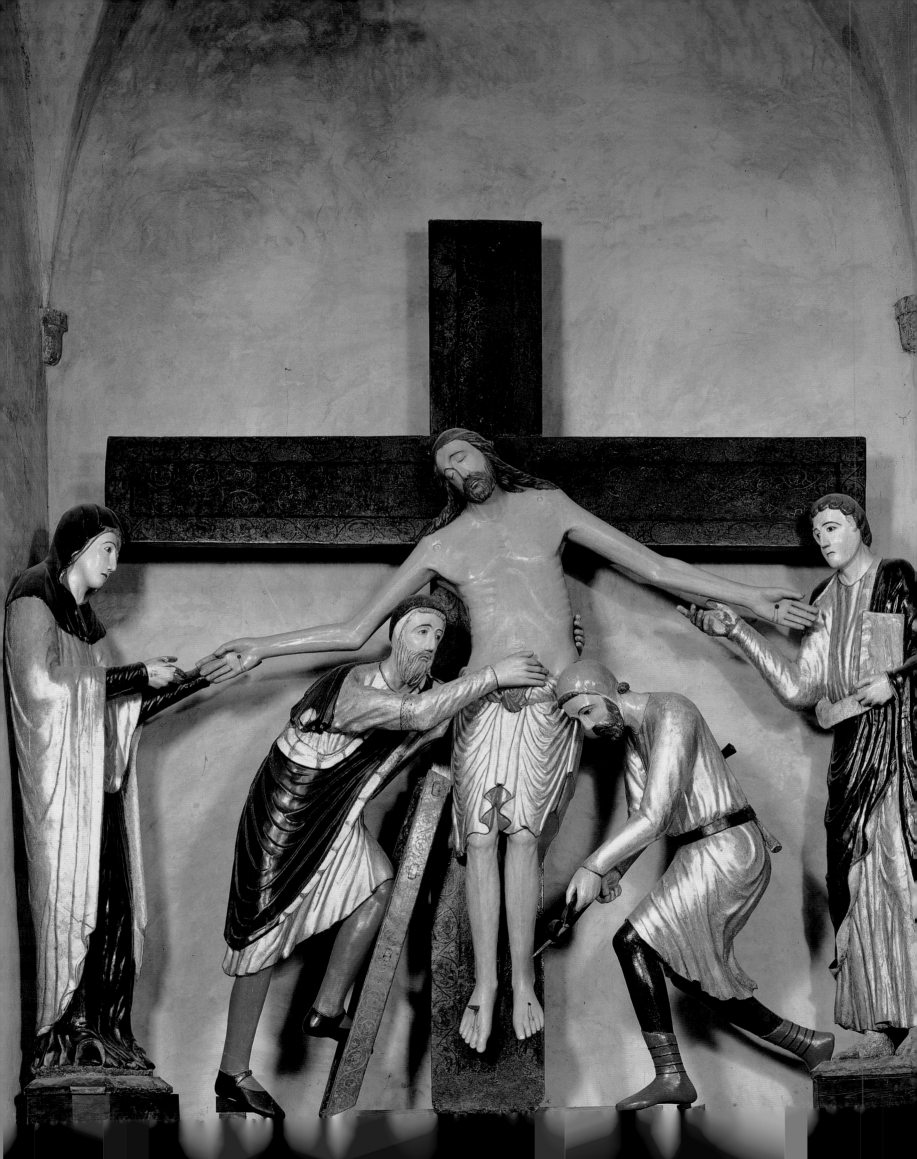

with Mary and Saint John becomes the central element of an image that speaks of the holy Trinity and of human death (figs. 158, 159). Inside an illusionistic chapel (realized through a first application in a monumental work of the then new system of linear perspective), Saint John gazes at Christ with deep sorrow and Mary, on our left, looks directly at the viewer and indicates her Son with a gesture. The fresco, located in the Florentine church of Santa Maria Novella, occupies a position on the west-

ern wall directly opposite a door in the facing, eastern wall that opens upon an external cemetery; Mary's gaze and gesture were thus intended for those who, entering the church from the cemetery, in front of them saw this image of Christ dying on the cross, a skeleton beneath the fictive altar and two patrons kneeling just outside the "chapel." Those entering from the cemetery also saw God the Father behind Christ on the cross, sustaining and raising his Son, and – between them – the Holy Spirit, the "breath" of new life. Mary's stern gaze and gesture thus had the force of words spoken to console the grief-stricken, as if to those coming into church from the tombs of their loved ones she said: "I too lost someone I loved: my Son. Even if he died, though (as all must one day die), he was raised up by his Father and gave me his disciples as my new sons and daughters."

Still more dramatic is a figure of Mary in one of the woodland chapels of the "Holy Mountain" shrine at San Vivaldo, in Tuscany. The chapel has a large image of the Crucifixion, which visitors approach through a door at the top of an external staircase. If, however, instead of mounting the stairs, they circle the building's exterior and pass through a side door into a low, narrow chamber at ground-floor level, they suddenly find themselves "under the

cross," (which is perfectly visible through an opening in the ceiling) (fig. 157) – "under the cross" alongside Mary, John, and the holy women. In this constricted space, where not more than one or two people at a time can actually fit, visitors stand right next to Christ's mother who, deeply grieving, looks up at the death of Him to whom she had given life.

Among the most celebrated older representations of Mary at the foot of the cross is a work signed by Benedetto Antelami and dated 1178: the large relief today is in the south transept of Parma Cathedral (fig. 160), but was originally incorporated in the parapet of a raised chancel. At the center of the relief – in line with the altar where Mass was celebrated – we see the body of Christ. The artist emphasizes this body, lifting the solid forms of the chest and arms from a background so rich as to leave our eyes no rest – it seems a tapestry covered with designs and inscriptions. The tight, repetitive folds in the robes of the scene's actors similarly give no visual repose, and our eyes inevitably seek the light-modeled surfaces of the Savior's body, further dramatized by the diagonal position of Christ's arms, in open contrast with the overall horizontality of the composition.

The descending diagonal of the arms, corresponding to the inclination of Christ's head and whole body toward his right, carries our gaze to a woman who holds the hand of the Crucified in her own, Mary, and – behind her – to the beloved disciple and holy women: to the friends for whom Christ gave his life, that is. On the opposite side – on Christ's left (the viewer's right) – are Christ's "enemies": the soldiers playing at dice for his tunic, the centurion Longinus and people deriding the Savior. That this jux-

163. Rogier Van der Weyden,
Mary Fainting, c. 1455. Johnson
Collection, Philadelphia.

164. Rogier Van der Weyden,
The Crucifixion, c. 1455. Johnson
Collection, Philadelphia.

165. Rogier Van der Weyden,
Deposition, 1435 – 38. Prado,
Madrid.

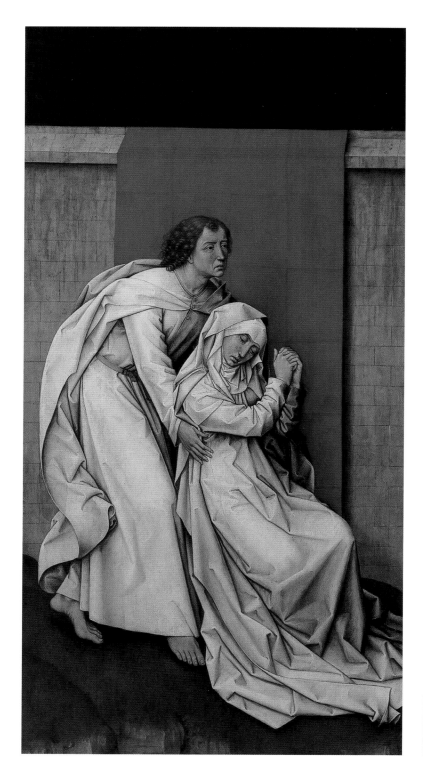
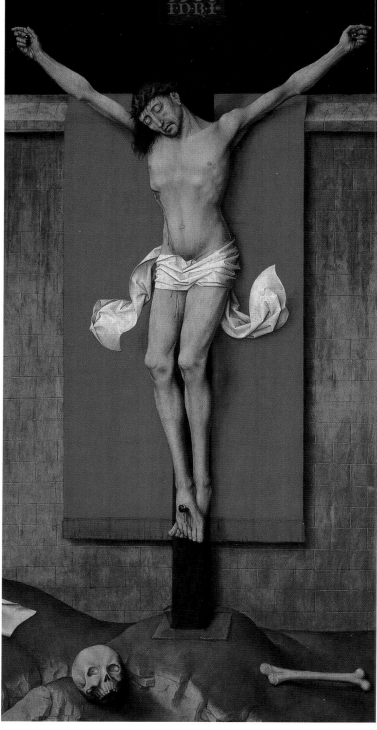

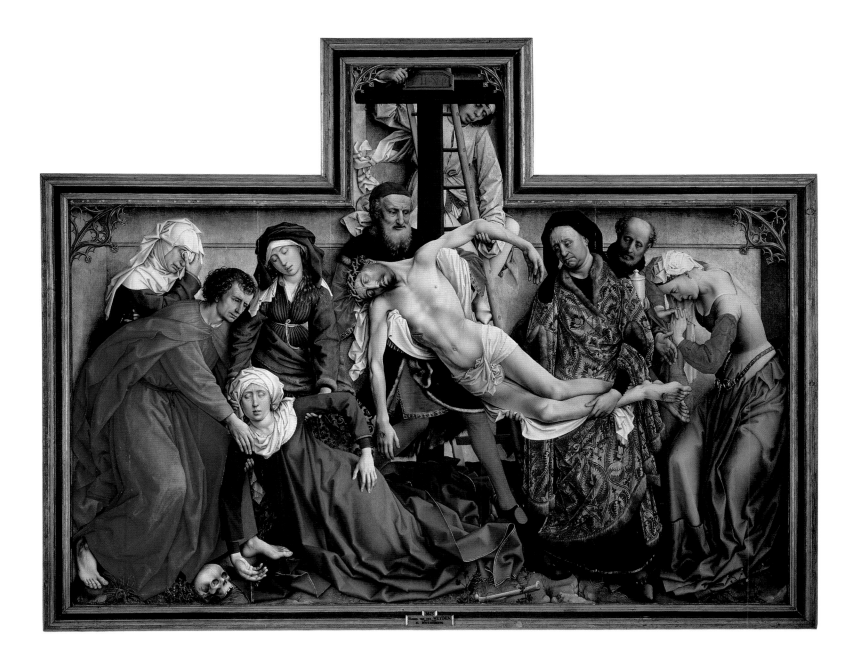

taposition of "friends" and "enemies" is *intentional* is suggested by the presence, on the side of Mary and Christ's friends, of a young woman with a chalice and a banner showing the cross, identified as "Ecclesia" (the Church: standing in front of Mary), while in the corresponding position on the side occupied by the "enemies" we see a woman richly dressed but humiliated, with her head pushed down by an angel behind her and a banner turned upside down. According to an iconographical scheme common at the time, the woman juxtaposed to "Ecclesia" (the Christian Church) stands for the Synagogue, shown as defeated.

The moving detail of Mary holding her Son's hand in her own as He is taken from the cross would be used by other artists, among whom, some fifty years after Antelami's relief, the author of a wooden *Deposition* group in Volterra Cathedral (figs. 161, 162), where the anonymous sculptor sensitively describes the strength and delicacy of the bond between Mary and the Son born of her body. In the trembling womanly hands that reach out to hesitantly caress Jesus' hand, we seem to hear the anguished words Mary

directs to Christ and then to Saint John in a contemporary mystery play by the Franciscan poet, Jacopone da Todi: "My son, your soul has fled, / O son of a woman bereft, / son of a woman who is no more, / my murdered son! / My son, once fair and healthy! / My son unequaled in beauty! / Son, who will help me, / now that you, son, have left me? / My son, fair and laughing, / with your white face and blond hair, / why has the world despised you? / My son, sweet and pleasing, / son of my awful sorrow, / people have treated you / so very badly! / O John, new son, / your brother is dead, / I feel the knife, / the sword that was foretold: / the sword that killed son and mother, / both gripped by cruel death. / Would I might embrace him, / mother and son locked in an embrace!"[38]

The most moving expression of this theme is furnished by the 11th-century monk called "the Virgin's troubadour," Saint Bernard of Clairvaux. Commenting on Simeon's prophecy that a sword would pierce Mary's soul, Bernard says to her: "Truly, a sword has pierced your soul, O our holy mother! Indeed it could never have reached the Son's flesh if it had not first passed through his moth-

er's soul. Once your Jesus (who was everyone's, but especially *yours*) had died, the cruel lance could no longer touch his soul; when, in fact, with no respect for death it opened his side, the lance could no longer hurt your Son in any way. But *you* it could hurt — in fact it pierced your soul. His soul was no longer there, but yours was unable to break away. Powerful pain pierced your soul, and we can with good reason consider you to be more than a martyr, for your participation in your Son's Passion far surpassed, in intensity, the physical sufferings of martyrdom."[39]

The mother's suffering alongside her Son in virtue of a deep psycho-physical bond would be developed as a subject especially by northern European artists of the waning Middle Ages. A large painting by Rogier Van der Weyden, for example, excludes other figures in order to focus on the reaction of Mary, fainting in the arms of John before the cross (figs. 163, 164). The same artist had illustrated this subject twenty years earlier, in a famous altarpiece now in the Prado Museum, where the curve of Christ's body taken from the cross is replicated in that of his mother, shown swooning amid eight other personages (fig. 165). But the more mature version — the painting in the Prado — has far greater religious impact, projecting a "silence" (in the austere chromatic limit of white robes on crimson) that suggests the interiority of some solemn, monastic rite.

Most dramatic of all, perhaps, is the extraordinary figure of Mary in a miniature of the third quarter of the 15th century (fig. 166), where the mother's limp hands hang right above her Son's corpse in a kind of embrace *in extremis*.

All such images are devotional extrapolations, without any real basis in Scripture. Their sources are to be found in medieval mystery plays, in religious poetry and in hymns like the *Stabat mater*, which tradition again attributes to the Franciscan Jacopone da Todi, who died in 1306. The images discussed in these pages in fact have the same function as his famous hymn: to let people experience Christ's sufferings emotionally, just as they believed Mary experienced them. A believer singing the *Stabat mater* at a certain point in fact asks Mary: "*Fac me tecum pie flere, / Crucifixo condolere, / donec ego vixero*" — "Let me weep with you for pity, / let me share the sufferings of the Crucified, / as long as I live."

There was, however, another version of the *Stabat mater*, similarly attributed to Jacopone, that the faithful sang not in Holy Week but at Christmas: instead of describing Mary at the foot of the cross, it imagined her beside the manger. And where the text of the original version goes, "*Stabat mater dolorosa, juxta crucem lachrymose, dum pendebat Filius …,*" the Christmas edition begins: "*Stabat mater speciosa, juxta foenum gaudiosa, dum jacebat parvulus.*" For those using both versions, there must have been a kind of salutary emotional contamination: the joy of Christ's birth, remembered in Holy Week, in fact intensified the pain felt at his death. So too with many of the images discussed in this chapter: the tender Christmas subjects must have remained, like remembered music, in the memory of believers, who thus felt greater anguish in the face of Christ's death — just like Mary in the diptych by Simone Martini discussed above (cf. fig. 123).

One Marian subject in particular insisted on

166. Master of the Rohan Hours, *Mary Mourning Her Dead Son*, c. 1420. Bibliothèque Nationale, Paris.

167. Rhineland Master, *Pietà*, 1330 – 1375. Metropolitan Museum of Art, The Cloisters Collection, New York.

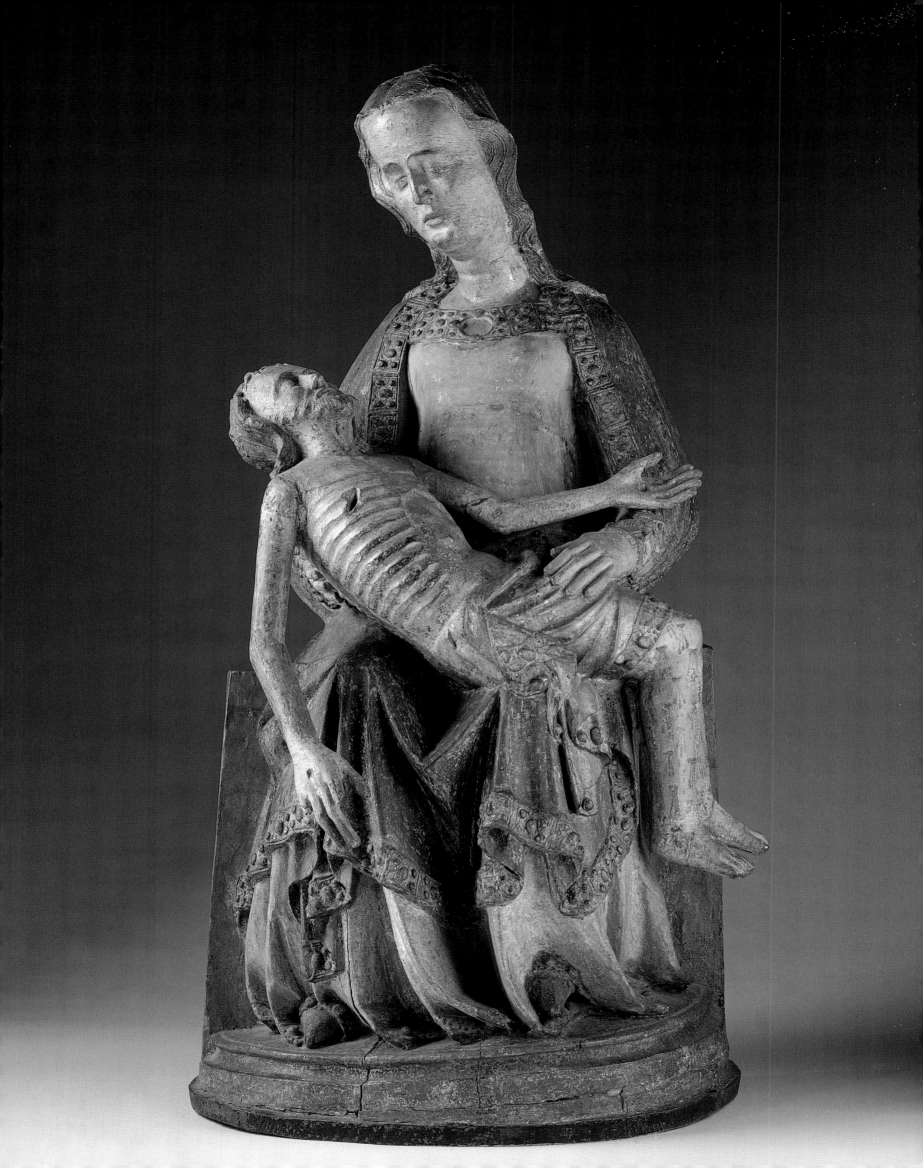

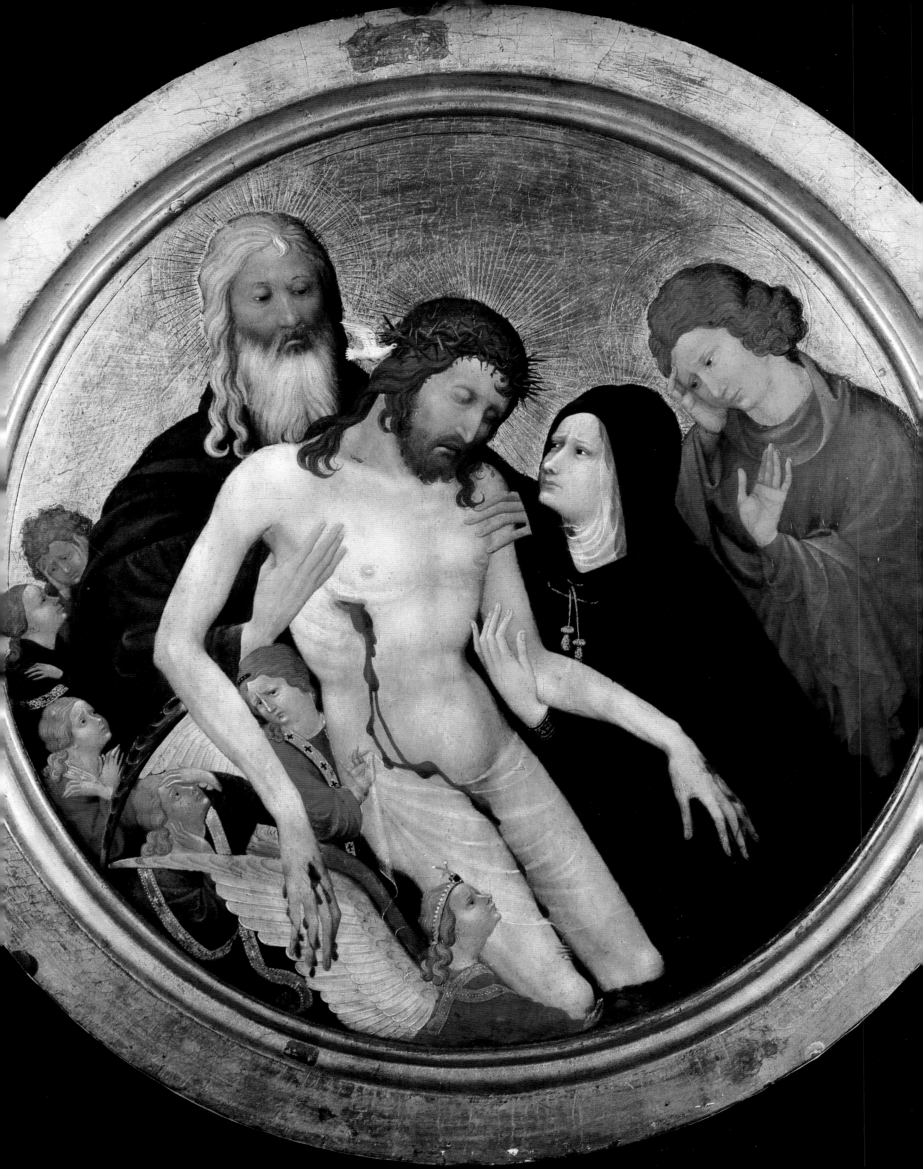

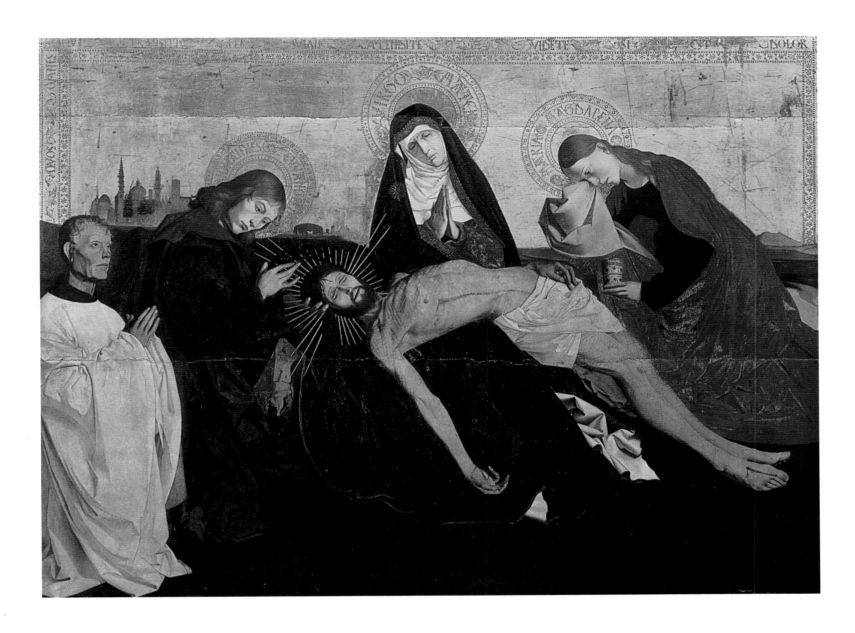

this imaginative double focus, the *Pietà*. Developed as an artistic subject in the 14th century from the sources just mentioned, the *Pietà* completed the theme of Mary's prescience: she who had conceived a Son so that he might offer himself for others (fig. 110), even dreaming of his death before he was born (fig. 111) and "seeing" the cross as she held the baby in her arms (fig. 124), in the end really saw him tortured and killed. "*Vidit suum dulcem natum, / moriendo desolatum, / Dum emisit spritum,*" the *Stabat Mater* says – "She saw her sweet, newborn child / die in anguish and alone / right up to his last breath." In some *Pietàs*, this emotionally charged recollection of Christ's infancy is suggested by the disparate scale of the Mary and Jesus figures: she big, he small, like a baby (fig. 167); in others, it is the Father, along with the Holy Spirit, who gives the Son's body back to his mother, thus enlarging the sorrow of the "immediate family" to include the Holy Trinity (fig. 168); still other *Pietàs* show the patron (fig. 169), making perfectly explicit the associative yearning expressed in the *Stabat Mater* when the singer is invited to tell Mary: "*Juxta crucem tecum stare, / et me tibi sociare / in planctu*

168. Jean Malouel, *Pietà with the Holy Trinity,* c 1415. Louvre, Paris.

169. Avignon Master, *Pietà,* 1460 – 70. Louvre, Paris.

desidero" – "I want to share your tears, staying with you at the foot of the cross."

Elaborated in northern Europe, in the context of German mysticism and the *Devotio moderna*, the *Pietà* became one of the characteristic forms of European Marian iconography. The classic configuration – Mary with her dead Son on her knees – would be most fully developed in Italy, where 15th-century Christian humanism gave particular value to the pathos surrounding the psycho-physical bond between mother and Son (fig. 170). The best known expression of the theme is Michelangelo's *Pietà* in Saint Peter's Basilica (fig. 171), commissioned by a French cardinal in 1497 when the sculptor was just twenty-two years of age. Done immediately after another youthful work, a statue of the pagan god of wine, Bacchus, for a collector of ancient art (and like that work an attempt on Michelangelo's part to satisfy his client), the Vatican *Pietà* sought to appeal to the "pietism" of the prelate who ordered it.

Michelangelo delineates the forms of Christ's tortured body with a delicacy that underlines the Savior's suffering, while the

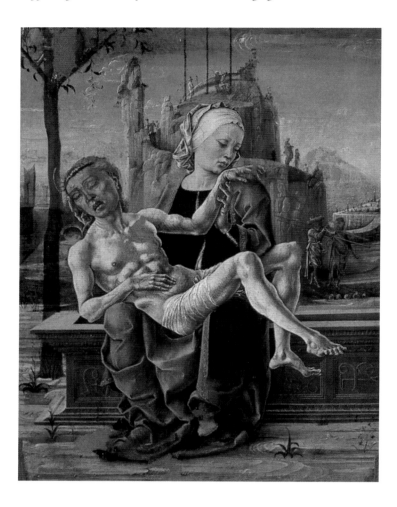

sad but calm face of Mary and the gesture of her left hand suggest deep reflection. Illustrating the lament not of several people but of the mother alone, the artist has the problem of believably supporting an adult male body on one woman's lap – a problem which, in the stylistic climate of late 15ᵗʰ-century art, Michelangelo could no longer solve with a marked disparity of scale, in the manner of medieval *Pietàs*.

That notwithstanding, he enlarged the Virgin's body as much as he dared, widening it with voluminous garments in order to create an adequate support for the body of Christ. He then tried to dissimulate Mary's corporeal dimensions under confused drapery folds, whose mobile surface does not allow us to grasp the size of the body beneath. He still had the problem of Mary's face, too small for so big a body: a fact which Michelangelo concealed under an elaborate, artfully arranged veil. Yet we cannot but notice the discrepancy, as in fact his contemporaries seem to have done, asking why he had made the mother of a thirty-three year old man seem so young. Michelangelo's famous reply – that Mary's virginity had preserved her from aging – was given many years later; when he carved this first of his *Pietàs*, the young sculptor was probably more concerned with esthetic and formal difficulties than with questions of content.

For all its beauty, that is, the *Pietà* in Saint Peter's is an immature work. In 1499, the year he finished the sculpture, the twenty-four-year-old Michelangelo was above all concerned with his own reputation as an artist, returning to the Basilica by night to carve his name on the band crossing Mary's chest, for fear that his *Pietà* be erroneously attributed to another master. Thus, despite its impact, this effort to amalgamate disparate stylistic elements into a coherent image corresponding to the spiritual sense of the subject, does not quite succeed; more convincing and more moving is the *Pietà* done a few years later by the seventy-year-old Giovanni Bellini (fig. 172), in which an already old Mary mourns her dead Son in a world reawakened to life, bending her head in silent obedience while all around her nature sings and, next to Christ's head, living branches grow from a severed tree trunk.

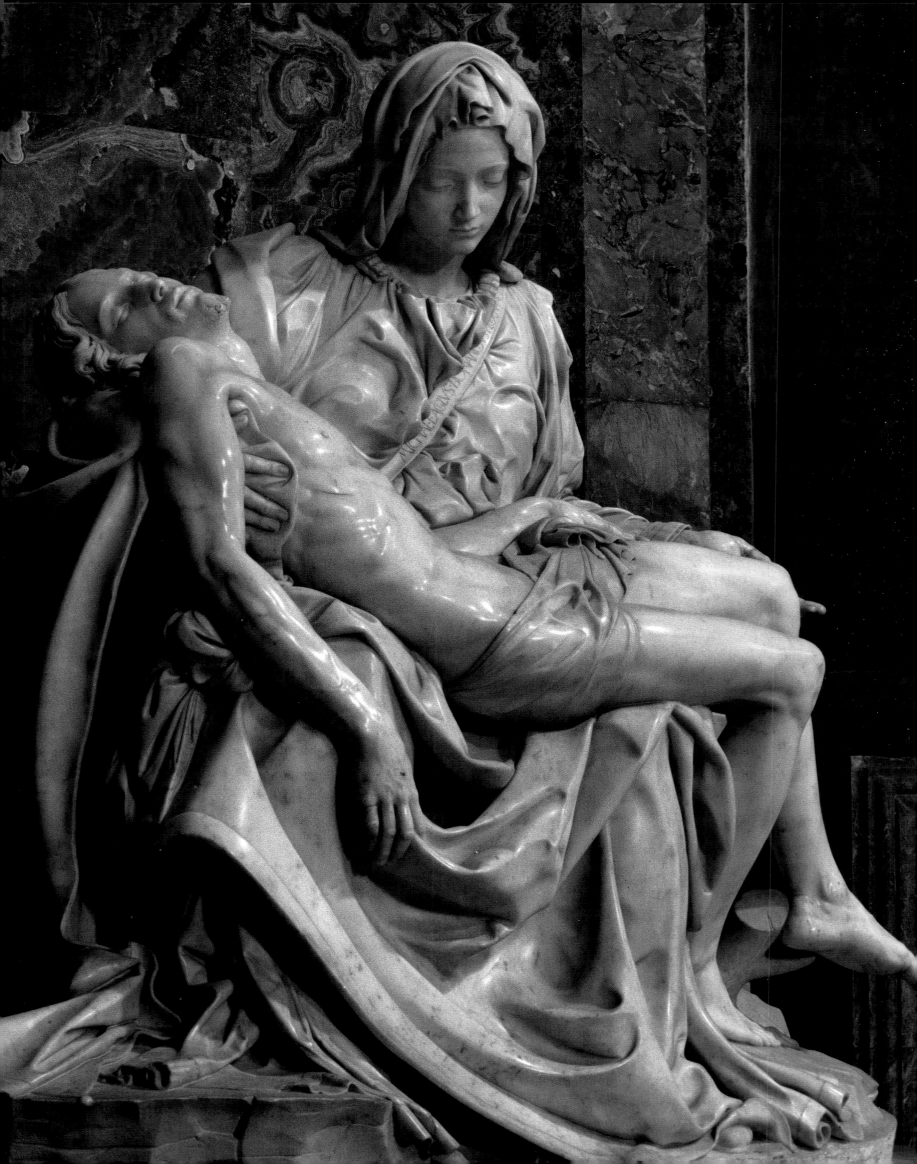

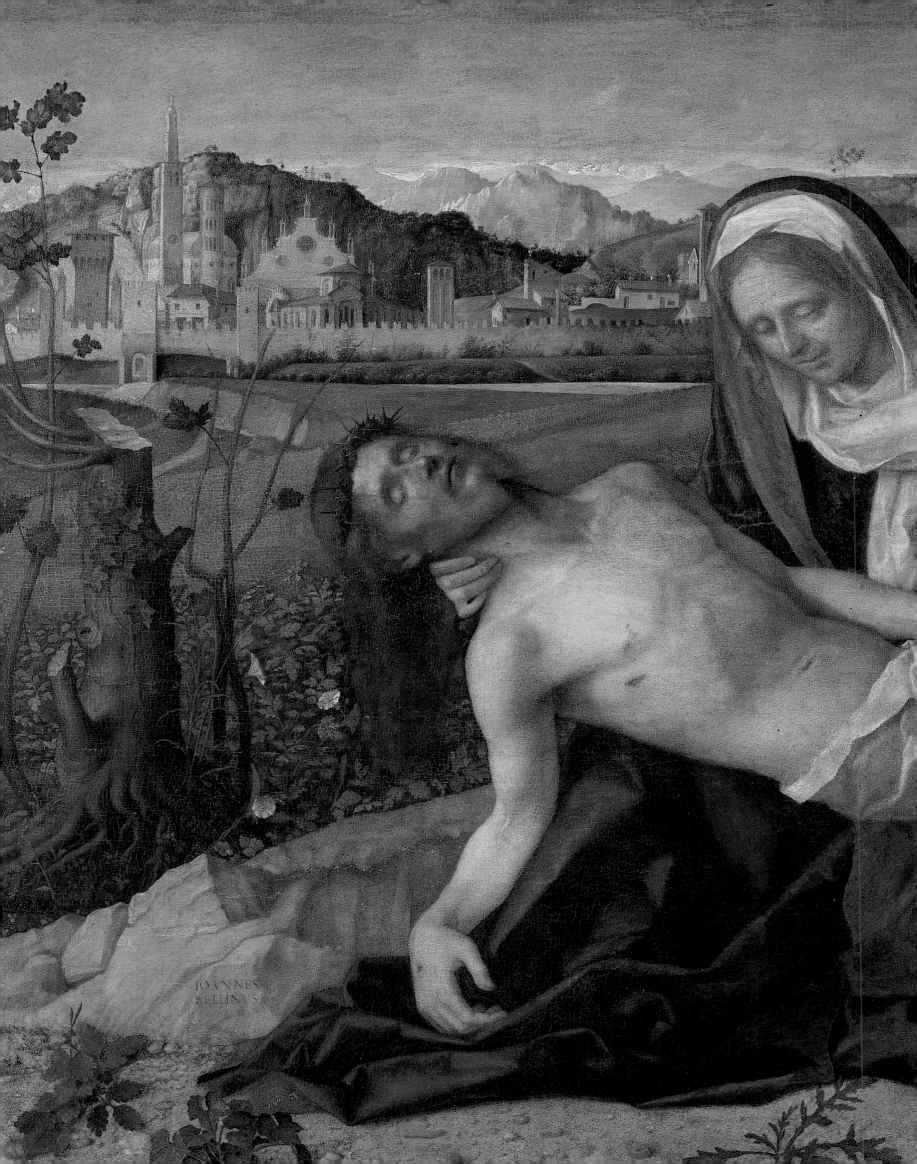

IOANNES
BELLINVS

172. Giovanni Bellini, *Pietà*, c. 1500. Gallerie dell'Accademia, Venice.

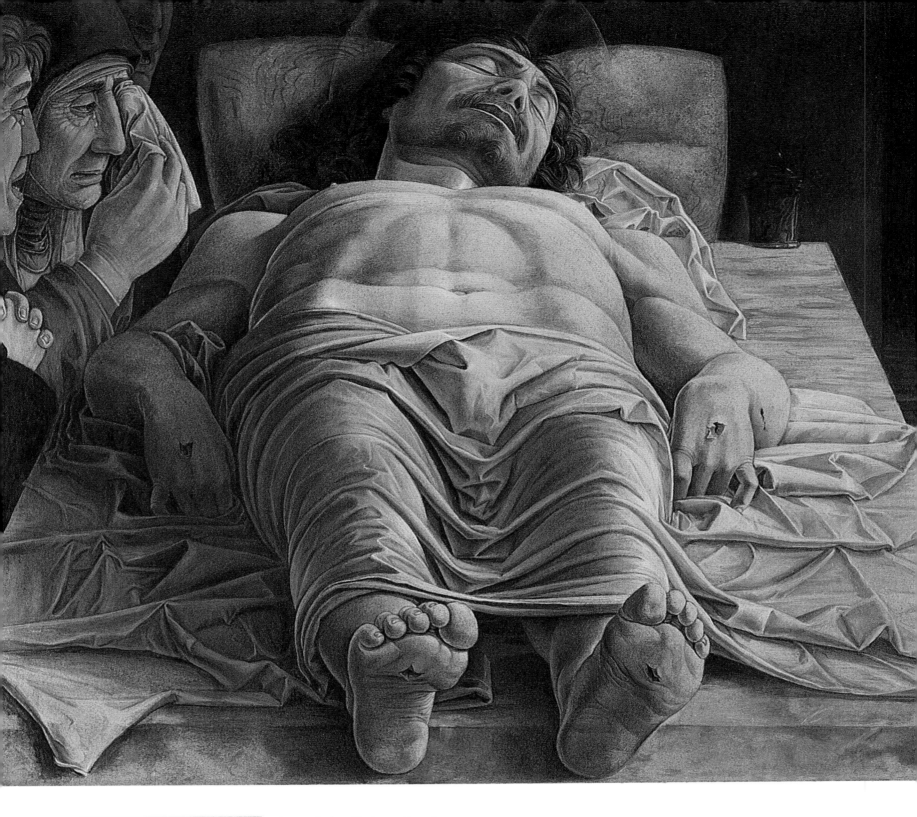

173. Andrea Mantegna, *Lament over the Dead Christ*, c. 1470. Brera Museum, Milano.

174. Guido Mazzoni, *Lament over the Dead Christ* (detail), c. 1475. Santa Maria degli Angeli, Busseto.

175. Guido Mazzoni, *Lament over the Dead Christ* (detail), c. 1490. Sant'Anna dei Lombardi, Naples.

176. Sandro Botticelli, *Lament Over the Dead Christ*, c. 1497. Museo Poldi Pezzoli, Milan.

177. Giovanni Battista Cima da Conegliano, *Lament Over the Dead Christ*, late 15th century. Galleria Estense, Modena. This work presents Mary fainting in the presence of her Son's corpse, in front of the open door of the empty tomb. In this way, the artist suggests a relationship between the mother's womb from which Christ came, and the womb of the earth to which he is about to enter, and alluding – in the shocking detail of Christ's hand between Mary's legs – to the nuptial bond linking Christ to the Church.

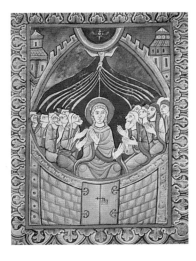

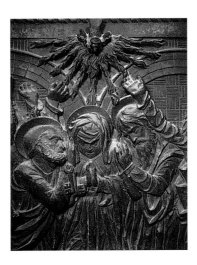

The mother's grief was intensified at the moment of her Son's burial, which artists often describe in convulsive terms appropriate to the funeral of a young man cut off in the flower of life. The distraught faces of Mary and John in Mantegna's *Dead Christ*, for example (fig. 173), or the mother's heaving paroxysm in Guido Mazzoni's *Lamentation* in Busseto (fig. 174), speak of unbearable and inconsolable pain, more pagan than Christian – almost despairing. So extreme a reaction was justified through reference to the Virgin's maternal memories, as already suggested, and in this case too it was Saint Bernard who defended Mary's "right" to respond emotionally to the loss of her Son: "Do not be astounded, brothers, when you hear that Mary was a spiritual martyr. Be astounded, rather, if you have forgotten that Saint Paul numbers among the worst sins of the pagans that they were without compassion. This sin was very far from Mary's heart, and should be far from that of her humble devotees. Someone might object though: 'But didn't she already know Jesus would die? And wasn't she fully sure he would soon rise from the dead?' Without doubt – she had absolute confidence in this outcome. 'And notwithstanding that she suffered when she saw him crucified?' Certainly, and in a most awful way."[40]

Mary's emotional suffering brought her to the point of physical prostration, as her figure in another of Mazzoni's *Lamentation* groups – the one in Naples, a work of the 1490s – suggests (fig. 175). A painting of the same years by Sandro Botticelli, in which we feel the influence of Savonarola, similarly presents Mary as overwhelmed by grief, nearly cataleptic at her Son's tragic murder (fig. 176); two details of this work "explain" the total collapse of the Savior's mother: her own womb, positioned at the geometric center of the composition and touched with silvery highlights; and the dark tomb that opens behind Mary like a second womb, not of life but of death. Still another painting of these years, Cima da Conegliano's *Lamentation for the Dead Christ* (fig. 177), similarly shows Mary fainting before the corpse of her Son and, again, juxtaposes her figure – on the right – with the open tomb on the left.

The conceptual link between the maternal womb from which Jesus had come, and the tomb in which he would be laid, particularly fascinated these artists in the last years of the 15th century. In a mystery play of the period, the Virgin apostrophizes her Son's sepulcher and asks: "Are you perhaps Mary? Are you the mother he so loved? Give him back, if you've embraced him, for I am the one who gave him suck!"[41] In Cima's painting, moreover, this link is emphasized by a shocking detail: practically at the center of the composition, Christ's left hand, stiffening in death, falls between his mother's legs, where she holds it in place!

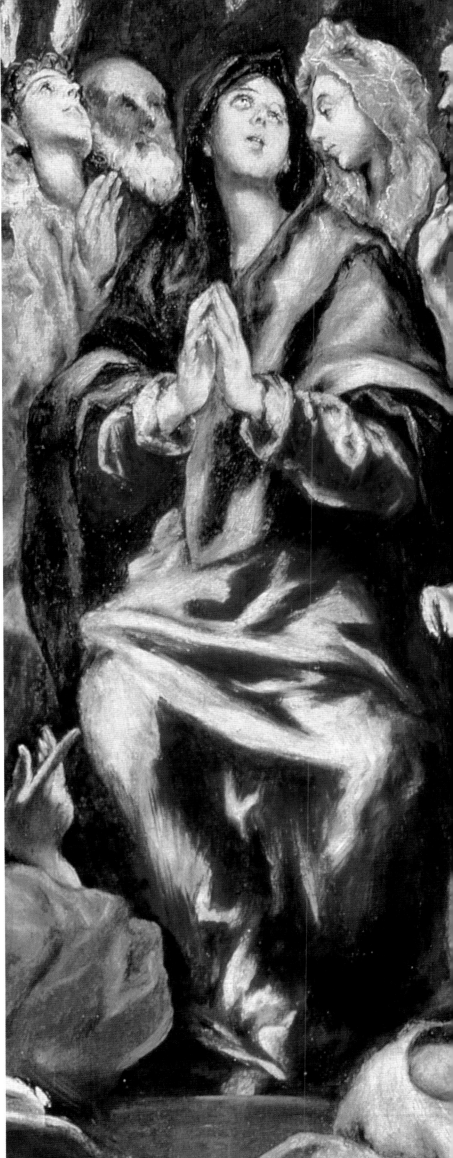

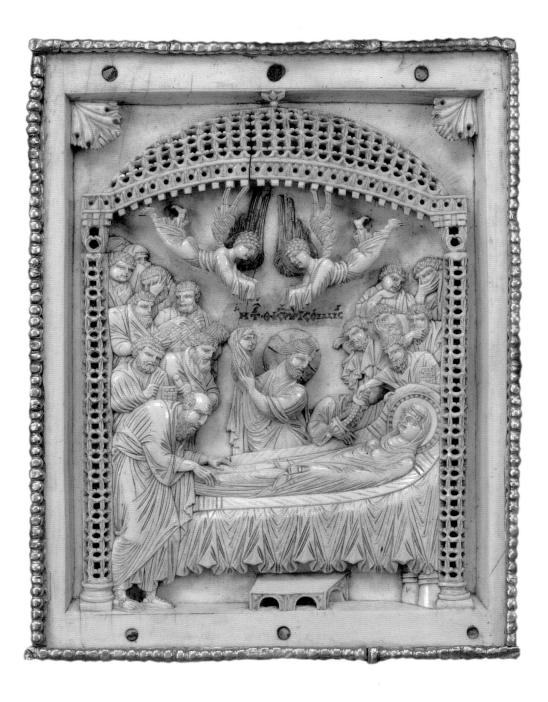

Clearly there is more involved here than the womb/tomb con-
nection. In these pages we have often suggested the nuptial sense
of Christ's relationship with Mary: now, looking at Cima da
Conegliano's painting, we are put in mind of words pronounced
by the Bridegroom and the Bride in the Song of Songs: knocking
at the door of his beloved, the Bridegroom says: "Open to me, my
sister, my love, my dove, my perfect one"; and she, in an intimate
aside, tells us: "My Beloved thrust his hand through the hole in
the door; I trembled to the core of my being" (Song of Songs 5:2
– 4). Nor should we be scandalized, since it was – precisely –
through his death that Christ revealed the ultimate significance of
lasting love between a man and a woman: "He loved the Church
and sacrificed himself for her..., to make her holy," says the
Pauline text mentioned in our first chapter, concluding that "in
the same way husbands must love their wives as they love their
own bodies...: a man never hates his own body, but feeds and

looks after it; that is the way Christ treats the Church" (cf. Eph-
esians 5:25 – 33).

Beyond its suggested parallel between the womb and the tomb,
Cima da Conegliano's image thus alludes to this mystical spousal
relationship, in which the "husband" loves the "wife" as his own
body, nourishing her and sacrificing himself for her; the painting
is in fact an altarpiece, and Christ's hand between Mary's legs was
meant to be seen directly above the consecrated bread and wine.

Pentecost, *Dormitio*, Assumption
Coronation and Intercession

It is in fact as a figure of the Church that Mary appears in repre-
sentations of the scriptural events that follow the death and res-
urrection of Christ: the Ascension (cf. figs. 35, 36, 37, 38) and
Pentecost. In the first case, her presence – *not* mentioned in the
New Testament – has symbolic value, as suggested above; in the

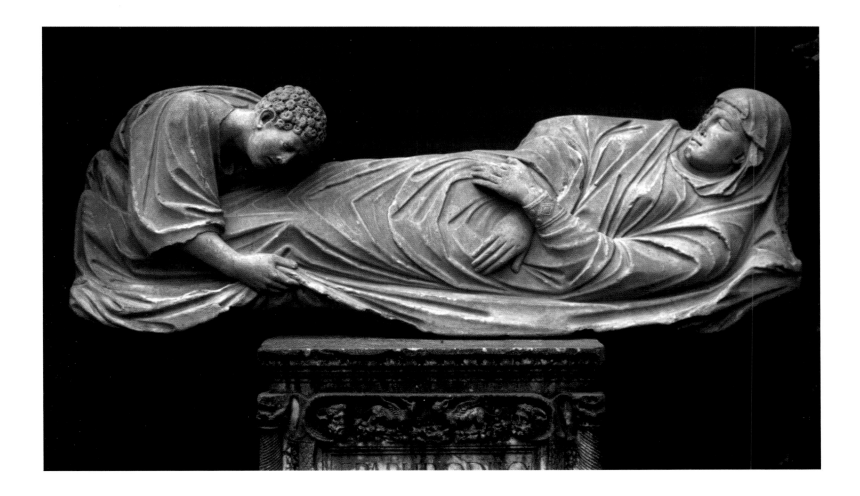

second, Pentecost, after the list of eleven apostles who "joined in continuous prayer" as they awaited the promised gift of the Spirit (Acts 1:13), we read that "several women, including Mary the mother of Jesus" belonged, forming part of this primitive nucleus of the Church (Acts 1:14). The account of the outpouring of the Holy Spirit does not specify Mary or others by name, but opens with the assertion that "when Pentecost day came around, they had all met in one room" (Acts 2:1). "All" is an inclusive term, and thus – together with the apostles, some women and the Lord's "brothers," Mary must also have been there.

Reasoning in this way, from the Middle Ages on artists put Mary at the center of the group of apostles, as if it had been she who instigated their "continuous prayer" and promoted the harmony in their internal dealings that would distinguish them. Thus when "suddenly they heard what sounded like a powerful wind from heaven, the noise of which filled the entire house in which they were sitting," and "something appeared to them that seemed like tongues of fire [and] these separated and came to rest on the head of each of them" (Acts 2:2 – 3), Mary once again found herself – this time in company with others – *under* the Holy Spirit (fig. 178). There really can be no doubt, for the text again uses inclusive terminology, affirming that "they were all filled with the Holy Spirit, and began speaking foreign languages as the Spirit gave them the gift of speech" (Acts 2:4). This means that Mary too spoke, perhaps reformulating her youthful *Magnificat* in "foreign languages" in light of her Son's passion and resurrection. To outsiders, the apostles appeared to "have been drinking too much new wine" (Acts 2,13), and artists often show them gesticulating and excited, but Mary at the group's center usually reacts differently, with an entirely interior ecstasy marked by deep peace (fig. 179). She burns as the others do and perhaps more than they (fig. 180), but with a still, silent flame (figs. 181,182).

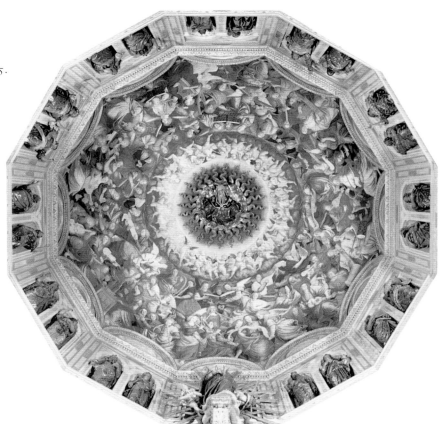

The end of Mary's life, like its beginning, belongs not to the Gospel but to Church tradition. Apocryphal texts of Jewish-Christian origin, already forming in the 2nd century and widely known by the 5th or 6th, describe her final "falling asleep," the so called *dormitio Virginis*, introducing the event with visions and premonitory visits by angels and Christ himself[42]; some of these scenes would be represented by artists, albeit rarely. When Mary's time finally came, the apostles returned from the distant lands in which they were occupied preaching the Gospel and the original Pentecostal nucleus was reconstituted, with Mary again surrounded by her Son's closest collaborators. Often in medieval art Christ is represented as well, taking his mother's soul (shown as a baby: cf. fig. 183) in his arms and thus creating a sort of "Madonna and Child" image in reverse, with the Son big and the mother small rather than the other way around.

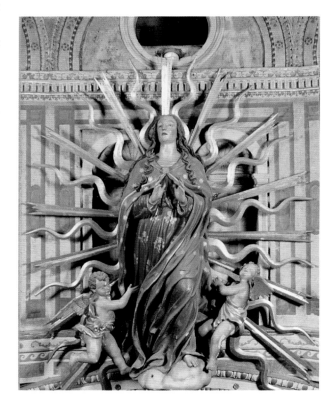

The special role of Saint John, to whom Christ had entrusted Mary with the words, "This is your mother," so that "from that moment the disciple made a place for her in his home" (John 19:27), is stressed both in the Apocrypha and in Christian art. The sculptural program of the original façade of Florence Cathedral, for example – which above the north door showed Mary looking at her newborn Son (cf. chapter three) –, above the south door showed the "new son" looking at his dead "mother": the apostle John, that is, burying Mary (fig. 184). Normally, however, Mary's "falling asleep" (*Dormition*) was not represented without some indication of what came after, and at Florence too there was – in the tympanum of this southern façade door – a figure of the adult Christ with the "infant" soul of his mother in heaven.

By the end of the Middle Ages, it had become the custom to depict the entire process of death and apotheosis: in the enormous altarpiece carved and painted by Veit Stoss for Saint Mary's in Cracow, for example, where from the principal scene in the lower register – Mary not lying in bed but (curiously) kneeling as she "falls asleep" in the midst of the apostles – the viewer's gaze ascends to Christ receiving her assumed into heaven, and then, in the altar's pinnacle, to the Holy Trinity crowning her.

These two events, the Assumption and Coronation, conclude the ac-

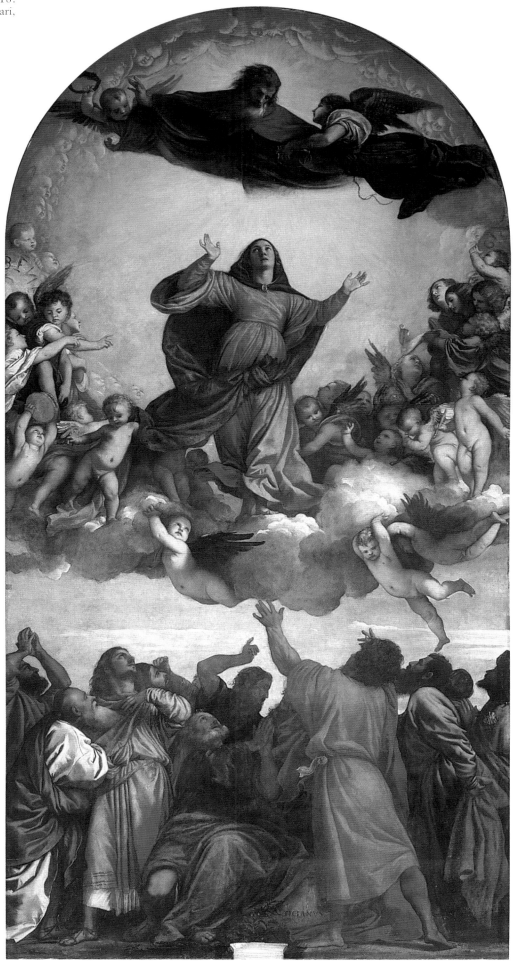

188. Interior of the Frari, with Titian's *Assumption* seen through the rood screen and against the apse windows.

189. Tilman Riemanschneider, *Assumption Altar*, c. 1505 – 15. Herrgotteskirche, Creglingen. This complex composition leaves an open space below Mary, in exactly the point where the priest saying Mass elevated the host and the chalice, thus obliging us to see the Eucharist celebrated in front of the altarpiece as part of the image. This arrangement stressed the faithfulness of God, who having created human beings with a body, saves us in the body and nourishes us with the Body of Christ so that the whole person, body and soul, may one day join him in heaven – just as Mary did in her Assumption.

190. Lodovico Seitz, *Coronation of Mary*, c. 1890. Santuario della Santa Casa, Loreto.

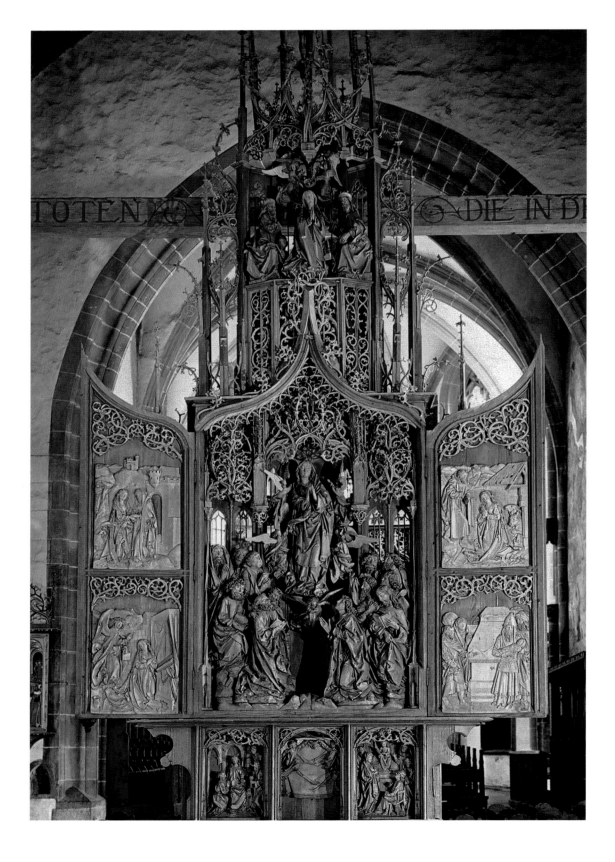

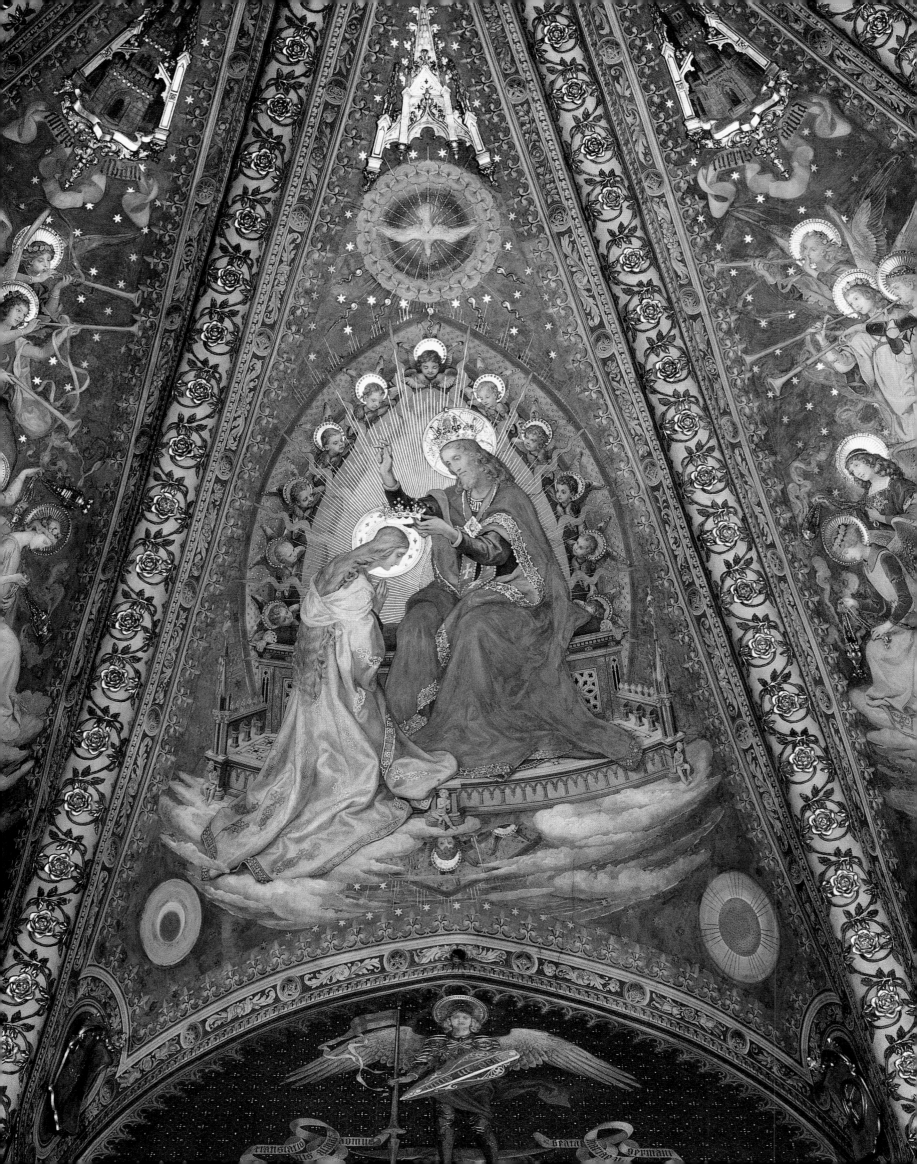

191. Jean Fouquet, *Mary Enthroned Beside the Holy Trinity*, c. 1450 – 60. Book of Hours of Etienne Chevalier, Bibliothèque Nationale, Paris.

192. Sebastian Dayg, *Mary Protecting the Church as Christ Stops His Father's Anger*, c. 1511. Cathedral, Heilsbronn.

count of Mary's life – or rather transfer it to another dimension. In truth, they represent two phases of a single process of elevation: the equivalent in the mother's life of her Son's resurrection followed by his Ascension to the Father's right hand. The basic event is the physical assumption of the Virgin, which – even if defined as a dogma only in 1950 – has been part of the way the Church has thought of Mary's end since the early Christian period. An apocryphal account known in medieval versions but of ancient origin describes how "the apostles laid the body [of Mary] in the tomb, filled with love and sweet sentiments as they wept and sang. Then, suddenly, a heavenly light enveloped them and they fell to earth, while the body was carried to heaven by angels."[43] In medieval Christian iconography, this visionary event was suggested by the *clipeus* or circle symbolizing heaven, previously used in Roman art in scenes showing the apotheosis of a hero; somewhat later, the circle became rays of light or simply an intense glow which associated Mary, still *in via*, with the reign of light where God dwells. At the Marian shrine of Saronno, for example, pilgrims looking up into the dome see a painted "heaven" with a figure of God the Father at its incandescent center (fig. 185), while just below – on the rim of the dome – they find Mary rising in an uncorrupted, virginal body that gives off rays like those emanating from God (fig. 186). And, as this image suggests, Mary's normal pose as she is assumed – with her hands raised – alludes to prayer.

This in fact is Mary's pose in the most famous version of the subject, the colossal image painted by Titian for the high altar of the Frari basilica in Venice (fig. 187), the first work in the artist's mature style. This Franciscan church is formally dedicated to "Saint Mary Glorified," and the altarpiece, commissioned by the prior of the religious community in 1516, sought to depict "glory," an explosion of light in the upper zone conveying its incandescent luminosity. Given the main altar's location in the church – in front of high windows completely filling the apse (fig. 188), the bright light in the upper zone of the altarpiece was also

meant to counterbalance the blinding glow of natural light with a still more intense supernatural radiance. Another brilliant formal solution in this work is the way Titian used the muscular raised arm of an apostle seen from behind, just right of center, as if to insist on the enduring relationship between Mary and the Church, between the glorified body of the mother and the bodies of the "sons" Christ gave her when, from the cross, he entrusted John to her care.

The fact of Mary's bodily Assumption has special meaning in the eucharistic context for which Titian's work was made. Christ's own body really present in the sacrament becomes, in fact, a fundamental key to understanding the altarpiece, which invites believers to see her from whom the Word took his physical body elevated in *her* body from earth to heaven. "He took you unto himself like a treasure," says a 14th-century poet, Antonio Beccari of Ferrara,[44] and at Mass celebrated at the high altar of the Frari we were meant to grasp the bond between the body of Christ, the body of Mary and the collective "body" – the Church – which eucharistic communion nourishes, strengthens and makes manifest. In another large altarpiece showing the Assumption, that by Tilman Riemanschneider at Creglingen (fig. 189), the artist leaves open the space below Mary and in front of which the celebrant elevates the host and chalice, obliging people present at Mass to see the *Eucharist* itself as part of the overall image: a sign and promise of future glory – an "elevation" of all humankind. Those attending Mass in front of this altar grasp something of the faithfulness of God, who, having created man with a body, saves him in the body and wants all of his human creature – body as well as soul – with him in heaven. Or, in less abstract terms, believers here grasp the love of the God who, born of Mary, did not want to be separated from the woman who had borne, nourished, and loved him.

But there is still more, for God wanted to positively *honor* that woman, to have her at his side, to "crown" her. Thus in the magnificent pinnacle of the Creglingen altarpiece we find a represen-

tation of the *Coronation of Mary*, the iconographic theme with which we opened our chapter on "Mary as figure" and with which, now, we can close this account of "Mary as woman." Numerous versions of this subject are illustrated in the preceding pages of our volume, and others will appear in the final chapter; here it may be helpful to suggest the subject's undying appeal with a spectacular Neo-gothic example (fig. 190), in which we again sense the risk of mythologizing the theme.

Pray for us, O Holy Mother of God

Mary's story does not really end with her arrival in heaven and with the high dignity given her there. A lovely miniature by Jean Fouquet (fig. 191), done for the patron of the Madonna of Melun Cathedral, Etienne Chevalier (cf. fig. 63), shows Mary in the realm of light, installed on a throne just below the level of that of the Triune God as privileged representative of an "immense multitude, that no one could count, comprising every nation, race, people and language" (Revelation 7:9). Seated in heaven, the highest of all the saints, Mary is still active though, standing up

for believers whose mother she is: in a curious German painting of the early 16th century (fig. 192), we find her protecting Church members of various states of life and hierarchical ranks, while the dead and risen Christ, in front of her, blocks the sword that the Father – justly angry with humankind – wields. On the sword so blocked, the Holy Spirit has come to roost!

Mary appears in this work, that is, as protector and consoler, intercessor and "queen" of that peace that men and women seek in the concrete events of their individual and collective lives. These indeed are the themes treated in our last chapter, which – examining the veneration of Mary in a specific place across a long period of time – seeks to give historical flesh and blood to theological and iconographical themes already treated in general in these pages. And, as indicated in our Introduction, among many possible "places," preference was given to Florence, an art city and a Marian city which formerly began its civil year on March 25th, the feast of the Annunciation and thus also of the Incarnation – the day on which Christians remember the fruitful "Yes" uttered by Mary when she responded to God's messenger.

[1] F. Jesi, "Nota," in M.Warner, *Sola fra le donne. Mito e culto di Maria Vergine*, Palermo 1980, p. 412.

[2] Cf. *Apocrifi del Nuovo Testamento*, ed. L. Morali, 3 vols., Casale Monferrato 1994.

[3] Jacques de Voragine, *La Légende dorée*, trans. J.-B.-M. Roze, 2 vols., Paris 1967.

[4] *Proto Evangelium of James* 4,2, in *Apocrifi*, cit. (above, n. 2), pp. 125 – 126.

[5] R. Laurentin, *Maria nella storia della salvezza*, Turin 1972, p. 139.

[6] J. Snyder, *Northern Renaissance Art*, cit (above, Intro. N. 14), pp. 348 – 355.

[7] *Revelations*, book IV. Cf. O. Benesch, *The Art of the Renaissance in Northern Europe*, Cambridge (Mass.) 1945, pp. 24 – 40.

[8] Ibid.

[9] Ibid.

[10] Voragine, *Légende dorée*, cit. (above, n. 3). vol. II, pp. 174 – 175.

[11] *The Birth of the Virgin* according to the most ancient version of the text, the Bodmer Papyrus dated in the 2nd – 3rd centuries, 3,6 – 7,7. Cf. *Apocrifi*, cit. (above, n. 2), vol. I, pp. 84 – 87.

[12] Ibid.

[13] Cf. *Apocrifi*, cit. (above, n. 2), I:149 – 156.

[14] E. Schaumkell, *Der Kultus der Hl. Anna An Ausgang des Mittelalters*, Freiburg 1893; P. Charlande, *Madame Sainte Anne et son culte au Moyen age*, Quebec 1921; K. Kunstle, *Ikonographie der christlichen Kunst*, Freiburg 1926 – 28, vol. I, p. 330.

[15] *Apocrifi*, cit. (above, n. 2), I:150 – 151.

[16] Sura 3,37 and Sura 19,16.

[17] *Apocrifi*, cit. (above, n. 2), I:190.

[18] Bodmer Papyrus 22, in *Apocrifi*, cit. (above, n. 2), I:96 – 97.

[19] Bodmer Papyrus 18, in *Apocrifi*, cit. (above, n. 2), I:93 – 94.

[20] Ibid.

[21] P. Humphrey, *Annunciazione*, in *Lorenzo Lotto: il genio irrequieto del Rinascimento*, Milan 1998, pp. 191 – 193.

[22] Saint Bernard, Homily IV,8 – 9. Cf. *Sancti Bernardi opera omnia*, ed. J. Leclercq, Rome 1957 – 1972.

[23] Saint Anselm, Discourse 52. PL 158, 955 – 956.

[24] Saint Leo the Great, Tract 48,1, in *Corpus Christianorum series latina*, Turnhout 1954 ff., 138A, 279 – 280.

[25] Hereford Codex, 34b, in *Apocrifi*, cit. (above, n. 2), I:99.

[26] B. Viola, *Bill Viola: Going Forth by Day*, catalogue of the exhibit at the Deutsche Guggenheim, Berlin, in 2002. Berlin, 2002, pp. 92 – 93.

[27] Bodmer Papyrus 26,5 in *Apocrifi*, cit. (above, n. 2), I:99.

[28] Various Authors, *La Madonna nell'attesa del parto. Capolavori del patrimonio italiano del '300 e '400*, Milan 2000, p. 46.

[29] T. Verdon, *L'arte sacra*, cit. (above, chap. 1, n. 5), pp. 152 – 157.

[30] Aelred of Rievaulx, Discourse 20 (*De nativitate Mariae*): PL 195, 322 – 324.

[31] A common interpretation of the Fathers of the Church. E.g., Discourse 160 of Saint Peter Chrysologus, Pl 52, 620 – 622.

[32] J. Snyder, *Northern Renaissance Art*, cit. (above, Intro. n. 14). p. 156.

[33] Voragine, *Légende dorée*, cit. (above, n. 3), *Invention of the Holy Cross*, p. 342.

[34] PL 159,305.

[35] J. Snyder, *Northern Renaissance*, cit. (above, Intro., n. 14), p. 179, and S. Gohr, *Anna Selbdritt*,

in *Die Gottesmutter. Marienbild in Rheinland und in Westfalen*, ed. L. Kuppers, Recklinghausen 1974, pp. 243 – 254.

[36] P. Barolsky, *The Meaning of Michelangelo's Pitti Tondo*, "Source," 22, 2003.

[37] Chapter 19 in most versions. Cf. *Apocrifi*, cit. (above, n. 2), I:387 – 428.

[38] A. D'Ancona, *Origini del teatro italiano*, 2 vols., Rome 1971 (reprint of the 1891 edition), vol. I, pp. 155 – 163; Various Authors, *Poesia religiosa italiana*, ed. F. Ulivi, M. Savini, Casale Monferrato 1994, pp. 75 – 94.

[39] Discourse for the Sunday in the octave of the Assumption, 14 – 15. Saint Bernard of Clairvaux, *Opera omnia*, cit. (above, n. 22), 5:273 – 274.

[40] Ibid.

[41] Ms. Ashburnham 1542 (1465), 86. Cf. T. Verdon, *The Art of Guido Mazzoni*, New York 1978, p. 185, n. 13.

[42] Cf. *Apocrifi*, cit. (above, n. 2), III: 163 – 256.

[43] Ibid., III:207.

[44] Cf. *Nuovo dizionario di mariologia*, cit. (above, Intro., n. 10), at the article: "Letteratura," p. 665.

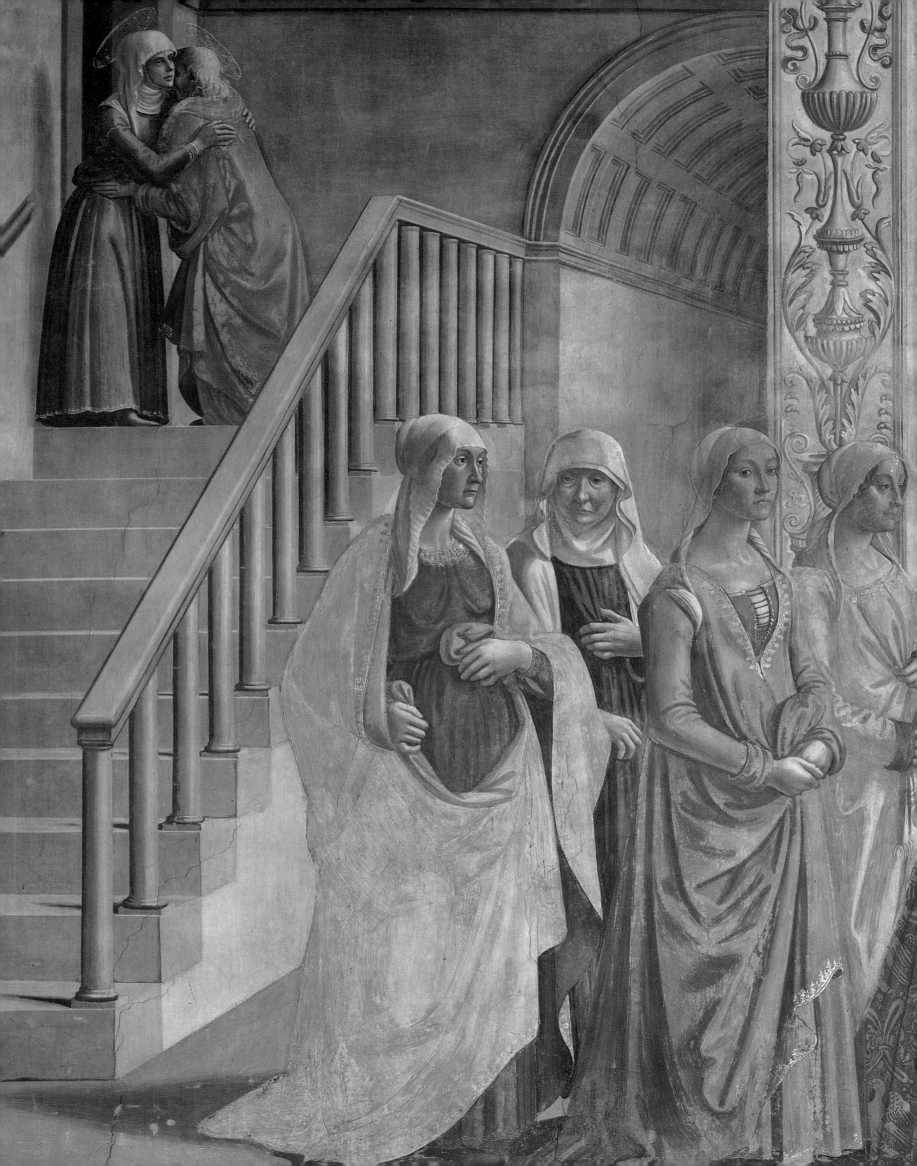

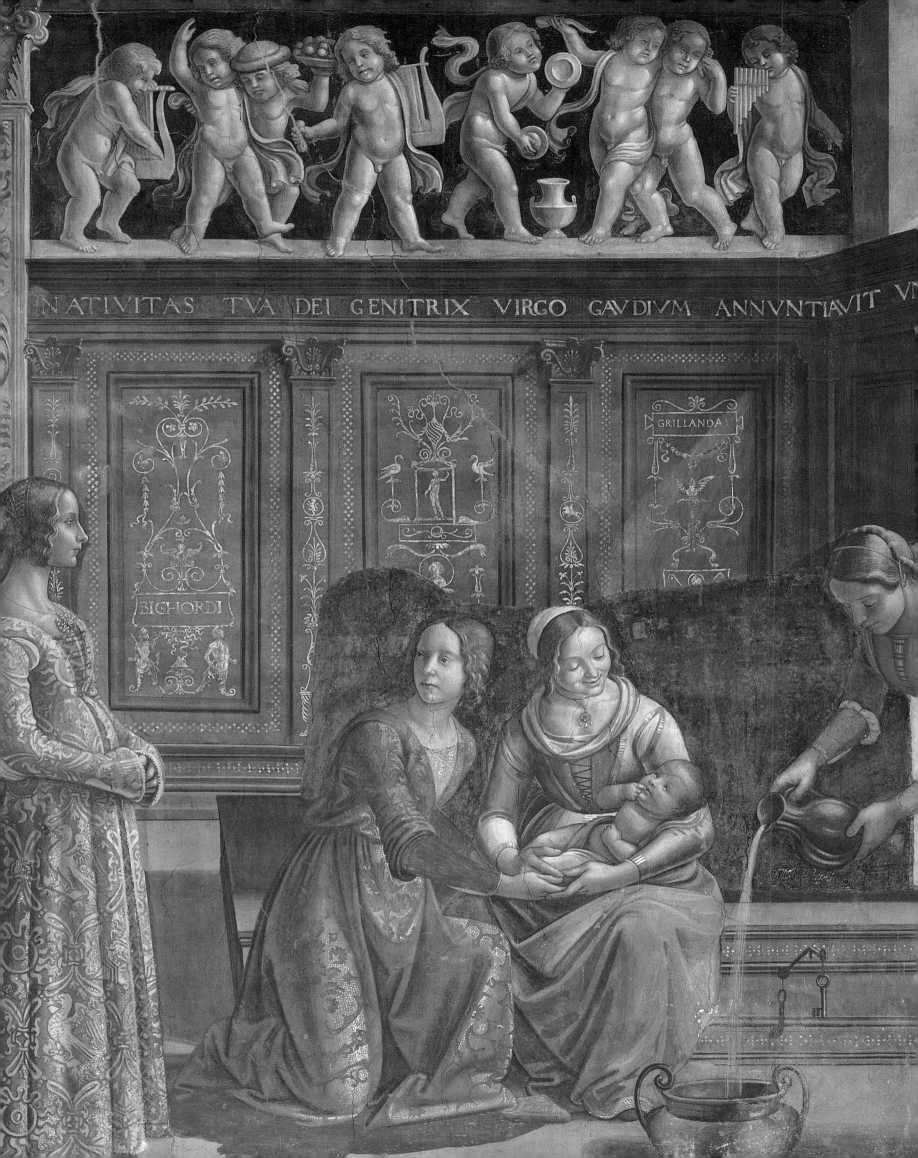

NATIVITAS TVA DEI GENITRIX VIRGO GAVDIVM ANNVNTIAVIT VN

BIGHORDI

GRILLANDA

Mary and the City: Florence

"There is a river whose streams refresh the city of God, the holy dwelling of the Most High. With God in her midst, the city can never fail; at dawn's first light he helps her."

These words of Psalm 45 [46], which in their original context connote the city of Jerusalem, for the last two thousand years have also connoted a woman. They are used by the Church on Marian feasts because Mary too, virgin but at the same time *mother*, was "refreshed" by the Spirit's flow, becoming "dwelling" of the God who "in her" remained for nine months. Mary is in fact a figure of "the holy city, the new Jerusalem," described in Christian Scripture as a woman "beautiful as a bride all dressed for her husband" (Revelation 21:2).

Such an association of ideas is not limited to the Bible. Greco-Roman antiquity similarly identified cities with women, and the most famous map created in the Roman Empire – the *Tabula peutingeriana* compiled in the 4th century – symbolized Rome and other urban centers with figures of feminine divinities. This metaphor, transmitted to the Middle Ages as part of Classical tradition (the only surviving version of the *Tabula* is in fact a copy datable to the 12th or 13th century), thus entered Western literary imagination, where Christians imbued it with social implications. Mary, who had borne Christ's body in her womb, was thought of as imaging the "Mother Church" (which carries in herself the body of a new humanity), and the Church was in turn conceived as an earthly image of the heavenly Jerusalem.[1]

Between the 11th and the 14th centuries, practically every European city would have identified with these ideas, and it is no accident that most of the important churches built in that period were dedicated to the Virgin Mother. In particular the cities of Tuscany, with their significant role in contemporary ecclesiastical reform, saw Mary as an ideal figure – as religious orders and confraternities claiming her protection, hospitals and orphanages dedicated to her, and artistic masterpieces depicting her all bear eloquent witness.[2]

Florence too mirrored herself in Mary, perhaps more than other cities. Politically Guelph, the city identified with the Church, the ideal "holy city" that from the time of Pope Gregory VII and Countess Matilda had functioned as guarantor of local freedoms in the face of the German emperors. Florentines erected two Marian sanctuaries, the basilica of the Santissima Annunziata and Orsanmichele; founded a religious order in Mary's honor, the "Ser-

vants of Mary"; and numerous lay sodalities dedicated themselves to her, among which the "Praise-singers [Laudesi] of the Blessed Virgin," the Orsanmichele Confraternity, and the Confraternity of Mercy. The city's new cathedral begun in 1296, "Our Lady of the Flower" [Santa Maria del Fiore], was not only dedicated to Mary but – as some scholars maintain – visually alludes to her, with the enormous dome built by Filippo Brunelleschi conceived as an image of Mary's pregnant womb.[3]

Beyond religious and civic symbolism, there was widespread interest in women in late medieval Europe, stimulated by that chivalric culture of which Florence was a leading center. Its spirit transpires in a 14th-century manuscript, the *Regia Carmina*, traditionally attributed to Convenevole da Prato, where "Florentia" is represented by a young woman with her hands crossed on her breast (fig. 193). Tall and slender, glowing with blond beauty, this maiden in a red and white embroidered mantle lined with green seems a distillation of late 13th and early 14th-century Florentine poetry inspired by the troubadour songs of southern France. We could imagine as addressed to her Guido Cavalcanti's verses: "In you the flowers and the greening, and all that shines and is fair to see," or his delightful song beginning: "Fresh new rose, pleasant springtime: singing gaily twixt bank and meadow I proclaim your rare gifts to the green."[4]

This "sweet new style" [dolce stil novo] came to stand for Florence: to symbolise its freshness and constitute its "image." Like a knight with his lady's scarf on his helmet, the ruling Guelph party – strengthened by victories over the Ghibelines in 1250 and 1289 – liked to display its gentle spirit. As a contemporary poetess, the so-called "Accomplished Damsel,"

194. Florentine master, *Maestà*, 12th century. Santa Maria Maggiore, Florence.
This painted high relief with Mary enthroned who presents her Son to us was meant to be seen above an altar where Mass was celebrated, and thus speaks with simple eloquence of the God who became real presence in the material world, at the same time stressing the enormous dignity of the woman who collaborated to make his advent possible.
The two sculptural heads, elements of great realism for the time, contain relics of Christ's cross and of the saints, and this work – as is clearer now, after its restoration finished in 2002 – thus constitutes a "real presence" of the Holy in the midst of the city.

put it: "In the season when earth puts forth her leaves and flowers, the joy of gentle lovers grows; together they seek the gardens where little birds their pretty songs do sing."

In stern medieval Florence, behind the somber facades of fortified mansions we thus find gardens "where little birds their pretty songs do sing": pleasure parks virtually Arab in spirit (fig. 3), like the famous "Paradise of the Alberti." In that dramatic age of feuds and bloody vendettas, Florence was glad to show another face, another heart. "All honest folk succumb to love," the Accomplished Damsel wrote; "gentlemen give days to love's service, well-born maids abide in joy."[5]

This courtly frame of reference, which suggests the climate of that distant time, helps bring our theme into focus. There was then, in art and poetry alike, an interweaving of sacred and profane such that Dante Alighieri, in his sonnet beginning "O you who pass along the way of love," did not hesitate to use biblical verses which the Church puts on Mary's lips: "O vos omnes, qui transitis per viam, attendite et videte si est dolor sicut dolor meus!": "O you who pass along the way, consider and see if there be any sorrow similar to mine" (Lamentations 1:12). Dante writes: "Consider and see if there be any sorrow similar to mine in weight."[6] We could say that the intense experience of love, whether sacred or profane, had inspired a single language, opened a single poetic vein.

And the ideal "figure" – the privileged *locus* where these poetic currents met – was still Mary, a virgin but also the "bride of Christ." The Marian title preferred by medieval and Renaissance Italians, "Madonna," literally: "my woman," in fact is double edged, serving

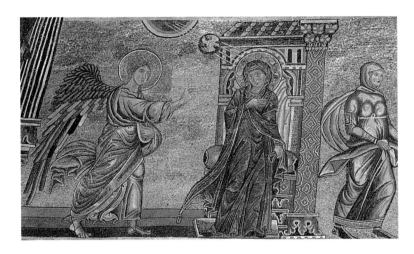

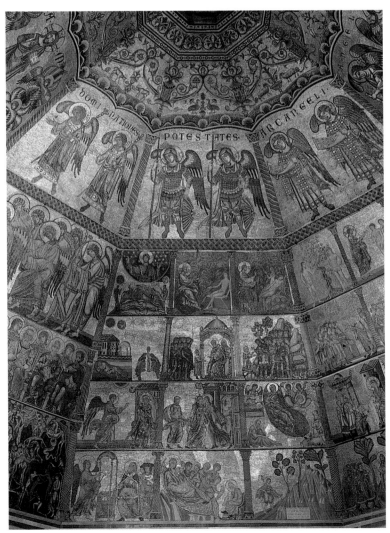

to identify both Mary and the woman beloved by the poet. Reading texts or looking at paintings of the 14th and 15th centuries, it is sometimes difficult to say which frame of reference dominates, the religious or the courtly: whether, that is, it was mere artist's license to give Mary the manners of a highborn maid, or whether those very manners were not the result of a process of idealization related to Marian devotion.

This was the moment when the rich cities of Tuscany redefined their "image" in modern terms, and at Pisa, Lucca, Siena and Florence, the principal churches were modified or rebuilt, first in the Romanesque style and then in the Gothic. The unifying religious theme was devotion to the Virgin Mother, venerated not only as a historic personage – the Hebrew girl who gave birth to Jesus – but also as "icon" and "figure" of communities who listen, believe, are filled with divine grace, and bear Christ to the world.[7] In Mary, medieval Tuscans contemplated the perfection of human nature, the beauty of our condition transformed by grace and restored to primordial innocence, an exemplar of values such as mercy, succor and attentive ("maternal") protection of individuals and entire populations.

The oldest type of Marian image common in Tuscany is the so-called "Majesty" or *Maestà* discussed in our first chapter: an icon, often monumental in scale, showing Mary seated on a throne, solemnly presenting her Son to the viewer. Among early Florentine examples, particular interest attaches to the large "Majesty" in Santa Maria Maggiore, today visible in its original splendor thanks to restoration completed in 2002 (fig. 194).[8] More than the work's richness, with vast areas covered in gold leaf, or the still Byzantine elegance of the artist's style, an unusual feature holds our attention: this "painting" is simultaneously a work of sculpture, with the bodies of Mary and the Christ Child in high relief. The date recently hypothesized for the work (which would shift its execution from the 13th to the 12th century), and the restorers' discovery in the thickness of the sculptural portions – specifically in the heads of Mary and Christ – of silken packets containing relics, invite us to ponder the degree in which, a century before Giotto, images still functioned as "icons" in the Eastern sense: as objective bearers of holiness, that is, real presences of the sacred in the everyday life of the city.

The relics, inserted in the parts of the image that are most "real" (the two heads modeled in plaster that stand out from the background), in fact, convey the historical character of Christian faith: they are identified, on bits of attached parchment, as fragments of

the cross of Christ and of the body of a saint. In a similar way, the painted image – which shows a child come forth from his mother's body – insists on the three-dimensionality of salvation history, and brings to mind an idea of John Paul II with regard to icons. Citing the patristic text that best sums up early Christian attitudes toward art – Saint John Damascene's *Discourse on Images* – the Pope in 1987 wrote: "The art of the Church must try to speak the language of the Incarnation, and to express with material elements him who has deigned to inhabit matter and to bring about our salvation through matter."[9]

The archaic "Majesty" in Santa Maria Maggiore seems to obey this norm. Situated over a eucharistic altar, the painting speaks with simple eloquence of God's becoming a "real presence" in the world of matter. The high relief figure of the Child, like the two scenes painted below – the *Annunciation* and *The Holy Women at Christ's Tomb*, in fact alludes to the body of Christ rendered present at Mass: the body conceived of Mary, risen from the tomb and now ascended to the glory of the Father. With figures of apostles in its frame, this "Majesty" also alludes to the Church, in which – as in Mary's womb – the Son of God is alive and active.

As its inclusion in the Santa Maria Magiore *Maestà* suggests, another key subject in Marian iconography in Florence was the Annunciation. Indeed, Florence was in a certain sense the city of the Annunciation, beginning its calendar year on March 25, the day of the angel's announcement to Mary nine months before Christmas: the day of Jesus' conception. Indeed, the child conceived that day bore the city's name: in an official document of 1412, ancient *Florentia* (which in the Middle Ages was called *Fiorenza*) designates Jesus "the first flower [*fiore*] of our salvation."[10] Even the dedication of the new cathedral, to "Our Lady of the Flower," alluded to the Annunciation.

197. Florentine master, *Annunciation*, 13th century. Santa Maria del Fiore, Florence (detail of fig. 43).

198 – 199. Florentine master and a sculptor, perhaps from Lombardy, *Annunciation*, mid 14th century. The figures, once in aedicules at right and left of the Bell Tower Portal, today are in the Museo dell'Opera di Santa Maria del Fiore, Florence.

Florentine artists would ponder the meaning of this event in the specifically "incarnational" terms of *time* and *space*. We grasp the relationship with *time* in the 13th-century mosaics of the Baptistery dome, for example, where the *Annunciation* (fig. 195) is situated in the northernmost of eight sectors, the first scene in the horizontal band in which the life of Christ is illustrated. In the other three horizontal bands, we see the life of Saint John the Baptist (under that of Christ), the life of the Old Testament Patriarch Joseph (above Christ), and – in the uppermost band – stories from the opening chapters of the Book of Genesis (fig. 196).

The program thus locates the announcement to Mary squarely *within the history of salvation*: directly above the analogous announcement made to Zachary – that, notwithstanding advanced age, his wife Elisabeth would bear a son; and below Joseph's dream, in which, still a boy, the patriarch saw sheaves of wheat and heavenly stars bow to honor him, despite his insignificance among the sons of Jacob. The program, that is, situates the *Annunciation* among things impossible to man which are, however, part of the plan of God, for whom "nothing is impossible" (as the Gospel account of the Annunciation in fact states: cf. Luke 1:37).

Above these three scenes, in the uppermost band we find *The Creation of Heaven and Earth*, which thus becomes the original context of the divine plan in which the "Yes" pronounced by Mary at the Annunciation would be decisive. Reading from the top down, the superimposition of the four scenes suggests that, in the very moment He fashioned the universe, and with a single "decree," God also prepared man's salvation, predisposing the freedom of the woman who, "in the fullness of time," would give birth to the Redeemer (cf. Galatians 4:4).

Among fifty-nine historical scenes in the Baptistery mosaic program, the *Annunciation*

thus figures as the "impossible" beginning of a new creation to which men and women gain access through Baptism: the beginning of a new "history of the world" focused – as are all the scenes in the narrative sectors of the dome – on Christ, the true beginning and end of history, its Alpha and Omega (as he is in fact represented in the central sector of the dome, above the altar).

The other aspect of this subject, the relationship with *space*, is suggested in a work executed shortly after the Baptistery mosaics: the marble relief depicting the Annunciation discussed in our first chapter, perhaps carved for the old cathedral, Santa Reparata, and today inserted in the south exterior wall of Santa Maria del Fiore, next to the Bell Tower Door (cf. fig. 43). In its transitional style between Romanesque and Gothic, the relief narrates the event with admirable clarity. At the viewer's left, we see the Angel bringing his message; he advances with vigorous pace, a vine on his left arm signifying fecundity. At the viewer's right is Mary; a lectern before her and the book in her hand suggest she was reading but has stopped to receive Gabriel's announcement, to which she responds in words cut into the marble: "*Ecce ancilla Domini*." And all at once the many words of the ancient Scriptures are fulfilled in the life of this young woman, as God's Word becomes flesh in her body.

Between the Angel who announces, and Mary who responds, the anonymous sculptor has positioned a symbolic building, a sort of tabernacle or miniature temple: two columns supporting a dome (fig. 197). On the dome's exterior, on the side toward the Angel, we see the hand of God, and inside the space defined by the dome the Holy Spirit erupts in the form of a dove; below the Spirit we read the words pronounced by Gabriel, "Ave gratia plena," "Hail, full of grace." The artist, that is, has visualized *in architectural and spatial terms* the mystery taking form in Mary's body, showing us a void filled with grace, the space of history inhabited by God, a creature's soul as tabernacle for the Creator Spirit.

An analogously "spatial" rendering of the Annunciation would be realized at several meters distance from this relief, above the neighboring Bell Tower Portal of the cathedral, in the second half of the 14th century. In the now empty aedicules to left and right of the door's crowning pinnacle, there once stood splendid figures of the Angel and Mary (figs. 198, 199). Passing through this door, the faithful passed "under the shadow of the Most High" and under the words pronounced by the Angel and accepted by the Virgin – the words that, in Mary, became God's Son. Entering the "womb" of the cathedral interior, Florentine Christians could thus perceive themselves as "sons of Mary" along with Christ – indeed, as "other Christs."

Another instance of the Archangel Gabriel and the Virgin Mary significantly placed to right and left of an entryway is Giotto's *Annunciation* in the Scrovegni Chapel in Padua, where the Angel and the Virgin, both kneeling, occupy identical "chambers" at right and left of the arched entry to the chapel that houses the altar (figs. 200, 201, 202). As it connects the two parts of the scene, the curve of the arch leading to this chapel seems to follow the flow of the announcement, the passage of the Word from the angel's mouth to Mary's heart, where it becomes flesh.

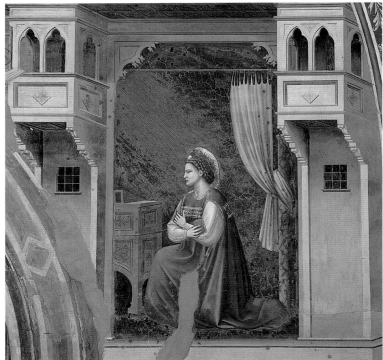

And under this scene, in the space of the chapel, we were meant to see the eucharistic bread actually become Body of Christ – another "incarnation": the extension to the life of the Church of that which had come about in the life of the Virgin. "Mary gave birth to only one Son," Augustine said, whereas "the Church bears many, destined to become one thanks to the one Son of Mary."[11] The sign of this unification – of this process by which "many" become "one," like grains of wheat in a single loaf – is the Eucharist, sacrament of God's presence in human history, divine life filling our life, "communion" between heaven and earth.

The Topography of Marian Devotion

The most revered image of the Annunciation in Florence, strongly "spatial" and eucharistic in character, is a fresco in the Sanctuary of the Santissima Annunziata ["Holy Mary Annunciate"], which popular piety believed completed by an angel (fig. 203).[12] The painting shows Mary at the instant in which she conceives the Savior: the book on the bench beside her is open to the words of the Prophet Isaiah, "Behold, a virgin will conceive…," and we can assume that she was reading; she has laid the book aside, however, as the Word becomes flesh within her. Mary's hands call attention to the womb soon to be filled, and her ecstatic gaze turns toward heaven, whence the Spirit will descend. The words "*Ecce ancilla Domini*" on the surface of the fresco express the Virgin's humble faith, and – when seen alongside the votive offerings, lamps, and rich silver ornaments of this altar – suggest the "value" of faith, "much more precious than gold" as the New Testament asserts: faith that in Mary wins "praise and glory and honor" for the whole human race (cf. 1 Peter 1:7).

This fresco is closely associated with the church for which it was executed, the Santissima Annunziata.[13] Originally a country chapel outside the city, the church became part of the "greater Florence" defined by expansion of the city's walls between 1284 and 1333. Earlier still – around the middle of the 13th century – a major street had been laid out, connecting the north side of the old cathedral with 'Santa Maria in Cafaggio,' as the Annunziata was then called. And from that time to the present, Florentines in great number have made their way to this church, to ask Mary's help in their personal and family needs; modern votive offerings and lit candles inside bear witness to the devotion that, for the last seven hundred and fifty years, has found a focus in this place.

The name of the access street, and the name used by Florentines for the church itself – "via de' Servi" and "la Santissima *Annunziata*" – sum up the history of this sanctuary. The Order of the Servi di Maria ["Servants of Mary" or "Servites"] was born around 1233, with the decision of seven Florentine noblemen to dedicate their lives to prayer and works of charity. Following the example of the Franciscans and Dominicans, already present in the city, the "seven founding saints" of the new Order lived in community, assuming the black habit symbolic of penance and the Rule of Saint Augustine. In search of greater solitude, in 1240 they withdrew to Mount Senario, twenty kilometers from Florence, but several years later returned to Santa Maria in Cafaggio – without, however, giving up their hermitage in the hills. From that time to the present, the Order's life has been marked by alternation between contemplation and apostolic service.

Back in Florence, in 1250 the Servites enlarged their small chapel and two years later had a fresco painted inside: an image of the "glorious Lady" whose name they had taken, Mary, shown at the moment in which she received the angel's announcement and gave her response. The artist, one Bartholomew, feeling inadequate to the task of painting Mary's visage fell asleep on the scaf-

200 – 201. Giotto, *Annunciation*
(detail), 1303 – 05. Scrovegni
Chapel, Padua.

202. Detail.

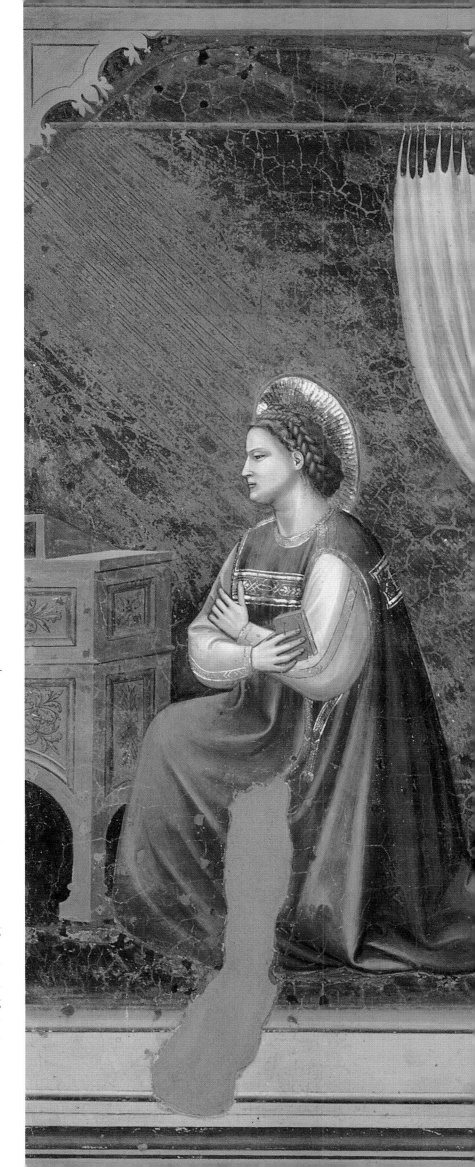

folding and, when he awoke, found the fresco finished. The subsequent attribution of Mary's face to angelic intervention, and the miracles soon linked to the image, made the church of the Annunziata one of the most important points of spiritual attraction in medieval Florence. The fresco we see today is a 14th-century evocation of the lost original.

Here as in other Marian shrines, uninterrupted use, and the popularity of the sanctuary, led to successive enlargements and modernizations of the buildings – as if every century wanted to pay homage to the Virgin, embellishing her basilica in the light of changing tastes. The arcaded loggia on the *Piazza* is a masterpiece of the late 16th-century; the cloister behind it, which serves as entry passage or "atrium," was designed by Michelozzo in 1447 and boasts frescoes of the 15th and early 16th centuries; the church interior, restructured and redecorated between the 17th and 18th centuries, has monuments and altars datable from the 15th to the 20th centuries.

The oldest works of art are concentrated around the church door, on the northern wall of Michelozzo's cloister. The stonework of the main portal goes back to a 14th-century enlargement of the structure, while the structural wall beside the door, to the viewer's left, is all that remains of the 13th-century chapel in which the Order was founded. The venerated *Annunciation* fresco is on the opposite face of this wall, immediately to the left of those entering by the main door.

It was here that decoration of the cloister was begun in the 15th century, with a fresco alongside the main door: a *Nativity* painted in 1460 – 1462 by Alesso Baldovinetti, showing Mary adoring her newborn Son (fig. 204). The fresco's placement is highly significant: for those entering the cloister from the piazza, the image indicated the main portal of the church; until 1476 it was,

indeed, the only painting in the atrium. It was Mary, therefore, whom Christians venerate as *Porta coeli*, "portal of heaven," who indicated the main portal of the church: in the fresco, she in fact turns toward our right, toward the door giving access to the basilica. Mary's face, painted when the plaster had already dried, has been lost: the filament of color, which never amalgamated with the plaster, has fallen from the wall surface. But we should imagine her expression as full of love for her Son, and it would have been this maternal gaze that guided us to the door, that followed us as we entered.

Crossing the threshold, we realize that the *Nativity* in the cloister occupies the same stretch of wall on which, inside, the miraculous *Annunciation* is painted. Believers who come to pray before an image of God's *promise* (the Annunciation was God's promise that Mary would have a Son), thus immediately see *fulfillment* of the promise, the birth of a child. The link between "promise" and "fulfillment" is clearly significant in this place where, for seven and a half centuries, men and women have come seeking gifts of grace. Indeed, in this atrium originally dominated by Baldovinetti's *Annunciation*, up to the 18ᵗʰ century there were innumerable votive offerings, images and memorial objects expressing individuals' gratitude for graces received, "promises" of God concretely fulfilled in people's lives. Florentines called the atrium the "cloister of vows."

203. Unknown painter, *Annunciation*, 14ᵗʰ century. Santissima Annunziata, Florence. Venerated for centuries in the Marian sanctuary of the Santissima Annunziata in Florence, this Annunciation – which the popular belief holds to have been completed by an angel – reworks a lost 13ᵗʰ-century image that represented Mary in the instant when she conceived the Savior. Set in a splendid marble tabernacle commissioned by the father of Lorenzo the Magnificent, Piero de' Medici called "the gouty" (see fig. 206), the work is today seen surrounded by votive gifts, silver oil lamps and a silver altarpiece, as if to stress the value of faith in God, which in Mary's "Yes" infinitely enriched humankind.

204. Alesso Baldovinetti, *Nativity* (detail), 1460 – 1462. Santissima Annunziata, Florence.

The cloister was part of an overall renewal of the complex, directed by Michelozzo, in which the chief element was an aedicule or tabernacle built to enclose the venerated fresco and its altar (fig. 206). Commissioned by Piero de' Medici in 1448, this small "temple" created a prayer-space in front of the image, an area of intimacy recalling the "inner chamber" that Jesus evoked, saying: "When you pray, go to your private room and, when you have shut the door, pray to your Father who is in that secret place" (Mt. 6:6). To assist at Mass in this space is like seeing Christ's "body," made up of Servite friars and the faithful, take shape in Mary's womb. It is here that today we find the votive gifts and candles: signs of a climate of prayer that has always marked the Santissima Annunziata.

The other Florentine Marian sanctuary was Orsanmichele, the old grain exchange converted to use as a church. Differently from the Santissima Annunziata, which at the moment of its foundation lay outside the city walls and was run by a religious order, Orsanmichele is situated "*in medio corporis ipsius civitatis ... et ... pro multis utilitatibus et necessitatibus Comunis Florentie plurimum opportune*," as a governmental ordinance of 1336 (authorizing the building's reconstruction after flood damage in 1333) puts it: "in the middle of the city ... and ... very useful for various needs of the Government of Florence."[14] Located midway between the cathedral and the town hall, Orsanmichele was literally "in the

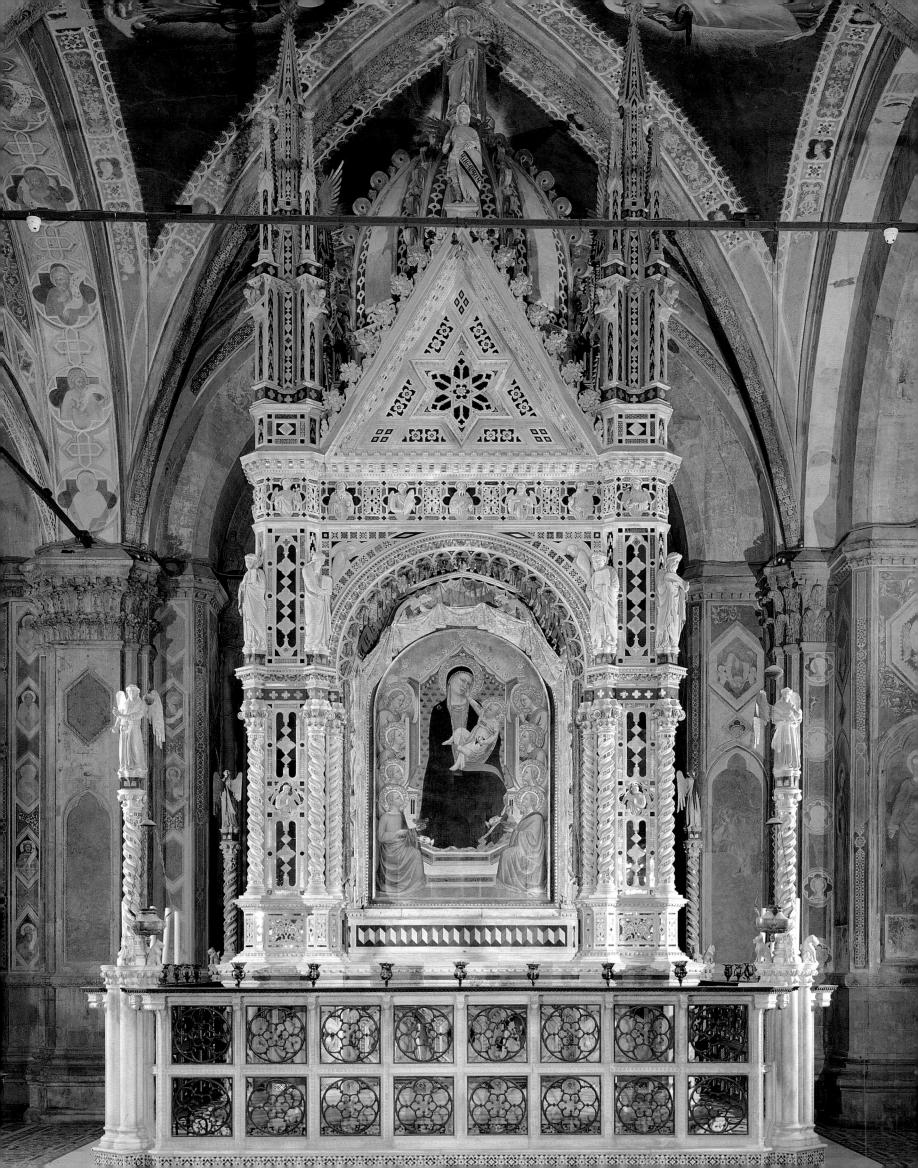

205. Andrea Orcagna and Bernardo Daddi, *Marble Tabernacle and Madonna and Child with Angels*, c. 1347 – 60. Orsanmichele, Florence. Placed in the second Marian sanctuary of Florence, Orsanmichele (the old grain market transformed into a church), this painting is enthroned in a spectacular monumental marble tabernacle carved by Andrea Orcagna. In this place where grain was doled out to the poor free of charge in times of famine, this figure of Mary alludes to nurturing and nourishment: to Christ, daily bread of believers, the "seed" who fell to earth and died to give eternal life to women and men.

206. Michelozzo, *Marble Tabernacle*, mid 15th century. Santissima Annunziata, Florence.

middle" of the oldest part of town, and – first as a merchant loggia, then as a church on the ground floor of the city granary – was a public structure, run for the Florentine authorities by a lay confraternity that conducted services before a painting of the Virgin housed therein.

The governmental ordinance of 1336 alludes to the image of *Mary with the Christ Child* before which the confraternity daily sang the *Laudes Mariae*, specifying that – in this structure to be rebuilt in the heart of Florence – "*gloriose Virginis Marie merita venerentur*" ("the merits of the glorious Virgin Mary should be venerated"). And, just as later at the Santisssima Annunziata, in Orsanmichele the venerated image was housed in an "oratory": a sort of open tabernacle that isolated the painting from the utilitarian space of the loggia.

The painting and its tabernacle, along with the loggia itself, had been damaged by fire in 1304 and again by flooding in 1333, and – in the new building decreed in 1336 – would be replaced by two masterpieces of Florentine Gothic art: Bernardo Daddi's delightful *Madonna and Child*, executed in the 1340s, and the spectacular architectural tabernacle built by Andrea Orcagna between 1352 and 1360 (fig. 205). Today we see these works as if in a museum, and do not easily grasp the atmosphere of fervent devotion that formerly surrounded them; but archival documents confirm that in 1349, the year following the worst outbreak of the Black Death, the monthly average of candles sold by the confraternity for use in Orsanmichele was 77,075![15]

The loggia's devotional function soon made its continued use as city grain exchange impractical, and that activity was formally suspended in 1367. In the following decades, the loggia's arches, originally open to the street, were closed, and the interior space so constituted was adorned with frescoes. Atop the light walls sealing the arches, an important series of stained glass windows was installed, illustrating the life and miracles of the Virgin Mary.

The iconographical program of the frescoes and stained glass, prepared by the Florentine writer Franco Sacchetti, is a virtual encyclopedia of medieval Marian lore.[16] The miracles represented are all localized, and in several scenes we find Orsanmichele itself represented, with Daddi's *Madonna* in plain view (fig. 207). The subject matter, familiar to 14th-century believers from sermons and through manuscript editions of a well known contemporary text, *The Miracles of the Virgin*, communicates the universality of the help offered by Christ's Mother. No one is excluded, and Mary goes so far as to save a condemned criminal who invokes her with his last breath, supporting the weight of his body at the moment of hanging (fig. 208).

Thus at Orsanmichele even more than at Santissima Annunziata, the images bear witness to a bond of filial confidence and tender love, defining a theme that later – in 15th-century Florentine iconography especially – would stress Mary's total willingness to assist her Florentine sons and daughters. One thinks, for example, of the woodcut showing an artist about to fall from scaffolding but saved by the Madonna he had been painting (fig. 209), or of Cosimo Rosselli's humorous *Madonna of Succor* in Santo Spirito, where, in response to a mother's urgent prayer, Mary wields a hefty club to dispatch a devil threatening the woman's child (fig. 211). One thinks also of the *Foundling Hospital Madonna* attributed to Francesco Granacci, a work of the early 16th century in which the typology of the "Mother of Mercy" – Mary covering the faithful with her mantle – is adapted to the specific situation of an orphanage, the "Foundling Hospi-

tal" dedicated to the Holy Innocents. Mary is shown against the backdrop of Brunelleschi's courtyard for the orphanage, a strong-bodied wet-nurse gathering the orphaned babes beneath her cloak (fig. 2 1 3). The smaller children are still in swaddling bands, as in Andrea della Robbia's reliefs on the hospital loggia in Piazza Santissima Annunziata, and the slightly older ones wear the black smocks in which they were in fact clothed, with (on the chest) the institution's emblem: a "Holy Innocent" in swaddling clothes.

This intimate, almost familial Mariology is associated with Orsanmichele for yet another reason. Until 1 3 6 7, the "palace of Orsanmichele" continued to serve as grain exchange, and after that date the upper floors became a city granary. The faithful thus venerated the *Holy Mother* in a place that spoke to them of *nourishment* – where grain was distributed to the poor in times of famine free of charge. Medieval piety, which took Christ to be the "living bread come down from heaven" (John 6:5 1), saw Mary as the "earth" from which that bread had sprung, with the result that, at Orsanmichele, Marian devotion was linked to the "daily bread" of Florentine men and women.[17] In this perspective, two symbolic details stand out in Bernardo Daddi's touching image of the Child who reaches up to caress his mother's cheek (fig. 2 1 4): the knotted cord around little Jesus' waist, alluding to penance, and the finch in his hand, a bird which made its nest among thorns and was associated with the Savior's future death. At Orsanmichele, that is, we were meant to recognize Mary's Son as the "grain of wheat" who, dying, would give life to humankind.

We should mention a third important *locus* of Florentine Marian devotion, together with the unusual image it houses: the old "Residence" or "Loggia" of the Confraternity of Mercy (ceded in the 16th century to another sodality, Santa Maria del Bigallo), with in its interior a fresco of the shop of Bernardo Daddi showing members of the confraternity as they venerate Mary (fig. 2 1 6).[18]

Despite its modest scale, the "Mercy Loggia" typifies essential aspects of Florentine identity, and it is no surprise that the first known city-view was executed in its interior (as part the just mentioned fresco: see fig. 2 1 6). Built during construction of the new cathedral, whose unfinished façade is in fact visible in the city-view, the Mercy Loggia expresses the social commitment required of people who frequent churches and cathedrals: a love of neighbor that gives concrete form to their love of God.

The Confraternity of Our Lady of Mercy, founded by Saint Peter Martyr in 1 2 4 4, had established itself in Cathedral Square in 1 3 2 1, in a small house corresponding to the present "Old Meeting Hall" or "Captains' Chamber" of the Residence. Thirty years later, in 1 3 5 1, an adjacent property was left to the Confraternity, which in 1 3 5 2 began work on enlarged institutional headquarters designed by Alberto Arnoldi, a sculptor perhaps also employed in decorating the nearby cathedral bell tower.

Confraternity members devoted themselves to charitable activities and prayer, and the ground floor of their new building had an oratory preceded by a portico open to the street, with a clear view of the statue of Mary with her Son carved by Arnoldi. This

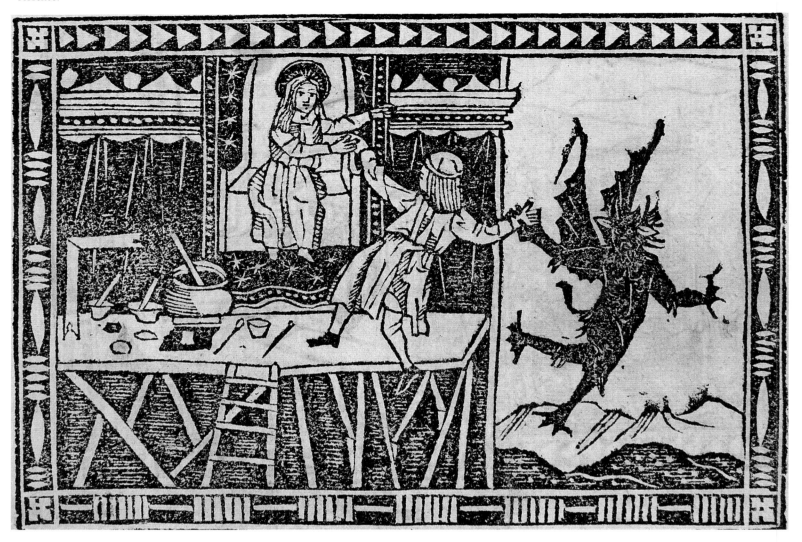

portico (fig. 25) occupies the corner between Cathedral Square and Via de' Calzaiuoli and functions as a kind of "doorway" to the vast space surrounding San Giovanni and Santa Maria del Fiore; in the 14th century, for those coming from the old grain exchange, Orsanmichele, or from the seat of government, Piazza della Signoria, it was a point of passage from the city's economic and political center to its spiritual one, the piazza containing the ancient Baptistery and the rising new cathedral.

This way of thinking of the Mercy Loggia – as a "doorway" between the world of moneyed power and that of religious faith – can suggest the function of the building and the character of the confraternity that erected it. Along with the oratory and meeting rooms, the Loggia also housed an orphanage in its upper stories: a fresco painted in 1386 for the building's exterior shows the elected officials of the confraternity, called "captains," entrusting abandoned children to women paid to look after them (fig. 212). A second fresco, done for the Captains' meeting room, evokes other activities of the Confraternity at that time: care of the sick and burial of the dead, suggested in twelve scenes from the life of Tobias, the Old Testament personage

who, disregarding official prohibition, had given religious burial to his Jewish brethren during the Babylonian exile.

The masterpiece of the iconographic program of the Loggia is the fresco of *Our Lady of Mercy* in which we find the already mentioned view of Florence (cf. again fig. 216). The painter, an artist close to Bernardo Daddi, shows Mary robed in a magnificent liturgical mantle – properly called a "cope" – and with a headdress not unlike a bishop's miter; he presents her, that is, as "sacerdotissa justitiae," as Saint Antoninus Pierozzi would call Mary in the 15th century[19]: a "priestess of social justice" with a ministry to the needy.

This "ministry" becomes explicit if we examine the circles embroidered on the border of Mary's cope, in which the corporal works of mercy are depicted. And all around her figure – as if Mary were speaking to us – are words describing the works: "visito," "poto," "cibo," "redimo," "tego," "colligo," "condo." In the name of the Confraternity and of the City, Mary seems to say: "I visit the sick and the lonely, I offer food and drink, I ransom back prisoners, I give a roof to the homeless."

Here as at Orsanmichele the specifically religious contents of

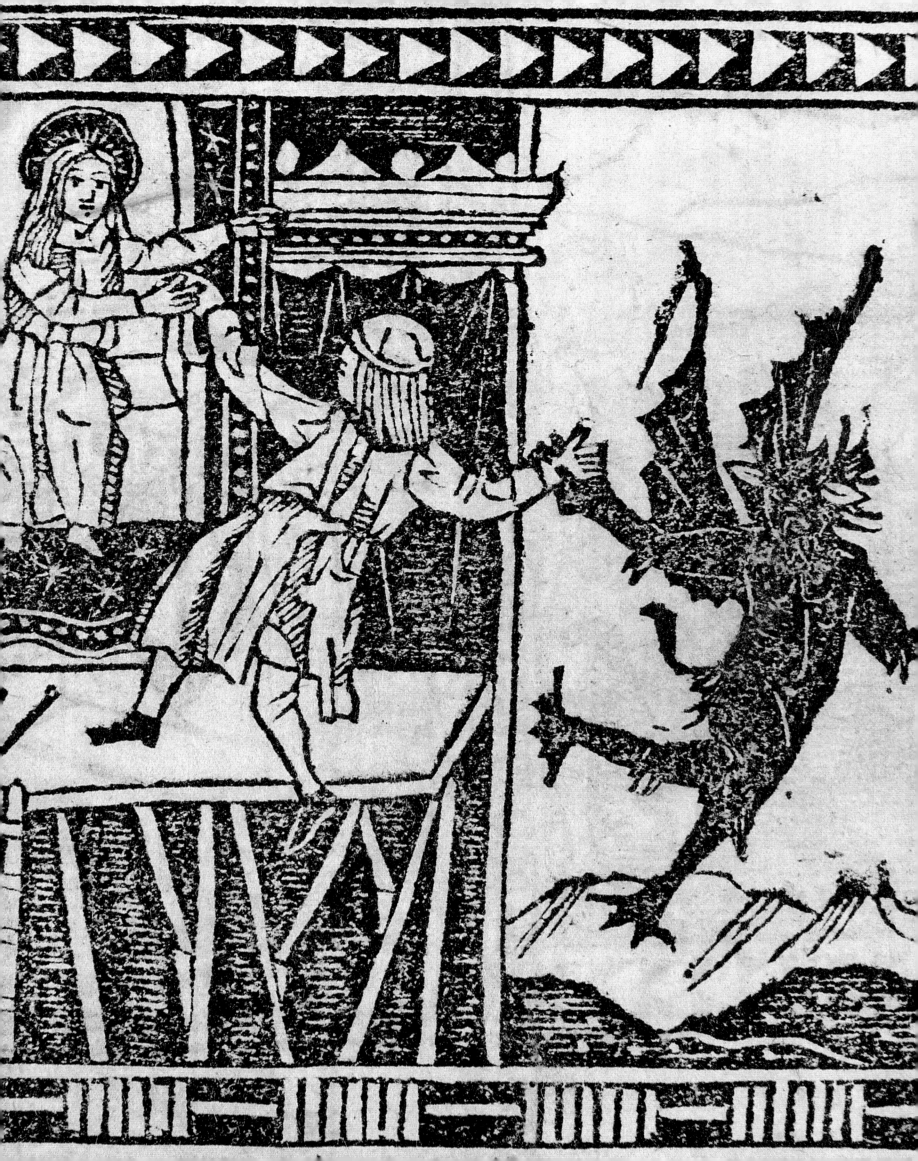

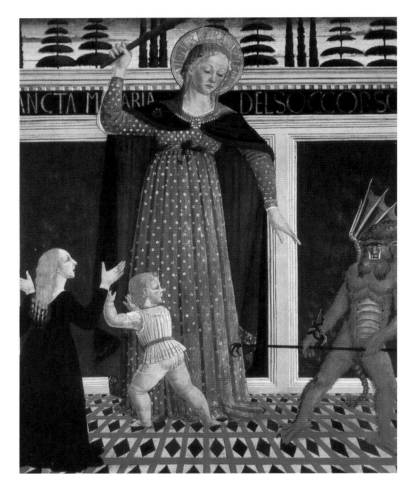

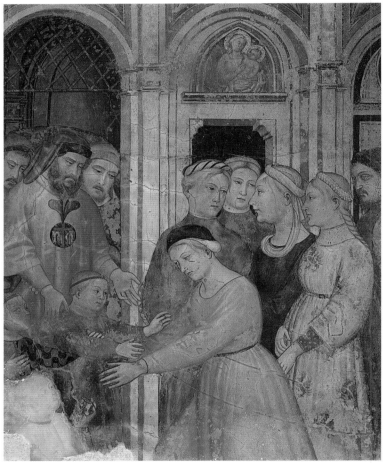

the image – the Christian's obligation to assist marginalized, suffering men and women – become part of the everyday life of Florence. Mary is the central figure in a public liturgy, with censer-swinging angels above her and men and women kneeling in prayer at right and left. Beneath the feet of this "priestess of justice" we see the houses of Florence, like flowers strewn along a processional route, with the white and green marble of the Baptistery agleam and the cathedral still under construction – as if the city were saying: "My buildings are of stone, but my heart is compassionate." And on Mary's breast, in the centermost circle of the cope, we read the words: "*Misercordia Domini plena est terra*," "The earth is filled with the mercy of the Lord."

Santa Maria del Fiore

The biggest Marian project in Florence, the new cathedral, has been left to this point in our chapter because the "duomo" houses works both earlier and later than many already discussed. In addition, some works already treated in these pages, even if chronologically later, were created for Marian localities – Santissima Annunziata and Orsanmichele – that precede and prepare construction of the new cathedral. It seemed reasonable, therefore, to reflect on specific iconographical themes – the solemnity of "Majesty" paintings, the theological approach to the Annunciation, the intimacy of popular devotion and the civic implications of Marian images – before considering the overlay and interpenetration of these themes in sculptural and pictorial works made for Santa Maria del Fiore.

The new Florence cathedral was born in a moment of crucial importance for the history of spirituality and of the visual arts.[20] The dedication, to "Our Lady of the Flower," and the intent, re-

called by Giovanni Villani, to "make the entire church of marble with carved figures" – to enrich it with sculpture, that is – are in fact fraught with meaning.²¹ The spread of Marian devotion in the later Middle Ages reflected a new incarnational awareness of Christ's humanity, and thus also of the *body* he assumed from Mary's body. The choice of *sculpture showing the body* for the decoration of Santa Maria del Fiore was related to this new theological emphasis: Dante suggests the link when, singing the praises of the "Virgin Mother" in terms at once *theological* and *physiological*, he says: "In your womb, that love rekindled / by whose warmth, in eternal peace, / this flower has germinated" (Paradise XXXIII, 7 – 9). As already noted, a document of the early 15ᵗʰ century explicitly connects the dedication of Florence cathedral to the Incarnation, setting March 25ᵗʰ, the Annunciation, as the church's commemorative feast, since on that day Jesus Christ

took root, "the flower and beginning of our salvation" ("*flos ac initium nostre redemptionis fuit benigna, humilis ac gratiosa incarnation filii Dei*").²²

It is thus no surprise that the architect chosen for the new cathedral, Arnolfo di Cambio, was a sculptor as well, nor that he immediately set to work on an impressive program of statuary. In accepting the Florentine commission, Arnolfo, who had learned to sculpt in Nicola Pisano's shop in the 1260s, collaborating on a pulpit for Siena Cathedral, found himself in open competition with Nicola's son Giovanni, then at work on statues for the façade of Siena Cathedral. Arnolfo ultimately lost, since his ambitious sculptural program for Santa Maria del Fiore, begun but never finished, would be dismantled in 1586 – 87 in hopes of creating a Renaissance façade. We can reconstruct the main lines of his project, however, thanks to a drawing made just before disman-

tling (fig. 215), and the many original statues today in the cathedral museum.

Arnolfo's façade was to have been a Marian frontispiece, in analogy with that of Siena Cathedral. In the tympanum above each of the three portals, a sculptural group of noble proportions illustrated episodes from the life of the Virgin: Mary giving birth, Mary enthroned with the Christ Child (fig. 217), and Mary's "dormition" or death (cf. fig. 184). Arnolfo had spent almost twenty years in Rome, and the influence of Classical sculpture is much more evident in his works for Florence than in Giovanni Pisano's for Siena: Arnolfo's grandiose *Mary Enthroned* for the central portal (fig. 217) seems a Juno figure, and the toga-clad Child is a little Roman senator. This statue, extraordinarily lifelike due to Mary's glass eyes, develops in classicizing terms the archaic *typus* of the "Majesty" (see above, figs. 73 and 76), defining a new

monumentality which would influence Giotto a few years later, when he painted a *Madonna Enthroned* for the church of Ognissanti (fig. 218).

The exterior program extended to the cathedral interior as well. Arnolfo's "Life of Mary," which on the outer façade concluded with her death and burial (fig. 184), continued inside with a mosaic above the main door showing her heavenly *Coronation* (fig. 25), designed by Gaddo Gaddi in the first years of the 14th century. Believers thus passed from three-dimensional images on the cathedral exterior – the sculptures – to an interior image gleaming with gold and color, a metaphor for the luminous life of heaven.

The exterior sculpture and interior mosaic were set in place when Santa Maria del Fiore's façade had been raised to barely a third of its height, with all the rest of the cathedral still to be built, and were already positioned when the painter of the Mercy Con-

fraternity *Madonna* "photographed" the work site (see again fig. 216). There followed an interruption of almost ninety years, as the master-builders who succeeded Arnolfo – Giotto, Andrea Pisano and Francesco Talenti – devoted themselves to the bell tower and completion of the nave and aisles of the cathedral. It was only in the last years of the 14th century that decoration of the interior façade was resumed.

Notwithstanding this interval of three generations, however, the Marian character of the program remained, and between 1390 and 1405 three works were executed to frame the *Coronation* mosaic: a large tabernacle or "chapel" at the right of those entering by the main door, with – inside it – the fragment of a fresco ascribed to Giotto (now in the south transept: an object of devotion called the "People's Madonna" and also the "Seminarians' Madonna"); the façade's central rose window showing Mary's Assumption, executed in the early 15th century to a design by Lorenzo Ghiberti; and a second tabernacle or chapel, to the left of those entering, with a contemporary painting on a Marian theme, the so-called *Double Intercession* (fig. 219).[23]

This painting on cloth – until 1843 in Santa Maria del Fiore but today in the Cloisters Collection, New York – has an unusual subject that epitomizes the *theological*, yet at the same time *popular* character of Marian devotion at the end of the Middle Ages. It represents the Holy Trinity together with Mary and a group of believers; from the image's upper zone, God the Father looks down and, opening his right hand, sends the Holy Spirit in the form of a dove upon the Son, shown kneeling in the lower left of the canvas. Christ in turn looks upward, as if to respond to his Father, to whom he moreover indicates the wound in his side with a gesture of his right hand.

With his other hand, Christ points to his mother kneeling in front of him. And Mary, looking at Christ, makes two significant gestures: with her left hand she lifts one of her breasts toward her Son, while with her right she presents several people kneeling in adoration before Christ. These people, smaller in scale than the "main actors" of the scene, represent different age groups and social conditions: there are old and young, lay folk and religious.

The intersecting gestures, and the web of relationships they imply, are explained by words painted in gothic letters on the canvas. As she shows him her breast, Mary says to Christ: "Most sweet Son, for the milk I gave you, have mercy on these people." That is to say: as she recalls to her Son the human nature he received from her and which he shares with all men and women, Christ's mother (who is also a figure of the Mother Church) intercedes for her other "sons" and "daughters," the faithful.

Christ then, lifting his eyes to God and pointing to the wound in his side, says – in a text that rises diagonally as if the words were literally ascending: "My Father, grant salvation to those for whom you wanted me to suffer the Passion." The Son, that is, reminds his Father that, if he obeyed the divine will and accepted death in the flesh he

had received from Mary, it was precisely to save these men and women for whom Mother Church now intercedes!

This singular subject derived from a 12th-century tract, the *Libellus de laudibus beatae Mariae virginis* of Arnault of Chartres. Mistakenly attributed to Saint Bernard of Clairvaux, the small work, widely known in the 14th century thanks to inclusion in a religious bestseller, the *Speculum humanae salvationis*, describes a very human circuit of "family pressure" in which Christians, knowing that Christ cannot refuse his mother any grace, turn to Mary, who approaches her Son "playing the card" of her maternity, sure that the Father will concede whatever his Son asks. And the Son does not hesitate to stress his own obedience to the Father to obtain what mother wants.

When it stood next to the central door of the interior façade, this large painting (2.39 × 1.53 meters) was a masterpiece of communication, using all available means to involve the faithful – as the "speaking" gestures and texts written on the surface suggest. At the same time, it completed the existing Marian program in that part of the cathedral, showing the eternal role of the woman who had borne Christ, held him in her arms, and died in the arms of his beloved disciple (the subjects of the exterior sculptures). Inside, the program again showed the young mother with her baby (in the tabernacle at the right of those entering), plus her Assumption and Coronation (the rose window and mosaic). And in the *Double Intercession*, the program illustrated Mary's role in the economy of eternity, as protector of Christians and their powerful advocate before Christ.

A common thread in the Marian iconography of Santa Maria del Fiore is in fact the glory to which Christ's mother has been lifted. This theme, the elevation of Mary, is repeated over and again, always in significant locations. We have already noted Gaddo Gaddi's mosaic in the arch above the main entrance (fig. 25): it is hardly an accident that, one hundred and thirty years later, the first of the stained glass windows commissioned for the drum bearing Brunelleschi's dome was again a *Coronation of the Virgin* (fig. 26), centrally positioned above the high altar in line with Gaddi's mosaic. Another 15th-century stained glass window – the center-façade rose window above Gaddi's mosaic – depicts the

217. Arnolfo di Cambio, *Maestà* ('Madonna with the glass eyes'), 1296 – 1302. Museo dell'Opera di Santa Maria del Fiore, Florence.

218. Giotto, *Maestà*, c. 1310. Uffizi, Florence.

event immediately preceding Mary's crowning: the already mentioned *Assumption* by Lorenzo Ghiberti, done in the early 1400s. And the same subject, carved by Nanni di Banco over the most important of the side doors, the "Porta della Mandorla" (which looks toward the Marian sanctuary of Santissima Annunziata), similarly proclaims the glory, prefigured in Mary, to which Christ calls all men and women.

In the new cathedral, that is, Florence articulated a "glorious" Mariology all its own, based on the surpassing dignity of the woman who is "humble yet exalted above all creatures," as Dante put it (*Paradiso* XXXIII, 2). The origin of this Mariology is ancient, rooted in the already noted Patristic identification of Mary with the Church: "The Church ..., like Mary, has perpetual integrity and uncorrupted fecundity, and what Mary deserved to experience in her flesh, the Church has preserved in its mind," Saint Augustine stated. As we saw, in the Middle Ages this parallelism had come to define a genuine "Marian ecclesiology," and a theologian of the 12th century, Blessed Isaac of Stella, had gone so far as to affirm that, "In the divinely inspired Scriptures, what is said in a general way in reference to the Virgin Mother Church should be understood to refer individually to the Virgin Mother Mary, and what is said in particular of the Virgin Mother Mary must be referred in a general way to the Virgin Mother Church. And whatever is said of one of the two can also, without distinction, be said of both."[24]

This writer adds that Mary and the Church are simultaneously *one* and *many* mothers, *one* and *many* virgins. "Both conceive through the action of the Holy Spirit, free of concupiscence, and, sinless, give the Father children." This is the way we interpreted the figure of Mary in the canvas once alongside the main inner door, the *Double Intercession*: as the Mother Church interceding with her Son for other "sons" and "daughters" she had generated – the Florentine faithful – while Christ in turn interceded with his Father. Blessed Isaac in fact asserts that "Christ is unique because the Son of one God in heaven and of one mother on earth," but is, at the same time, "the firstborn among many brothers and sisters; unique by nature, by grace he associates

219. Lorenzo Monaco (?), *Double Intercession*, c. 1400. Metropolitan Museum of Art, The Cloisters Collection, New York. Originally in Florence Cathedral, this so-called "double intercession" image, painted on canvas and attributed to Lorenzo Monaco or his shop, sums up the theological and popular character of Marian devotion at the end of the Middle Ages. The subject, derived from a 12th-century text, situates Mary's intercessory role within the context of family life: Christians turn to Jesus' mother, knowing that her Son can deny her nothing. She then turns to him, stressing her role as his mother and nurturer, and He finally asks his Father for that which Mary wants.

many with himself, in order to make them one with him."[25]

It is Mary who makes this "association" of believers with Christ possible: Mary from whom Christ took his human nature, and in whose elevation – in whose Assumption and Coronation – the whole human race finds itself "associated" with God's glory. The basic iconographical program of Santa Maria del Fiore, spelled out in the above listed works, was focused on this human participation in Christ's glory made visible in Mary.

We grasp how important it was to communicate these ideas looking again at Donatello's *Coronation of the Virgin* (fig. 26). In this earliest and centermost (eastern) window of the drum, believers were meant to contemplate the lifting-up of our human nature in Mary, and – as they advanced from the nave – to feel themselves caught up in an ascent toward heavenly glory. The two windows flanking the *Coronation* similarly evoke this ascent from earth to heaven: Paolo Uccello's *Resurrection of Christ* and Ghiberti's *Ascension*, respectively in the north-eastern and south-eastern positions. Indeed, so important was it to concentrate "ascensional" subjects in the eastern windows visible from the nave, that the narrative sequence of the cycle was manipulated: rather than follow the order we find in the New Testament, the program groups the three scenes related to Christ's infancy in the western faces of the drum, with at their center an *Annunciation* (a window designed by Paolo Uccello but destroyed by lightening in 1828 and removed); at north-west is a *Nativity* by Uccello, and at south-west a *Presentation in the Temple* by Ghiberti. The two scenes treating the Passion were relegated to the north and south faces of the octagonal drum, out of sequence in terms of the entire cycle but also between themselves, since the *Deposition* by Andrea del Castagno precedes the *Agony in the Garden* by Ghiberti. And to guarantee that the program would be perceived in Marian terms, the *Coronation of the Virgin* was illogically inserted between Christ's Resurrection and Ascension!

This curious organizational scheme made it possible to define the cathedral's principal axis with Mary-related scenes, thus extending the Marian emphasis of Arnolfo's façade and of Gaddo Gaddi's mosaic. At the same time, it articulated the Christian faith in highly positive terms, for Mary – crowned by her son between representations of his own Resurrection and Ascension – seems to assure believers gathered in the nave that, "If the Spirit of him who raised Jesus from the dead is living in you, then he who raised Jesus from the dead will give life to your own mortal bodies, through his Spirit living in you" (Romans 8:11).

Taken together, these images imply a "theology of hope" encompassing the whole human being, body as well as soul called to the glory of heaven. This theology moreover implies a unified anthropology, to which even the Florentine Neo-Platonists would give their assent. One of the greatest of these, Marsilio Ficino – a canon of Santa Maria del Fiore, commemorated in the south aisle in a handsome monument that shows him gazing heavenward, said that the human body is worthy to host man's intelligence because, "already erect, looking not down at the earth but upwards,

our body acknowledges heaven as its true father-land."[26] Ficino's words articulate a Christian anthropological vision that, in the art of Florence Cathedral, found expression in the figure of Mary.

Mary and Renaissance Humanism

This optimism regarding man was part of a new awareness of the intrinsic dignity of the person that, in the context of 14th and 15th-century Florentine humanism, decisively influenced Marian iconography. The reason is obvious: a rediscovered interest in *man* necessarily included *woman* and above all woman as *mother*, the physical and moral vehicle of the transmission of life. Indeed, Renaissance art's ability to blend solemnity and intimacy in images of captivating beauty is born of a cross between this new belief in man and the ancient faith in a Man-God, Jesus Christ the Son of Mary.

Such a mix was not the exclusive province of great masters: even a relatively minor painter, Rossello di Jacopo Franchi, easily achieved it, as is evident in his small *Madonna of Humility* for the Bini family oratory in the Oltrarno quarter, painted in the early 15th century (fig. 220). Mary's dreamy beauty, and the Child's gesture as he pulls his mother's veil to himself, are rich in meaning. The Madonna is seated, not on a throne but on the ground – on a cushion set directly on the ground, that is – in token of her humility. Yet Mary's humility, in accepting the mysterious mission God has given her, introduces the incomparably greater humility of God's Son, who accepted to be the son of a human woman. Indeed, the significance of the veil that little Jesus pulls toward himself is precisely this: the Son of God "veils" his divini-

ty beneath the human flesh given him by Mary. The mother's thoughtful expression, touched by sadness, alludes to Christ's supreme act of humility when – in his assumed flesh – God's Son died on the cross for sinners: the suffering announced to Mary shortly after Jesus' birth, when Simeon told her that "a sword will pierce your own soul too" (Luke 2:35).

We should remember that this painting was an altarpiece, and that the image of mother and child would have been seen "through" the Eucharist. Just beyond the bread in the hands of a priest, that is, believers saw Jesus' little body in the arms of his mother, and understood something of the two great mysteries of Christian faith: the Incarnation – in which, transcending Nature's limits, God's Son was born in a human body – and the Passion, in which Christ died and rose in the same body.

"Seeing" and "understanding" were an important part of Florentine spirituality in the early 15th century. In the *Little Book of Christian Doctrine* attributed to Saint Antoninus Pierozzi (compiled from the 1420s onwards, even if printed only in 1473), among the sins associated with "the experience of seeing" is insufficient ardor in contemplating Christ really present in the Eucharist: "when you are negligent about going to see the body of Christ," the author says.[28] Paintings such as Franchi's *Madonna of Humility* were meant to help spiritual people more deeply feel the connection between the Sacrament and the "body *seen*."

The *perceptive realism* suggested by Saint Antoninus' language provides a key to the *stylistic realism* of the most innovative painter in early 15th-century Florence, Masaccio, and helps explain his rejection of the fairytale elegance of such contemporary masters as Lorenzo Monaco, Gentile da Fabriano, and Rossello di Jacopo

Franchi. Or, to put it more clearly, literal faith in a "real presence" of Christ's body and blood in the Eucharist was an element in artists' choice of a stylistic idiom able to communicate the *reality* and *presence* of solid bodies seen in space.

The first in an important series of Madonnas by Masaccio is perhaps the San Giovenale Triptych, today in the parish church at Reggello (fig. 221). The completion date of the Triptych, April 23, 1422, is fully three months after the young artist's entry into the Painter's Guild on January 7 of the same year,[29] and it is thus legitimate to suppose that Masaccio already knew the great works of the Florentine tradition whose "continuer" he would become: the "Majesty" at Santa Maria Maggiore, Arnolfo's statues for the Cathedral, and above all Giotto's *Madonna Enthroned* at Ognissanti (figs. 194, 217, 218). The strong plasticity of Masaccio's figures in the Triptych, their monumental arrangement and even the presence of two angels before a throne on a projecting step clearly echo what Giotto had done a hundred and twelve years earlier.

Masaccio must also have understood the expanded meaning of similar images: Mary not only, or at least not *mainly* an individual — a single person — but as a collective presence, the

221. Masaccio, San Giovenale Triptych, c. 1422. Pieve di San Pietro, Cascia di Reggello, Florence.

222. Masaccio, *Madonna with Child* (the central element of the Pisa altarpiece), c. 1426. National Gallery, London.

"Domina" of the Book of Revelation, a figure of the Church in prayer, interior and contemplative: the Mother whose heart ponders all that regards her Son. Such interiority, which we find in Arnolfo's and Giotto's Madonnas, has been perfectly assimilated here — as later in Masaccio's *Virgin and Child with Saint Anne*, where Mary's reflective, practically sibylline mood is still more pronounced (fig. 223), and again in the almost somnolent *Madonna* of his Pisa altarpiece, lost in thought, absorbed in ineffable mystery (fig. 222). From Dante's time forward, Florentine Marian imagery seems in fact to have reactivated the ecclesiological dimension typical of the Patristic age, thanks to a rediscovery of the Church Fathers in contemporary Humanism.[30]

Every "Mariology" implies a specific Christology,[31] for Mary is "bearer" of God's son, "throne" of the divine wisdom she presents to the world: Christ, the Word made flesh in her body. This relationship is clear, for example, in the little Jesus in Arnolfo's statue, who bears a scroll to show that he is the *Logos*, the "Word," the perfect expression of the Father's being (cf. fig. 217). Masaccio too underlines this theological aspect — the divine Word made flesh — imbuing the infant Christ with heroic dignity and even monumentality,

as in the *Virgin and Child with Saint Anne*, where the Herculean baby enthroned before Mary's womb lifts his right hand in solemn blessing.

In the San Giovenale Triptych, by contrast, little Jesus is more natural, even humorous: a baby who tests his muscles, stiffening his body for an instant in his mother's arms as he puts his right hand in his mouth. Indeed, the Child's naturalness seems at odds with Mary's almost ritual solemnity.

What we see is not a merely "natural" gesture, however. The hand filling little Jesus' mouth has theological meaning as well, for – when born as a human baby – God's *Logos* falls silent: the Word does not speak, or rather speaks "wordlessly" through the vulnerability of his infant body. Human flesh – our human nature, even in its spontaneity – becomes the privileged *locus* for communicating the mystery of God.

Masaccio does something similar with the little Jesus in the Pisa altarpiece, where the baby's right hand – again in his mouth – is balanced by the left, which takes grapes from Mary's hand. The Word of God, silent except for the eloquence of his body, here takes food allusive to the Passion from his mother's hand, thus defining the meaning of his body in function of the needs of the Church. It is not hard to connect the grapes with wine, blood, Christ's redeeming Passion and the "Mother Church" who asks the Son of Man to die for the sins of other men who – like him – are her sons.

In these works, naturalness of gesture not only does not exclude but positively *invites* theological interpretation, because the Incarnation means exactly that: God revealing himself from within our human experience. The tenderly humorous babes of the San Giovenale Triptych and the Pisa Altarpiece seek to elicit a "normal" emotional reaction, extending a 14th-century iconographic tradition focused on the child at play with its mother, because in Christ the new "norm" of the relationship between God and man is inscribed in the ordinariness of human experience: in our feelings, in our emotions, in our "flesh." And, as noted above, in these works we often find explicit references to the future Passion and death of the Child.

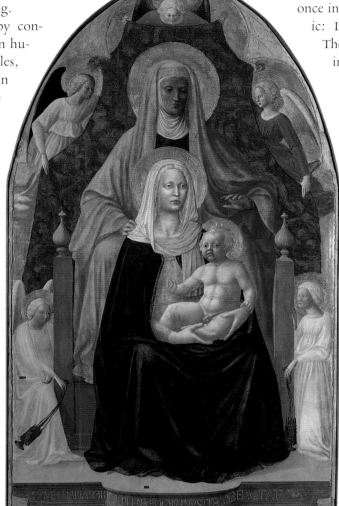

223. Masaccio (with Masolino?), *Virgin and Child with Saint Anne*, c. 1424 – 25. Uffizi, Florence. Painted by Masaccio, perhaps in collaboration with Masolino and perhaps for the church of Sant'Ambrogio in Florence, this work represents the female genealogy of Christ in its successive stages. The Child is placed in front of the womb of Mary his mother, who in turn is seated between the legs of her mother, Saint Anne. We thus see a body "born" of other bodies: the life of God become part of our history, born in our flesh literally as "Son of Man" or, rather, "of Woman."

224. Detail.

Of the same years as the San Giovenale Triptych is the most masterful expression of this tenderness at once intimate and joyous, fierce and even tragic: Donatello's *Pazzi Madonna* (fig. 227). There, in Mary's gaze of consuming love into the child's eyes, we seem to hear Saint Antoninus' teacher, Blessed Giovanni Dominici, in letters of exhortation he wrote in the early 15th century to the cloistered nuns of Corpus Domini Convent, in Venice, which constitute one of the most eloquent testimonials to the spirituality of the period. Addressing the nuns, Dominici said: "Seek [Christ] in yourselves, O lofty minds, companions of Mary, *quia regnum Dei intra vos est* Adore him, embrace him, hold him tight, kiss him, hide him away (Joseph may see but not touch the babe): hold him to the breast of your charity, letting him alone drink fully of your love"[32]

Speaking then to the "active religious," as he calls them – not choir nuns but lay sisters, normally illiterate working class women, Dominici continues: "Be like the ox and ass ..., smell the sweetness of this flower born amongst you, lick him, play with him, sing him sweet lullabies: such cooing and gurgling is dear to him when it springs from love."[33]

And in another letter, in which Christ is described as "tiny, naked, cold, crying and kicking his little legs in the hay" as he places his "sweet little mouth" on his mother's breast,[34] Dominici explains the spiritual meaning of such tender feelings: "Christ, born in the human heart, grows a little at a time. The temperature warms, the days grow longer, the earth more fair, birds chirp for pleasure, Mary rejoices, Joseph is glad, angels sing, the heavens shine, the stars grow brighter, shepherds come running, the Wise Men preach, their pack animals gaze on in wonder, the hay flowers, God and man are mixed together."[35]

In the Florence that, in the 1420s, was building a children's hospice dedicated to the Holy Innocents – and that since the 14th century had another orphanage in Cathedral Square with external frescoes depicting the melting tenderness of women for the children entrusted to them – exploration of this most basic of human bonds, the relationship between a woman and a baby at once playful and potentially tragic, became a task of the

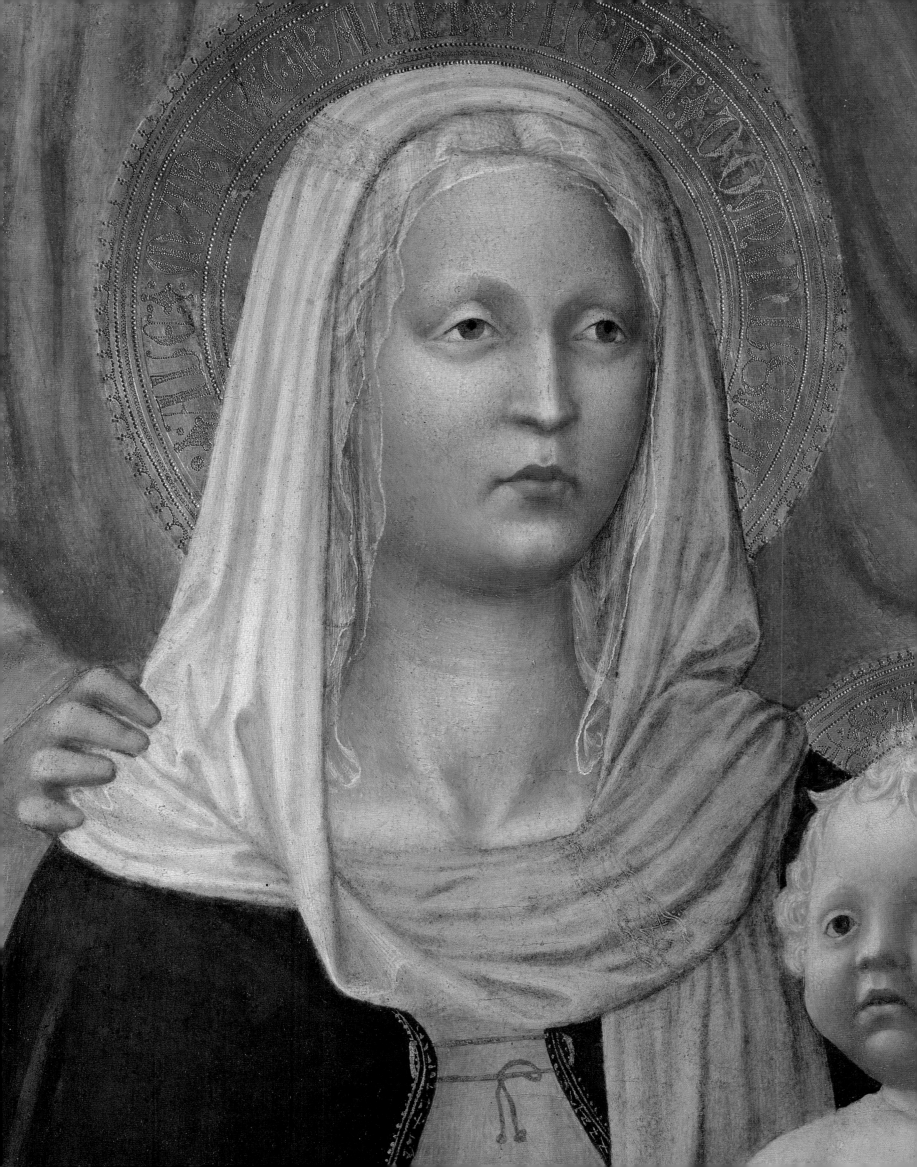

new religious art, among whose highest expressions we should count these Madonnas by Masaccio.

And, as noted above, it was all conceived in *liturgical* terms. We were meant to see the tender, white body of the baby just beyond the white host made of many grains of wheat which, "dying," become bread for human sustenance. In this process, Mary has a unique role: in the *Virgin and Child with Saint Anne*, for example, she holds the little leg of her Son the way a housewife holds dough for kneading into bread (fig. 223). Masaccio, that is, shows how Mary "makes" the body of her Son from her own body! We note, though, that guiding his mother's hand is the small hand of Jesus, because – even in her maternal role – Mary remains, as Dante called her, the "daughter of her Son."[36]

We are dealing here with "sacramental" spirituality at once realistic, corporeal and deeply concerned with the mystery of life. The *Virgin and Child with Saint Anne* recounts, in effect, the feminine genealogy of Christ, visualizing its successive stages. The baby is placed in front of the womb of his mother Mary, but Mary is in turn seated between the legs of *her* mother, Saint Anne: body born of human body, God's life produced in our history, in our collective flesh, thus becoming "Son of Man."

After Masaccio's death in 1428, a painter still more sensitive to this mystical dimension came to the fore: Blessed John of Fiesole, more generally known as "Fra Angelico," a member of the Dominican Order. Two Annunciation scenes by this master, in the Friary of San Marco a few hundred meters from Santissima Annunziata, invite comment.[37]

The better known of the two is at the head of the main staircase (fig. 225). Mary, similar in type to the Virgin in the Annunziata fresco (cf. fig. 203), is shown as an ideal figure of the friar's life: her clothing resembles the Dominican habit and she is shown seated before the door of a monastic cell in an arcaded cloister like that at San Marco. The cloister in the fresco stands, moreover, inside an "enclosed garden" (separated from the forest by a wooden fence), and thus symbolizes Mary's heart, according to the traditional reading of a passage in the Song of Songs where the "Bridegroom" says to the "Bride," "You are an enclosed garden, my sister, my bride: an enclosed garden, a sealed fountain" (Song of Songs 4:12). In the same way, the friar's heart was to be an "enclosed" space, virginal in character, where only Christ might enter.

In her profound attention to the angel, Angelico's annunciate Virgin taught the friars (who saw the fresco when they climbed the stairs from the cloister to the upper corridor en route to their cells) how to use their hours of rest, study and prayer. As the Bride says in the Song: "I sleep but my heart is watchful. A noise! It is my Beloved knocking: 'Open to me, my sister, my

love, my dove, my perfect one ...'" (Song of Songs 5:2).

The other *Annunciation*, in one of the cells in the east arm of the corridor, is still more interior in tone, more contemplative (fig. 226).[38] Once again the scene is set beneath the arcades of a cloister, but the viewer here is *inside*, not outside: near the slender figure of Mary, shown kneeling as she listens to an angel also *inside* the cloistered space. There is no garden or other landscape indication: the entire visual field is occupied by a white masonry background against which three figures emerge with stark drama: the Virgin, the angelic messenger, and – at the viewer's left – a Dominican saint who contemplates the event.

There is a fourth actor in the scene, not immediately perceptible but essential to the image's formal and narrative balance: light. Stealing in from the left together with the angel, a gentle luminosity penetrates and fills the space: an extraordinarily subtle pictorial effect, white on white, a milky glow on the surface of the plaster wall depicted in the fresco. At the very instant in which Mary conceives, Angelico shows us "the true light, that which enlightens every man" (John 1:9) enter and fill this cloister just as Christ enters and 'fills' Mary's life.

And the yearning on Mary's face – intense and confident, humble yet strong – suggests the response to which every human being is called, the "conversion" from darkness to the Light which is salvation. Indeed, as light invests this space which – like the relief on the south side of the Cathedral (fig. 197) – stands for Mary's womb, it also invests the fabric of her robe, the hem of which is diaphanous in token of a spiritualization to which, from this time forward, all humans are called.

Mary in the Houses of the Wealthy

Angelico's frescoes at San Marco, like the contemporary architectural improvements to the Friary, were paid for by a wealthy banker, Cosimo de' Medici called "the Elder." When work at San Marco was finished, Cosimo asked the architect employed there, Michelozzo, to build him a sumptuous town house, Palazzo Medici (subsequently "Medici-Riccardi"). In 1459 the chapel of this palace was decorated with frescoes by a pupil of Fra Angelico's, Benozzo Gozzoli.

Taken together, these facts suggest the new orientation of patronage and art in the second half of the 15th century: private, aristocratic, focused on family life. Painters still had an interest in subjects of great conceptual complexity: for the same chapel of the Medici Palace, for example, Fra Filippo Lippi painted the altarpiece shown in our first chapter (fig. 57), with Mary who adores the newborn Christ Child, with the baby's body directly below the Holy Spirit "effused" by God the Father – a brilliant layering of themes relative to the Trinity, the Incarnation and the Eucharist (the panel was on the chapel altar, and Lippi's Christ Child would have been directly in front of the priest as he consecrated the bread and wine at Mass).

Yet most works produced in this period were less theological, more intimate, and the mansions of Florentine nobles, merchants and bankers gradually filled with images allusive to family life.[39] It was the "Age of the Madonnas," so to speak, and the preferred subject was Mary with her little boy. Filippo Lippi himself gives the tone of this *bourgeois* style, in a painting still visible in Palazzo Medici (fig. 228): a Madonna, fashionably dressed in a brocade dress and head scarf trimmed with gold and pearls, embraced by the Child whose shirt is of some marvelously light fabric, such as the sons of the rich wore. Only the magnificent colored marble background evokes a sacral dimension, and Mary's position – in a classicizing niche, as if she were a living statue – is curious. She is all too visibly a human woman, just as the affectionate little Jesus is visibly a human child: Lippi in fact reveals the baby's genitals to emphasize that God's Son has become "true man."[40]

The market for private images was flourishing, and all the painters and sculptors of the period tried their hand at this genre. A charming relief in glazed terracotta by Luca della Robbia suggests the liveliness of these products, which were almost always highly individual (fig. 229). Yet if we compare these pretty Madonnas – a bit thoughtful but basically healthy mother figures – with Donatello's *Pazzi Madonna*, absorbed in passionate contemplation of her Son (fig. 227), it is clear that something has been lost, some indefinable inner tension been relaxed.

This aristocratic style reaches its peak in the 1480s and '90s, in the art of masters employed by the important families, Sandro Botticelli and Domenico Ghirlandaio in particular. The refinement of Botticelli's exquisite *Magnificat Madonna* (fig. 230) – in which Mary writes the New Testament canticle, her hand again guided by that of her son – stems from the artist's extension to the whole composition of the "calligraphic" conceit of his subject; it is a formal masterpiece in which, however, aside from the Virgin's generic air of melancholy, little suggests deeper religious or human content.[41] Similarly, Ghirlandaio's scenes of the *Life of the Virgin* frescoed in Santa Maria Novella (fig. 231) invite us to admire the splendid interiors of patrician palaces and the rich clothing worn by their inhabitants; but of the humble maid of Nazareth, Christ's mother and perfect disciple, we see little.

Fra Girolamo Savonarola, the fiery preacher from Ferrara who settled in Florence, would fulminate against such works. In a Lenten sermon of 1496, after complaining that young men amused themselves identifying sacred figures in paintings with

living women, calling one "Magdalene" and another "Mary," he spoke directly to artists, saying: "You painters do harm, and if you knew the resulting scandal you wouldn't paint figures such as these, filling our churches with human vanity. Do you really think the Virgin Mary went around dressed as you depict her? I assure you she dressed like a poor girl, simply and modestly, and was so well covered that all you could see were her eyes. Saint Elisabeth too dressed simply. You would do everyone a favor if you wiped out the suggestive figures you have painted: you show the Virgin Mary dressed as if she were a prostitute!"[42]

Exploring the Psyche

Botticelli eventually succumbed to Savonarola's influence, becoming one of the friar's followers and producing, at the turn of the 16th century, works tinged with the preacher's feverish religiosity. Other artists made the shift even sooner, including Botticelli's brilliant pupil, for example, Filippino Lippi (son of the Carmelite friar Filippo), who, as early as the 1480s, began to explore complex inner states in his painted subjects, as if seeking a way out of the frivolity of contemporary art: a new realism, psychological in character.

Among Filippino's "psychological" masterpieces is a panel in the Florence Abbey, *The Vision of Saint Bernard* (fig. 232), originally painted for a small monastery controlled by the Abbey, Santa Maria alle Campora di Marignolle, outside the city's southernmost gate, the Porta Romana.[43] During the 1529 siege, when the troops of Charles V occupied the entire southern perimeter of Flo-

226. Fra Angelico, *Annunciation*, c. 1440. Cell 3, Convento di San Marco, Florence.

227. Donatello, *Pazzi Madonna*, c. 1422. Gemäldegalerie, Berlin.

rence, including the area where Santa Maria di Marignolle stood, the Abbey monks saved this painting, transferring it from the war zone to their church inside the city walls.

The subject is an event made famous in the 13th-century text, the *Legenda aurea*: a mystical vision in which Saint Bernard of Clairvaux, a monk-theologian who had often written of Mary with poetic force, in a moment of weakness was visited by the Virgin, who restored his courage. Filippino's interpretation underlines both the privacy of this experience and its mystic intensity, situating Bernard in a sort of rustic study where the books required for his work are arranged in the irregularities of a rock formation, and a tree trunk supports the lectern on which Bernard, robed in the white habit of the Cistercian Benedictines, is shown leaning.

The saint had been writing on the theme of the Annunciation: the open book in the center of Filippino's composition shows the relevant text from Saint Luke's Gospel, the words perfectly legible. Now, however, Bernard lifts his eyes and sees Mary enter escorted by angels. That is, he sees an "annunciation" in which the roles are reversed: Mary comes to him just as Gabriel had come to her, to announce salvation. The Virgin, pale and hesitant as if she personally experienced the exhaustion of her troubadour, places her hand on the page where Bernard had been writing, and the saint lifts his own hands and looks at Mary in astonishment. In his expression we see love and dawning understanding.

This entire episode is isolated in the foreground of the picture: the other monks, beyond the rock formation, do not see Mary but only a light in the sky. We by contrast – like Saint Bernard

himself – see first hand the help Mary gives the saints: Filippino in fact concentrates our attention on the large figures in the foreground, enclosing the event in the tightly packed "psychological space" that extends from the viewer to the wall of rock. An inscription on the frame suggests the meaning this painting had for the man who commissioned it, Piero di Francesco del Pugliese, shown in prayer on the right: In rebus dubiis Mariam cogita, Mariam invoca, "In matters which raise doubts, think of Mary, invoke Mary."

The other Florentine master who, starting in the 1480s, "re-read" Marian piety and iconography in psychological terms was Leonardo da Vinci. Two works in particular can suggest the novelty of his approach: the *Virgin of the Rocks* and the *Virgin and Child with Saint Anne*, both now in Paris, with a slightly different version of the former in London, usually considered later in date.[44]

In the Paris version of the *Virgin of the Rocks*, painted in Milan but perhaps on the basis of ideas developed before Leonardo left Florence in 1481, we see Mary in the center with the child Saint John the Baptist kneeling in prayer, at her right (the viewer's left), and baby Jesus at her left, in the act of blessing (fig. 233). Behind Jesus, a kneeling angel points to little John the Baptist on the other side of the composition, and Mary, at the center, has one hand on Saint John's shoulder while the other descends toward the head of her Son.

These overlaid, intersecting gestures hold our attention. The angel's stiff, pointing hand is actually "framed" – set as if in parentheses – by Mary's left hand, descending, and the right hand of Jesus, raised in blessing. This left hand of the Virgin must have stirred admiration in 15th-century viewers: Leonardo's skill in foreshortening is consummate, and shows perfect mastery of certain aspects of North Italian illusionism developed in Antonello da Messina's work in Venice and in paintings by Mantegna. But the impact of three hands shown in proximity, and the accumulation of eloquent but distinct gestures are ultimately Florentine inventions, originating perhaps in the bronze statuary group that Leonardo's teacher, Andrea del Verrocchio, was completing in these same years for Orsanmichele: The Incredulity of Saint Thomas.

Here, as in Verrocchio's group, moreover, we have the impression that all the gestures – especially the angel's as he points at Saint John – are *functional*, giving the answer to some question, showing the solution to some problem. But if Saint John, so clearly indicated by the angel, is the "answer," then what is the question? If the little Precursor is the solution, what is the problem? In a word, why does the angel point to little John the Baptist with such emphasis?

Who is John the Baptist in the New Testament and in Christian tradition? Actually, he has several roles: as the "precursor" who prepared the Lord's way, preaching repentance; as an exemplar of ascetic life, who while still a child chose the desert (a fact stressed by 13th– and 14th-cenury hagiography and popular legend, and well known in Florence which claimed John as its patron saint). But the Baptist's main role in the New Testament is *to identify Christ as the one who must suffer*. At the culminating moment of the Baptism, when from heaven God the Father calls Jesus his Son, Saint John from the earth identifies him as the *Agnus Dei*, the "Lamb of God."

From the heart of the Jewish tradition, that is, John – the last and greatest of the prophets, a second Elijah – identifies Jesus as the *sacrifice acceptable to God* for the salvation of his people, and does so with a term – "lamb" – that suggests the meekness with which Jesus would let himself be led to slaughter. Turning again to Leonardo's painting, we note that – if Saint John personally "symbolizes" the Passion – Jesus, in blessing the prophet of his own death with the sign of the cross, clearly accepts and even

welcomes that destiny. How does Mary react in the face of this "complicity": of little Saint John announcing, and baby Jesus accepting, the Passion? As painted by Leonardo, the Virgin does two distinct but related things, clearly indicated by her gestures. With her beautifully foreshortened left hand she begins a protective movement: the hand descending to caress her little boy's head is an absolutely natural, maternal gesture, an instinctive reaction. But with her other hand – the one we see on Saint John's shoulder and which most scholars interpret as a gesture of welcome – Mary tries to stop the little "precursor." Her unnaturally bent wrist, her long arched fingers pressed into the child's back and her stiff thumb do not "welcome" Saint John but *arrest his forward movement and pull him back!* The little prophet of the Passion leans toward Christ, who in his turn welcomes him with the very sign of his own future death on the cross, but the mother reacts immediately and instinctively, distancing the danger from her Son with her right hand, even as her left begins a gesture meant to protect her child.

Her left hand *begins* a gesture, but cannot complete it. That hand descending – open and concave, corresponding to the convexity of the small head it must protect – will never reach the head, because the vertical rhythm of its movement is interrupted by the horizontal gesture of the angel (horizontality underscored by the yellow lining of Mary's cloak). Indeed, the angel's gesture disturbs not only the rhythm of Mary's hand but the

whole composition of the central group: a circular composition that starts with Mary's gaze, descends toward John the Baptist, turning with Mary's wrist, descending again along her thumb and Saint John's right arm, finally reaching Jesus where it begins to rise again, returning to Mary, whose left hand should complete the circuit. It is basically the same "closed circle" composition we see in Botticelli's *Magnificat Madonna*, widely used in the 1480s by Pietro Perugino as well, and later by Perugino's pupil, Raphael.

In the *Virgin of the Rocks*, Leonardo destroys the harmony of this compositional scheme with the angel's gesture indicating Saint John because he wants to suggest, in the central figure, Mary, a state of mind that is anything but harmonious! A true mother, Mary tries to keep the prophet of the cross far from her Son, *but cannot:* her natural protective instinct is impeded by a supernatural plan, in which – as the angel insists – the prophet and precursor of Christ's Passion necessarily has part.

That a late 15th-century artist could imagine, and a contemporary public understand so complex a psychological drama is confirmed by the other work illustrated here, the *Virgin and Child with Saint Anne* (fig. 234), depicting a theme which Leonardo elaborated in various forms during his Milanese years and thereafter. Back in Florence in 1501 he exhibited a large preliminary drawing, now lost, which the agent of the Duchess of Mantua, a certain Fra Pietro da Novellara, described as follows: "The only thing

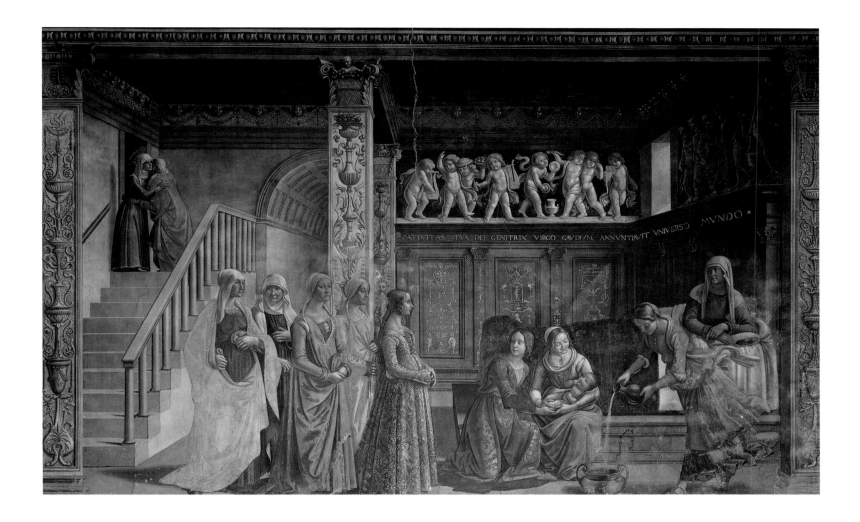

[Leonardo] has done since he returned to Florence is a sketch in the form of a cartoon. It shows a Christ Child, about a year old, who – as he breaks free of his mother's arms – reaches out to a lamb and seems to hug it. The mother, almost rising from Saint Anne's lap, reaches out to separate her baby from the lamb, which is a sacrificial animal standing for the Passion. Saint Anne, also rising a bit, seems to want to prevent her daughter from separating the child and the lamb; perhaps she represents the Church, which does not want Christ's Passion impeded …"[45]

Even if the subject of the *Virgin and Child with Saint Anne* is different from that of the *Virgin of the Rocks*, it is clear that the two paintings have the same theological and dramatic structure, dealing with the human nature of the young mother who wants to separate her beloved baby from a symbol of his Passion (here the lamb, in the other work little Saint John).[46] And in both instances, the mother's protective effort is impeded by a personage whose task is to insist on the religious "necessity" of the Passion. The ease with which Fra Pietro da Novellara writes these things to the Duchess Isabella d'Este is striking, though: as if he takes it for granted that, as a cultured person, she will readily understand them. We know he had frequent contacts with Leonardo as he promoted his noble patroness' interests, and it is possible that – in the passage just quoted – Fra Pietro is citing

230. Sandro Botticelli, *Magnificat Madonna*, 1480 – 81. Uffizi, Florence.

231. Domenico Ghirlandaio, *Birth of the Virgin*, 1485 – 90. Santa Maria Novella, Florence.

the painter's ideas and even his words. In these works, Leonardo shows us a curiously "modern" Mary: a woman with problems who must struggle to remain faithful to her vocation. Among many elements that influenced this new way of imagining the Virgin, we should mention devotion to Our Lady of Sorrows, officially sanctioned in 1423 and promoted in Florence by the Order of the Servants of Mary at the Santissima Annunziata (it was in fact for this community that Leonardo executed the cartoon of the *Virgin and Child with Saint Anne* seen by Fra Pietro da Novellara). The biblical basis of this devotion is the Gospel passage in which Simeon, holding the newborn Jesus in his arms, prophesies the Passion and announces to the young mother that a sword will pierce her heart too (Luke 2:35).

The same ideas help us understand the Louvre version of the *Virgin of the Rocks*. The subject, again, is Mary who "foresees" the Passion with that almost physical awareness of her Son's future suffering which we find in traditional iconography. But Leonardo transforms the tradition, creating – in place of symbolic allusions such as grapes or the veil – a tight-knit human unity through groups of persons whose contrasting emotional reactions unfold as in Classical tragedy. And in place of the generic melancholy of the Madonnas painted by his contemporaries, Leonardo shows a woman whose fluid, changing state of mind

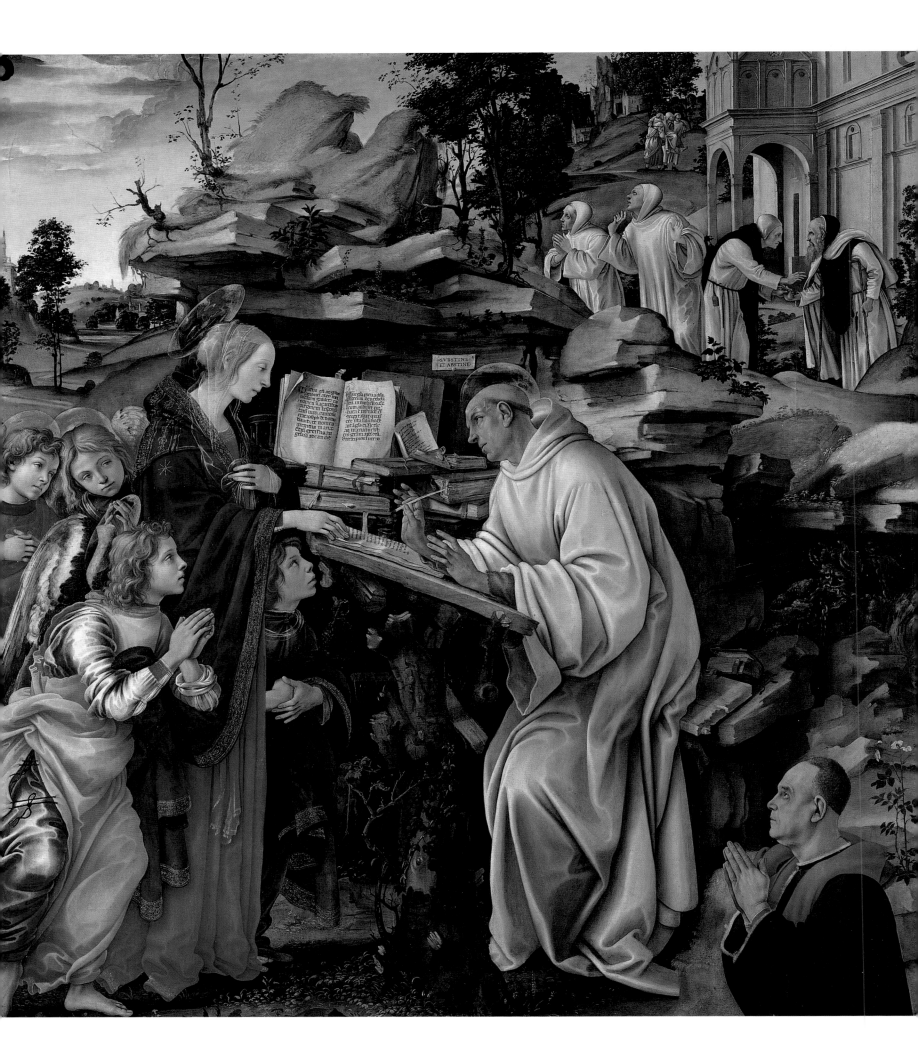

232. Filippino Lippi, The Vision of Saint Bernard, c. 1485. Badia Fiorentina, Florence. Done for a small monastery on the outskirts of Florence, this work was moved into the city to save it from destruction, during Charles V's siege of Florence in 1529. The subject derives from the 13ᵗʰ-century Golden Legend: to Saint Bernard, a monk theologian who had written much of her, Mary appears in vision, to give strength to his soul, momentarily uncertain. Near the portrait of the donor at the lower right, an inscription suggests the moral sense of the image, inviting viewers to always seek Mary's help when in doubt. Like other works by Filippino Lippi, this painting illustrates a new, psychological trend in Florentine art at the end of the 15ᵗʰ century.

suggests the conflict between nature and grace within her. His subject is the dramatic coexistence, in Mary, of perfect docility before God's will with her nature as a human woman who – albeit free of sin – must still struggle to remain obedient. We sometimes find this drama described in 15ᵗʰ-century poetry: in Fra Battista Mantovano, for example, whose verses "paint" a figure of the Virgin surprisingly similar – at least as regards to interior complexity – to Leonardo's Mary figure in these two works: "Non ridens, non tristis erat, sed mixtus utroque vultus; terram membris habitat, Olympum mente" (Her face was neither smiling nor sad, but a mixture of the two; her body dwelt on earth, her mind in heaven").[47]

Even the mysterious geological formation we see in the Virgin of the Rocks should probably be understood in the context of this interest in Mary's "psychological martyrdom." In devotional and theatre texts of the 15ᵗʰ and early 16ᵗʰ centuries, Mary sometimes recalls Christ's sepulcher in relation to her own pregnancy and to her Son's infancy. In one devout text, for example, we read that the "new tomb" that received Christ's body when he was deposed from the cross "stands for the virginal womb of his mother."[48] And in the mystery plays of the period, Mary, accompanying her Son's dead body to burial, reproves the Archangel Gabriel for having duped her, asking poignantly: "Is this then the joy you promised, saying that I would be 'blessed among women'?"[49] In a particularly moving passage she speaks directly to the sepulcher, saying: "O cruel stone, are you perhaps Mary, are you the mother that so loved him? Release him from your hard embrace, for I am the one who gave him suck …"[50]

These reflections sketch contexts and define limits within which the religious imagination of the late 15ᵗʰ century moved with considerable freedom. The Virgin of the Rocks and the Virgin and Child with Saint Anne are in fact products of that freedom: humanist commentaries on traditional religious ideas, illuminated by Leonardo's gift of penetrating naturalistic observation. Both paintings take for granted – in the "actors" (the personages shown) and in the "audience" – enlarged psychological and emotional capacity, broadened moral aperture and new greatness of spirit. These qualities, indeed, must have been among the "wonders" that, according to Giorgio Vasari, Florentines rushed to admire in Leonardo da Vinci's cartoon exhibited in 1501: not only the compositional complexity and technical refinement we imagine in that lost masterpiece, but also an amazing capacity to interweave complicated and nuanced relationships in the form of human drama.

Mary in the Tondo Doni

The work in which we sense a kind of "response" to Leonardo's innovations is the Tondo Doni by Michelangelo Buonarroti (fig. 235), commissioned by Agnolo Doni and his wife Maddalena Strozzi.[51] Executed after completion of the David in 1504 but before the artist's return to Rome (1506 – 1508), the Tondo Doni affords a clear vision of Michelangelo's qualities as painter in the years immediately preceding the frescoes of the Sistine Chapel ceiling. Painstaking restoration in the early 1980s in fact revealed the same luminous colours found in the Sistine Chapel (where the authorities had simultaneously begun an analogous cleaning process), and the absolutely parallel results of the two restoration projects support the conclusion that, in the Tondo Doni, we have the sole example of Michelangelo's panel painting to have reached us complete and perfectly preserved.

The one area of doubt regarding the work has to do with its subject, often described as a "Holy Family," even though significant iconographic elements do not correspond to that theme: above all, the five nude youths in the background. To all effects and purposes, the full iconographic sense of the Tondo Doni is still unclear, despite numerous efforts at exegesis.

The first writer to comment on the work, Giorgio Vasari, does not in fact call it a Holy Family. This 16ᵗʰ-century art historian describes the painting as "an Our Lady [una Nostra Donna], who – kneeling on both legs – has a baby in her arms which she gives to Joseph, who accepts him from her."[52] Vasari was struck by the central figure, Mary, and by the complex movement of her body, which dominates the whole foreground of the picture. He goes so far as to specify her state of mind, claiming that "Michelangelo lets us see … her wonderful contentedness" – an inner condition Vasari recognizes "in the turn of the head of Christ's mother, and in the way she keeps her eyes fixed on her Son's surpassing beauty." He says moreover that Mary's "contentedness" derives in part from "the pleasure she has in sharing the Child with that holy old man, who – with equal love, tenderness and reverence – takes him from her" (modern scholars tend to read this movement in the opposite sense, as the "holy old man" giving the Child, and Mary accepting him). Vasari says nothing of the little Saint John the Baptist behind the central group, and explains the nude figures in the background as a bravura display of anatomical knowledge on the part of the young Michelangelo: "To put his extraordinary artistic skills to better show, in the background of this work he painted many nudes leaning on each other, standing and seated."[53]

This description by Vasari is conceived in conventional terms

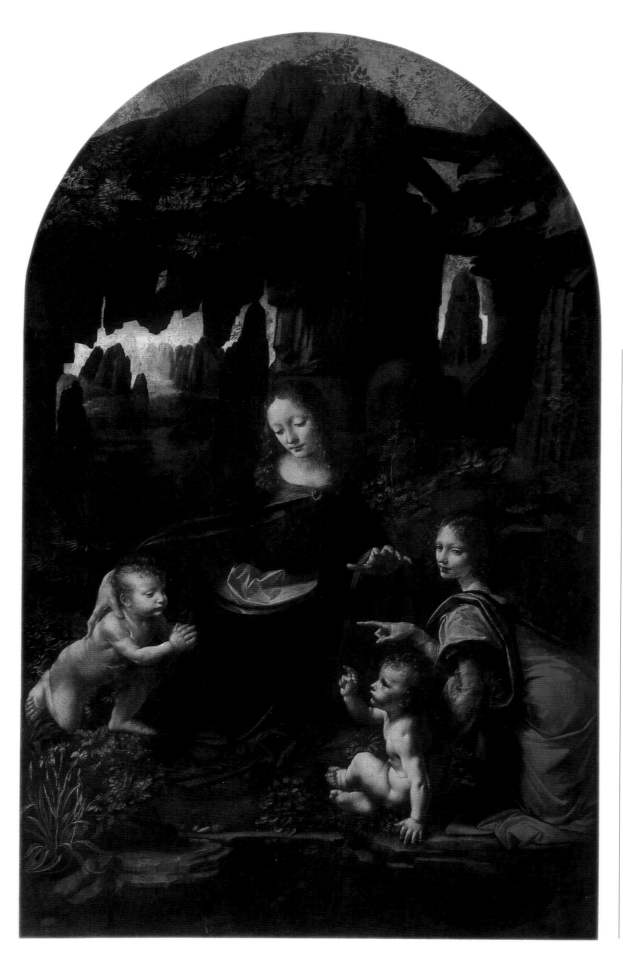

233. Leonardo da Vinci, *Virgin of the Rocks*, 1483 – 86. Louvre, Paris. In the Paris version of this theme, Leonardo, an accomplished interpreter of human psychology, draws upon the tradition of Marian theology and devotion to suggest the inner drama Mary experienced. An angel indicates little John the Baptist as the precursor who will announce Christ's death, and the baby John in fact turns to Christ, who blesses him in acceptance of this fate. But Mary, who as mother wants to distance her Son from suffering, tries with her left hand to protect his head but cannot do so, since the angel's hand pointing to the prophet of suffering, John the Baptist, interferes with her instinctive movement.

234. Leonardo da Vinci, *Virgin and Child with Saint Anne*, 1510 – 13. Louvre, Paris. Different in its subject matter from the *Virgin of the Rocks*, but similar in dramatic and theological structure, this painting shows Mary as a young mother trying to separate her Child from the lamb which symbolizes Christ's future death. Again, though, Mary's desire to protect Jesus is thwarted by another personage – in this case Mary's own mother, Saint Anne, who seems to insist upon the necessity of the future passion. As in the *Virgin of the Rocks*, Leonardo here creates an image of human psychological interaction, with "actors" whose emotional reactions unfold as in classical drama. Using women who are also mothers, he explores the expanded psychological and emotional potential of "Renaissance man" to project a new image of human dignity.

that call to mind hundreds of late 15th-century panel paintings with religious subject matter, from the "Mystical Nativities" of Fra Filippo Lippi – which show Mary contemplating her Son with Saint Joseph and/or the little Saint John the Baptist nearby and other figures in the background (cf. fig. 57) – to innumerable variations on the theme developed in Sandro Botticelli's shop, especially by Jacopo del Sellaio.

When, however, we turn from Vasari's text back to the Tondo, such categories are clearly inadequate to explain the absolute novelty of what Michelangelo created. For a compositional format more or less common in Florentine art at the turn of the 16th century, Michelangelo Buonarroti provides an unusual solution: a dynamic central group that, with an upward spiralling movement, activates the composition vertically, not only on the first plane – as in *tondi* by Botticelli (see above, fig. 230) and Luca Signorelli – but *in depth*. And for the most common subject of the whole religious repertory, Mary, Michelangelo invents a figure which is genuinely unique in the entire history of Christian art. His "Our Lady" in the *Tondo Doni* has nothing to do with Marian types dear to the late 15th century – lyrical, a bit sad, conventionally sweet – which Michelangelo knew and had even used a few years earlier, for his *Pietà* in Saint Peter's Basilica, carved in 1497 – 98 (cf. fig. 172).

But why abandon Marian typologies sanctioned by centuries of popular piety, to create, in the *Tondo Doni*, a woman athlete whose muscular arms are *uncovered* (a detail that must have deeply troubled Michelangelo's contemporaries)? The artist's documented interest in Greco-Roman sculpture does not suffice to explain so radical an innovation, which moreover would be fundamental in the development of Michelangelo, who in the years following the *Tondo Doni* often represented heroic women, more masculine than feminine in appearance. The new Marian typology is therefore the first and most important interpretive problem regarding the *Tondo Doni*.

A second problem has to do with Michelangelo's "Joseph," also new in typology, a break with earlier tradition. In medieval and 15th-century art, the protector of Mary and Jesus was normally shown on the fringe of depicted events: often asleep and in any case *separated* from Mary, as if artists wanted to underline the vicarious nature of Joseph's roles as "husband" and "father." An increase of devotion to Saint Joseph in the late 15th century improved his pictorial status, and in a *Holy Family* by Luca Signorelli – a work almost contemporary with the *Tondo Doni* – the saint has a monumentality very like that which Michelangelo gives him.[54] Yet Signorelli's Joseph remains physically and psychologically separate from Mary and the baby, a thoughtful observer, whereas in the *Tondo Doni* Michelangelo shows us an extraordinarily virile old man who, with unheard of familiarity, spreads his legs around the Virgin's body: an interpretation of the theme without any precedent and simply shocking.

The third interpretive problem has to do with the nude figures

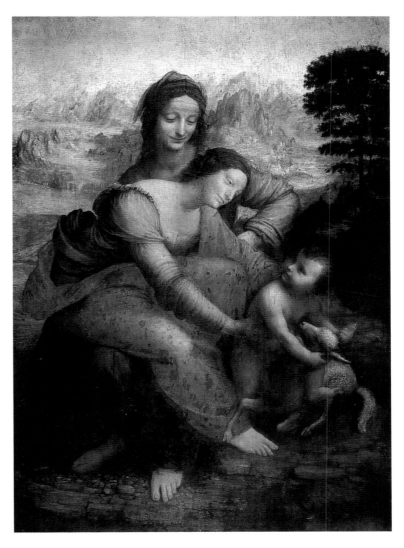

seen at left and right of the central group, beyond the grey band that divides the composition horizontally, as if it were the coping of a wall separating the foreground terrain from a lower area in the middle background (fig. 56). These five nude youths, muscled but fleshy, lean on one another as they embrace and exchange meaningful glances. Every effort to explain the *Tondo Doni* has to come to terms with these figures' role in the overall interpretation of the painting.

A possible key to the iconography of the *Tondo* is furnished by Marsilio Ficino, the major humanist of the Neo-platonic circle that had taken shape in the Medici household from the 1460s onwards: a thinker still active in the years in which Michelangelo lived in the Medici Palace (1490 – 92). In his *Convivio* (a commentary to Plato's *Symposium*), Ficino develops the ideas which – in the ancient original text – were introduced by Socrates in response to the question: "Which is the truer love, that which a man feels for a woman or that felt for a boy?" Socrates chose homosexual love because, he said, it is more likely that this evolve from sensual bond to spiritual friendship. According to Socrates, whereas heterosexual love produces mortal offspring in the body, "Platonic" homosexuality – once purified of its physical element

235. Michelangelo Buonarroti, *Tondo Doni*, c. 1504 – 06. Uffizi, Florence. Michelangelo responded to Leonardo's innovations with this painting commissioned by Agnolo Doni and his wife, Maddalena Strozzi, in the first years of the 16th century. As the only finished panel painting by this master, the *Tondo Doni* is in fact Michelangelo's most developed work prior to the Sistine ceiling. The iconography, of difficult interpretation despite numerous attempts to decipher the image, presents Mary as the central element of a rising, spiral composition developed in the foreground and background. Michelangelo invents a new Marian type: a powerful woman rising to receive the Son who, coming out of God his Father, is about to descend into her womb. Perhaps inspired by the writings of Marsilio Ficino, Michelangelo here makes Mary a universal symbol of human desire: of the act of desiring generated by the loving gaze and of the spiritual yearning of the human creature for God.

236. Detail.

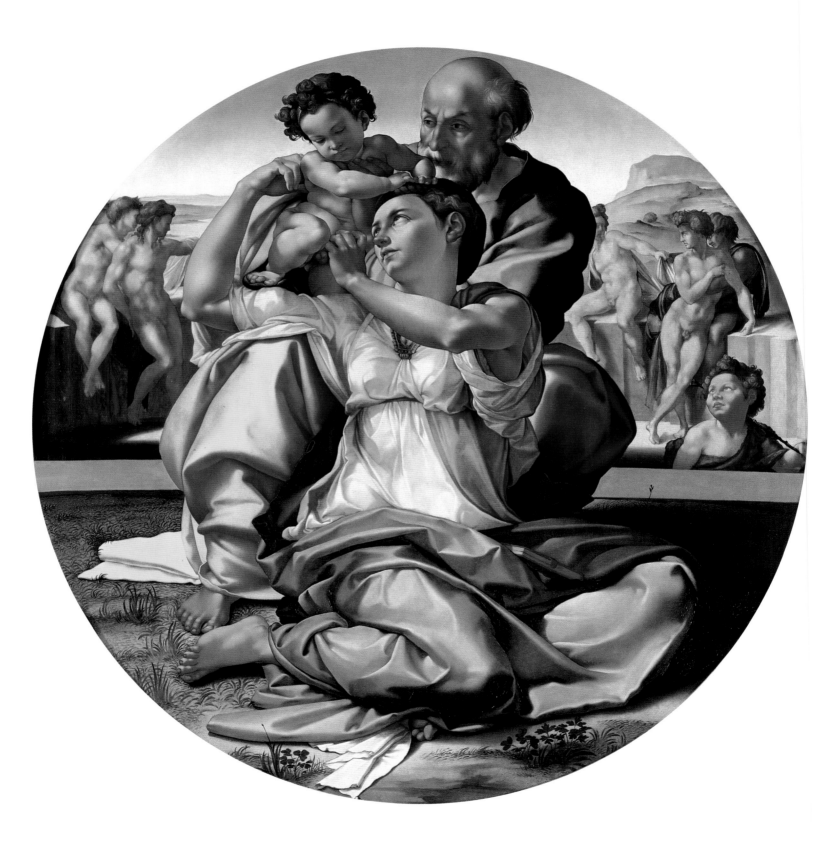

– generates immortal ideas in the soul.[55]

The experience described by Socrates follows an exact pattern. The lover feels an initial physical attraction on seeing a given person, but this attraction remains neither physical nor exclusive, for the lover soon perceives that the beauty which draws him is similar to beauty seen in other objects as well, and thus broadens the horizon of his desire. He then comes to see that beauty of spirit is more honorable than exterior comeliness, and from there goes on to consider the abstract beauty of institutions, laws and sciences, arriving finally at the vision of a single "science": that of universal beauty.

er hand we are called to contemplative life, the act of looking at a beautiful person will lift us to reflect upon his "spiritual and divine form" ("*a forma et corporalis aspectu ad spiritalis atque divinae considerationem erigimur*"). And if we are destined for the active life, we will try to preserve the initial visual pleasure through friendship, which permits us to look at and converse with the admired person ("*in sola illa videndi et conversandi oblectatione perseveravamus*"). Ficino says that contemplative love leads to a purely spiritual state, whereas sensual love leads downward to base actions, and active love keeps us midway between the two; and these three ways of looking and loving have differ-

Ascending in this way from things of earth to spiritual realities, the lover comes finally to contemplate absolute beauty, which is true, divine, pure, clear, limpid. And at that point, contemplating true beauty with the eyes of his mind, the lover becomes a friend of God and "immortal," as Socrates puts it.[56] According to the Platonic text, this ascent toward God unfolds in successive phases, but *always originates with the act of looking at another person*; it begins, that is, with a loving gaze directed toward the person who attracts us.

Ficino, who was a humanist but also a priest, and from 1487 onwards Canon of Santa Maria del Fiore, reformulated Plato's text in Christian categories, translating the erotic language of the original into the mystical terminology of the Fathers of the Church (who had similarly made use of terms and mental categories deriving from Plato). Thus, speaking of the "two Venuses" – spiritual attraction over physical attraction – Ficino distinguishes three intermediate stages, one of which is equidistant from the other two, which in their turn gravitate toward the absolute forms of love: at one end of the spectrum, contemplative love, and, at the other, mere satisfaction of the body's baser needs ("*ad ministeria viliora*").

Ficino says that all human beings incline to one of the stages between the two extremes. In practice, he defines three different ways of living: people drawn to contemplative love will live on the basis of spiritual knowledge; those whose inclination pulls them in the opposite direction will live according to the senses; and between these two possibilities there is the active life. Yet in all three cases, Ficino says, love begins with the act of gazing at an attractive body, and it is only the subsequent reaction that differentiates one kind of lover from another. If we incline toward the "*voluptuosa vita*," we will soon descend from visual pleasure to tactile desire ("*a visu ad concupiscentiam tangendi discendimus*"); if on the oth-

ent names: "divine," "animal," "human."[57]

In the *Tondo Doni*, Michelangelo appears to reproduce Ficino's tripartite division, showing us three kinds of love in three distinct areas of the painting. The nude youths in the background, on a terrain that is lower than the foreground area, 'descend' to tactile pleasure, touching each other and embracing. By contrast, on the elevated terrain of the foreground, Mary – always an ideal figure of the contemplative life – lifts herself toward God revealed in her Son. And in the middle, equidistant from Mary and from the nude youths, Saint John the Baptist, "the friend of the Bridegroom" (John 3:29), gazes with intense ardour toward Mary and Christ.

The loving gaze that we see not only in Saint John, but also in Mary and even in the nude youths, is in fact the most evident point of connection with Neo-Platonic ideas. For Michelangelo, as for Ficino following Plato, everything seems to begin with the act of looking: with a gaze that generates desire. The nudes, Saint John, and Mary all do the same thing, in fact: they look. The nude youths look at each other, with desire that remains closed upon itself, unable to move beyond the threshold of the senses; John the Baptist, midway between the "pagan" background and the "Christian" foreground, turns his back on the nudes to look toward Christ. And Mary, gazing up into the eyes of her Son, seems ecstatic, physically lifted up by love (fig. 236).

"*Amor itaque omnis incipit ab abspectu*," Ficino had written: "Every form of love begins with sight,"[58] and the same intuition allowed Michelangelo to invest these nine figures in the *Tondo Doni* with extraordinary visual and emotional harmony, uniting them even as he distinguishes them. The psychological linchpin of the entire composition is the gaze, imbued however with different meaning in the nudes, in Saint John and in Mary. Vasari seems to have grasped this central role of the act of looking, for he insists that

"Michelangelo lets us see" Mary's interior state "in the turn of the head ... and in the way she keeps her eyes fixed on her Son's surpassing beauty."

If we read the painting in this way, even the revolutionary figures of the "holy old man" and Mary become intelligible. The old man in the *Tondo Doni* flouts the iconographic tradition of a passive Joseph, separate from Mary, for the simple reason that *he is not Joseph*: he does not represent the surrogate father, that is, but the real one, God, from whom the Son proceeds *ab aeterno*.[59] Vasari was mistaken when he said that "the holy old man ... takes" the baby from Mary; it is rather the baby who "emerges" from the Father, with his left foot on the Father's thigh and his little hands in Mary's hair to maintain his balance. The Baby, with his right foot on Mary's arm, is about to push himself up and over, in order to descend into the Virgin's womb. Mary in turn lifts herself up in order to cooperate with the Baby's complex movement, and as she does so turns to look at him.

Michelangelo, that is, depicts the temporal and moral "moment" of Incarnation, when of his own free will the eternal Word came forth from the Father to assume human flesh in the body of a woman, and could do so because the woman freely cooperated. Silvery highlights on Mary's gown in fact call attention to her womb, ready to receive the small God descending, and the *closed* book on her knees is a traditional symbol of the ancient Scriptures "fulfilled" (and therefore "closed") with the advent of the Word incarnate.

Michelangelo's Neo-Platonic education led him to lift this mystery above details of physical generation and beyond sex distinctions. Mary here is neither woman nor man, but an ideal fusion of "masculine" physical power and "feminine" emotional force. The meaning of the event is thus freed from conventional categories of family life and centered in the gaze of ineffable yearning that rises from Mary to Christ: from a "virgin" who is also "mother" of the "Son" whose "daughter" she simultaneously is, in utter transcendence of the normal laws of Nature.

In this work, Michelangelo expands the idea of "artistic subject" to the fullest degree, making his central figure, Mary, a universal symbol of human desire – of the act of desiring generated by the gaze, of the creature's longing for its Creator. Mary's body, in its strong upward-spiraling movement, brings together the physical and psychic energies of all the other figures in the *Tondo*, her "open" pose, in turn, opening and clarifying the complicated poses of the nudes, and completing that of Saint John, just as the open desire for God written on her face sublimates their desires: the specific desire for a Messiah, in John, the representative of the Chosen People, and the inchoative aspirations of the gentiles, whose philosophers dreamed of a love able to transcend human nature – a spiritualization of "natural" desire, the deep sense of

which would be revealed by the Author of Nature Himself, when the Word became flesh.

The subject of the *Tondo Doni* is this central figure, at once energetic, yearning, contemplative: the virgin daughter of Israel who gathers in her own being the desire of the ages, the desire of every human being to see God. And it is precisely *desire*, in a Neo-Platonic and above all in a biblical sense – the longing of all humankind active in Mary – that explains the "wondrous contentedness" Giorgio Vasari saw here. Here desire was fully satisfied, because in Mary God recognized the urgency of human longing and its purity, the energy and power of human love – qualities which Michelangelo communicates in the dramatic upward movement of the Virgin's body, the expression *ad extra* of interior response to an invitation from on high.

Mater dolorosa, Mater gloriosa

The optimism characterizing man's relationship with God in the *Tondo Doni* was fated to disappear. Political and social upheavals that, in barely thirty years, transformed Florence from ancient republic to dynastic principality called for a new "style" in the city's inner life and in its art. Two works of the 1520s suggest typical features of this style: the *Lamentation Over the Dead Christ*, by Andrea del Sarto, and Jacopo Pontormo's *Burial of Christ*. Commissioned for women's monasteries, these paintings present Mary as protagonist in a timeless, almost eternal, ritual of grief – as if the "river which refreshes the city of God" (Psalms 45 [46]: 5) had been reduced to a stream of tears.

Del Sarto's *Lamentation* (fig. 237), today in the San Salvi Refectory, was painted between 1523 and 1524 for the high altar of the Camaldolite monastery church of Luco, in the Mugello, at the behest of the abbess, a Florentine noblewoman named Caterina della Casa.[60] The image has strong eucharistic connotations, with a chalice and paten bearing the host in the center foreground, directly below Christ's lifeless body taken down from the cross and here ready for burial. Clearly this painted body was meant to be seen, during Mass, just beyond the sacramental body present in the bread elevated at the consecration. Yet the epicenter of the composition is not Christ but Mary, shown contemplating her Son's left arm, which she holds up in front of her womb. Around her a group of disciples mourns Christ's death and, behind them, at the left, the open tomb (here as forty years earlier in Leonardo's *Virgin of the Rocks*) alludes to Mary's womb that had enclosed her Son's body for nine months before his birth.

The other work – a *Deposition* or *Burial of Christ* commissioned by the aristocratic Capponi family for its chapel in the church of a Benedictine women's monastery on the south side of the Arno, Santa Felicita – was painted by Jacopo Pontormo between 1527 and 1528 (fig. 238).[61] The dazed state of the personages in this

238. Jacopo Carucci called "Pontormo," *Deposition* or *Burial of Christ*, 1526 – 28. Santa Felicita, Florence.
This famous work offers a visual synthesis of the political, social and religious upheavals that marked European and Florentine life

between the end of the 15th and the early decades of the 16th centuries. The dazed look of the actors, with eyes drained of hope and anguish on their faces, suggests a psychological instability that the artist underlines in the physical instability of the poses and

of the overall composition. Gone is the perfectly balanced pyramidal structure invented in Florence a century earlier; gone too is the optimism typical of Renaissance humanism, with its sense of the human capacity to impose order on the world. Mary's inconsolable

grief seems to make Pontormo (who includes himself among the mourners) a prophet of the modern spirit, burdened as it is with uncertainty as it lives the faith in history's crucible.

scene, with anguished faces and eyes empty of hope – their physical and psychological instability, and the paradoxical gaiety of the colors – suggest the mood of Florence in these years that witnessed the city's last, losing struggle against the Medici, the brutal invasion of Italy by foreign armies, and the trauma of Luther's reform which split the Church and Europe in two.

With the Santa Felicita *Burial of Christ*, Renaissance art as seen in Masaccio and Angelico, in Leonardo and Michelangelo, comes to an end. The optimism and sense of man's ability to give order to his world are no more, and – in place of straightforward gazes and quiet courage – Pontormo shows us disorientation and fear. In place of a traditionally stable compositional scheme – pyramidal and centralized – here everything sways, rotating around an empty core.

And here, as in Andrea del Sarto's *Lamentation*, the figure dominating the upper part of the painting is Mary, on whose face we read infinite, inexpressible sorrow. She inclines her head and stretches out her arm toward the body of her Son, who seems to be born again (albeit in death) from his mother's body. In his "existential" reading of the subject, Pontormo – whose own psychological fragility is well known – seems to anticipate the travail of the modern spirit. The artist's self portrait among the mourners at Mary's left (our right), speaks of the uncertainty but also intensity of a faith lived out in the crucible of history.

In the later 16th century, the Counter Reformation – eager to reiterate traditional beliefs and wary of novelties – tended to discourage a fresh approach to religious subject matter. Mary, ever present in Catholic iconography, came to have less conceptual weight – as if the poetic vein she had inspired from early Christian times to the 16th century were finally running out. Even in unquestioned masterpieces such as Jacopo da Empoli's *Annunciation* for the Strozzi Chapel in Santa Trinita, signed and dated 1603, we have a sense of *déjà vu*.[62] There is exemplary clarity in the treatment of subject, as explicitly requested by the Council of Trent, but we miss the individuality and psychological penetration of 14th-, 15th- and early 16th-century Madonnas. Despite the signs of middle class comfort with which Jacopo da Empoli surrounds her, Mary seems finally to have become the pious "poor girl" Savonarola imagined.

From the 17th to the mid 18th century, the Madonna remains among the religious personages most often represented, and we find her venerated by angels and saints practically everywhere, an institutional figure whose presence is "necessary." And among important Baroque projects, the splendid Chapel of Mary's Nativity in San Frediano, realized between 1649 and 1699 with paintings by Alessandro Gherardini, deserves mention.[63] In the canvas over the altar is a *Nativity of the Virgin* and, directly above it – in the lunette fresco – we see the Apostles around Mary's empty tomb, gazing up toward an *Assumption* in the chapel dome. Our eye is led, that is, from Mary's birth in this world, through her death and finally to her entry into the glory of heaven: everything is didactically clear and visually dramatic, an effective Baroque "machine" (as such ensembles of images were called).

This period produced many apotheosis images – domes in churches, *trompe-l'oeil* ceilings in private mansions – which similarly let people "see heaven." In the ecclesiastical versions, Mary is almost always represented, if not as the principal personage then at least as a spectator. But use of the same pictorial language in contexts at times sacred, at times profane ultimately deprived the idiom of all specific meaning, reducing biblical and hagiographical subjects, along with historic and mythological ones, to mere decoration. Baroque artists mass-produced spectacular but predictable images, that is, and visitors to churches learned to expect a glorious painted "heaven" with, among other figures, Mary. A glimpse at the clouds and general configuration was probably all most people vouchsafed such scenes.

A first reaction against similar excesses is perceptible in the *Acts and Decrees* of the Pistoia diocesan synod, which already in 1786 called for reforms similar to those finally realized by the Second Vatican Council.[64] "It is to be desired that bishops concern themselves with the seemliness of the churches in their care, removing from the same all that superfluous pomp which renders said churches neither more respectable nor more devout," Article 37 states. "In consequence of which, it might be appropriate, in country parishes, to have only one altar with, on it, only the crucifix or, at most, a picture of the patron saint or perhaps of the most holy Virgin, correcting moreover the abuse of normally keeping such images – whether of the crucifix or of the holy Virgin or some other saint – covered, the which inspires nothing but superstition."[65]

In search of a more authentic, focused spirituality, the 19th century would rediscover the past. From the 1830s through the 1850s, the Madonnas of Antonio Marini, court painter of the Grand Dukes of Tuscany, recapture the style and mood of Raphael's Florentine years: the first lustrum of the 16th century, when young Sanzio had articulated a personal synthesis of Leonardo's innovations. This neo-Renaissance style would continue for another twenty years in the art of Marini's sole pupil, Pietro Pezzati.

The 19th century's great discovery, however, was the Middle Ages. After the frivolity of late Baroque art, and the chill of Neo-

classicism, the Gothic Revival offered secure refuge from modern secularism through an energetic "rescue" of Christian tradition. The most important Marian work of the late 19th century, the new façade of Santa Maria del Fiore, was indeed perceived as a return to the religious and civic values of the most glorious period of Florentine history, the 14th century.

A text published for the unveiling of the new façade in 1884 speaks openly of this recovery of traditional values: "In the Middle Ages ... when all was symbol and allegory, artists depicted the history of the City of God and of pilgrim humankind, prayerful and triumphant in Him and in his glory. They liked neither abstruse symbols nor abstract allegories, seeking rather to show the truths that dominate every thought and are graven in every heart: the truths we all hold to be foundation and beginning of the universe, of the City, of the family – just as in this façade [of Santa Maria del Fiore], where the symbols have been chosen from that which ordinary people find sweetest in religion. In the eyes of our forebears, these great churches ... were a kind of synthesis of Christian society and of the communion of the city of man with the City of God."[66]

National pride had a role in this project, for the Neo Gothic façade was paid for in part by the royal family, the House of Savoy, and in part by the people of Italy through voluntary contributions. Florence, which had been the first political capital of the new Kingdom of Italy, remained its spiritual center, and the city's cathedral served as a kind of Temple of the Nation. The whole upper part of the new façade is in fact dedicated to Italy's poets, artists, thinkers and scientists (including Galileo), and the three crowning gables designed by the architect of the façade, Emilio De Fabris, had they not been suppressed would have exalted the Christian Architecture, Christian Poetry and Christian Music of Italy in past centuries.

The unsigned encomium of the façade quoted above insists that this assembly of historical personages and events, with its many echoes of the original façade by Arnolfo (cf. fig. 215) and of other Florentine works, constitute a return to the "truths" that formerly dominated "every thought" and were "graven in every heart," being by all considered foundation and beginning "of the universe, of the City, of the family."[67] And in the organization of the façade, the figure emblematic of these "truths" is Mary, present in a beautiful statue above the main portal – an allusion to the statue carved by Arnolfo di Cambio six centuries earlier (cf. fig. 217). Mary's role in this "visual epic" of Italian culture is explained by the author of the façade's iconographical program, the philosopher Augusto Conti: "As the mother of the Man-God, Mary the virgin is inseparable from the Redeemer in the Old and New Testaments and in the Christian era: in her find inspiration the Prophets, the Universal Church, Councils, Popes, Fathers, Doctors and Saints, the Sciences, the fine Arts, the Crafts, Charity, love of family and of the Fatherland, and in particular this Cathedral."[68]

Like the façade itself, Conti's long sentence is over laden, and – as a critic of the time remarked – "most people will lose their way looking for Aristotelian unity."[69] But the most pointed criticism came

from ordinary people, who dismissed the outcome of sixty years of competitions, public debates, referenda and rhetoric with one awful, typically Florentine epithet: "a chocolate cake."[70] The new façade of the Temple of the Nation was a masterpiece of the confectioner's art: an enormous, expensive pastiche of forms and ideas evoking a romanticized past, lacking in "Aristotelian unity." Indeed, the only unifying element in the entire composition is the inflated figure of "Mary the Virgin" as "mother of the Man-God," etc., etc., etc.

Conti's astonishing catalogue – a positivist "litany" that makes Mary not only a figure of the Church, but figure and type of every other imaginable reality (biblical, cultural, charitable, associative, political) – suggests a kind of *imaginative exhaustion*: a reduction of the chief poetic figure of the whole Christian tradition, Mary, from Woman, Bride, Mother and Queen to mere "unifying idea," "common thread," "hermeneutic key."

The 20th century would rediscover the poetry of Mary thanks to various factors: biblical studies, which have given Christians a renewed sensitivity to the literary richness of her figure in the New Testament; social changes, which, in many parts of the world, give new weight to the contribution of women; and the fragmentation and existential loneliness of the contemporary era, in which many again feel the urgent need for a Mother who can "pray for us now and in the hour of our death."

Many Marian paintings of the second half of the 20th century illustrate the rediscovered specificity and originality of contemporary religious art. Primo Conti's *Madonna and Child*, done for a church in the Isolotto quarter – Our Lady of Grace, whose cornerstone was laid during the National Marian Convention of 1954 – suggests the post-war search for a less rhetorical idiom in which to express the intimate human and divine contents of Christian themes. Conti's simplified forms and vigorous brush strokes mirror an Italy that, in those years, was opening its soul to modernity.

By contrast, the handsome *Holy Family* by Alfredo Cifariello, commissioned in 1984 for the church of Saints Gervase and Protasius, celebrates the vitality of earlier tradition along with a unique capacity to rearticulate the spirit of the past in contemporary terms. Trained in Pietro Annigoni's studio, Cifariello succeeds in translating early 16th-century Florentine monumentality into touching and familiar scenes, rich in humanity yet not wanting in transcendence.

What might the future bring? If, as many claim, the time now beginning is destined to be "a woman's millennium," should we expect significant developments in the interpretation and visualization of Mary? It is at all events clear that Marian iconography allows artists to explore issues of great contemporary interest: the role of women, the gift of children, the life of the family.

In light of its history, Florence could become a center for such exploration. Indeed, the subject and site for an important Marian work there are already indicated, since the city has been waiting 165 years for a stained glass window of the *Annunciation* in Santa Maria del Fiore, to replace the window by Paolo Uccello in the western oculus of the drum destroyed by lightening in the early 19th century.

But are we still able, today, to visualize the Annunciation?

Are we able to imagine a freedom that transforms itself into service, a *dignitas* that expresses itself in humility? Do we still nourish the hope written on the cope of the 14th-century *Madonna* in the confraternity loggia (cf. fig. 216), that the earth be "filled with the mercy of the Lord"?

If the answer is "no," do we at least desire to rediscover that hope, that faith, that love? In Florence and in Florentine art of the past, Mary has stood for greatness of heart, religious and human "piety," and "whatever in creatures constitutes goodness," as Dante put it. Acceptance of such a heritage goes beyond "cultural programming," requiring a response similar to Mary's own: a fecund

"yes" that inserts all who pronounce it in the mystery she lived two thousand years ago.

In the Gospel indeed "mother of Christ" is the title of all those who listen to God's word and put it into practice (Luke 8:21).

And Mary herself is the icon of a collective calling, a figure of the city that can never fail since God is in her midst. Thus the wish or – more exactly – *prayer* with which this book ends is that Europe may again open its heart to God's Spirit, accepting the Life its own history offers it, in order to rediscover a freshness and generosity that – in the past, at least – Europeans recognized and loved in the Virgin Mother of Christ, Mary.

¹ Cf. St. Augustine, *La Vergine Maria. Pagine scelte*, ed. M. Pellegrino, Milan 1987; R. Cantalamessa, *Maria, uno specchio per la Chiesa*, Milan 1989; L. Gambero, *Maria nel pensiero dei padri della Chiesa*, Milan 1991; G. Ravasi, *L'albero di Maria. Trentun "icone" bibliche mariane*, Milan 1993.

² T. Verdon, *La Toscana e il Giubileo*, in *Toscana nuovo millennio. Cultura, percorsi, eventi per il Giubileo e oltre*, ed. G. Cherubini and N. Baldini, Florence 1999, pp. 48 – 66.

³ I. Lavin, *Santa Maria del Fiore. Il Duomo di Firenze e la Vergine incinta*, Rome 1999.

⁴ R. Ceriello (ed.), *I rimatori del dolce stil novo*, Milan 1950, p. 46.

⁵ G. Kay (ed.), *The Penguin Book of Italian Verse*, Baltimore 1958, pp. 52 – 53.

⁶ Ceriello, op. cit. (n. 4), p. 109.

⁷ T. Verdon, *L'arte sacra in Italia*, cit. (chap. 1, n. 5), pp. 90 – 118.

⁸ Various Authors., *L'"Immagine antica" della Madonna col Bambino di Santa Maria Maggiore. Studi e restauro*, ed. M. Ciatti and C. Frosinoni, Florence 2002.

⁹ Apostolic Letter *Duodecimum saeculum*, 4.12.1987, in *Acta Apostolicae Sedis* 80 (1988): 241 – 252. Cf. John Damascene, *Discourse on Sacred Images*, 1,16, in *Die Schriften von Johannes von Damaskos*, ed. B. Kotter, Berlin-New York 1975, vol. III, pp. 73 – 75.

¹⁰ 'Delibera' of the Comune di Firenze, 29 marzo 1412. Cf. C. Guasti, *Santa Maria del Fiore. La costruzione della chiesa e del campanile secondo i documenti*, Florence 1887, p. cxiii. Cf. T. Verdon, *Costruire una casa per il Signore* (in the series "Alla riscoperta di Piazza del Duomo in Firenze", 1), ed. T. Verdon, Firenze 1992, pp. 93 – 115.

¹¹ Sant'Agostino, *Sermo* 195,1 – 3; PL 38, 1018. 12 D.M. Turoldo, R.M. Tacci, M. Del Piazzo, P. Bargellini, *Il santuario di Firenze. Storia e arte alla SS. Annunziata*, Milan 1957.

¹³ T. Verdon, *Arte, fede, storia. Guida alla Firenze cristiana*, Florence 1999, pp. 73 – 81.

¹⁴ D.F. Zervas, *Orsanmichele dalle origini al Settecento*, in *AA.VV.*, *Orsanmichele a Firenze*, ed. D.F. Zervas, Modena 1966, 2 vols., 2:9 – 264, cf. p. 43.

¹⁵ Ibid., p. 81; cf. note 18, p. 96.

¹⁶ Ibid., p. 168 ff.

¹⁷ Ibid., passim.

¹⁸ H. Kiel, *Il Museo del Bigallo a Firenze*, Florence 1977; H. Saalman, *The Bigallo. The Oratory and Residence of the Compagnia del Bigallo e della Misericordia in Florence*, New York 1969; T. Verdon, *La Piazza e la carità. Gli istituti di aiuto fraterno intorno al Duomo*, in *I tesori di Piazza del Duomo* ("Alla riscoperta di Piazza del Duomo in Firenze", VI), ed. T. Verdon, Firenze 1997, pp. 9 – 40.

¹⁹ *Summa teologica*, Verona 1740, t. I, tit. 15, chap. 3.

²⁰ T. Verdon, *Spiritualità e arti figurative*, in *La Cattedrale di Santa Maria del Fiore a Firenze*, vol. 2, ed. C. Acidini Luchinat, Florence 1995, pp. 19 – 30.

²¹ G. Villani, *Cronica*, VIII, 9, Florence 1845 – 1846. Cf. E.N. Lusana, *La decorazione e le sculture arnolfiane dell'antica facciata*, ibid., pp. 31 – 72; T. Verdon, "Tutta di marmi e con figure intagliate": la facciata di Santa Maria del Fiore," in *La facciata di Santa Maria del Fiore* ("Alla riscoperta di Piazza del Duomo in Firenze," V), ed. T. Verdon, Florence 1996, pp. 7 – 32.

²² See above, n. 10.

²³ M. Meiss, *An Early Altarpiece from the Cathedral of Florence*, in "Bulletin of the Metropolitan Museum of Art," XII, 1945, pp. 302 – 317; T. Verdon, *The Intercession of Christ and the Virgin from Florence Cathedral. Iconographic and Ecclesiological Significance*, in *La Cattedrale come spazio sacro. Saggi sul Duomo di Firenze* (Atti del VII Centenario del Duomo di Firenze), 3 vols., ed. T. Verdon e A. Innocenti, Florence 2001, II, t. 1, pp. 130 – 149.

²⁴ *Sermo* 51. Cf. PL 194, 1862 – 1863.

²⁵ Ibid.

²⁶ *Teologia platonica de immortalitate animarum*, X, in Marcile Ficin, *Théologie de l'immortalité des âmes*, Paris 1964, vol. II, pp. 59 – 60.

²⁷ T. Verdon, *Aspetti della spiritualità fiorentina nelle arti figurative intorno al 1422*, in *Masaccio 1422. Il Trittico di San Giovenale e il suo tempo*, ed. C. Caneva, Milano 2001, pp. 103 – 112.

²⁸ *Libretto della dottrina cristiana attribuito a Sant'Antonino arcivescovo di Firenze*, ed. Gilberto Aranci, Florence 1996, p. 78.

²⁹ B. Cole, *Masaccio and the Art of the Early Renaissance*, Bloomington (Indiana) 1980, p. 112.

³⁰ For the patristic influence on Quattrocento thought, cf. C. Trinkaus, *In Our Image and Likeness. Humanity and Divinity in Italian Humanist Thought*, 2 vols., Chicago 1970.

³¹ For Quattrocento Christology, cf. M. Gronchi, *La Cristologia di S. Bernardino da Siena. L'imago Christi nella predicazione in volgare*, Genoa 1992.

³² B. Giovanni Dominici, O.P., *Lettere spirituali*, ed. M.-T. Casella e G. Pozzi, Freiburg 1969, p. 83.

³³ Ibid.

³⁴ Ibid. p. 99.

³⁵ Ibid. p. 159.

³⁶ T. Verdon, *La Sant'Anna Metterza: riflessioni, domande, ipotesi*, in "Gli Uffizi. Studi e ricerche", 5, 1988, pp. 33 – 58.

³⁷ W. Hood, *Fra Angelico a San Marco*, New Haven-London 1993, pp. 255 – 272; T. Verdon, *L'arte sacra in Italia*, cit. (above, chap. 1, n. 5), pp. 139 – 149.

³⁸ T. Verdon, *Arte, fede, storia*, cit. (above, n. 12), p. 67.

³⁹ R.G. Kecks, *Madonna und Kind. Das häusliche Andachtsbild im Florenz des 15. Jahrhunderts*, Berlin 1988.

⁴⁰ L. Steinberg, *The Sexuality of Christ in Renaissance Art and in Modern Oblivion*, New York 1983.

⁴¹ R. Lightbown, *Sandro Botticelli*, Milan 1989, pp. 82 – 85.

⁴² Sermon of Friday after third Sunday of Lent 1496; M. Ferrara, *Prediche e scritti*, Milan 1930,

p. 387. Cf. M. Hall, *Savonarola's Preaching and the Patronage of Art*, in *Christianity and the Renaissance. Image and Religious Imagination in the Quattrocento*, ed. T. Verdon and J. Henderson, Syracuse-New York 1990, pp. 493 – 522.

⁴³ L. Berti, U. Baldini, *Filippino Lippi*, Florence 1991, pp. 182 – 183; cf. T. Verdon, *Arte, fede, storia*, cit. (above, n. 12), pp. 86 – 87.

⁴⁴ T. Verdon, *Spiritualità rinascimentale nella Vergine delle Rocce: saggio di metodo interpretativo*, in "Arte lombarda," 66/67, 1986, pp. 100 – 112.

⁴⁵ A.S. Mantova, archivio "Gonzaga," serie E, xxviii, 3, busta 1103. Cf. E. Solmi, *Leonardo*, Florence 1900, p. 129.

⁴⁶ But in the big Leonardo drawing in the National Gallery, London, in place of the lamb we find Saint John the Baptist.

⁴⁷ Cited in C. Cavedani, *Del concetto religioso espresso nel gruppo della Sacra Famiglia di Guido Mazzoni*, in "Memorie di religione," series 3, t. 13, Modena 1852, pp. 193 – 203. Cfr. T. Verdon, *Art of Guido Mazzoni*, cit. (above, chap. 2, n. 41), pp. 109 – 110.

⁴⁸ See, for example, the *Dichiarazione di alcune cose pertinenti alla morte, sepoltura, descender al Limbo, risuscitare, manifestarsi, ascender in cielo, seder alla destra del Padre et potestà del nostro Signor Jesu Cristo per modo di dialogo*, Biblioteca Medicea Laurenziana, Ashburnham 310 (242), c. 4v.

⁴⁹ *La Passione del Nostro Signore*, Biblioteca Medicea Laurenziana, Ashburnham 1542 (1465), c. 74v.

⁵⁰ Ivi, 86.

⁵¹ T. Verdon, *Amor ab abspectu. Maria nel Tondo Doni e l'umanesimo cristiano*, in *Teologie a Firenze nell'età di Giovanni Pico della Mirandola* (V Centenario della morte di Giovanni Pico della Mirandola: Vivens homo 5), ed. G. Aranci e P. De Marco, T. Verdon, Bologna 1994, pp. 531 – 552. On the Doni family, see A. Hayum, *Michelangelo's Doni Tondo: Holy Family and Family Myth*, in "Studies in Iconography," 7/8, 1981/1982, pp. 209 – 233; A. Cecchi, *Agnolo e Maddalena Doni committenti di Raffaello*, in *Atti del Congresso internazionale di studi su Raffaello*, Urbino-Florence 1987.

⁵² Giorgio Vasari, *Vita di Michelangelo*, in *Le opere di Giorgio Vasari*, ed. G. Milanesi, Florence 1906, vol. VII, p. 158.

⁵³ Ibid.

⁵⁴ On the development of the iconography of Saint Joseph, see C. Hahn, "Joseph Will Perfect, Mary Enlighten, and Jesus Save Thee." The Holy Family as Marriage Model in the Mérode Triptych, in "The Art Bulletin," 68, 1986, pp. 54 – 66.

⁵⁵ M. Ficino, *In Convivium Platonis*; R. Marcel (ed. e tr.), *Marsile Ficin. Commentaire sur le Banquet de Platon*, Paris 1956.

⁵⁶ *Symposium* 209e – 212a: cf. R. Jowett, *The Dialogues of Plato*, New York 1892, 1, pp. 334 – 335.

⁵⁷ *Oratio* 6, caput viii (R. Marcel, *Marsile Ficin. Commentaire*, cit., above n. 55, p. 212).

⁵⁸ Ibid.

⁵⁹ I owe this intuition to professor Leo Steinberg, who shared it with me in conversation more than thirty years ago.

⁶⁰ S. Padovani, *Compianto su Cristo morto*, in *Andrea del Sarto 1486 – 1530. Dipinti e disegni a Firenze* (exhibit catalogue, 8 novembre – 1 marzo 1987, Palazzo Pitti), ed. M. Chiarini, Milano 1987, pp. 129 – 131.

⁶¹ T. Verdon, *L'arte sacra*, cit. (above, cap. 1, n. 5), pp. 247 – 255; Id., *Arte, fede, storia*, cit. (above, n. 12), pp. 104 – 107.

⁶² S.L. Giovannoni, *La Cappella Strozzi*, in *La chiesa di Santa Trinita a Firenze*, ed. G. Marchini, E. Micheletti, Florence 1987, pp. 170 – 175.

⁶³ L. Conti, M.N. Cortini, M.F. Vadalà Linari, *San Frediano. Un culto, un popolo, una chiesa*, Florence 1997, pp. 99 – 101.

⁶⁴ M. Verga, *Le riforme ecclesiastiche di Pietro Leopoldo*, in *Le riforme di Pietro Leopoldo e la nascita della Toscana moderna*, ed. V. Baldacci, Florence 2000, pp. 61 – 70.

⁶⁵ Ibid, p. 68.

⁶⁶ "G.R.," *L'arte cristiana. Augusto Conti e la facciata del Duomo di Firenze*, Prato 1884, p. 3. Cf. T. Verdon, "Tutta di marmi e con figure intagliate." *La facciata di Santa Maria del Fiore*, in *La facciata di Santa Maria del Fiore* (in the series "Alla riscoperta di Santa Maria del Fiore in Firenze", V), ed. T. Verdon, Firenze 1996, pp. 7 – 32; Id., *L'arte sacra in Italia*, cit. (above, chap. 1, n. 5), pp. 313 – 317.

⁶⁷ Cf. above, n. 64.

⁶⁸ A. Conti, *Alcune parole sugli ornamenti della facciata*, in G. Porciani, *In omaggio a Santa Maria del Fiore miracolo d'arte, ricordo artistico-letterario*, Florence 1887, p. 10; cf. C. Cresti, *Firenze, capitale mancata. Architettura e città dal piano Poggi ad oggi*, Milan 1995, pp. 74 – 75; cf. A. Poma Swank, *Il programma decorativo della facciata e l'iconografia mariana nell'Ottocento*, in *La facciata di Santa Maria del Fiore*, ("Alla riscoperta di Piazza del Duomo in Firenze", V), ed. T. Verdon, Florence 1996, pp. 33 – 70.

⁶⁹ Article of C.J. Cavallucci in "La Nazione," 1 December 1883.

⁷⁰ A. Poma Swank, *Il programma*, cit. (above, n. 68), p. 41.

Appendix

Index of the Artists and Their Works

Numbers in italics refers to illustrations